The Missing Mother

Edited by Andrea O'Reilly
and Martina Mullaney

DEMETER

The Missing Mother
Edited by Andrea O'Reilly and Martina Mullaney

Demeter Press
PO Box 197
Coe Hill, Ontario
Canada
K0L 1P0
Tel: 289-383-0134
Email: info@demeterpress.org
Website: www.demeterpress.org

Demeter Press logo based on the sculpture "Demeter" by Maria-Luise Bodirsky
www.keramik-atelier.bodirsky.de

Printed and Bound in Canada

Cover image: *Usually she is disappointed, 2018*, Martina Mullaney
Cover design and typesetting: Michelle Pirovich
Proof reading: Jena Woodhouse

Library and Archives Canada Cataloguing in Publication
Title: The missing mother / edited by Andrea O'Reilly and Martina Mullaney.
Names: O'Reilly, Andrea, 1961- editor | Mullaney, Martina, 1972- editor
Description: Includes bibliographical references.
Identifiers: Canadiana 20240466012 | ISBN 9781772585087 (softcover)
Subjects: LCSH: Motherhood,–Social aspects. | LCSH: Mothers,–Social conditions.
Classification: LCC HQ759 .M57 2024 | DDC 306.874/3,–dc23

 Funded by the Government of Canada | Canadä | The publisher gratefully acknowledges the support of the Government of Canada

Contents

Introduction

The Missing Mother

Andrea O'Reilly and Martina Mullaney

The Missing Mother interdisciplinary online conference, from which this collection is developed, took place via Zoom in April 2021 at the University of Bolton and was organized by Dr. Martina Mullaney, Dr. Julie Prescott, Dr. Valerie O'Riordan, and Dr. Paul Hollins. It featured keynote speaker Dr. Andrea O'Reilly (York University, Toronto). It came from Martina Mullaney's research on the missing mother and her previous discursive project *Enemies of Good Art*. More than three hundred delegates registered for this two-day event, with thirty-four papers presented; on average, one hundred delegates were in attendance across both days. Women gathered from Australia, Europe, Canada, and the United States, working around childcare needs and joining online from offices, studios, and kitchen tables.

The conference aimed to address spaces of scholarly and creative enquiry from which the figure of the mother has historically been missing. Papers ranged from lived experiences of institutional sexism and its consequences to maternity as academic work in an art context. Ciara Healy gave a powerful account of unexplained infertility as taboo in representations of the childless mother in art through the work of Elina Brotherus. Jill Marsden looked at constructions of maternity in fiction, and Martina Cleary addressed the symbolic order of the mother. Irish politics and the campaign for reproductive rights were the focus of Rachel Fallon's work. Papers were delivered as performances and traditional academic papers and were positioned as conversational and collaborative. The conference was a platform from which artists and scholars could launch ideas, however personal, radical, and angry they might have been.

This collection, developed from the conference, explores the concept of the missing mother from two interrelated standpoints: the mother as absent in society and the mother as absent in a woman's selfhood. The first perspective considers why and how the mother is disregarded, discounted, or dismissed in art, literature, culture, policy, and law, whereas the second perspective explores why and how a woman has lost, forgotten, forfeited, or abandoned her maternal identity. As we were working on the collection and writing this introduction, we were reminded of the portraits of the hidden mother in Victorian photography and saw them as an apt visual metaphor for this collection. When photographs were taken in the Victorian era, it took fifteen or so minutes for the camera to capture the image; thus, mothers were required to hold their children and keep them still until the portrait was taken. However, since the photograph was of the children and not the mother, the mother was hidden behind or under textiles. Despite the many variations on how the mother was hidden in these portraits, what remains constant, as Susan E. Cook emphasizes, is that "the mother is defined through her effacement."

However, this need to hold a child does not sufficiently explain why the mother had to be so invisibilized in these portraits. In her article "Why Do Victorian 'Hidden Mother' Photographs Shock Us?" Andrea Kaston Tange argues that these portraits "make literal the expectations placed upon Victorian women: to be manifestly embodied, labouring, supportive beings—holding, cleaning, clothing—and then to still that labour for a picture-perfect moment." She elaborates:

> Activity is erased by photography, literally blurred out of the picture if a subject moves. The better the mother's work, the crisper the photograph, the more perfect-looking the child. Paradoxically, the photograph's stillness is made possible by a mother's continuous labour, and her labouring body is emphasised by the textiles that drape its contours. Erasing her is therefore a wilful act: a viewer must *choose* to read this mother as hidden.

Paradoxically, as Tange notes, it is the mother's work that has kept the child still and made the photograph possible. Moreover, though the mother is camouflaged, she is still highly visible. The effacement of the mother and the erasure of mothering are intentional; the viewer chooses not to see them. In this, as Tange writes, "The hidden mother photographs

are not an historic oddity but part of a continuous history of pretending that mothering is fundamentally marginal." However, in many of the portraits, whether intentional or not, the mother renders herself and her motherwork visible to, in Tange's words, "defy the trope of invisibility and offer silent resistance to implied invisibility."

Like the hidden mother portraits, this collection seeks to expose the effacement of mothers and the erasure of mother work in society—across law, policy, culture, art, and literature—to defy and subvert this invisibilization of mothers and mothering. The hidden mother portraits also serve as an apt visual metaphor for the second theme of the missing mother of this collection: the denial or abandonment of a woman's own maternal identity. Whether it is a society that erases the maternal or a woman who forsakes it, this collection aims to consider the why, how, what, who, and where of the mechanics of the missing mother in both society and self. Following Tange, we believe and assert the following:

> We owe it to generations of mothers to resist the narrative that the work of mothering is so easy to erase. We might productively align ourselves with the "hidden" bodies whose intimate connection to children is central to every one of these photographs. At the same time, we must acknowledge that there is something ridiculous— and occasionally even violent—in these efforts at erasure.

With this collection, we align ourselves with these hidden mothers to seek and find the missing mother in society and self.

The book's first section considers the missing mother in society—why and how mothers and mothering are disregarded, discounted, or dismissed in art, literature, culture, policy, and law. The opening chapter "Absent(ed) Mothers in Ireland and Elsewhere: Erasures of Maternity in Adoption Law, Policy, and Literature" by Alice Diver explores the concept of maternal erasure via nonconsensual relinquishments in law and literary fiction. It argues that recent legislative reforms in Ireland perpetuate the shame and stigmas surrounding unwed motherhood, regardless of jurisdiction. The timeless literary trope of the erased mother—rendered invisible and silent for the apparent good of society, her child, or herself— is rich with warnings, irony, and symbolism. Lawmakers could do worse than look to some of the fictional narratives on erased maternities for insights and guidance as to how (and why) forced infant relinquishments frequently violate basic human rights and the concept of maternal dignity.

The deliberate erasure of mothers—in both law and literature, across differing genres, eras, and national boundaries—represents a deep failure on the part of society to acknowledge the importance of natal connection and authentic identities. In the next chapter, "The Missing Maternal Body in the Narratives of Young Catholic and Muslim Mothers in Poland," Joanna Krotofil, Dorota Wójciak, and Dagmara Mętel analyze how in the Polish sociocultural context, embodied maternal subjectivity is erased from public discourses and the mothers' own stories. Specifically, they look into religious and medical discourses on early motherhood and trace how their alliance traps women in silence about their embodied experiences and how women navigate these dominant practices.

The next three chapters explore how mothers and mothering are missing in art. In her chapter "The Missing Mother: Feminism's Ghettoization of Artists with Children," Martina Mullaney identifies the mother as missing from feminism and art history by examining the anthologies, conferences, and group exhibitions dedicated to these subjects. Due to the exclusion of art derived from maternal experience, art and writing on maternity operate in spaces and initiatives dedicated to them, a form of feminist separatism by default. In contemporary art exhibitions, art on the maternal experience must seek its opportunities, as maternity rarely features in mainstream contemporary art spaces. The following chapter, "Unseen and Unheard: How the Histories of Missing Mothers Informed the *Aprons of Power* Performances" by Rachel Fallon, builds upon the previous chapter to explore how the performance of aprons signifies hidden social histories of mothers. The chapter is dedicated to all hidden, missing, and unacknowledged mothers, especially those failed by the Irish system. The following chapter, "Art's Otherwised Orphans: Conceiving the Disoeuvre and Recognizing Art's Cultural Mothers" by Felicity Allen, discusses the significance of "cultural mother"—that is, public acknowledgement and historicization of women's work in visual art. She shows how a lack of recognition was for her generation and others analogous to being orphaned and introduces her concept of the disoeuvre to establish a more complex and inclusive reading of art, especially that made by people positioned as marginal. Finally, as part of a wider series of discursive events, she discusses the series of Disoeuvre Household exhibitions showing intergenerational women artists.

"Mother Ireland and Missing Mothers: Staging Maternal Encounters in Alanna O'Kelly's *The Country Blooms, a Garden and a Grave* (1990-

1996)" by Kate Antosik-Parsons interrogates how the allegorical Mother Ireland contributed to a feminine imaginary that effectively erased mothers who failed to adhere to conservative societal norms. She explores how feminist artmaking critiqued universalizing representations of the maternal by focussing on missing mothers and addressing themes directly challenging the static Mother Ireland. For Antosik-Parsons, O'Kelly's collective famine works negotiate complex encounters with the maternal body and fleshes out the nuances of maternal lived realities, contributing to the dismantling of the iconic Mother Ireland. This section's final chapter, "The Regenerative Potential of Myth in Reconstituting the Missing Mother" by Martina Cleary, uses an autoethnographic approach to explore the missing mother as it relates to the control of maternity within the Irish cultural context. It discusses the implications for mothers and daughters living within a culture where maternity is the most contested of all territories. Drawing upon feminist and psychological sources, this chapter discusses the potential of myth to provide more woman-centred sources for navigating the psychological space between mother and daughter. Here, myth is examined for its potential to regenerate and reconstitute what has been suppressed, erased, or forgotten.

The second section explores the missing mother in women's selfhood— that is, how and why the mother identity has been marginalized, lost, forgotten, forfeited, or abandoned. The first four chapters consider the abandoned maternal self in literature. The opening chapter, by Andrea O'Reilly is "Critiquing, Correcting, Defying, and Displacing Normative Motherhood: Reading Five Narratives of Mothers Who Leave as Demon Texts: *Hiroshima in the Morning, Patsy, The Shame, I Love You But I've Chosen Darkness*, and *When I Ran Away*". The chapter examines five narratives of maternal absence along a continuum from critique to displacement to argue that while temporary absences away from husband and family may result in a critique of normative motherhood, it is only when maternal absence is more lengthy and mothers do not return to their marriages that normative motherhood can be fully displaced to make possible empowered mothering. In other words, these texts of maternal absence suggest that empowered mothering can only be achieved outside the nuclear family and with the mother living apart from her children as a noncustodial parent. The next chapter, "The Missing Mother in *King Lear*" by Emma Dalton, considers the critical response to Rachel McDonald's 2012 staging of *Queen Lear* to argue that theatre critics and

scholars should look to motherhood studies for insight. The physical manifestation of the missing mother character was met with negative criticism when the space of the longed-for mother was filled with a complex mother figure who did not live up to expectations. Dalton argues that Queen Lear's behaviour can be understood through the lenses of unruly women and intensive mothering. In the next chapter, "Fictions of Maternity: Reading and Rewriting the Mother in Three Narratives of the Abandoned Wife," Jill Marsden argues that the mother is missing from the dominant patriarchal marriage plot. Specifically, the chapter explores what it means to be a mother once one is no longer a wife, an issue both raised and elided by the classic narrative of the abandoned wife: Simone de Beauvoir's *The Woman Destroyed*. Situating Patricia Highsmith's *Edith's Diary* (1977) and Elena Ferrante's *The Days of Abandonment* (2002) in dialogue with Beauvoir's text, Marsden argues that a matrifocal reading renders visible the strong mother within the story of the "broken" wife, revealing not only how the literary protagonists read their respective maternal scripts but also how motherhood might be rewritten once divested of patriarchal assumptions.

The final chapter on the missing mother in literature, "Making Masculine Maternity Visible in A.K. Summers's *Pregnant Butch*" by Christa Baiada, explores how the interplay of text and image essential to the genre of graphic narrative functions to make masculine maternity both present and visible. Summers's graphic memoir brings the butch mother's body and complex experience of pregnancy to the forefront. In doing so, Baiada argues, *Pregnant Butch* contributes to an unmooring of maternity from femininity that broadens our cultural vision to recast maternity as also masculine. It makes space for the butch mother, as well as the wider community of masculine-identified or genderqueer mothers, in discourses and representations of mothering from which they are too often missing.

The next chapter, "Mother to the Other", by Ciara Healy, examines what it means to have missed out on conventional concepts of motherhood due to infertility. Specifically, the chapter highlights through poetry and academic writing how female infertility has been stigmatized in historical, psychological, medical, feminist, and visual art discourses. It proposes an alternative ontology of mothering, supported by the ideas of new materialism. In the final chapter, "Pregnancy, Postpartum, and OnlyFans: Missing and Absented Performances of Motherhood", by Clara Kundin uses an autoethnographic approach to explore her experiences as an online sex worker during her pregnancy and postpartum period. Using

her narrative as a guide, Kundin identifies missing representations of mother sex workers and the lack of acceptance around maternal sexuality while demonstrating the complexity around performances of maternal identity and sexuality, both online and off.

Conclusion

O'Reilly's research on motherhood and feminism explores the disavowal of motherhood in twentieth-century academic feminism and its disappearance in the twenty-first century and offers possible explanations for this disappearance and disavowal, whereas Mullaney's research questions the invisibility of the woman artist with children, canon forming, and the negation of maternity from the history of feminism and art. This collection expands upon these explorations to consider how and why the maternal is disavowed and disappeared in society as enacted in law, policy, culture, literature, and art, and how and why this happens with individual women when they deny or forfeit the maternal dimension of selfhood. This collection also considers reasons for this disavowal and disappearance, suggesting the maternal is marginalized in society because of the larger cultural devaluation and disparagement of mothers and mothering. However, the collection also shows how mothers recover and reclaim the maternal in society and themselves. Continuing with the visual metaphor of the hidden mother in the Victorian portraits, this collection seeks to pull back the veil to uncover and reveal the mother so marginalized and maligned in and by patriarchal culture. In this, women may find the missing mother in society and themselves and achieve empowerment.

Works Cited

Cook, Susan. "Hidden Mothers: Forms of Absence in Victorian Photography and Fiction." *Nineteenth-Century Gender Studies*, vol. 17, no. 3, 2021, https://www.ncgsjournal.com/issue173/cook.html. Accessed 14 Sept. 2024.

O'Reilly, Andrea. *Matricentric Feminism: Theory, Activism, Practice*. 2nd. ed. Demeter Press, 2021.

Tange, Andrea Kaston. *Psyche*. https://psyche.co/ideas/victorian-hidden -mothers-and-the-continued-erasure-of-mothering. Accessed 14 Sept. 2024.

Mom's Room

Victoria Bailey

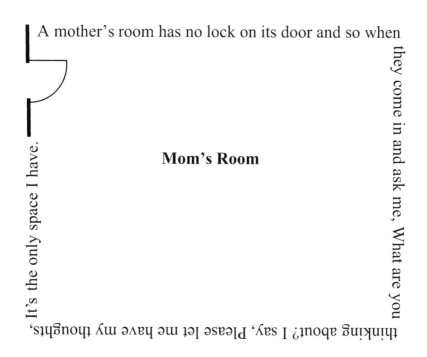

A mother's room has no lock on its door and so when they come in and ask me, What are you thinking about? I say, Please let me have my thoughts, It's the only space I have.

Mom's Room

Heart of Fool's Gold

A.S. Compton

Stand night vigil
contemplating impotence of
wanting to change the world,
of energy and hope wasted, of
so many good intentions
without fruition.

Intending impartiality, but becoming
 cynicism. apathy.

Daily weight of dumped dinners,
tired tantrums, and broken toys against
bright and perfect pictures, knowing
we'll never be as glittery and appealing.

> *Pyrite*
> Imitation of gold, easily seen for
> a fraud. Undesirable,
> sharp but brittle, useless.

Nighttime vigils amongst discarded
ore, those of us too exhausted to
continue. Where together can
become
simple harmony, a spark,
with which to build
pyrite pathways of solar power.

Everyday guilt of motherhood,
of getting it wrong, of hopes wasted
like useless pyrite, until
we build to transcend,
raise up a future
far brighter than the past.

Section I
The Missing Mother in Society

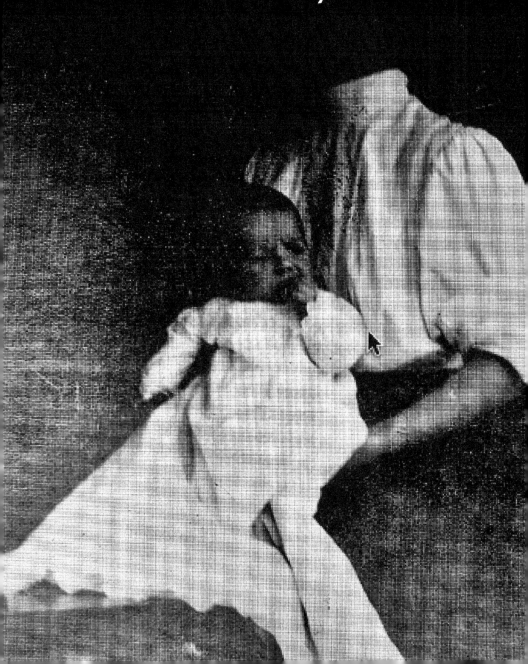

1.

Absent(ed) Mothers in Ireland and Elsewhere: Erasures of Maternity in Adoption Law, Policy, and Literature

Alice Diver

Introduction

> Why did it take people having to tell their life stories before those in government listened? It was about protecting other agencies and other people and not about protecting the vulnerable people who had been adopted or lost their lives in mother and baby homes.
>
> —Richard O'Donoghue

This chapter analyses the concept of maternal erasure in adoption law and policy by examining how certain works of fiction have represented orphanization and nonconsensual infant relinquishment. It looks then to some of the recent discourse on Ireland's Birth and Information Tracing Act (2022)[1] and how this piece of legislation, though far from perfect, might serve as a potentially useful template for other jurisdictions seeking to promote or reform adoptee rights (such as access to information and familial reunion). Regarding maternal erasure, it is a

particularly relevant statute given that it excludes searching mothers from its open access remit; likewise, it is not particularly aimed at the easy achievement of familial reunions. Yet analysis of its slow journey towards enactment provides telling insights into the Irish state's long history of high-walled shaming and ill-treatment of unmarried mothers and their children. Ireland's system of incarceration—as a means of dealing with unwed motherhood and illegitimacy—served as a model for many other jurisdictions (such as Canada, Australia, and the United Kingdom). A brief look at maternal testimonies gleaned from reports and inquiries held in Ireland, England, and Northern Ireland is also included here.

As Emily Hipchen observes of adoption searches, "The problem is universal, its politics never very far from the nerve ends of everyone who by virtue of being born, being severed, is looking to reunite" (10). I argue in the first half of this chapter that the various literary and cultural tropes on erased, invisible motherhood have served to inspire—if not reinforce—those sociolegal customs and norms demanding that unwed motherhood should be neither seen nor heard. A policy of maternal absenting renders mothers irrelevant and facilitates the legalized relinquishment of their infants by reinforcing the myths of orphanization, which then also serve to discourage any hope of subsequent reunion. The figure of the erased mother has been represented in works of literary fiction across differing eras and genres (such as in the Victorian golden age of adoption and dystopian novels), with maternal invisibility appearing as both harmful and heritable. It is an essential device, however, as decision-makers need the myth of consensual relinquishment to enable, justify, and legalize forced adoptions.[2]

Absent(ing) Maternity: Literary and Cultural Tropes as Sociolegal Templates?

> The legal landscape of adoption requires an explanation of the government policy objectives that led to the increased usage of non-consensual adoption.
> —Samantha Davey

Tropewise, the invisible, erased mother figure has a long legal, sociocultural, and literary history across many genres and jurisdictions, not least

in Ireland, England, and Canada. Her absence is tied to a policy of deliberate orphanization (where a child who is not an orphan is treated as one legally to enable their transfer to another family or homeplace) and the need to achieve the consensual relinquishment of her child. In various novels (discussed below), her absence may be underpinned or occasioned by some romantic or monstrously Gothic narrative (e.g., *Jane Eyre* [1847] and *Wuthering Heights* [1847]), where the orphan may be a hero or villain, perhaps with supernatural elements aiding their reunion or quest for redress or preventing further intergenerational harms. Maternal invisibility may be framed as largely irrelevant (e.g., *Anne of Green Gables* [1908]) or as an egregiously feckless deliberate absence, even where it is tied to poverty and social vulnerabilities (e.g., *An Episode of Sparrows* [1955]). Conversely, maternal erasure may be backdropped by simmering societal unrest—or eventual revolt—in some near-future dystopia (*Logan's Run* (1967)). It might be presented as a particularly malign and politically motivated device (*The Handmaid's Tale* (1985)), or as a profoundly benevolent, altruistic career choice (*The Giver* [1993]), where, as ever, the law's role is to enable and justify the orphanization of the commodified child and ensure the easy relinquishment of motherhood.

Most cultures have a long history of highly emotive, folkloric tales on infant abandonment and the loss of motherhood, consensual or otherwise. Many laws and customs (on the practice of exposure for example) can similarly be traced back to or before the age of Classical Antiquity. As John Francis Brosnan argues, "To trace adoption historically is an interesting commentary on racial and national life" (332). Generally, the folklore on the loss of motherhood offers stark warnings: Reunions are likely dangerous and should be discouraged where possible. The abandoned, othered child may well return seeking revenge, in the form of an adult human, a spirit, or a demon. The reasons for infant relinquishment, voluntary or otherwise, were often complex, including, for example, poverty, abnormality, illegitimacy, or some "religious, ominous, and spiritual reason" (Israelowich 218). It is unsurprising then that, as Cheryl Nixon argues, by the eighteenth century, the definition of orphan had become expansive, allowing for "multiple possibilities" (4). Wealth, privilege, and the occasional happy familial reunion abounded until the forceful imagining of Victorian writers reframed the orphan as a generally destitute, abandoned waif, possibly afflicted by illegitimacy. Uncertain or unknowable ancestries were likely harmful, and, arguably,

maternal erasure might have served a protective purpose. Mary Shelley's *Frankenstein* (1818) offers an especially Gothic take on the dangers of abandonment, foundling searches for origins or answers and the potentially monstrous nature of any subsequent rejection or reunion with one's creator or genitor (Diver). The Brontës' tendency to rely upon orphanhood, or early abandonment, of their chief protagonists is most relevant here. There might be slow-burning, stoic heroism, as in *Jane Eyre,* with eventual rewards (familial and fiscal) arising from the orphan's politely determined resistance. Jane does not deliberately seek out her genetic kinfolk, finding them only by accident, after much stumbling about through storms and muddy bracken. Her mother—conveniently and normatively deceased—remains invisible: We are given little of her back story, which, though worthy, is largely irrelevant for much of the plot. She was married and therefore respectable, though she did not marry well, so there is still some element of shame and mystery. Oddly, Jane is never seen to be particularly curious about that long-lost side of her family, although we might assume that such things must have crossed her mind at some point in between the various moments of high drama. Her eventual familial reunion and substantial inheritance involve no direct challenges to the prevailing laws, policies, or social norms: Her mother was married, making Jane a legitimate Eyre and heir(ess).

Yet like many foundlings of this and earlier eras, she had the power to spark the sort of communal fears fuelling the "prevalent eighteenth-century cultural view of a bastard" and their "capacity to disrupt the smooth transfer of property and to poison the emotional well-being of the legal family" (Zunshine 503). It is perhaps because of this that both she and her mother had to be frequently rendered invisible, via a convenient death, rehomings, and disappearances, freeing Jane up for her triumphant, abuse-overcoming narrative. As a stoic adoptee and orphanized scholar, she is perfectly placed to emerge as a heroic protofeminist. Had she instead deliberately sought out information on her original relatives or demanded from her adoptive carers (the Reeds) some form of kinship, inclusion, or restitution, the novel's outcome might have been quite different.[3] After marrying Rochester, Jane's motherhood is glossed over at the novel's end, almost to the point of being erased and rendered irrelevant. In some respects, her motherhood takes on a dangerous element, which requires her to make sharp decisions grounded in the need to relinquish or remove those offspring who lack knowable ancestry

or legitimacy. Though overjoyed at the birth of her son, she immediately dispatches Adele, her husband's ward (like Jane, an orphaned fosterling but with a wanton and unwed deceased birth mother) to a school abroad, rendering the girl just as invisible as the attic-imprisoned Bertha Mason.

The key message for anyone seeking out hidden familial connections seems to be that kinship searches and attempts at reunion must not be forced. Any eventual rewards will need to be slowly earned through patience and humility. Jane, wronged many times, knows her place as an outsider and never deliberately attempts a search. She only knocks by chance and in desperation upon the locked doors of her long-lost relations after wandering soaked and half-starved through a suitably symbolic wilderness. A gatekeeping servant takes much convincing before she allows this odd stranger to approach the family hearth. The parallels with modern-day searching are obvious to any adoptee who has attempted to overcome the brick walls of sealed birth records or parental vetoes on identifying information. Jane at least had the status of a known name (Eyre) and a respectable legitimacy (heirship) going for her, unlike many other orphans, both then and now. Yet there was still a need for erasure and invisibility—inherited from her late mother—throughout much of her abusive childhood to confer a fuller sense of legitimacy upon her. Bronte reinforces a key myth of orphanization here given that Jane was being cared for by her genetic kinfolk (albeit poorly). For her good, and that of the Reeds apparently, she was orphanized and hidden away behind the foundling school's walls. Like her mother, she has been erased from view, and it is hardly surprising that she will eventually choose a similar pathway for her adopted daughter, Adele, when the opportunity arises. All of this is in keeping with much of the folklore surrounding illegitimacy and unknown ancestry. Even when her presence or true identity is not hidden away behind thick curtains, institutional walls, governess invisibility, layers of mud, or a handy pseudonym, Jane still often finds herself accused of being an elf, a witch, or a fairy. To lack a mother or father is to possess a problematic characteristic in terms of inheriting shame and stigma even when one might have been taken in by a substitute family, thereby affording some degree of social propriety.

Having an unseen, unknowable mother can foreshadow significant behavioural issues, as with the vengeful demon-seed, cuckoo characters, such as Heathcliff (*Wuthering Heights*). Vindictive acts by those who were abandoned or rejected by their mothers seem to be expected and

normative. Reunions with sympathetic kinfolk or restoration to one's rightful inheritance might eventually occur, but this is not guaranteed, nor is it likely to unfold well. Heathcliff's obscure background, for example, remains a mystery; his situation worsens profoundly as soon as his substitute father dies. Like many other foundlings in this era of literary fiction, he inherits much of the invisibility of his missing—presumably unwed and possibly deceased—mother, gradually becoming even more of a banished enigma than he was at the novel's beginning. He is permanently stigmatized and socially excluded, under this kinlessness. By later vanishing himself way to hidden places and by committing acts unseen, he somehow manages to amass a fortune, emerging reinvented and (relatively) socially acceptable. This veneer of decorum falls away once he starts to ruin the lives of all around him via an ill-advised attempt at reunion with his beloved sister Cathy. She will herself disappear into death immediately after becoming a mother, keeping up the tradition of maternal absences.[4] Such intergenerational invisibilities, and a deep sense of shame, do tend to be heritable things, especially where maternity-erasure has arisen from an apparent decision to forsake voluntarily one's child. It bears noting too that Heathcliff in many ways epitomizes the untrustworthy foundling. His mother is utterly absent (although she may well be living for all we can glean from the narrative). His demeanour and manner become increasingly demonic as the book progresses, and he is responsible for several maternal—and indeed paternal—erasures, affecting the early lives of Hareton, Linton, and Cathy and ensuring that cycles of abuse, maternal erasure, and intergenerational harms are passed on to his few descendants or legal heirs.[5]

Law's role is of quiet enablement or silent complicity. Adoption practices and policies of that time—such as they were, in an absence of statutory legal regulation—did tend to reinforce many of the truisms and tropes of nineteenth-century fiction. Early legislative reforms in England and Wales served as blueprints for several other Western jurisdictions and were reliant upon Roman notions and doctrines. They classed the orphaned and/or illegitimate child as filius nullius (i.e., a child of no one). The Poor Laws (1834) sought to promote workhouses as places of refuge—a disturbing notion that would, bizarrely, be argued in connection with Ireland's system of maternity homes nearly two centuries later. The focus of law and policymakers was largely on the protection of legitimate heirs and their interests to ensure just and fair inheritances and

easy property transmissions. Social exclusion of those who could neither claim nor evidence legal kinships (Frost) was necessary to achieve this. Again, the excision of genetic ties demanded the complete erasure of mothers and was often painted as somehow being for the best in terms of socially rehabilitating all concerned via a foundling system demanding severance from original ancestry. Children benefited from the erasure of their sociocultural illegitimacy, while mothers were shielded from accusations of sin, having engaged in extramarital sexual activity.

In sum, happily resolved adoptive placements (with little to no scope for maternal or familial reunions at any stage) in this era require both the deletion of mothers and the orphanization of the foundling. This was especially so where such children were to be transplanted across national borders via lucrative transactions (for the adoption agencies at least). England's Adoption of Children Act (1926) sought to regulate these informal domestic arrangements of fosterage or indentured child labour. Shortly thereafter, The Adoption of Children (Regulation) Act (1939) was enacted to oversee and check the exportation of vulnerable infants, introducing some basic child safeguarding measures, in theory. Unscrupulous financial gains were still being made by the various bodies involved in this industry (whether private, state, philanthropic, or church-based). Mothers and children were again required to permanently self-silence and vanish quietly, without fuss, remaining forever invisible. Injustice and discrimination were evident, with new secrecies and modes of shaming over unknown or illegitimate birth status still holding sway in both postwar periods (Keating). Issues of search and familial reunion tended, in many of this era's works of literary fiction, to be either ignored altogether (with adoptee gratitude or complete ignorance of their status often predominating) or couched in dire warnings of disappointment and imminent danger should a search for one's original mother or kinfolk be attempted. Birth relatives—not least mothers—in popular works of the time were almost invariably erased, depicted as absent or deceased, ill-meaning or afraid, and prone to fecklessness, denials, and rejections.[6]

The next five decades would see an egregious yet legalized walling-in of unwed mothers and infants in many jurisdictions. The sealing-up or falsification of birth information, often permanently, was likewise seen as an essential kindness. Profound neglect, abandonment, or abuse of the orphanized child—either by genetic relatives, the state, or substitute carers—remained a frequent plot point in popular works of fiction. In

Rumer Godden's *An Episode of Sparrows* (1955) for example, the gradually abandoned child Lovejoy struggles to survive after her seldom-seen mother deliberately vanishes from their already distressingly meagre life. Having already been neglected both physically and emotionally, the girl then faces the dangers of entering the punitive child-protection system of 1950s post-war London. As a motherless child, she will herself be rendered invisible, caged within the strict, dehumanizing regime of a church-led orphanage. The austere system is funded by unseeing—and largely uncaring and absent—philanthropists. The identities of the kinless children must be completely erased, their anonymity underpinned by a strong sense of shame and profound expectation of gratitude. The orphanized Lovejoy would inherit, and thereby protect, the invisibility and imprisoning anonymity of her erased, absent mother by disappearing behind the high walls of this institution. Though profoundly harmful to her, this vanishing is a necessary element of her mother's escape to society. She can exist unburdened by a maternity that she no longer needs or desires (and so cruelly discards). Thankfully, Lovejoy is rescued from the system by her frequently invisible, increasingly frail, reclusive neighbour, Olivia. Her last-minute intervention marks her as the most caring, effectual mother figure in the book, despite her childlessness and spinsterhood. Having set up a trust fund to ensure the child's kindly fosterage with caring, non-stranger, substitute parents, Olivia, this quasi-adoptive mother, then quietly passes away, again in keeping with the predominant trope of absent motherhood.

I examine this novel in detail because it captures much about the child-protective legal regimes of this era, the golden age of adoption in many jurisdictions.[7] The Lovejoy character is orphanized, rendered more invisible than even her absent, abandoning mother. Erasure and shame can be easily inherited, regardless of jurisdiction, genre, or era. Though set in England, the system ensuring maternal erasure is church-led, shame-filled, and designed to hide orphans from public view. As such, the novel offers a rare glimpse of what life inside such institutions must have been like for the children of absented mothers from the perspective of an older child (who resists all attempts to have her identity altered or hidden away behind walls, austere clothing, and set norms of behaviour). The book also, significantly, highlights the failings of the law, of this and earlier eras, calling to mind the sin-shaming workhouse model of Victorian social policy. Likewise, the period in which the book is set was

still characterized by strict customs and policies aimed at ensuring secrecy via a permanent sealing of birth records and lifelong silences from relinquishing mothers in most jurisdictions where a child adoption industry was evident. Nothing less than lasting maternal erasure and absence—via well-crafted anonymity measures and blood-tie severance—would do, given the industrial levels of child displacement, domestic and international.

From the perspective of the adoption law draughtsman or jurist, it makes much sense to embed fuzzy imagery of consensual, deliberately altruistic maternal exits. These notions would later falter if mothers might express a desire to keep their child, have some future form of contact with them, or record their maternal identity accurately to enable some future reunion as subsequent reports into forced adoption practices in, for example, Ireland and England would later reveal. As the United Kingdom's Joint Committee on Human Rights recently noted in its findings on *The Violation of Family Life: Adoption of Children of Unmarried Women* (1949–1976) in England and Wales, "By saying mothers gave up their babies for adoption, there has been a perpetuation of a view that they didn't care or love their babies enough to keep them and were content to give them to another family."[8]

Where myths of consensual maternal relinquishment can no longer be underpinned by a sense of shame or stigma (at unwed motherhood, or the notion of illegitimacy), it becomes necessary for policymakers to raise the spectre of a highly harmful birth environment. This can be seen very clearly in *An Episode of Sparrows*: The book represents a sort of bridge between the era of Victorian shaming (over illegitimacy and unwed maternity) and the post-golden age eras of adoption, where the need for maternal erasure tended to be grounded in some form of insurmountable, dangerous inadequacy (such as poverty, neglect, or abuse). In other words, the sociolegal notion that one's motherhood was willingly surrendered was still key, but the reasons for doing so had begun to change. The shame of unwed birth-giving might have diminished, but the inability to adequately mother due to a lack of money or societal or familial support still saw the need for systems of child adoption, which demanded maternal erasures (either by anonymity, or court-ordered bars on child contact). Selfless, self-imposed maternal deletion would still be framed as a noble act, aimed at a greater good or to protect the best interests of the relinquished, vulnerable child. Adoptive parents are also reassured in the

sense that external challenges to their fresh-forged parenthood would not arise any time soon; discomfiting and unwanted contact with birth relatives would similarly not have to be endured.

Taken to extremes, such maternal erasure via apparent altruism achieves a harsh, permanent form of infant relinquishment by completely negating the rights of the mother and her child. Works of dystopian or postapocalyptic fiction use this erased motherhood model to critique it and the societies and cultures in which it occurs. The brutalized and enslaved surrogate mothers of Atwood's *The Handmaid's Tale* perhaps offer the most obvious example of how deleted maternity—and the lost ties of relatedness occasioned by it—can almost always be bluntly justified in law and policy to achieve a social benefit, such as curing widespread infertility and maintaining population levels. Framed by law and society as fallen women, these Handmaids already carry the deep stigma of not having conformed to their society's strict new standards of behaviour. They are therefore essentially to blame for their situation. Given new scarlet-robed identities, they are hidden away from the public gaze. Anonymizing uniforms, prison-like living conditions, and constant chaperoning reinforce their less-than-human, rightless status. They endure commodified lives—re-named and frequently violated—and are forced to engage in elaborate ceremonies and rituals aimed at eradicating their presence from the processes of conception and childbirth. Legal proceedings—or some other form of an adoption ceremony—are not needed here to transfer parenthood or erase maternity, given that the issue of parentage has been settled long in advance of conception. These women will not be permitted to keep their babies on the basis that they were never their children. Trafficking occurred preconception, which is justified in law because society and the greater good require them to relinquish motherhood and any vestige of human rights to achieve a higher, noble aim. The parallels with forced adoption practices in Ireland and England are obvious, as some of the maternal testimonies to government inquiries make plain. As one Northern Ireland mother notes in her evidence: "To be forced to carry your baby and just hand her over and just walk away was a terribly, terribly hard thing.... I made her wee clothes and I had embroidered her initials inside her clothes in the hopes that, if her name was changed she might at least have her initials. And I still have her other clothes today" (358).[9]

As John McLeod has further argued, "Adoption is fundamentally

imbricated in the landscape of economic impoverishment and wealth; [the] material, social, cultural and racial circumstances" (2) of the system cannot be easily overlooked. Yet central to all of this is the deletion and overwriting of genetic maternity. The manufactured invisibility and anonymity of the birth mothers negates and erases their basic rights, not least human dignity, and indeed those of their children in terms of loss of original identity and familial kinship. The most horrific elements of some of the maternity-erasing stories are often mirrored in the lived realities and testimonial narratives of the survivors of maternity homes in Ireland, England, and elsewhere. Inquiries in various jurisdictions (such as Canada and Northern Ireland) are still trying to uncover and address the full extent of the many atrocities uncovered over the past century. Laws and policies aimed at reform and redress are likewise struggling to achieve meaningful sociocultural change and legal reform as the section below outlines.

Ireland (and Elsewhere): Legacies of Maternal Invisibility, Recent Attempts at Reform

> A scathing indictment not just of the institutions it examined
> over a period of five years, but of the society that required them
> —Pat Leahy

This section looks at Ireland's controversial Report into Mother and Baby Homes (2021)—parts of which have since been largely discredited—on the basis that it serves in many ways as an exemplar of how investigations might well perpetuate the erasure of victims. This report sparked litigation over its callous disregard for significant portions of some of the mothers' testimonies.[10] An earlier investigation (The McAleese Report [2012]) had similarly sought to deny or minimize Ireland's unsettling record of gendered abuse and its "architectures of containment" (Smith). It failed to censure those in power who oversaw harsh processes of moral reform for unmarried pregnant women, a lucrative byproduct of what was a robust, decades-long adoption industry both within Ireland and beyond. The recent enactment of the Birth Information and Tracing Act (2022) in Ireland is a long overdue and highly significant, if imperfect, attempt at legislative reform.[11] Put bluntly, it allows some adoptees to apply for

access to their birth and early life records, giving rise to the possibility of reunions occurring between natal kin. To some extent, it does finally acknowledge that the loss of motherhood via forced adoption is a profound human rights violation, which merits some form of meaningful redress. The Act does not, however, in a key failing, permit birth mothers to access information on their relinquished children unless the adoptee has since died. Yet as the Act's Pre-Legislative Scrutiny Committee Report (2021) notes, few of the relinquishing mothers consulted as part of the Inquiry expressed a wish to remain permanently incognito (9).

By not affording them open access to information on their lost descendants, the new legislation perpetuates various injustices and entrenches maternal erasure. It reinforces the notion of a lingering, perceived need for their complete removal. From their testimonies, many of the mothers had been subjected to profound shaming, underscored in many cases by a lifetime's worth of thick-veiled, stigmatizing secrecy—all of which was aimed at ensuring the permanence of their forced relinquishments. The McAleese Report—though profoundly equivocal and grossly inadequate in both tone and inaccurate conclusions on the absence of abuse—did at least admit that many Irish institutions were steeped in "secrecy, silence and shame" (2).[12] The most recent inquiry into Ireland's Mother and Baby Homes (2016–2021), which seemed to suggest in places that infant relinquishments were almost always consensual, sparked a High Court challenge. It was eventually determined that the Commission's poor treatment of the respondent survivors was in and of itself illegal, breaching statutory obligations on fairness and transparency (Ryan). The respondent mothers who had provided substantial evidence, were not, for example, given sight of the 2021 Report before its release. The investigated institutions were, however, privy to the Commission's findings in advance (O'Rourke 8). Again, visibility and accurate truth-telling matter.

Somewhat disingenuously, the 2021 Report opens with the assertion that a portion of the blame lay with "the fathers of their children and their own immediate families" (1). As such, "the institutions under investigation provided a refuge—a harsh refuge in some cases—when the families provided no refuge at all" (1). Such an argument ignores the primary sources of gendered stigmas and systemic misogyny, which are often byproducts, if not the aims, of state or church-led policies. On the issue of whether infant relinquishments were found to be mainly non-

consensual, Ciara Breathnach highlights how, bizarrely, the phrase "no evidence" is "repeated 102 times in the [Irish] Final Report: history and memory are pitted against one another in a very unfair, and highly gendered fight." She continues: "Written records of the powerful trump the spoken words of survivors. This is lip service to oral history, yet other forms of oral testimony, such as the institutions' reporting of uncertified deaths, are unchallenged."

The Commission framed secrecy (in the form of falsified or destroyed birth records) as a means of protecting the mothers' privacy rights, thus preserving their reputations, rather than a mechanism for deleting their motherhood. There are clear parallels with Atwood's dystopian vision, where political necessity required the subjugation of mothers and highly gendered injustices, not least within the Commission's glib observation of the overarching concerns of the nascent Irish government in the 1920s. Newly independent (much like the rulers of Gilead, one assumes), its lawmakers were too concerned with establishing "administrative systems for the new Irish Free State and fighting a civil war" (57) to pay more attention to the safety of its most vulnerable women and children. Allegations of decades-long abuse were significantly downplayed, with a clear element of denial and victim blaming—for example where the Commission suggests that only "a small number of complaints of physical abuse. The women worked but they were generally doing the sort of work that they would have done at home" (5). Moreover, they often "were admitted to mother and baby homes and county homes because *they failed to secure the support of their family and the father of their child*" (5; my emphasis).

Recommendation 26 of the Scrutiny Committee Report, though disregarded by the Bill's drafters, is especially significant, demanding clearer acknowledgment of the non-consensual nature of many infant relinquishments: "The Bill should be amended to provide for a reciprocal right for mothers to receive their full records, including information about their child" (30). Worryingly too, it was suggested—in contravention of the General Data Protection Regulation, (GDPR) data protection laws and Articles 8 and 10 of the European Convention—that there is no right of access to personal information held by church authorities, given that this is "the property of the holders and they have the right to determine who gets access" (14).[13] The failure to include such a right perpetuates the erasure of the mothers ensuring that their invisibility remains indelible.

Adoptees seeking their medical history are, similarly, it seems, not to be trusted with such information, lest they are somehow able to track down their birth relatives as a result. The application process requires the doctor's name to be given so that they, rather than the applicant adoptee, can be sent the medical files in question, presumably as a supervising intermediary. It is difficult to see the logic behind this requirement, other than to assume, yet again, that we—as adoptees—are not to be trusted with our truths, lest we misbehave. Another barrier to accessing birth information is the compulsory advice session on privacy rights, which must be done before the records can be released. This too seems to assume that adoptees are perhaps incapable of rational thought or appropriate social behaviours.

That many mothers and their infants suffered significant "abuse, neglect and exploitation" (McGettrick et al. 1) at the hands of the system is at least now beyond question. Northern Ireland's Report into Mother and Baby Homes and Magdalene Laundries (1922–1990) (2021) further stressed the extreme vulnerability of unmarried pregnant women in this era: "Those who entered homes did so due to limited alternative options or, in many cases, because they were urged to do so by family members, members of the clergy or other influential individuals" (McCormick et al. 4).[14] The resultant invisibility is pervasive, with many written records of the time essentially silent as to whether or not the "appropriate authorities were always informed about the criminal circumstances of these pregnancies" (McCormick et al. 4). The Report continues: "In at least one case, it appears that the authorities were not informed about a case of incest. In other instances, it is clear that victims of sexual abuse were moved on to a Good Shepherd St Mary's home, to work in its laundry, after they gave birth in a mother and baby home" (McCormick et al. 4). That such systemic erasures of women had a wider sociocultural context is also clear. "A retired RUC [police] officer also offered testimony on Magdalene laundries, but later withdrew it," leaving "an important gap … in the oral testimony on police involvement" (McCormick et al 3). One can only wonder at the reasoning behind such a decision. That a wide range of continuing human rights abuses demand further and rigorous investigation is beyond question. As Maeve O'Rourke has recently observed about Northern Ireland:

The most clearly apparent of these ongoing forms of human rights violation are: continuing disappearances, continuing denial of the right to identity, continuing interference with freedom of expression, continuing discrimination, and a continuing lack of an effective investigation and other measures to ensure access to justice and redress for widespread, systematic and gravely harmful human rights abuses. (2)

Deirdre Mahon and colleagues have further stressed that "human rights-based redress is required urgently," comprising of "formal apologies, compensation payments and access to rehabilitation services" with financial redress for victims. Adequate funding is needed to ensure meaningful "truth investigation," including "voluntary DNA testing, voluntary support services to assist family reunification, the establishment and maintenance of gravestones and markers, and victim-survivor led artistic and other forms of memorialisation" (16). Elsewhere, similar inquiries speak to an equally painful legacy, for example in Canada where some church-led apologies have, gradually, been forthcoming (Andrews; Hamilton; MacDonald).[15] State apologies have (to an extent) also been offered by the Australian and Irish governments, reflecting shared histories of unmarked infant burial sites and highly abusive care regimes.[16] In England and Wales, a state apology has been called for but seems unlikely to happen anytime soon. The recent findings of the Joint Committee on Human Rights on the Violation of Family Life: Adoption of Children of Unmarried Women 1949–1976 (2022) confirm that "thousands of children of unmarried women were adopted even though their mothers did not want to let them go. Many of those affected, both mothers and children, have faced life-long suffering as a consequence of this separation" (4).[17] The UK government refuses to accept responsibility for the harsh, gendered laws and policies of this era (and, significantly, for the omissions within them), attempting instead to argue that the abusive behaviours of some public sector medical personnel did not somehow fall within the remit of state responsibility or its duty of care (5). The mothers' testimonies highlight that their ill-treatment in both maternity homes and NHS hospitals—especially during labour—often amounted to a deliberate punishment for having been unmarried and pregnant. As the authors of the UK Inquiry noted, "The mothers we heard from were subjected to cruelty because they were considered to have transgressed" (4).

Ironically, the terms of reference of the UK Inquiry were not set out to include human rights violations that might fall within the definitions of inhuman or degrading treatment. Many mothers reported instances of egregious abuse or discriminatory neglect during their pregnancies or labour. By focussing instead on potential violations of the right to family life, the Inquiry restricted itself to a highly qualified, fragile right, one easily outweighed by other considerations (such as the best interests of the child or the privacy rights of adoptive parents). The very definition of family life—as seen in much of the Strasbourg jurisprudence and domestic case law—can be quite nebulous. Suppose a mother has never seen or held her child or been permitted to care for them. In that case, courts might easily find that no ties of family life (beyond those of mere genetics) have arisen, ostensibly through a lack of emotional bonds or remembered relatedness (Diver 103). Likewise, where domestic courts seek to place or free a child for adoption, any interference with the parents' Article 8 of the European Commission of Human Rights, relating to family life, can be justified based on being necessary, fair, and proportionate. In other words, it should be easy to find that family life (and its relevant rights, such as they are) never arose and therefore could not be infringed upon. Had the Inquiry looked at Article 3 ECHR issues or the breach of such underpinning principles as equality of treatment or human dignity, the need for redress and a formal apology might have become more urgent.

As in Ireland, many mothers who survived these homes still have no way of knowing if the child they—often very unwillingly—relinquished might yet still be alive many decades later. Unlike Ireland, however, adoptees in England and Wales have generally had open access to their original birth certificates, since the mid-1970s. The UK's Joint Committee on Human Rights Report (2022) notes that some applicants still face unseen and unacknowledged difficulties in this regard, to the extent that "The Government should monitor and publish compliance by local authorities with adherence to the guidance that sets down deadlines for responses to requests for adoption records" (5). As ever, reforming laws and policies may be nicely drafted and well-intentioned, but chronic failures of proper implementation and monitoring can still scupper the best intentions of legislators.

Ireland's Institutional Burials Act 2022[18] warrants mention here. It is aimed at permitting excavation of land "associated with an institution

owned, operated, controlled or funded by a public body." It seeks to afford "dignity to persons buried there by "recovering human remains buried ... in a manifestly inappropriate manner." That such a statute was needed indicates the strong likelihood of neglect and abuse of many illegitimate infants and evidences the abject lack of dignified burials for those children who did not survive their time in various Mother and Baby Homes.[19] Yet, questions have been raised over whether memorialization might offer a better option at certain sites than excavation, DNA testing of remains, or proper reburials. The issue of using DNA tests to identify infant remains is sparking the usual debates over relatives' privacy rights versus the need for truth recovery, the nature of meaningful reparations, and the potential consequences of having a DNA (historic remains) database.[20] As Jude Murray notes, the Burials Act provides for the "forensic testing of samples in certain circumstances for the purposes of identification of human remains after an Identification Programme is completed." It could be argued that a failure to unearth, identify, and in some way repatriate these victims to their original, familial identities amounts to a permanent disregard of difficult truths that surely merit some form of acknowledgment.

In terms of erasing maternities and adoptee identities—and leaving untouched potential evidence as to how the infants died or were perhaps ill-treated in life and afterwards—a simple memorialization in the absence of excavation seems suggestive of some of the blind-eyed denials of the past. Egregious human rights violations should not be overlooked or forgotten simply because much time has passed (or there would be some inconvenience to landowners). It is difficult to see how meaningful remembrance or adequate redress might be achieved in the absence of identifiable kin connections. Affording the deceased victims some measure of belated dignity in death—via respectful exhumation, DNA-identification, kin-tracing, and proper (re)interment—does not seek to "re-write the past" as some have suggested (Murray).[21] Rather, such an approach seems entirely necessary given the severity and extent of the events in question. As has been argued, the sites are in many ways akin to those discovered in the wake of political conflicts and atrocities (Shannon).[22] Given that there may have been no (or sparse) written or verbal evidence of these babies' existence, the use of DNA tests may be the only way of achieving some sense of closure or familial reunification, as many closed-record or veto-afflicted adoptees know only too well.

As with gamete donation and closed records adoption (domestic and cross-border alike), such testing may offer the only means of revealing previously hidden or unknown ancestries, which might point to some uncomfortable past truths. The need for redress may take on a different complexion, if certain revelations point to the abandonment and/or abuse of women and children by those who held positions of power or high social esteem. A fear of causing upset to those in authority, or to their descendants and relatives, should not be used as an excuse to avoid truth recovery.[23] Ireland's long legacy of secrecy, subterfuge, and maternal erasure has yet to be adequately addressed. As Matt Shannon, an Irish Teachta Dála (TD) argued in the Dáil, Ireland clearly has "a shameful past in respect of how we dealt with mothers and children and how the State victimised some of these people who found themselves faced with unplanned pregnancy, separation, rape or incest." He continues:

> Part of that shame relates to how the State and religious actors colluded to hide pregnancy and how, having hidden pregnancies, some institutions, religious and otherwise, financially profited from forced adoptions and forced labour.... In some cases, this shameful abuse extended to the under-reporting or failure to report to the deaths of children in institutional homes. This is a significant stain that can never be fully washed away.

Conclusion

> The institutions responsible for carrying [forced adoptions] out have either disappeared over the years, such as government departments whose names and mandates have changed multiple times in the interim, or are reluctant to admit their participation, such as many of the religious denominations that operated maternity homes for unwed mothers.
> —Standing Senate Committee on Social Affairs, Science and Technology

As Marianne Novy has argued, "Truth and fiction, reality and pretense —these oppositions are impossible to escape in considering the literary and historical treatment of adoption" (4). The mother and baby

institutions[24] in Ireland, England, and elsewhere were repositories of sharp truths and convoluted fictions—not least that infant relinquishments were almost always generally consensual and that maternal erasures were an essential kindness towards so-called fallen women needing to hide their shame. The adoption industry demanded and ensured the invisibility of unwed mothers during and long after their pregnancies. These women, once chastened, might eventually return to society, perhaps via displacement to a different jurisdiction. But this was often only possible in exchange for permanent loss (and subsequent self-denial) of their motherhood. Moreover, the fragility of unwed and socially unsanctioned motherhood was easily damaged or erased by sociocultural customs of shaming and othering. Even where some form of reunion (or information release) eventually occurred, additional challenges still tended to arise beyond those of the more straightforward long-lost relative narratives. There may be deep guilt over relinquishment or thinly veiled fear of encountering an unknown, unexpected relative, as the various literary tropes and templates on abandonment and foundlings bear out. It is hardly surprising that some mothers in Ireland and elsewhere opted to self-erase, seeking to remain hidden or anonymous for many decades afterwards, if not permanently.[25]

The Irish Government Guidance on the Birth and Information Tracing Act 2022 preserves the mythology that maternal anonymity and willing relinquishment were a near-universal aim of most unwed mothers It stresses that this "will allow parents to register a no contact preference prior to their information being released ... this ensures that the parent's right to privacy and wish for privacy will be communicated."[26] The emphasis on such parental privacy at the expense of adoptee welfare and identity rights also preserves several of those literary traditions associated with the unwelcome, much-feared foundling (e.g., *Wuthering Heights* and *Frankenstein*), perpetuating the dangerous message that adoptees should have no right to actively seek out identity information or inheritance and must show gratitude for any or all dignities that might be gifted to them (e.g., *Jane Eyre*). The greater good of parental privacy, adoptive or natal, seems, yet again, to be a sacrosanct social necessity (e.g., *The Handmaid's Tale*) to the extent that adoptee rights are better understood as mere privileges, for which we should be profoundly and silently thankful (e.g., *An Episode of Sparrows*). Within the Irish Government Guidance, there is a small glimmer of hope hidden in plain sight among the list of things

that an adoptee applicant might hope to access (in addition to, if lucky enough, one's birth certificate, original name, and early life information). The heading Provided Items refers to "any item held by the Adoption Authority or Tusla, which was provided by a relevant parent, carer or other family member for the purpose of being made available to another relevant person on request." It continues: "*The item could be a letter, photograph, memento or other document or object.* It could have been provided historically, or it could be an item which was lodged through the Contact Preference Register (my emphasis).[27]

Including such a provision suggests a belated recognition of how some mothers (or other relatives) must have hoped or expected to be found one day or might have perhaps subsequently changed their mind about the situation as time passed. It points also to the fundamental human need for connection to our origins: here, the otherwise insignificant item becomes, to the adoptee or relinquishing mother, a precious mnemonic, deliberately left behind (and meant to be found) as a small kindness or search-relevant breadcrumb. Literary fiction can serve as a reminder of how truth-finding matters, with basic human truths often tending to reveal themselves eventually despite laws and customs on secrecy. Jane Eyre becomes an heir by having inadvertently used her true signature on a portrait, whereas certain family resemblances in *Wuthering Heights* point to troubling undercurrents of possible genetic relatedness that explain—and drive—key aspects of the narrative. A distraught Lovejoy (e.g., *Episode of Sparrows*) recites the memorized names of seeds she has collected (or, more accurately, stolen) for self-comfort postabandonment, with heavy symbolism of familial loss and genetic disconnection. She is later saved from utter despair within the orphanage by the unexpected glimpsing of a familiar, mother-substitute Madonna statue, which symbolizes her lost home and hard-won, self-cultivated kinships.

Whether legislative reforms, ongoing inquiries, and calls for redressive action might spark the same sort of dramatic, justice-grounded resolutions remains to be seen. In the meantime, adoptees can perhaps take some comfort from society's apparently increasing acknowledgment if not yet perhaps a fully sympathetic understanding of our innate need to overcome or undo the maternal erasures and losses of our pasts.

Endnotes

1. https://data.oireachtas.ie/ie/oireachtas/act/2022/14/eng/enacted/a1422.pdf

2. Thanks are due to my colleagues in the School of Law, QUB, and to the editors of this collection for their insightful comments and helpful advice during the drafting of this chapter. Any lingering errors are entirely mine.

3. She might have found herself locked away in an attic of her own, mirroring Bertha Mason's existence for having dared to challenge key social norms.

4. Arguably, her absence is needed here to restore social order. Once she disappears, so might Heathcliff (and their scandalous connection). That her ghost remains present is telling; it cannot invade the sanctity of the family home but still serves to drive the story forwards. Again, the parallels with closed-records adoption practices are evident in terms of excluding the shameful absented mother(s) to try and ensure a quiet life for others.

5. Genuine orphans were in no way guaranteed an easier narrative journey in this era, but they do seem to have had a slightly better chance of eventually achieving some happy outcome. Dickensian mythologies involving the absent mother also tended to suggest this (Peters 17).

6. The 1930s saw some attention being paid to child welfare concerns (via the Recommendations of the Horsbrugh Committee), which sought bans upon advertising, informal (i.e., unregulated) adoptions, and the so-called baby farms seen in the previous century.

7. Lovejoy's eventual situation more closely resembles that of an old-fashioned, privately sponsored wardship or de facto fosterage. Significantly, she bonds more with the kindly, caring Vincent (her former landlord) than his distracted, childless wife, Ettie, who often fades into the grey background. Other mother figures in the book are highly visible in terms of how fiercely they protect their children and how cruelly they exile and demonize the kinless Lovejoy (e.g., Mrs Malone, Sparkey's mother).

8. https://publications.parliament.uk/pa/jt5803/jtselect/jtrights/270/summary.html

9. www.health-ni.gov.uk/sites/default/files/publications/health/doh-
 mbhl-final-report.pdf

10. Department of Children, Equality, Disability, Integration and Youth's
 Final Report of the Commission of Investigation into Mother and
 Baby Homes, Jan 2021 (Updated Nov. 2021), https://www.gov.ie/en/
 publication/d4b3d-final-report-of-the-commission-of-investigation-
 into-mother-and-baby-homes. Their remit also included infant vac-
 cine trials, burial of their remains, and investigation of specific homes.
 As the Clann Project noted, the High Court's declaration confirmed
 that the 2021 Report "wrongly denied survivors the right to comment
 on many draft findings." Their redress recommendations did not
 "accurately reflect the survivors' evidence." A list of "impugned
 paragraphs" should be read in conjunction with this "fatally flawed"
 Commission Report, http://clannproject.org/wp-content/uploads/
 Clann-Press-Release_17-12-21.pdf.

11. A previously unsuccessful iteration can be found in The Adoption
 (Information and Tracing) Bill (2014), which focusses on maternal
 vetoes, citing a need to protect (birth)mothers' constitutional privacy
 rights, framed as paramount under O'T v B (1998) WJSC-SC 11911.
 Under this draft Bill, the right to identity was not absolute, having
 to be balanced against an overarching maternal right to privacy: Any
 adoptee seeking birth information would have been required firstly
 to agree to not attempt contact with birth relatives. Additionally,
 natural parents (an archaic and stigmatizing phrase) could apply for
 such a veto so that their information would be permanently sealed,
 all of which significantly undermines the concept of open records
 (and leaves room for paternal anonymity).

12. As the Clann Project has argued, these findings contradict the tes-
 timony of the survivors, see further http://clannproject.org/wp-con-
 tent/uploads/Clann-Press-Release_17-12-21.pdf.

13. This is in keeping with a wider policy of ill-treatment, denial, and
 invisibility (for those deemed illegitimate). It was also suggested that
 "the abuse of boarded out children was not relevant to the
 Commission's Recommendations on redress."

14. As to whether inspections were carried out, see The Report of Historical
 Institutional Abuse Inquiry (2017), which "admonished both the Good
 Shepherd Sisters and the Ministry of Home Affairs/ Department of

Health and Social Services and the Social Work Advisory Group for what it identified as a systematic failure" over several decades (6). See further, https://www.hiainquiry.org historical-institution-al-abuse -inquiry-report-chapters.

15. See Leyland Cecco; The Truth and Reconciliation Commission; MacDonald; Standing Senate Committee on Social Affairs, Science and Technology

16. See The Report of the Australian Senate's Community Affairs References Committee; Fronek and Cuthbert; Short.

17. In Scotland, a similar Inquiry has led to a formal apology. See further https://www.gov.scot/publications/historical-adoption/

18. See further the Report of the Pre-legislative Scrutiny Committee (2021), available at https://data.oireachtas.ie/ie/oireachtas/committee/dail/33/joint_committee_on_children_equality_disability_integra-tion_and_youth/reports/2021/2021-07-15_report-on-pre-legisla-tive-scrutiny-of-the-general-scheme-of-a-certain-institutional-buri-als-authorised-interventions-bill_en.pdf. See also The Tuam Home Survivor's Network Press Release (Jan 2021) https://www.tuam-homesurvivors.com/press-releases

19. See also the UN's recent call (Sept. 2022) for 'adequate redress for systemic racism and racial discrimination in childcare institutions' in Ireland (1940s–1990s), which highlights how "Because of their prolonged time in institutions, these children were exposed to height-ened risk of corporal punishment, sexual abuse, and physical and verbal abuse, with life-long consequences, including on their right to enjoy the highest standard of physical and mental health. Some of them were also subjected to vaccine trials." https://www.ohchr.org/en/statements/2022/09/ireland-un-experts-call-adequate-redress-systemic-racism-and-racial.

20. https://www.oireachtas.ie/en/bills/bill/2022/23/. See further Corless and Linehan.

21. Murray argues that "we should not try to re-write the past. It would be better to mark the spot and say that those people will never be forgotten."

22. Shannon, Report of the Special Rapporteur on Child Protection.

23. For an example of an attempt to induce panic, see McQuinn.

24. Many survivors of the institutions object to the use of the word "homes" in connection with these institutions (Coen et al, 14).

25. Testimonies gleaned in Ireland and elsewhere suggest that some mothers were victims of rape or incest. It is not my intention to diminish or ignore their fears and concerns in any way. It is difficult however to see how a meaningful right to identity via the release of accurate, unredacted birth information can be drafted as anything other than absolute, to avoid inequality of treatment based on birth status.

26. https://www.citizensinformation.ie/en/birth_family_relationships/ adoption_and_fostering/tracing_your_birth_family.html

27. Available https://aai.gov.ie/images/BITA_2022_Public_Information_ Leaflet.pdf. The new support website foregrounds on its homepage a further reminder of the need to register a contact preference https:// www.birthinfo.ie/.

Works Cited

Andrews, Valerie. *White Unwed Mother: The Adoption Mandate in Postwar Canada*. Demeter Press, 2018.

Australian Senate's Community Affairs References Committee. *Commonwealth Contribution to Former Forced Adoption Policies and Practices*, 2012, www.aph.gov.au/Parliamentary_Business/Committees/ Senate/Community_Affairs/Completed_inquiries/2010-13/commcon-tribformerforcedadoption/report/index.htm. Accessed 7 Sept. 2024.

Blackford, Holly. "Unattached Women Raising Cain." *South: A Scholarly Journal*, vol. 51, no. 1, 2018, pp. 36–53.

Breathnach, Ciara. "A Dark, Difficult, and Shameful Chapter." *History Workshop*, 21 Jan. 2021, www.historyworkshop.org.uk/family-child-hood/mother-and-baby-homes-report/. Accessed 7 Sept. 2024.

Brosnan, John Francis. "The Law of Adoption." *Columbia Law Review*, vol. 22, no. 4, 1922, pp. 332–42.

Cecco, Leyland. "Nearly 100 'Potential Human Burials' Discovered at British Columbia School." *The Guardian*, 26 Jan. 2022, https://www. theguardian.com/world/2022/jan/26/nearly-100-potential-human-burials-discovered-british-columbia-school-indigenous-people. Accessed 7 Sept. 2024.

Clann Project. "Press Release." *Clann,* Dec 17, 2021, http://clannproject. org/wp-content/uploads/Clann-Press-Release_17-12-21.pdf. Accessed 7 Sept. 2024.

Coen, Mark, Katherine O'Donnell, and Maeve O'Rourke. *A Dublin Magdalene Laundry.* Bloomsbury, 2023.

Corless, Catherine, and Naomi Linehan. *Belonging: A Memoir of Place, Beginnings and One Woman's Search for Truth and Justice for the Tuam Babies.* Hachette, 2021.

Davey, Samantha. *A Failure of Proportion: Non-Consensual Adoption in England and Wales.* Bloomsbury, 2020.

Department of Children, Equality, Disability, Integration and Youth. *Final Report of the Commission of Investigation into Mother and Baby Homes. Government of Ireland,* 22 Nov. 2021, https://www.gov.ie/en/ publication/d4b3d-final-report-of-the-commission-of-investigation-into-mother-and-baby-homes/. Accessed 7 Sept. 2024.

Department of Justice. *Report of the Inter-Departmental Committee to Establish the Facts of State Involvement with the Magdalen Laundries. Government of Ireland*, 9 Aug. 2021, https://www.gov.ie/en/collection/ a69a14-report-of-the-inter-departmental-committee-to-establish-the-facts-of/. Accessed 7 Sept. 2024.

Diver, Alice. *A Law of Blood-ties: The 'Right' to Access Genetic Ancestry.* Springer, 2014.

Diver, Alice. "'Monstrous Othering': The Gothic Nature of Origin-Tracing in Law and Literature." *Adoption and Culture*, vol. 9, no. 2, 2021, pp. 247–75.

Fronek, Patricia, and Denise Cuthbert. "Apologies for Forced Adoption Practices: Implications for Contemporary Intercountry Adoption." *Australian Social Work*, vol. 66, no. 3, 2013, pp. 402–14.

Frost, Ginger Suzanne. *Victorian Childhoods.* Praeger, 2009.

Hamilton, Scott. *Where Are the Children Buried?* National Centre for Truth and Reconciliation, 2022.

Hipchen, Emily. *Coming Apart Together: Fragments from an Adoption.* The Literate Chigger Press, 2005.

Israelowich, Ido. "The Extent of the 'Patria Potestas' during the High Empire: Roman Midwives and the Decision of 'Non Tollere'" as a Case in Point." *Museum Helveticum*, vol. 74, no. 2, 2017, pp. 213–229.

Keating, Jennifer. *A Child for Keeps: The History of Adoption in England, 1918-45*. Palgrave MacMillan, 2008.

Leahy, Pat. "Mother and Baby Homes Report Finds 'Rampant' Infant Mortality, 'Appalling' Conditions for Thousands." *Irish Times*, 12 Jan. 2021, https://www.irishtimes.com/news/social-affairs/mother-and-baby-homes-report-finds-rampant-infant-mortality-appalling-conditions-for-thousands-1.4456447. Accessed 7 Sept. 2024.

MacDonald, David. "Canada's Hypocrisy: Recognizing Genocide Except Its Own against Indigenous Peoples." *The Conversation*, 4 June 2021, https://theconversation.com/canadas-hypocrisy-recognizing-genocide-except-its-own-against-indigenous-peoples-162128. Accesed 7 Sept. 2024.

MacDonald David. *The Sleeping Giant Awakens: Genocide, Indian Residential Schools, and the Challenge of Conciliation*. University of Toronto Press, 2019.

Mahon, Deirdre, et al. *Mother and Baby Institutions, Magdalene Laundries and Workhouses in Northern Ireland: Truth, Acknowledgement and Accountability*. Truth Recovery Design Panel NI Executive, 2021.

McCormick, L., et al. *Mother and Baby Homes and Magdalene Laundries in Northern Ireland, 1922–1990*. Government of Northern Ireland, 2021.

McLeod, John. *Life Lines: Writing Transcultural Adoption*. Bloomsbury, 2015.

McGettrick, Claire, et al. *Ireland and the Magdalene Laundries: A Campaign for Justice*. IB Tauris/Bloomsbury, 2021.

McQuinn, Cormac. "Thousands of Illegally Adopted People to Have Inheritance Rights from Two Sets of Parents." *The Irish Times*, 13 Jan. 2022, https://www.irishtimes.com/news/politics/thousands-of-illegally-adopted-people-to-have-inheritance-rights-from-two-sets-of-parents-1.4775954. Accessed 7 Sept. 2024.

Murray, Jude. "Does the Institutional Burials Act Respect the Dead or Bury Our Shame?" *Irish Legal News*, 10 Oct. 2022, https://www.irishlegal.com/articles/jude-murray-bl-does-the-institutional-burials-act-respect-the-dead-or-bury-our-shame. Accessed 7 Sept. 2024.

Nixon, Cheryl. *The Orphan in Eighteenth-Century Law and Literature: Estate, Blood, and Body*. Routledge, 2011.

Novy, Marianne. *Reading Adoption: Family and Difference in Fiction and Drama*. University of Michigan Press, 2007.

O'Donoghue, Richard. "Dáil Éireann Debate on the Birth Information and Tracing Bill." *House of Oireachtas*, vol. 1016, no. 5, 20 Jan. 2022, Oireachtas.ie. Accessed 7 Sept. 2024.

O'Rourke, Maeve. *A Human Rights Framework: Background Research for the Truth Recovery Design Process*. NI Executive, 2021.

Peters, Laura. *Orphan Texts: Victorians, Orphans, Culture and Empire*. Manchester University Press, 2013.

Ryan, Orla. "'We've Been Totally Vindicated': State Admits Rights of Mother & Baby Home Survivors Were Breached." *The Journal*, 2021, https://www.thejournal.ie/mother-and-baby-home-commission-high-court-settlement-5633597-Dec2021/. Accessed 15 Sept. 2024.

Shannon, Geoffrey. *Human Rights Issues at The Former Site of The Mother and Baby Home, Tuam, Co. Galway*. Government of Northern Ireland, 2018.

Short, Damien. "When Sorry Isn't Good Enough: Official Remembrance and Reconciliation in Australia." *Memory Studies*, vol. 5, 2012, pp. 293–304.

Smith, James. *Ireland's Magdalen Laundries and the Nation's Architecture of Containment* University of Notre Dame Press, 2007.

Standing Senate Committee on Social Affairs, Science and Technology. *The Shame is Ours: Forced Adoptions of the Babies of Unmarried Mothers in Post-war Canada*. Government of Canada, 2018.

The Truth and Reconciliation Commission. *Honouring the Truth, Reconciling for the Future*. The Truth and Reconciliation Commission, 2015.

Tuam Home Survivors Network. "Press Release." *Tuam Home Survivors Network*, 1 Nov. 2021, https://www.tuamhomesurvivors.com/press-release. Accessed 7 Sept. 2024.

Zunshine, Lisa. "Bastard Daughters and Foundling Heroines: Rewriting Illegitimacy for the Eighteenth Century Stage." *Modern Philology*, vol. 102, no. 4, 2005, pp. 501–33.

2.

The Missing Maternal Body in the Narratives of Young Catholic and Muslim Mothers in Poland

Joanna Krotofil, Dorota Wójciak, and Dagmara Mętel

Introduction

In the introduction to the edited volume *Philosophical Inquiries into Pregnancy, Childbirth, and Mothering*, Sheila Lintott and Maureen Sander-Staudt note that the "hidden mother"—a widespread practice in nineteenth-century infant photography[1]—is a fitting metaphor for many contemporary projects on motherhood and mothering—where maternal subjectivity is downplayed. In this chapter, we will argue that in Poland, where Catholicism remains the dominant religion, pregnancy and birth are highly medicalized (Oleś-Bińczyk; Mazurek) and feminists are reluctant to engage with mothers (Graff)—the embodied nature of motherhood is erased from public discourses and mothers'[2] own stories. As we will demonstrate, based on the in-depth interviews with Polish religious mothers, the mother as an embodied subject is missing in many contexts of maternal practice, and young mothers struggle to overcome this absence. First, we will look closely at the disappearance of the maternal body in the religious constructions of a mother. Next, we will discuss how in medical settings, mothers are reduced to physical bodies controlled by medical experts and denied their subjectivity and agency. We then

analyze the alliance between medicine and religion in the Polish socio-cultural context and the effects this entwinement of medicalization and religious discourses has on mothers. In the final part, we focus on how mothers try to break the silence and regain their embodied subjectivity.

Some scholars are careful not to essentialize mothering by linking the maternal to the flesh and locating it in the realm of nature (Budrowska; LaChance Adams; Walsh). This reluctance to engage with the maternal body is related to the ways the category of "natural mother" has been used in the past to confine caring work to women and universalize maternal experiences. We argue, however, that women whose bodies are erased in the dominant discourses, both religious and antiessentialist, face demands that disregard their suffering and deprive them of an important basis for imagining and experiencing positive, affirming ways of becoming mothers. Mothering is an embodied practice, which is enabled by the body and constituted through a range of experiences related to conceiving, gestating, birthing, and caring for a child. The engagement with the complexity of embodied mothering has the potential to vitalize debates on matricentric feminism (O'Reilly, "Matricentric Feminism"; for the Polish context, see also Graf) and bring back the missing mother to feminist agendas. Following the growing body of literature bringing together studies on maternal experiences from the West and the non-Western peripheries advancing matricentric feminism, we contribute to this project by focusing on the sociocultural context of post-socialist Central and Eastern Europe, which continues to be a marginal location in feminist thought and knowledge production (Marling).

The insights presented here are based on in-depth interviews with sixty-two mothers[3] conducted as a research project exploring religion, mothering, and identity among young Catholic and Muslim mothers in Poland.[4] In this study, we set out to explore how religion and other dominant ideologies on motherhood shape young mothers' experiences and practices. We chose to focus on Catholic women as adherents of mainstream religion in Poland and Muslim mothers who were included as representatives of "religious others," who have been marginalized and often experience mistrust and hostility. All mothers in the second group were converts to Islam, the majority of them were raised in Catholic families and were familiar with Catholic teachings. We collected narratives of mothers whose youngest child was five years old or younger

through individual interviews and a moderated group discussion. All women were birth mothers to at least one of their children. All participants shared a sociocultural background largely influenced by Catholicism and experienced mothering as central to their lives. Our respondents were immersed in the patriarchal institution of motherhood (O'Reilly, "We Need to Talk") and mostly functioned in neotraditional families (Peskowitz); all but three were married, and they were primarily responsible for caring for their children and households; in most cases, the husbands were the primary providers for the family. Although individual circumstances varied, our respondents fulfilled at least several tenets of patriarchal motherhood.[5]

While our respondents struggled at times to see any role that religion played in their experiences related to mothering and provided only limited reflections on the medicalization of pregnancy and birth, a close reading of over one thousand pages of interview transcripts brought to our attention the strong presence of religious and medical framings of mothering. These were expressed in the silences, omissions, and occasional explicit reproductions of religious or medical voices. Our methodological approach to the analysis of these absences stems from the observation that in discourse-based research, we ought to be attentive to the inherent possibilities of keeping the silences as data (Mazzei). Lisa Mazzei notes that: "purposeful consideration of the unspoken or the unspeakable presents a more holistic understanding of the narrative stories collected as data" (40). This call alerted us early on in the data-collection process to the particular "absence" in the narratives created by mothers who erased themselves from their stories about mothering, and, most significantly, left out the embodied realities of the conception, gestation, birth, and the postpartum period. As Rachelle Chadwick observes concerning birthing bodies, silence matters and reveals a particular understanding of the maternal body. Chadwick argues that "While birthing bodies are rarely directly addressed, problematized or theorized, assumptions about the nature of these bodies pervade medical, activist and social science discourse. Birthing bodies are thus paradoxically both absent and omnipresent" (1-2). Thus, the silence we come across in our research is subjective and political. On the political level, the silence about embodied aspects of mothering is enforced by the dominant ideologies, whereas at the individual level, it is a response to the oppression and harm that cannot be named. In the following section, we will start

unpacking the absence of the maternal body by taking a closer look at the dominant religious discourse on mothering in Poland.

The Disappearance of the Body in the Religious Constructions of a Mother

For the adherents of gender-traditional religions, the construction of mothers as distant, idealized objects of inherently masculine framings continues to have an impact on how they experience themselves as mothers. In the canonical texts of Catholicism and Islam, the two religious traditions we focused on, a mother is a venerated symbol of willing and selfless devotion (Oh) and motherhood is seen as a key "natural" element of female identity (Radzik). The Catholic teaching presenting the Virgin Mary as a mother and a virgin emphasizes her chastity and is often accompanied by expressions of antibody and antisex attitudes (Adamiak). Although the Vatican documents on human reproduction highlight the unity of the body and spirit in a person (Lauritzen), the latter's primacy renders the maternal body invisible.

This religious construction of the relationship between a mother and her body is reflected in our study. The maternal body receded out of view and was denied a place of its own in the stories told by mothers. Asked directly about how they perceived the relationship between the body and religion, some mothers explicitly separated mothers from their sexual bodies. Alicja, a thirty-year-old Catholic mother, evoked the aforementioned ideal of a woman who effortlessly combines loving and caring mothering with chastity: "I don't know. I suspect the Church does not want a mother to be voluptuous when it comes to outfits. And I guess a loving mother, this loving, caring." Ewelina, a thirty-five-year-old Catholic mother, described how she detached herself from her pregnancy and birth and observed how this attitude was aligned with the pervasive silence regarding pregnancy and birth in the Catholic Church: "I think, if we do not go to the sources, we don't look for special circles we won't come across anything. Because in my first pregnancy, just going to the church and not being in any groups, I never heard anything special. It is simply 'a moment of life, nine months, ok, it will pass'.... In the Church, this stage of life is a bit marginalized." Ewelina indirectly referenced some grassroots initiatives struggling to acquire clout in Polish Catholic circles, promoting positive experiences of birth and supporting women

with traumatic birth experiences. As Ewelina noted, however, these kinds of organizations function outside of mainstream Catholicism and are not broadly known. The distancing from the embodied reality of pregnancy was also manifested in the dismissive ways some mothers engaged with their pregnancies. Kasia (twenty-five) recalled her efforts to make the pregnancy invisible and insignificant: "Some women, I don't know, they are as if ... they treat themselves in special ways and because of that, other people treat them differently, and so on.... I was creating this distance, so others saw that it was not entirely my thing, so I was not carried on anybody's shoulders."

Catholic and Muslim mothers referenced the Virgin Mary as an ideal. Anna, a thirty-two-year-old Catholic, "Mary was, I don't know, well, a mother of Jesus, right? And I started identifying with her more ... when I became a mom, I started identifying with her more and asking her for help. And I felt this bond with her...she is so competent, so ideal." For the mothers who converted to Islam, Mary retains her importance but no longer as the Mother of God but the only woman mentioned in the Quran by name (Nieuwkerk). While some Muslim mothers saw Mary as more "multidimensional" than the figure venerated by Catholics, in the majority of cases, the Catholic tradition continued to shape their perception of Mary. Some mothers reflected on Mary being the role model of the "missing mother" and noted the hardships inherent in following that model. Natasza (a thirty-one-year-old Catholic mother) poignantly stated:

> Mary is a space of meekness and ineffability. There are things that happen, but you have to keep them in your heart (for yourself). Such things that I will not be able to go through on my own. And Mary was in the same situation. How to keep it to yourself? How can I live knowing that as a woman, as a mother, I will never be 100 per cent understood? ... In such a context, so as not to be the first in the relationship, the well-being of my child is more important.

These narratives on the Virgin Mary bring to mind the iconographic tradition of depicting the Mother of God in Hodegetria icons. Hodegetria is "showing the way"—that is, showing her son the way. With one hand, she holds the blessed infant, and with the other, she points to the saviour (Evdokimov). Her body is fully covered, and her robe is merely a canvas

for the holy infant (Łazar-Massier; Imbierowicz). The embodied nature of Mary's mothering is more visible in earlier iconic representations, which depict the Virgin suckling Christ. According to Marina Warner, however, these images "represented women's humility" (207) and their acceptance of punishment for Eve's sin. The author argues that the Catholic enthusiasm for natural mothering, including nursing, underlines "the idea that women must submit to the biological destiny of the Fall also lends its support. Lactation, as well as the pain of labour, is a prime part of that penalty" (207–08).

Similarly, Ann Neumann argues that the ontological merging of being female and bearing pain has religious origins in the story of original sin and continues to serve religious purposes. In the Catholic tradition, the fragment in Genesis (3:16) is often quoted in discussions on labour pain: "Unto the woman he said, I will greatly multiply thy sorrow and thy conception; in sorrow thou shalt bring forth children; and thy desire shall be to thy husband, and he shall rule over thee." This legitimization and naturalization of women's pain play an important role in the disregard for pain and discomfort related to reproduction so often manifested in various settings and is also deeply internalized by mothers.

The Disappearance of the Mother Turned into a Medicalized Body

The distancing of mothers from their embodied subjectivity was further reinforced by the medicalization of early mothering experiences. Medical interventions move the birth of the child beyond the woman and reduce the mother to a body devoid of subjectivity, often objectified and dehumanized. Mothers who give birth within the medicalized model struggle to integrate the body and mind and find a balance between their will and biological determination (Nowakowska). Barbara Katz Rothman describes the disappearance of maternal subjectivity in medicine:

The history of Western obstetrics is the history of technologies of separation. We've separated milk from breasts, mothers from babies, foetuses from pregnancies, sexuality from procreation, pregnancy from motherhood. And finally we're left with the image of the foetus as a free-floating being alone, analogous to man in space, with the umbilical cord tethering the placental ship, and the mother reduced to the empty space that surrounds it.

The development of obstetrics at the beginning of the twentieth century moved childbirth into the hospital in many parts of the world. In Poland, the assumption that pregnancy and childbirth require medical management is widespread and rarely questioned by expectant mothers. The medicalization of pregnancy, birth, and women's bodies epitomizes a broader process which "occurs when life events come to be understood as questions of illness and are then subject to the authority of medical institutions with their cadre of experts from whom we expect proper diagnosis and isolation of our health problems" (Parry 785). In the context of childbirth, medicalization is manifested in the increased use of ultra-sounds during pregnancy, fetal heart monitoring, high caesarean-section rates, and other biomedical means of maintaining surveillance over a pregnant body. Based on these indicators, mothers in Poland appear to be subjected to strongly medicalized treatment. According to a Euro-stat report, the proportion of births by caesarean sections in Poland, at 40 per cent, is one of the highest in Europe. It is worth noting that in Poland, as in many other countries, the medicalization of pregnancy and birth has been paralleled by the crisis of midwifery, which became appropriated into and subordinated by the obstetric institution. As Rodante van der Waal and Inge van Nistelrooij note: "The absence of both objective information and continuous support attest to the separation of the rela-tionality between mother and midwife, leading, again, to a strategic diminishment of their subjectivity. This effectively results in a shift in priority from the mother's best interests to what is understood to be the baby's best interest" (6). It is not only the relational relationship between the mother and the midwife, but most importantly the caring relationship between the mother and the child she is gestating, birthing, or nurturing that becomes obscured. Under the medical gaze, the child is separated from the mother and placed at the centre of attention, while the mother is reduced to the body, alienated and stripped from intentionality and competence, including the intention and ability to protect her child and facilitate its well-being. Maternal well-being comes secondary in med-icalized settings and the mother's concerns, needs, and preferences are systemically downplayed or ignored.

In this framework, when the pregnancy ends, the baby is delivered by a doctor or midwife rather than given birth to by the mother. The understanding of childbirth as an active relational cooperation between mother and child is replaced by the notion of a mother as an obedient patient. In the first-person narratives we collected, mothers moved

themselves into a passive position. In the stories, they told us that conception, gestation, and birth happened somewhere beyond their corporeal selves. As mothers are separated as subjects from their bodies, they rarely question what is being done to them and often cannot give personal meaning to their experiences. This is reflected in the way in which the carnality of birth was referenced in a routinized manner; the mothers are reluctant to relate their own unique birth stories. For example, Ela, a thirty-three-year-old Muslim, narrated the birth in the briefest manner: "I was given an epidural. I had a whole lot of equipment connected to myself. It was not cool, but of course when the baby appeared all this, you know, it was no longer important." In these stories, the missingness of the embodied maternal subjectivity does not result from the continuity between the self and the body (Merleau-Ponty) but from a radical rapture and being reduced to the material body in medical settings. Such patriarchal framing, as Adrienne Rich points out, degrades women's potentialities, endows mothering with passivity, and removes it from the "realm of decision, struggle, surprise, imagination and conscious intelligence" (280).

When encouraged to tell their stories about their children's births, the mothers similarly structure them. To begin, they identify risks and follow that with the description of the correct procedures performed in a manner determined by medical knowledge. Mothers as protagonists are described as having no competency in bodily matters. The scenography constituted by the hospital environment in which the birth is processed is often unfamiliar, one which the mother does not understand, does not belong to, and is not attuned to. The explanations regarding instruments and procedures are scarce. The moments when a mother can follow her urges or intuitions, reduce discomfort, or enhance joy are almost completely absent.

The reliance on medical authority is not limited to the moment of delivery; the same absence of embodied subjectivity pervades the post-partum period. Sonia (thirty-one), who gave birth by Caesarean section, described how she surrendered to medical authority during her recovery: "In the hospital, it hurt so much, that ... well badly, but she came here, she lifted me, immediately. I was so achy. This lady lifted me, well too quickly, obviously, perhaps it needs to be this way, but it hurt me so much." By the introjection "perhaps it needs to be this way," the mother submitted to the authoritative truth, which is more powerful than her bodily sensation of extreme pain, signalling that she was not ready to raise a child.

The Alliance between Medicine and Religion

In many contexts, biomedicine is seen as a system replacing religion by providing alternative views on the relationship between human beings and their bodies and the experiences of pain and suffering (Burns Coleman and White; Westfall). However, as Elizabeth Burns Colman and Kevin White observe, "Medical science is deeply coloured by cultural and religious beliefs" (13). Despite the unquestionable position of the paradigm of differentiation between religion and medicine in official discourses, in the context of reproduction, practices and concepts that involve medical and religious arguments and aims do not merely coexist but can be seen as entangled and "pursuing medical and religious goals within one and the same framework" (Lüddeckens and Schrimpf, 11). In Poland, this is visible in the alliance between religion and medicine formed to restrict reproductive rights, particularly the right to abortion. The political entanglement of the medical authority and the Catholic Church, fuelled by antiabortion lobbying, resulted in, inter alia, the introduction of the so-called conscience clause. This highly unregulated tool deployed by doctors and other medical professionals plays an important role in undermining the rights of women seeking assistance in situations qualifying them for legal abortion or trying to access contraception (Druciarek; Mishtal).

The fragmentation resulting from the separation of the self from the body in the context of highly medicalized reproductive procedures, which takes away an important source of power and fulfilment from women, has been heavily criticized in feminist literature (Davis-Floyd and Davis; Davis-Floyd; Lauritzen; Rothman). Our data points to how the ideology supporting medicalization is entwined with religious discourses. The "compulsory masochism" (Budrowska) of Polish mothers, which can be linked to the figure of the Virgin Mary, requires them to be silent about their bodies. The medicalized perspective deems pain, humiliation, and helplessness self-evident (Doroszewska and Nowakowski), while the religious discourse legitimizes these experiences as natural and justified. This is well illustrated by Sylwia's (a thirty-one-year-old Catholic) recollection of what she prayed for during birth: "I knew that thousands of women before me had given birth in worse conditions, and without anaesthetics and without care, and some sort of breech births and so on. And I knew that my birth was very normal, very classic, and that it just had to hurt like that. So I was just asking for strength... not to pass out."

Although the Church opposes the use of many advances of medicine in the context of procreation, such as the termination of pregnancy due to medical reasons, the use of IVF, or the fertilization of human ovum for medical research purposes (Lauritzen), both the medical and religious framings split the foetus from the mother and place the mother in the background. When deployed together, they become powerful means of trapping mothers between the figure of a bodyless mother and that of a mother reduced to a physical body with no subjectivity or agency. Describing the pervasive presence of the figure of Mary in a medicalized birth context, Zuzanna Oleś-Bińczyk notes:

> The culture adopted the memory about the woman exalted by God and integrated into a vision of a woman who is passive and ready to accept whatever awaits her and to fulfil others' expectations. Therefore, the suffering because of the use of some medical procedures experienced by birthing women is easily excused by the role they have. The humiliation experienced by women on Polish delivery wards fits in with this scheme and thus makes sense. (58)

The pregnant body is owned by medical professionals and disciplined by different spectators ascribing to the ideology of medicalized pregnancy and birth. Alicja (thirty-years-old), who had the experience of being pregnant in two different socio-cultural contexts, described the difference in the following way:

> The first pregnancy was the most fantastic in my opinion because we were in Australia and nobody told me what to eat, what to do, what not to do.... I felt for myself what's good, what's not and when I was tired, I immediately said that I need to rest, and if I didn't need to I was very active, so I liked that a lot. That's why I know that the first pregnancy was the coolest because the second one, when I was already here in Poland, under the watchful eye of my mother-in-law [a physician], my sister, everybody was like "Can you eat this? And should you eat it? Or should you rest now? Oh you must be tired?" And it kind of takes away that pleasure of pregnancy.

This quote draws attention to gestational mothers being denied the experience of pleasure, which is so radically separated from pregnancy that

for many, it becomes unimaginable. Alicja does not complain further, but the identification of this particular form of dispossession sends us to a silent place, where Alicja refuses to articulate what the pregnant mother is left with.

This internalized medical view of pregnancy and birth gives the fetus unquestioned primacy over the maternal body. Ultrasound technology allows the body of the mother to be bypassed and closely monitors the child's wellbeing (Basden Arnold). A passive object of medical examination, the mother becomes literally invisible. The experience of excessive examinations carried out without the patient's consent was shared by many women, including Justyna (thirty-one), who recalled: "Different doctors examined me; they did not introduce themselves. The examinations were painful, so it was not nice. But I was aware that I had to submit to these examinations, so that they could know what was happening with my child." When mothers look at their bodies through the lens of their child's well-being, they see the body as imperfect and at times as inadequate and experience it as an object of medical and at times divine interventions. Aneta (twenty-five), a mother diagnosed with severe anaemia in her second pregnancy who gave birth to a healthy child, completely erased her own role in this positive outcome: "There was also a little bit of a problem, anaemia, which required injections and all in all praise to God that there was no hypoxia for the baby either. This is also a big credit to my doctor and praying in my opinion. I prayed throughout the pregnancy."

Breaking the Silence and the Reappearance of the Missing Mother

The examples of the missing maternal embodied subjectivities raise questions concerning the possibility of reflexive engagement with embodied mothering and foregrounding of the maternal subjectivity. The almost palpable elisions and silences about the body in the narratives of our participants were occasionally punctuated by some mothers who attempted to reiterate its importance. Marta (thirty-two, Catholic) articulated the sexual and embodied nature of mothering and called for mobilization and action to prioritize the needs and difficulties of real, terrestrial mothers within local religious communities. She passionately argued that mothers should receive practical advice from more

experienced women in their parishes rather than being asked to meet high demands with no support: "In every single parish, there should be somebody responsible, somebody who would teach these women." Marta's voice, which would be likely to be ignored by progressive feminists as entangled with patriarchal discourses, embraces the religious tradition in which she was raised.

The mothers praying during birth are equally difficult to position from the perspective of progressive feminism and within the modern imaginary (Taylor). Their turning to God—when the medical authority starts to crumble, the trust is broken, or the abuse becomes too apparent—is not easily categorized as manifestations of autonomy or the fighting for individual rights or agency. To make matters even more ambiguous, the mothers do not always place themselves at the centre and pray for the wellbeing of their children, accepting the bodily suffering or harm. To cope with disorientation, lack of information about the procedures they are subjected to, and the pain and fear during pregnancy and childbirth, the Catholic and Muslim mothers evoke the trust in God's will. These acts, however, constitute important moments when the mother is not missing. She is acting, redirecting her expectation to get necessary assistance from a medical expert to God. Most importantly, in her experience, she is seen and heard by God. When religious mothers find a space for religious thinking in the birthing room, their narratives reveal that for many, the answer to the problem of missing embodied subjectivity does not need to come in the form of one of the constitutive elements of the modern imaginary, such as the right to a happy, pain-free life. It is not necessarily a complete elimination of suffering and pain, but restoring the sense of participation in a meaningful relationship as a subject in which the mother is no longer reduced to an objectified body and the bodily pain can be validated. Monika, a Catholic mother in her early thirties, for example, stated: "During my third birth, I saw a cross above the doors.... And this gave me consolation that He was suffering over there, and I was suffering here."

These examples illustrate that the embodied maternal subjectivity is not missing completely but remains tacit, drowned by the louder voices of religious and medical authorities. The mothers struggle with undoing power differentials, putting into words and bringing into symbolic representation their embodied experiences ignored or obscured by the dominant discourses and often escaping consciousness. These attempts

to articulate the story of the pregnant, birthing and postpartum bodies, however tentative and quiet, are invaluable, as "speech that 'breaks the silence' of the perceptual world, spreading a further layer of significance over it and, at the same time, bringing the subject into relationship with their self" (Crossley 79). The young mothers recognized the value of these efforts and spoke about their longing for spaces where the missing mother can be made present in her embodied form. Emma (thirty-two), for example, stated: "I wanted to share it so much and I felt that the fact that I was sharing it, that I was telling about it was such a release of air and emotions. I remember that this was a very important part of the postnatal experience."

For converts to Islam, breaking the silence was often associated with open distancing from Catholicism and Polish culture and the explicit and reflexive searching for other ways of being and doing things. Janina's (twenty-eight) recollection of the Quranic description of the birth of Jesus (Isa) illustrates the process: "The story of birthing Marjam.... Only now scientists are confirming that the way she delivered Prophet Isa, they are now proving that actually it is easier and better for a woman, even the position, or the fact that she ate so much, and only now scientists are able to confirm what was written in Qur'an long time ago."

Concluding Remarks

In this chapter, we have traced how Catholic and Muslim mothers in Poland disappear as embodied subjects being trapped between religious, medical and underdeveloped feminist discourses which rarely break "the second wave silences" (O'Brien Hallstein) . While some scholars carefully avoid the risk of naturalisation which comes with linking maternal to flesh, this cautionary approach can be countered by Lauritzen's arguments, who observes that "an appeal to embodiment is inextricably tied to the context in which it is made" (119). In the context in which diminishing subjectivity and untold suffering becomes a norm, the attention to the body seems warranted and necessary.

As our respondents embrace the gender traditional religions, they remain detached "from the goals of progressive politics" (Mahmood); however, their narratives draw attention to the often ignored embodied ways to "inhabit the norms," which are marginalized in popular feminist discourses (15). Our results demonstrate how missing mothers can

reappear in ways that often remain invisible from the perspective of mainstream feminism and support a call for matricentric feminism. The historical and cultural specificity of maternal experiences discussed in this chapter reveals the intertwined influence of religious and medical practices on the disappearance of embodied maternal subjectivity. Rachelle Chadwick applies Avery Gordon's concept of social hauntings to explain the influence of ideologized historical notions of birth on the experiences of contemporary birthing mothers. Applied to our data, the idea of haunting also captures the impact religious imaginary has on mothers who were raised in a cultural environment saturated by Catholic ideas. Although the narrative on labour pains, as a punishment, is not particularly prominent in contemporary Catholic teaching, it is alive enough to be repeatedly evoked in instances "when the over-and-done-with comes alive" (Gordon 16) and haunts the way labour pain is imagined and endured.

While it is difficult to comprehend this relationship between the practice and maternal silence if we think about the birth as an isolated event, it becomes more apparent when we consider the entirety of the practices surrounding the transition to motherhood. The silence is partly enforced by the audibility of expectations narrated during the antenatal period and shaped in a process that starts long before a moment of conception. As Tina Miller demonstrates in her research, the dreams, aspirations, and expectations about perfect birthing experiences are narrated with relative ease; they belong firmly to the realm of what can be told and are shaped by the conspiracy of silence on the part of medical professionals, popular media, books, and films, and friends and family members completely obscuring the challenging parts of the embodied parenting. The haunting silences of previous generations are captured in the narratives of the mothers who often admit that they did not have open conversations with their mothers, sisters, or friends about what it is like to be pregnant, give birth, and go through the postpartum.

The popular feminisms constructed in the neoliberal context that position women as autonomous, confident, and desiring sexual subjects who actively and knowingly make choices lead to the alienation of feminist agendas (Chen). In the Polish context, this image of a feminist project is discursively weaponized, as those identified as feminists are often juxtaposed with "ordinary women" (Imbierowicz). Feminists are constructed as rejecting traditional gender roles and threatening the

existing structures of dominance (Hall). In this view, "an imaginary divide between 'feminists' and 'mothers'" situates the experiences of the "domesticated" mothers as inconsistent with feminist projects and largely ignored by feminists (Król and Pustułka 379). We argue that in the quest to develop matricentric feminism, equal attention should be paid to narratives of compliance and resistance, as well as the silences about pregnancy, birth, and the postpartum period. As the examples provided by Muslim and Catholic mothers suggest, reflexivity afforded by being listened to allows the "missing mothers" to question some of the discourses and practices and regain their embodied subjectivity not only outside of the religious or medical institutions but also within them.

Endnotes

1. "Hidden mother" practice was used to conceal a mother (usually with fabric) who had to support and soothe her infant during the lengthy process of making a portrait but was not meant to appear on the photograph.

2. We choose to use the terms "mother" and "maternity" as gendered subject categories, not as an essentialist sex differentiation. We acknowledge that the experiences of exclusion and marginalization might be experienced by all people with a uterus; however, we chose to use the terms corresponding with the identity categorisations of our respondents.

3. Forty-four of our participants self-identified as Catholics and eighteen as Muslims. The women were aged between twenty-two and forty; they had between one and three children. The category of "young mother" relates to the fact that their children were aged one month to five years.

4. This work was supported by the National Science Centre, Poland, under Grant 2019/35/D/HS1/00181.

5. According to Andrea O'Reilly, these include the following: essentialization, privatization, individualization, naturalization, normalization, idealization, biologicalization, expertization, intensification, and depoliticalization of motherhood (O'Reilly, "We Need to Talk").

Works Cited

Adamiak, Elżbieta. "Macierzyństwo Boga i Maryi w Teologii Feministycznej." *Salvatoris Mater*, vol. 1, no. 1, 1999, pp. 256–71.

Budrowska, Bogusława. *Macierzyństwo jako punkt zwrotny w życiu kobiety.* Wydawnictwo Funna, 2000.

Burns Coleman, Elizabeth, and Kevin White. "The Meanings of Health and Illness: Medicine, Religion and the Body." *Medicine, Religion, and the Body.* Edited by Elizabeth Burns Coleman and K. White. Brill, 2010, pp. 1–14.

Chadwick, Rachelle. *Bodies that Birth: Vitalizing Birth Politics.* Routledge, 2018.

Crossley, Nick. *Reflexive Embodiment in Contemporary Society: The Body in Late Modern Society.* Open University Press, 2006.

Davis-Floyd, Robbie. *Birth as an American Rite of Passage.* University of California Press, 1992.

Davis-Floyd, Robbie, and Elizabeth Davis. "Intuition as Authoritative Knowledge in Midwifery and Homebirth." *Medical Anthropology Quarterly*, vol. 10, no. 2, 1996, pp. 234–69.

Doroszewska, Antonina, and Michał Nowakowski. "Medykalizacja opieki okołoporodowej w Polsce." *Zeszyty Naukowe Ochrony Zdrowia. Zdrowie Publiczne i Zarządzanie*, vol. 15, no. 2, 2017, pp. 172–77.

Druciarek, Małgorzata. "Prawa kobiet w czasach populizmu." *Instytut Idei*, vol. 12, 2017, pp. 46–50.

Evdokimov, Paul. *Sztuka ikony. Teologia piękna.* Translated by Maria Żurowska. Wydawnictwo Księży Marianów, 1999.

Graff, Agnieszka. *Matka feministka.* Wydawnictwo Krytyki Politycznej, 2014.

Gordon, Avery. *Ghostly Matters: Haunting and the Sociological Imagination.* University of Minnesota Press, 1997.

Katz Rothman, Barbara. "Plenary Address." Midwives Alliance of North America Conference, New York City, 1992.

Imbierowicz, Agnieszka. "The Polish Mother on the Defensive? The Transformation of the Myth and Its Impact on the Motherhood of Polish Women." *Journal of Education Culture and Society*, vol. 3, no. 1, 2020, pp. 140–53.

LaChance Adams, Sarah. *Mad Mothers, Bad Mothers, and What a Good Mother Would Do: The Ethics of Ambivalence.* Columbia University Press, 2014.

Lauritzen, Paul. "Whose Bodies? Which Selves? Appeals to Embodiment in Assessments of Reproductive Technology." *Theology and Medicine. Embodiment, Morality, and Medicine.* Edited by Lisa Sowle Cahill and M. A. Farley. Springer, 1995, pp. 113–26.

Lintott, Sheila, and Maureen Sander-Staudt. "Introduction." *Philosophical Inquiries into Pregnancy, Childbirth, and Mothering.* Edited by Sheila Lintott and M. Sander-Staudt. Routledge, 2012, pp. 1–17.

Lüddeckens, Dorothea, and Monika Schrimpf. "Introduction." *Medicine – Religion – Spirituality. Global Perspectives on Traditional, Complementary, and Alternative Healing.* Edited by Dorothea Lüddeckens and M. Schrimpf. Transcript, 2018, pp. 9–21.

Mahmood, Saba. *Politics of Piety: The Islamic Revival and the Feminist Subject.* Princeton University Press, 2005.

Marling, Raili. "Opacity as a Feminist Strategy. Postcolonial and Postsocialist Entanglements with Neoliberalism." *Postcolonial and Postsocialist Dialogues Intersections, Opacities, Challenges in Feminist Theorizing and Practice.* Edited by Redi Koobak, et al. Routledge, 2021, pp. 64–108.

Mazurek, Emilia. "Macierzyństwo pod medycznym nadzorem. Wybrane aspekty medykalizacji macierzyństwa" *Kultura-Społeczeństwo-Edukacja,* vol. 5, no. 1, 2014, pp. 75–93.

Mazzei, Lisa. *Inhabited Silence in Qualitative Research: Putting Poststructural Theory to Work.* Peter Lang, 2007.

Merleau-Ponty, Maurice. *Phenomenology of Perception.* Translated by Colin Smith. Routledge, 1962.

Miller, Tina. *Making Sense of Motherhood: A Narrative Approach.* Cambridge University Press, 2005.

Mishtal, Joanna. *The Politics of Morality: The Church, the State, and Reproductive Rights in Postsocialist Poland.* Ohio University Press, 2015.

Neumann, Ann. "The Patient Body. Narratives of Female Pain." *The Revealer,* 30 Sep. 2016, https://therevealer.org/the-patient-body-narratives-of-female-pain/. Accessed 10 Sept. 10.

Nieuwkerk, Karin van. *Women Embracing Islam: Gender and Conversion in the West*. University of Texas Press, 2006.

Nowakowska, Luiza. "Refleksje nad ciążą i porodem. Perspektywa krytycznej analizy dyskursu." *Kultura-Społeczeństwo-Edukacja*, vol. 5, no. 1, 2014, pp. 9–24.

Oh, Irene. "Motherhood in Christianity and Islam: Critiques, Realities, and Possibilities." *Journal of Religious Ethics*, vol. 38, no. 4, 2010, pp. 638–53.

Oleś-Binczyk, Zuzanna. "Medykalizacja ciąży i porodu w Polsce." *Kobiety w społeczeństwie polskim*. Edited by Alicja Palęcka, H. Szczodry, and M. Warat. Wydawnictwo Uniwersytetu Jagiellońskiego, 2011, pp. 43–63.

O'Brien Hallstein, D. Lynn. "Second Wave Silences and Third Wave Intensive Mothering." *Mothering in the Third Wave*. Edited by Amber E. Kinser. Demeter Press, 2008, pp. 107–18.

O'Reilly, Andrea. *Matricentric Feminism: Theory, Activism, Practice*. Demeter Press, 2016.

O'Reilly, Andrea. "We Need to Talk about Patriarchal Motherhood. Essentialization, Naturalization, and Idealization in Lionel Shriver's *We Need to Talk about Kevin*." *Journal of the Motherhood Initiative for Research and Community Involvement*, vol. 7, no. 1, 2016, pp. 64–81.

Parry, Diana. "We Wanted a Birth Experience, not a Medical Experience: Exploring Canadian Women's Use of Midwifery." *Health Care for Women International*, vol. 29, no. 8–9, 2008, pp. 784–806.

Peskowitz, Miriam. *The Truth Behind the Mommy Wars: Who Decides What Makes a Good Mother?* Seal Press, 2005.

Radzik, Zuzanna. *Kościół kobiet*. Wydawnictwo WAM, 2020.

Rich, Adrienne. *Of Woman Born. Motherhood as Experience and Institution*. W.W. Norton & Company Ltd., 1986.

Taylor, Charles. *A Secular Age*. Belknap Press, 2007.

Rodante, van der Waal, and Inge van Nistelrooij. "Reimagining Relationality for Reproductive Care: Understanding Obstetric Violence as Separation." *Nursing Ethics*, vol. 5, Jan. 2022, pp. 1186–97.

Walsh, Denis. "Childbirth Embodiment: Problematic Aspects of Current Understandings." *Sociology of Health & Illness*, vol. 32, no. 3, 2010, pp. 486–501.

Warner, Marina. *Alone of All Her Sex: The Myth and Cult of the Virgin Mary.* Oxford University Press, 2013.

3.

The Missing Mother: Feminism's Ghettoization of Artists with Children

Martina Mullaney

Introduction

This rant. This rant is angry. This rant is not hopeful. This rant wants you. Know it. This rant is about the mother. She being forgotten. Been obliterated. Rendered obsolete. Not having it, negated. Like that's alright. Like fuck. It is. This rant is angry. This rant is ranting. This rant is not hopeful. You may not want it. Neither does she. She is missing.

My research on the missing mother comes out of a project I initiated after the birth of my daughter, titled *Enemies of Good Art*. It was a series of discursive events held in public art spaces in London and broadcast on Resonance 104.4FM between 2009 and 2012. On a practical level, it critiqued the institutions that made it difficult for artists with children to visit. More broadly, it asked questions about the nature of art practice for the artist with children. Meetings were organized with the agreement of the institutions involved, and intended as provocations. I used rage and anger as a creative tool to progress the project and hoped others might do likewise. As a practising artist in London and a new mother, I felt immediately alienated from the world of artwork, artmaking, art show-ing, and seeing art for reasons not clear to me at the time. I incited other mother artists with children to air their frustrations in public, too.

Something needs stirring we're being hung out to dry. And I'm not talking about drying up. They're closing our institutions. And I'm not only talking only about the art ones. The lifeline. The shower before them called it a sure start. And it surely was for a time. No, this is not a matriarchal wet dream. This is London, our sisters are not coming. They can't. They have been sliced up, butchered, separated, frog-marched into individualization.

The work of *Enemies of Good Art* was promoted on social media as a movement: angry art mothers making visible the invisibility of the mother. At the time, the project related to my work-life situation; I made the personal political. Together with the other mothers I worked with, we risked exposing our vulnerability to the art world where only the most professionals survive. All of this took place in the wake of an imploding world economy of 2008. Feminism was about to enter its third wave as mothers were hit hardest by the draconian austerity measures imposed by the Tory government of the day. This chapter investigates feminism and its neglect of the mother, in all her forms. Having raged in public through *Enemies of Good Art* for visibility as a mother and artist, I sought refuge in feminism as the obvious space.

Broadcast it. Feels fucking good to have this platform. Bring the rage in disguise to their doors. They invited us in. They invented us. What the more fuck. I don't understand. Don't they know what we're up to? We're critiquing your fucking lack. We're no threat. They know how this works. Pay us lip service for a while and we'll fuck the fuck off. The wave is killing us. Kill the waves. In it for the long haul. Stay angry she said. She said anger is good. She should know. Read all the books. Knows how the psyche works. I'm still learning.

In Search of the Mother

In "Why Have There Been No Great Women Artists?", Linda Nochlin famously critiques the European art canon as white, male, and Western. In her polemic, she highlights the omission of women artists from the canon of art history and traces it back to the academy, where women students were regarded as little more than a muse. In a documentary on her life, Paula Rego talks of the treatment of female students while she studied at the Slade; they were regarded as little more than sexual fodder for male students who would go on to be great artists. Women would

marry and start families; they were therefore not worthy of serious consideration as contenders for careers in the art world. Taking Nochlin's argument that women have largely been written out of the Western canon, I problematize the "mother" concerning the formation of feminist-informed art. I argue that maternity as a subject in art is missing from the feminist canon, and indeed, where it is included, one work is cited repeatedly: Mary Kelly's *Post-Partum Document*.

Baltic, Gateshead. Young artists award. Kids long past toddling. Wanted to taste independence. She wanted to taste art. Small Prick with name badge wanted to exercise his soft power. Another millennial male offered to throw an eye over them while she studied the work. Followed, again by Small Prick. Robotic officious health and safety bullshit imparted in her direction. Made his fucking day. Threats, passive aggressive like a good conformist. Delusional fool, the art world is no bohemian, cool, liberal haven. It's pure capital, and you Small Prick are just another insignificant underpaid replaceable cog. Frogmarched to the lift, consoled themselves with ice cream. Another great art experience.

I went looking for the mother in feminist thought. I systematically went through foundational feminist publications, prominent texts, group exhibitions, collections of women's art, and conferences in search of the mother. I researched key terms, such as mother, mothering, motherhood, and maternal. In the following examples of what I consider to be significant publications in forming the feminist canon, I concluded that the mother is largely missing.

Shoot the fuckers who won't let her in. She did. Still got nowhere. Learned Fems tried to claim her. She was having none of it. Feral. She was having none of it. In a class of her own. A time of her own. Another fucking room of her fucking own. On her own. They were not friends. Solanas and Firestone. Didn't need to be. Probable. What do I know I wasn't there. Not romanticizing after these two. She was a bitch and she knew it. Another call to arms. So to speak. For all the fucking good it did. And bad-tempered fems were rocking it. Then. They didn't want us to disappear. No fucking Sub Burbs for them. Nope. And yet. Everyone uses it. Feminists hoodwinked by the fucking term. Apparently no other word will do. Incomparable. Derived from semen, fucking semen. Fem writers using it to describe fem artwork. What the fucking fuck. No seminalis here. Genitive seminis. Full of possibilities. Seminality.

In major anthologies of feminist art and writing, I have found that if the mother is referenced it is mostly or solely concerning the work of Kelly and her *Post-Partum Document*. Subsequently, I found that omissions occur in many other contexts where you would expect motherhood to be acknowledged. Some important examples are as follows: "Women only" group exhibitions of feminist art, such as the decade-defining exhibition, *WACK!, Art and the Feminist Revolution*; conferences and symposia in an art context relating to feminism, such as art historical conferences. Only recently have the Association of Art Historians' yearly conferences included papers on maternity. Historically, the proportion of papers delivered on feminist concerns has remained low even in "women only" art collections and archives in the United Kingdom (UK), such as The Newhall Art Collection, Murray Edwards College, University of Cambridge and The Women's Art Library, Goldsmiths University of London.

Wakefield, Hepworth. Szapocznikow last day. Workshops. No more fucking art carts. Can't leave the nine-year-old. Have to stay in a two-hour workshop gluing shitty pieces of paper together. Nothing they can't do at home. Making art with kids is boring as fuck. Don't want to hang with these overprivileged darlings. Darling. She wanted to see the fucking art. Where's the crèche? (Enemies Pop Up Tate) Where is the fucking crèche? More health and safety monologues. Zoned out. Again. But you cannot ignore her. The substratum. Again. Irigaray. And. Her. leash. Again.

Publications demonstrating the lack of interest in motherhood within feminist art discourse, include the anthology *Twenty Years of MAKE Magazine: Back to the Future of Women's Art*, a collection of essays and exhibition reviews from the former *Magazine MAKE*. In this anthology, the word "mother" is not in the book's introduction. It is also not mentioned in any of the introductions to the six organizing sections of the book. No reference to the maternal is mentioned in any of the essays to which I refer. In the first section, the one most likely to include the mother in some context—*Sexuality and The Body*—not even the pregnant body is referred to, nor is the postpartum body or the body concerning childbirth. The issues of motherhood and the body are so insignificant that the word "childbirth" is mentioned only on page twenty-six, relating to bodily functions and Kiki Smith about an exhibition of her work at the Whitechapel Gallery. Smith refers to milk and placenta in a notebook.

Reference to the mother is made in section four, in an essay on photography by Anna Douglas in which she discusses the works of Sally Mann and others, mostly about the criticism she received for the work she made with her children (154). The focus here is not on motherhood per se but what is at stake in this chapter is the sexuality of the children.

Child sick, I'm so sorry. Never in my life have I been offered so much money. Not today either. Still burning up. He. Somewhat sympathetic. Need the money. Campylobacter. Again, camp-pylo-bacter. Cam-pylo-fucking-what. Child about to combust. Hottest week of the fucking year. Small flat feels smaller. What to do. Phone. Hydrate. Don't panic, do panic. He long gone not a word till this has blown over. Bastard. Again. Single mother artists. Struggling. What family life, and art making. Is this art. Bloody art now. Run reds. Get to the people who know. She's her usual self, if red. It takes more than a village. No help here from the sisterhood. Don't know where to find the sisterhood in this place. Where is utopia.

In Collectivity

One important example of the absence of information about motherhood in art is the archive of the Women's Art Library at Goldsmiths University of London. The archive was the initiative of a group of artists in the 1980s. Its founding aims were to provide an opportunity to document artwork made by women artists. In an attempt to rebalance the canon of Western art, the library collected documentation and ephemera relating to exhibitions by women artists regardless of subject matter or art form. During my doctoral research, I looked into the archives of the Women's Art Slide Library and found that even there the word "mother" was underrepresented. In the online database supporting the archive, "mother" is a contentious term; although the word is used in the supporting research around art production, it is rarely used by artists supporting their practice; a few artists do use the term in their statements. A direct search for artists in the online catalogues using the terms "mother," "maternal," and "motherhood" resulted in relatively few returns. Using the same search terms in the wider context of the archives produced considerably more results. In the collection documenting artwork and art exhibitions, there was only one box of material that the archivist thought might relate to the mother. Interestingly, documentation of Kelly's *Post-Partum Document*

was not submitted for inclusion in these archives.

Fucking paid work. Unpaid work. All fucking work. Who gives a shit. Christ on a bike. Child on the back. Cheapest form of transport. Efficient. Dangerous. Avoid battles with rammed buses. Get to work on time. Get to childcare—on time. Risk being told off, again. Infantilised. Again. Who's the fucking child here. Running the gauntlet. Oxford Street in the morning. Wigmore on the return. Not enough time between destinations. Women running both. Waiting for me to fuck up, again. Watching clocks. Irigaray, bring on the revolution. The Substratum is depressing. The Substratum is killing us. They should know better. Where are all the feminists?

The archive of *MAKE Magazine* reveals that of the ninety issues published during its nineteen years in production only one issue was dedicated to mothers. Even more surprisingly, in this special issue on the mother, the word "mother" is not included in the title or on the front or back covers. Althea Greenan, archivist and librarian of the MAKE archive (2015), recounts that the editors decided to remove the word "mother" because they felt it would be "off-putting" to their readership and therefore could affect sales.

The idea that the mother could be "off-putting" was at the core of my doctoral research and creative practice. The fact that the mother is missing from key spaces of feminist thought and creativity is testament to the wider struggles mothers face in the world of work. Viewed largely as an impediment to the serious nature of artmaking, having children was regarded as a betrayal of one's genius (Connolly).

Childcare ends at 5.45. Yes I need to leave at 4.30. No, I don't have family in this country. No dad lives two hundred and thirty-three fucking miles away. Yes, I have to leave at 4.30, every day. No I don't have time for lunch. You have overloaded my schedule. No I can't get into work at 8.30. No I don't have childcare from 7.30. Half-term. Nightmare. Why only for three days. Why not a full day. My working week has not changed. Can't rock up an hour later. Can't return an hour earlier. This is the leash. Child-care provision is a tease. This good fifty-two year old virgin doesn't give a fuck. Neoliberal scum. How are we supposed to do this. State doesn't give a fuck. This dick doesn't give a fuck. School doesn't give a fuck. I give no FUCKS anymore.

In Curation

The collection *Feminisms Is Still Our Name: Seven Essays on Historiography and Curatorial Practices* (2010) brings together leading feminist scholars, art historians, and curators to suggest new ways feminism might regroup and renew itself (xvii). The terms "mother," "motherhood," "maternal," and "children" are not listed in this publication. Jessica Sjöholm Skrubbe and Malin Hedlin Hayden edited the collection, which stems from the conference *Feminism, Historiography, and Cultural Practices* (2008) at the Moderna Museet in Stockholm. At the time of writing, the editors felt that "historiography within the discipline of art history had not (yet) succeeded in including feminist art history and curatorial practices in its scope" (xiii). I suggest that while feminism was much maligned by the canon that has formed around art history in its more general understanding of the term. Feminism fell afoul of the traps of canon forming, art on and of maternity was consequently written out of the history of feminism and art.

The following is a summary of the above-mentioned collection, which includes contributions from Mary Kelly, Griselda Pollock, and Amelia Jones. Kelly is listed as the first contributing writer but not concerning *Post-Partum Document*. Amelia Jones looks at feminist art from 1970 to 2009 and examines the recent resurgence in feminist art activities by younger women artists. Jones discusses feminist art history and how the Western canon has overlooked it. She introduces the concept of parafeminism, a new form of feminist thinking and practice that includes notions of sexual difference and gender. However, she does not mention the mother or maternity as a subject worthy of artistic exploration (43). Griselda Pollock questions liquid modernity and feminism and the dangers of categorizing feminism as a movement, destined to be killed and forgotten (105). Other authors in this book also fall into this trap. For example, Hedlin Hayden argues against women-only themed shows (57). She acknowledges the historical necessity of grouping women but warns of the dangers of ghettoizing women. Jessica Sjoholm Skubbe also explores these concerns concerning the feminist canon and its potential demise under a populist phallocentric approach to feminist writing of history (87).

What's with all the biologicals. Disguised anger. We know where it comes from. Still angry. That could be good. Ape western white males and get it. Adored. Fucked. Be like them. Be them. Fuck them. Minimal. Conceptual. Sexy. Cool. Available, brilliant and dedicated. Cocks. Don't ape Western White Males and get it wrong. Mother crude ugly care. Bloody. Visceral. No thinking required. In your face ripped open vaginas. Body parts galore. Got my own trauma to deal with. Know what fucked up mess your body is. We used to talk about how your husband doesn't give a shit about your labour. We still need to talk about how your husband gets to have his fucking career. And fuck you.

Lolita Jablonskiene questions what a contemporary feminist exhibition might need to consider in the context of the former Eastern bloc countries and Western postcolonial theories (141). Renee Baert also addresses the problematics of historiographies of feminist art and feminist art exhibitions (157). The essay collection claims to reflect current thinking in feminist art writing and curatorial practices. Although Pollock, Sjoholm, Skubbe, and Hedlin Hayden reflect on the dangers of anonymity in the collective history of a discipline and the risks of it staying within its confines, they also continue the problem by organizing and contributing to the discursive event and subsequent publication that bring this collection of women feminist thinkers together.

Have to leave London or die trying. Reaching for the bottle. Daily. Still breastfeeding. Four. Helps us sleep/no/sleep. Sleep. Take every opportunity. Stay visible. Why. Mortgage needs it. Profile needs it. Work less. Rely on the state more. Bullshit, that state is not interested. Single. Supplement. Suspended. Fucking Neo-liberals. Tory Cunts, are Cunts, but you know they're Cunts. Single mothers deleted. Again. Felt like a burden. Not technically homeless but couldn't go home. You're going through a breakup love. Two expensive degrees. Stop balling. Return, kick him out. It's just another fight. Homeless. Bags packed. Child in arms. We're out. No plan. Emergency, at the mercy of friends/friends of/friends/friends. Did I end up here. What The Fuck. Panic. Can't breathe. Disarmed.

The following is a review of the texts in the exhibition catalogue *WACK!: Art and the Feminist Revolution* (2007). The words "mother," "motherhood," and "maternal" cannot be found in the index. Of the eighteen sections comprising the exhibition, one section is dedicated to "family Stories" but does not refer to mothers. Of the 120 artists, only

nine works refer to mothers or their representation. A small number of artists in the exhibition catalogue refer briefly to the subject of motherhood and the obvious examples of Kelly's *Post-Partum Document*, Susan Hiller's *Ten Months* and Valie Export's film *Invisible Adversaries*. That such a key exhibition claiming to be a reassessment of feminist art gave such scant attention to maternity demonstrates a disregard for the subject, rendering the mother invisible in this context.

Peggy Phelan, another contributor to the catalogue, intentionally or otherwise, misses an opportunity to talk about maternal concerns. She mentions Kelly concerning Laura Mulvey's film *Riddles of the Sphinx*, noting that some elements of the *Post-Partum Document* were included in the film as she considers it an important feminist work. However, she does not say why the *Post-Partum Document* is an important work. *Riddles of the Sphinx* is steeped in maternal conflict closely connected to the struggles of second-wave feminist activism, such as the demands for equal pay and the lack of affordable childcare. Phelan looks at feminist performance art from the 1970s: radical, naked (some), bloody, and defiant. It is a comprehensive survey of work from the period, highlighting sexism in the art world, the male gaze, and women artists reclaiming the gaze. She does not, however, refer to maternity and artwork derived from maternal experiences.

Shulie saw this coming. Radical solution. W-i-p-e-o-u-t . This acid-spittin' man-hating bitch is not going quietly. If she has to. Sub-urb-ia. She's going solo. Will drag herself there. Not you. Headspace. Let her genius flow. Declare her. She fires this. Got there on her own. Safer to be a single. For fear of parochial doing. Kid loves it. Mother makes it. It being art. All happy then. Fucking anecdotes. Why so many of them? Is this anecdotal? Jane would know. Is this where we get to with this? Can't not tell the personal. Still political. Not that you would know it.

Marsha Meskimmon presents an alternative view of 1970s feminism as a global movement, working against the Anglo-American canon. She advocates for a Francophone feminist perspective while addressing the importance and spread of feminism in the Anglophone world. She notes that Australian feminism is not a derivative of Anglo-American feminism but is accountable to its geography and the histories of colonialism. She draws on its position with the United States in geographic terms and its relationship to Indigenous peoples as a formerly European settler community in Asian-Pacific geography. More importantly, she writes of the

established feminist canon as being the preserve of the few. So why was this the case? How did it become so? I would suggest this is because this emerging feminist canon ignored maternity. Feminism adopted the limitations of canon forming, limitations that Nochlin draws attention to in *"Why Have There Been No Great Women Artists?"* While canon forming continues to be problematic, I maintain that maternity as a subject in art is systematically elided.

Insurance policy does not cover children. Good Neoliberal Virgin gets off on sending them home. More rules to choke us by. Not quite enough rope to finish the job though. Keeps us in our place. Divide and conquer. No such thing as society. Bitch (Thatcher) meant community. Only the individual. And. The family. She meant nu-cle-ar-s only. Nice tidy units. Divide and conquer. Look after number one. Fuck everyone else. Fuck yourself if you have to. Replace religion. Jesus. At least that particular patriarchal indoctrination used the word. Love. All bullshit. To the child in me for a while it felt. Hopeful. No love in the Neo-Lib. Only self-care there.

In New Possibilities

While the women's movement in the UK was well underway during the 1970s, feminist art had not been established. What was to be considered feminist was still up for debate according to Lucy Lippard. Establishing a feminist aesthetic unapologetically was a paradigm shift that Lippard believed had to happen. Recognizing her feminist awakening after the birth of her son, she realized that women were elided by the established male-dominated art machine of the late 1970s, which was when she wrote her ground-breaking book, *From the Center: Feminist Essays on Women's Art*. Although she recognized the radical feminist in herself, she concluded that the hierarchies of the established patriarchal superstructure, as coined by bell hooks, could not be crushed and that the promised revolution would not happen. She argued that change would be slow, only if everyone concerned pulled their collective weight. Her solution, which was not without its problems, was to adopt a separatist strategy for survival and to establish a strong feminist art scene (11). Lippard admitted that this had the potential to become inward-looking and confined within its parameters, but it was better than nothing. For the maternal artist, however, she continued to be written out of the history of feminist art.

Kill the Family. Kill the parent. Kill the capitalist, nu-clear, neoliberal two fucking kids F A M I L Y. Dogs. Mother. Love the Mother. Again. Love the mother. Reclaim her. Own it. What about the father? What about him? He's doing just fine. Where the fuck is she. Massacred while we were sleeping. Love. Everywhere. You might think while you drive your husband's car you're in the driving seat. Love. Like fuck you are. We may no longer scrub on hands and knees but we are still scrubbers.

More recently, Andrea Liss in *Feminist Art and the Maternal* looks for a feminist maternal in art practice and suggests we consider the maternal as a new way to think about feminist knowledge and the possibility of rethinking maternal culture. Where might these new forms of maternal culture operate in the context of feminist art shows and gallery spaces? Can they potentially infiltrate a contemporary art world without the labels "feminist" and "maternal"? What happens to a work of art derived from feminist maternal subjectivity when we try to remove these labels? The introduction to *Feminist Art and the Maternal* mentions anecdotal experiences where the mother is not included in prominent feminist collections. Liss recounts a conversation with a colleague, a renowned feminist art historian, who suggested that she risked reifying essentialism. Liss, like Adrienne Rich before her, wanted to write a book on motherhood as a "relatively unexplored area of feminist theory," (13), arguing the case for a greater understanding of the work of feminist artists working in and of the maternal. The book pays tribute to the early mothers of the women's movement who did not turn away from motherhood; as a result, it engages the usual list of established artists that have made work on the subject from the early 1970s onwards: Mary Kelly, Laura Mulvey, Susan Hiller, Mierle Laderman Ukeles, Renee Cox, and Catherine Opie. She does, however, go on to explore the work of the lesser well-known art collectives, such as Mother Art. Without exception, all the artists included have made work on the body constructed around the mother-child experience. Although Liss's work is a welcome development and a significant publication in terms of investing in motherhood as part of a feminist debate, the book does not ask how works of art can address imbalances in the art world. I would also add that much of the recent attention on motherhood in art focuses on childbirth and the body as the locus for reproduction and as a site of reproductive trauma, as demonstrated through the *Birth Rites Collection* currently housed at the University of Kent in Canterbury.

Why can't we. On the grounds that your child is underage. Well I know that. She's strapped to my fucking chest. See. We cannot admit her. You are not admitting, fool. I am. She is underage. She does not understand language. Yet. Your child does not meet the age restriction. She's a fucking baby. I want this. Let me in. Policy imparted again. Later we manage it. Organised by artists. The only one of us there. Music was too much. She howled. I. We left. Venice was romance. Up your arse England. This is exhausting. Like a bad boyfriend who fucks and eats. Half-dead unresponsive lump. His claim on love tenuous. Hanging on like a desperate cow. No hot fucking, here. Tricky this is about to become, love. In the end there was nothing. No more fight left. Can't take em all on. It's everywhere. Too fucking much. Where is utopia.

In Connecting the Disconnect

If feminism could not make space for the mother, then artist-mothers would make their own space. In 2009, *Enemies of Good Art* held its first meeting at the Whitechapel Gallery, within the exhibition *The Nature of the Beast* by artist Goshka Macuga. In 2010, Andrea Franke began her project *Invisible Spaces of Parenthood, a Collection of Pragmatic Solutions for a Better Future* while an undergraduate student at Chelsea College of Art. The college, after a brief consultation period, elected to close the nursery. This action made eight workers redundant and left twenty-two families (including Franke) without childcare. In response, as a political act, Franke produced a temporary crèche as part of her degree show. The project went on to have further incarnations at the Show Room Gallery in London, where the artist explored alternative possibilities of childcare, child play, and parenthood. By 2011, other groups were forming and hosting their own discursive/art events on the subject of the family in the art world. These groups included Crib Notes, organized by Kim Dhillon, which is a series of curator-led talks at the Whitechapel Gallery to accompany each of their main exhibitions. The public was encouraged to bring their children (under five) from 10:00 to 11:00 am (before opening to the public) for a walk around the exhibition with the curator followed by a short question and answer session. These sessions were, for the most part, attended by mothers and their small children; fathers rarely showed up.

The Birth Rites Collection claims to be the only collection in the UK solely dedicated to the subject of childbirth. The collection was founded by artist and curator Helen Knowles after the birth of her second child in 2006, when Knowles began to explore public representations of childbirth within her practice. *Brood Work* (2009) is a project based in Los Angeles and is the work of Iris Anna Regn and Rebecca Niederlander. They promote the interconnectedness of creative life and family life. Their collective group exhibitions aimed to show works made by artists after the onset of parenthood and not about parenthood itself. Notably this project is concerned with the combined forms of care that parenthood is suggestive of and not mothering or motherhood, which is suggestive of maternal experience only. Their work is not confined to women only nor does it promote a feminist agenda. *The Mothership Project* in Ireland first met in 2013. It is a network of Irish parenting visual artists and arts workers, much as *Enemies of Good Art* had done. Their collective activities included public meetings for artists where children were not excluded, lectures, and public demonstrations in an attempt to highlight the plight of working artists and the lack of opportunities for artists with children. *Cultural ReProducers* is an online community of cultural workers; its central focus is the cultural sector as it addresses the need for more family-friendly policies from cultural institutions. Founded by artist Christa Donner in Chicago, the *Cultural ReProducers* website acts as a repository of information on all things relating to the challenges of being a parent in the cultural sector. The website contains an exhaustive list of publications, exhibitions, and essays on this subject. Other recent similar initiatives include *The Procreate Project* and *The Mother House* in East London. This project took its lead from Judy Chicago and Miriam Schapiro's *Woman House* project from 1972.

Other significant internet-based projects utilizing social media as a platform for the promotion and dissemination of information include *Artist as Mother as Artist, Digital Institute for Early Parenthood,* (formally *Project Afterbirth), Desperate Artwives, Mewe, Motherhood: A Social Practice, and Artists Parents Index.* Individual practices include Lenka Clayton's *Artists Residency in Motherhood* project in the United States. Clayton organized her studio practice around the demands of motherhood, secured funding and built a website to document the process. The result was a series of works generated from her early motherhood experiences.

One of Ten Memorable kisses in Art, Picasso and some unknown, unlucky woman. The patriarch. Powerful men in the art world. He leans. She under him. Waiting. He's hot and strong. In control. Successful. Love him. Hairy chest. Big Cock. Mills and fucking Boon. Timing is everything. Babies. When. Career. When. University education. When. Fucking bio clocks again. When. Faith. We are still fucking waiting. Waiting for the right fucking time to do all of this shit. In the wrong order. Heaven fucking knows when this is supposed to take shape. Not to be hot. Too old now to start again. Too fucking old now to start at the fucking start again. Entry level. Too fucking cheap with a family. Out of fucking sync.

Conclusion

In the art world the "mother", whether she is the subject of art or the maker of it, sits in her own context, of group exhibitions, publications, and discursive events. Through my research, I have identified that the mother is missing from several key feminist creative and intellectual contexts. Opportunities for artists who are also mothers to pursue maternally-centric practices continue to run the risk of ghettoization as demonstrated in the list of initiatives above. In 2020, Artist Helen Sargeant self-published *Maternal Art Magazine* about maternal art practices. A small journal, *Maternal Art Magazine* attempts to make critical and creative space for women artists with children. Sargeant understands the journal as a series of publications sitting alongside the addition of a website selling artwork by artists included in the magazine. At great cost to the representation of maternal art, this initiative encountered difficulties in securing adequate funds, resulting in the demise of this important work.

In 2014, Tracey Emin declared you cannot be a mother and an artist. Emin's statement coincided with her solo show at the Gagosian Gallery London (2014). In this statement, Emin declared that she could not be a great mother and great artist. She maintains that to excel at one would be to the detriment of the other. Emin also professes that the artist Margaret Harrison was not a household name. Much to Harrison's outrage, Emin suggests that while Harrison may be deserving of the accolades that come with fame and notoriety, her maternity has held her back. This unhelpful commentary by Emin supports the myth that

Nochlin attacked in her essay "Why Have There Been No Great Women Artists?"—that of the lone independent artist tortured in his studio, a male preserve where only the most dedicated survive and thrive. Emin believes that children and art practice do not go together, a belief that Harrison, like Nochlin, rejects because there are many ways to live and be an artist. Harrison also points to the women of second-wave feminism who paved the way for female artists today. Women like Linda Nochlin, Lucy Lippard, Griselda Pollock, Mary Kelly and Althea Greenan provided a platform for women artists in an art world that largely excluded them.

In *Why Stories Matter: The Political Grammar of Feminist Theory*, Clare Hemmings sees academic feminism as something removed from the lives of ordinary women, despite the many forms of feminism (2). Meanwhile, many of the concerns of second-wave feminism, such as childcare and the pay gap, continue to be issues for women, despite the advances in activist feminism and the Equal Pay Act of 1970. My generation, born in the 1970s, has, for the most part, turned to feminism after the birth of children; we are too young to have lived through the activism of the 1960s and 70s but not young enough to feel that we do not need feminism. Nevertheless, I cannot help but feel nostalgic for a time when activism and collectivity promised a better world or the possibility of one.

She is not dead. She is not living. Apologises for what? They think she is grateful. They think she always enjoys it. It. They think she was made for. It. What else is she for? Played out daily. She needs them to love. Too big to take on. This paradigm shift.

Her power for fuck's sake.

She alone.

Asshole.

Works Cited

The missing mother is taken from Griselda Pollock's essay "Missing Mothers: Inscriptions in the Feminine in Differencing the Cannon."

Butler, Cornelia H., and Lisa Gabrielle Mark, eds. *WACK!: Art and the Feminist Revolution*. MIT Press, 2007.

Connolly, Cyril. *Enemies of Promise*. Harper Collins, 1973.

Franke, Andrea. *Invisible Spaces of Parenthood: A Collection of Pragmatic Prepositions for a Better Future*, The Show Room, https://www.theshowroom.org/publications/invisible-spaces-of-parenthood. Accessed 14 Sept. 2024.

Harrison, Margaret. "Tracey Emin is Wrong on Motherhood—Having Children Doesn't Mean You Can't Be a Good Artist." *The Independent*, 5 Oct. 2014, https://www.independent.co.uk/author/margaret-harrison. Accessed 14 Sept. 2024.

Hedlin Hayden, Malin, and Jessica Sjoholm Skrubbe, eds. *Feminisms Is Still Our Name: Seven Essays on Historiography and Curatorial Practices*. Cambridge Scholars Publishing, 2010.

Hemmings, Clare. *Why Stories Matter: The Political Grammar of Feminist Theory*. Duke University Press, 2011.

hooks, bell, *Ain't I a Woman: Black Women and Feminism*. Pluto, 1990.

Lippard, Lucy R. *From the Center: Feminist Essays on Women's Art*. Plume Books, 1976.

Liss, Andrea. *Feminist Art and the Maternal*. University of Minnesota Press, 2009.

MAKE Magazine, Motherhood and Women's Art Practice, Issue 75, April/May, Women Artists Slide Library, 1997.

Nochlin, Linda. "Why Have There Been No Great Women Artists?" *Art News*, 1971. https://www.artnews.com/art-news/retrospective/why-have-there-been-no-great-women-artists-4201/

Pollock, Griselda. *Differencing the Canon: Feminist Desire and the Writing of Art's Histories*. Routledge, 1999.

Robinson, Hilary. *Feminism, Art, Theory, An Anthology 1968-2000*. Blackwell, 2006.

Sargeant, Helen. *Maternal Art Magazine: Stay at Home*, https://maternalart.com/magazine old/issue-one. Accessed 14 Sept. 2024.

Throp, Mo, and Maria Walsh, eds. *Twenty Years of Make Magazine: Back to the Future of Women's Art.* I.B. Tauris, 2015.

Willing, Nick. "Watch Paula Rego, Secrets & Stories Online." *Vimeo,* 15 May 2022, https://vimeo.com/ondemand/paularegosecretsstories. Accessed 14 Sept. 2024.

4.

Unseen and Unheard: How the Histories of Missing Mothers Informed the *Aprons of Power* Performances

Rachel Fallon

Introduction

This chapter is about aprons and mothers. It is dedicated to all hidden, missing, and unacknowledged mothers, especially those failed by the Irish state. The *Aprons of Power* are artist activist symbols referring to and informed by the containment of mothers and the absence of their voices within Irish state systems. Conceived as artworks and articles of resistance, the *Aprons of Power* (2018) were first performed for the Repeal! Procession as part of the Artists' Campaign to Repeal the Eighth Amendment for the 2018 EVA International Biennale in Limerick, Ireland. The aprons were specifically created to acknowledge the hidden histories of women in the Magdalene Laundries. These were generally women whose sole act of societal transgression was to become pregnant outside marriage. In predominantly Catholic Ireland, these women's existence was shameful. Therefore, the Irish State, in collaboration with religious orders and the wider moral community, felt that it was imperative to remove these mothers from the general population for undefined lengths of incarceration. These women were erased from society, and their stories went unheard. The story of these women is part of

the wider history of the oppression of women's reproductive rights in Ireland. For this reason, it was important to me to create an art activist work that sought to acknowledge these missing mothers and draw attention to the legacy of their absence.

The Magdalene Laundries

The Magdalene Laundries existed in Ireland from the foundation of the Irish Free State in 1922 until 1996. In 1993, the Sisters of Our Lady of Charity sold part of their convent attached to the Sean McDermott Street Laundry to a developer, leading to the discovery of a mass grave containing 155 unnamed corpses. The ensuing revelations of long-term abuses of young women and mothers within these institutions led to the final laundry closing in 1996. Up until then, thousands (JFMR) of pregnant, unmarried mothers and potentially wayward girls were incarcerated in Magdalene Laundry institutions and Mother and Baby Homes run by the Catholic Church—their children taken away from them and their maternal status hidden. Though not directly involved in incarcerating these women and girls, the Irish state failed to protect and defend their individual liberty and human rights. Through commissions and reports, which have given incomplete histories, it has continued to suppress their voices (McAleese; Murphy).

I chose aprons because of their history within the institution. Upon entry to a Magdalene institution, the woman's hair was cut, her name was changed, and her clothes were taken and replaced with sacklike dresses and aprons (Sillem). It is these missing mothers that I want to remember in the *Apron of Power* performances. In creating this work, I wanted to subvert the function of the apron as a garment of servitude. In this chapter, I examine the significance of the colours, such as white and its association with moral righteousness. This chapter also looks at how types of textiles, such as fine pink silk, and the use of military mottos can call attention to silenced motherhood. I show how positions—such as the raising of skirts used in anasyrma, the ancient gesture of lifting the skirt to expose the female genitals in an act of cursing or a show of strength—can create a space of agency. The *Aprons of Power* performances seek to bring awareness to this injustice. Although anasyrma may be used in eroticism or lewd jokes, the use I refer to in this case is as an apotropaic gesture, one used to ward off evil or curse an

intruder or attacker. It is a subversive power gesture, such as collectively protesting against repressive reproductive laws and the denial of maternal experience.

I also discuss the history of the missing mother within Irish state systems and its relationship to the contemporary fight for women's reproductive rights and health care (the repeal movement) and how the *Aprons of Power* performances in 2018 drew attention to these still invisible women and mothers.

Repealing the Eighth Amendment

The *Aprons of Power* were first performed for the Repeal! Procession for the Artists' Campaign to Repeal the Eighth Amendment at the 38th EVA International Biennale, Limerick on Friday 13 April 2018. The Artists' Campaign to Repeal the Eighth Amendment, a subgroup of a wider repeal coalition movement, had been instigated by visual artists Cecily Brennan, Eithne Jordan, and Alice Maher and poet Paula Meehan in 2015 as an online signatory protest against the Eighth Amendment of the Irish Constitution, Article 40.3.3. The Eighth Amendment equated the life of a fetus with the life of a living pregnant woman. This article had been added to the Constitution in 1983 following a bitter campaign. It severely compromised women's bodily autonomy and maternal healthcare and effectively banned abortion in all instances in Ireland. The campaign for a referendum to abolish this Eighth Amendment, known as the Repeal Campaign, was about reproductive rights. It was about women and the role that motherhood played in their lives, about people who may or may not have wanted to be pregnant, who were dealing with difficult situations, illness, and tragedy and whose voices had up until this point rarely been heard or acknowledged. The Campaign to Repeal the Eighth Amendment was a response to the treatment of women by the Irish state, religious orders, and society, particularly those women who were pregnant and unmarried. There is a direct link between the women sent to the Magdalene Laundries and the women insisting on bodily autonomy and abortion healthcare provisions.

From the foundation of the Irish Free State in 1922 until 1996, at least ten thousand girls and women were imprisoned in Ireland's Magdalene institutions; they were forced to do unpaid labour in commercial and for-profit businesses, primarily laundries and needlework, and were

subjected to severe psychological and physical maltreatment. The women and girls incarcerated included those perceived to be promiscuous, unmarried mothers, and the daughters of unmarried mothers. These women were primarily working class and poor, the most socioeconomically vulnerable whose charge had been handed over to the Catholic religious orders by successive Irish governments. Many of these women were confined for decades. Most of those who left never spoke of the experience or the children taken from them. They were effectively removed from society and silenced.

In "Ireland's Magdalene Laundries: Confronting a History Not Yet Past," Maeve O'Rourke and James Smith explain that Magdalene Laundries "served the purposes of 'containing' the problem [sexual abuse] and avoiding shame." They were used as alternatives to prison and as institutions for the detention of women and girls in need of mental healthcare. Magdalene Laundries worked in tandem with the Mother and Baby Homes where some fifty-six thousand unmarried mothers and fifty-seven thousand children passed through the homes during the period 1920–1998, examined by the Final Report of the Commission of Investigation into Mother and Baby Homes. The conditions in the Magdalene Laundries and convents were punitive. The women and girls were locked in. The windows were barred, and high walls surrounded the buildings. Visits from the outside world were discouraged. The women could not send mail. They became invisible inside. No release date was given, and there was no appeal mechanism. Their hair was cut, their names were often changed, and they were forced to work all day for no pay. Their behaviour was constantly monitored. If they were suspected of transgressing the rules, they were swiftly and severely punished physically and mentally. The younger girls were denied an education. Many believed they would die there (O'Rourke and Smith).

The Final Report of the Commission of Investigation into Mother and Baby Homes (Murphy), published in 2021, reports that twenty-five thousand women and an even larger number of children likely lived in the county homes, which the commission did not examine. Many of these women and children still have no access to their data; their stories have been erased (JMFR). In a 2021 press release, the Clann Project, a working group whose purpose is "to establish the truth of what happened to unmarried mothers and their children in 20th century Ireland," states that "the Commission of Investigation wrongly denied survivors the right

to comment on many draft findings" and that "the Commission's redress recommendations are among findings which do not accurately reflect the survivors' evidence."

As part of the Campaign to Repeal the Eighth Amendment, a small group of artists, of which I was one, collaborated to create large-scale textile banners. Alice Maher and I wrote a proposal for the EVA International Biennale to create a procession of banners through Limerick as a reclamation of the streets for women. This procession was to follow a traditional confraternity route, beginning at the Limerick College of Art and Design, once the Good Shepherd Magdalene Laundry, through the main streets of the city and over the river to the exhibition space at a disused dairy factory at Cleeves. This route had particular symbolic resonance. In Ireland, confraternities were Catholic voluntary associations of lay people, predominantly men, created to promote special works of Christian piety and achieve personal sanctity using special devotional practices. Their overall aim was to promote religious observance under church hierarchy.

Limerick had the largest confraternity in the world, at one stage with over ten thousand members enrolled; on average, six thousand men attended meetings four nights a week (Noonan). Using this historic route was important to the Repeal! Procession because women were not allowed to be part of these events. The women in the Good Shepherd Magdalene Laundry or any Magdalene Laundry were not allowed to leave the building or walk freely in these streets. These women were being punished for having had babies and becoming mothers and denied the experience of being mothers, existing in a state of stasis forever trying to cleanse themselves of this sin.

This sleight of hand accorded them respectability in the moment they erased their maternity, absolutely denying their role as mothers. This situation was further compounded through Mother and Baby Homes, where both forced and illegal adoptions made these mothers completely invisible. The question for me was how to portray such a narrative symbolically and powerfully while remaining ethical and not appropriating their stories. It was important to me to allude to the origins of the Limerick College of Art and Design, which had once been a Magdalene Laundry, and to include these women's histories and how they were shamed and hidden from society. This societal shaming continues today with the stigmatization of single mothers and women seeking abortions,

contraceptives, and other forms of reproductive healthcare.

No women or children were allowed to take part in these processions which were a complete patriarchal appropriation of physical public space; instead, the women were referred to by the clergy of the time as rabble. I searched for a symbolic item that could carry the weight of this history without co-opting a singular narrative. In 2012, Tanya Sillem created a blog for an RTÉ (Ireland's national broadcaster) prime-time episode on the Magdalene Laundries. These were the first documentaries on the topic aired on national television. Although the topic was being discussed in the wider media and as part of an inter-departmental committee in the government, this was a notable opening up of the subject to the general population (O'Rourke and Smith). It was here that I first read a quote from Mary Merritt, incarcerated at High Park Magdalene Laundry in 1947: "The first thing they did was take all my clothes, give me a big serge skirt, a big white apron, a cap and some boots."

I had a history with aprons, or pinnies as they were often referred to. My mother made them for me and my four sisters when we were children as a way of keeping our clothes clean while doing domestic chores or eating. For her, it was a necessary object, cutting down on the washing for a family of nine. Later, I realized my brothers never had special over-alls—stains and dirt were an acceptable part of being a boy.

An apron is a functional item of clothing. It is used in the service industry in its plain white form, a garment that signifies servitude. Its ubiquity belies the high level of cleanliness needed to keep it looking pristine. However, the present-day diminutive standing of the apron is a far cry from its historical origins, which are both powerful and patri-archal. Two Minoan snake goddess figurines dating from approximately 1600 BCE wear garments around their hips that cover their genitals in an apronlike fashion. The Old Testament tells of Prophet Jeremiah's golden apron, covered in precious jewels. The Pope wears an apron called a gremial, and the Masonic and Orange orders have their adamic aprons to signify their power and status. Aprons once also referred to an indi-vidual's social status; the colour of the apron indicated an individual's standing in the community; green, for example, indicated a tradesperson (Beatty).

Adam and Eve wore a fig leaf apron, which was created to cover and protect their genitals and considered a sign of their shame. This is in direct opposition to the practice of anasyrma, where the uncovered vulva

is powerful and protective. Anasyrma, or the raising of skirts, is the exposure of the female genitals to ward off danger and curse invaders. It is a practice that has taken place throughout history and the world as a powerful form of female protest. In Nigeria in 1929, during the Ogu Umanwanyi, or Women's War, the Igbo women practised the method of protest called sitting on a man, where they stripped and wore short loin cloths and warrior regalia to protest colonial oppression and the British attempt to tax women and census their property (Mbah).

There are also both mythological and real accounts of anasyrma or 'raising of skirts' happening in Ireland. In the myth Tain Bo Chuailgne, 150 naked women exposed their "boldness" to CuChulainn. The famous warrior had to lower his eyes to avoid the sight and was overcome by their power. On September 23, 1977, the *Irish Times* reported an eyewitness account from 1913 of feuding men armed with clubs and pitchforks arriving at a house in County Galway where only the woman of the house was at home. She came out to confront them and raised her skirt above her head, causing them to flee (Blackledge).

I liked the idea that these aprons could be powerful when they are typically seen as a submissive artifact and an insignificant motherly thing. I wanted to return that power to disenfranchised women. I wanted to turn a garment offered to women in their difficult circumstances, as a sign of their supposed shame, on its head and reject its function of servitude and signifier of morals.

When the aprons are worn down they are plain, unadorned white. The choices of white linen and pink silk played a formative role in their creation. Textiles and colour have always held societal meaning. Sumptuary laws excluded all but the elite from certain fabrics or colours (Wilson). Later, religion and the hygiene movement would underline these meanings. White became synonymous with virginity, purity, and wealth. For those with inadequate washing facilities or who carried out dirty work, it became a mark of their station in life. The association of white as a symbol of purity and cleanliness was attached to the idea that fallen women in the Magdalene Laundries could repent for the stains on their souls by washing them out of dirty laundry. Stains stand out (Giszczak).

The colour of the chosen pink silk on the underside of the aprons is soft; the colour reminds one of the practice of anasyrma. It is the pink of the genitalia, the cunt and the underbelly. It was important too that

this was expensive pink silk fabric, acknowledging the sexuality that was denied these missing women. This was what they had to keep hidden on the inside to survive. When the aprons are raised, they reveal the inner and intimate as opposed to the outer veneer. In doing so, they reveal an inner truth which gives them power. I wanted to wield colour to underpin the messages of individual and collective protest and to reject the previously accepted truths.

The painted eyes—eyes reminiscent of the "Hamsa" or "Eye of Fatima," a large stylized eye representing the eye that sees everything—stand as protection and signifiers of witness to the harsh regime of incarceration, while the stark black felt letters come from patriarchal systems. The decisions around the words are best summed up by a quote: "This is the oppressor's language yet I need it to talk to you." These words are from the Adrienne Rich poem "The Burning of Paper instead of Children," in which she expresses the frustration and inadequacy of language to articulate the reality of the suffering at hand yet the necessity of using it to claim it as a method of resistance.

They are the words chosen by the military to motivate their forces and articulate their power. I liked the idea of subverting military mottos, turning them on their head to give them new meaning, so the translation from Latin of the Italian Penitentiary Guard motto "Despondere Spem Munus Nostrum" becomes a reassuring and vigilant "to ensure hope is our role." And "Sub Lege Libertas," the motto of the Italian State Police, becomes "Under the Law Freedom" (Polizia). Lifting the aprons erases the individual. In the context of the raised aprons, these words take on a new meaning. In conjunction with specific performance sites, the words lend their power to underline what has been previously missing from this space. For example, when the apron "I Remember" is raised at the site of a closed-down Magdalene Laundry at Sean McDermott Street, it articulates a history of the oppression of mothers. The Apron "to ensure hope is our role" was performed at the 2018 Referendum to the Irish Constitution to Repeal the Eighth Amendment at a beach in front of the Irish Sea, which has been traversed by many women needing to access abortion in the United Kingdom. It takes on a positive and supportive meaning for those women whose healthcare needs have remained underground and unrecognized. In these moments, each particular apron becomes a beacon—a performance that does not depend on a particular performer. The performer becomes every woman, thereby creating collective action.

Conclusion

The *Aprons of Power* performances aim to draw attention to these missing mothers and to seek to include their history in present-day dialogues. At the opening of the 38th Eva Biennale in Limerick, the six performers wearing the aprons of power walked at the back of the Repeal! Procession. Dressed in dark clothing, except for the plain white aprons, the performers enacted the visibility and physical presence denied to their Magdalene sisters. Following behind the dancers and the beautiful, colourful silken banners of the Artists' Campaign to Repeal the Eighth Amendment, they were a jolt of reality. They were visual reminders of the number of women and mothers who were historically missing from our streets, hidden behind laundry walls and kept in institutional buildings, out of sight and out of mind. When the procession arrived at its final destination, the banners were arranged in the yard of the old butter factory and the artist Breda Mayock began to sing her specifically composed song for the occasion: "This Is How We Rise." The six female performers stood in front, and as she sang, they slowly bent forward and raised their aprons, held them high above their heads, arms stretched up in a victory stance, and displayed their pink silken, military motto-ed underside. They used their bodies to represent all those still fighting for those responsible to be held accountable and their voices to be taken seriously. The apron stands as a beacon to give power to their experience and agency to that voice. The intention is to send a message of solidarity and acknowledge these women's presence. A domestic garment often associated with mothers, the aprons signal that we will use whatever humble and ordinary means are at our disposal to dissent against oppressive regimes. In wearing the aprons of power, the body, particularly the maternal body, becomes acknowledged as an important part of the protest.

The Referendum to Repeal the Eighth Amendment took place six weeks after the Repeal! Procession at EVA International Biennale, Limerick resulting in the thirty-sixth amendment of the Constitution of Ireland, which permits the Oireachtas (Irish Parliament) to legislate for the provision of abortion services in Ireland. Subsequently, the aprons of power have been exhibited and performed in other jurisdictions where abortion is prohibited as symbols of solidarity, such as Belfast in 2019, Warsaw in 2022, and Budapest in 2023. At each exhibition, I explain the context of the aprons and their relationship to the Magdalene Laundries and the missing mothers. I performed each apron separately

in a series of public performances. The work has been cited in many publications.

The *Aprons of Power* were acquired by the Arts Council of Ireland in 2018. In 2022, the Museum of Modern Art in Warsaw commissioned an apron of solidarity, a companion apron with a red silk underbelly and a Polish motto for their exhibition: "Who will write the history of tears?" Through circulating the aprons on social media platforms, such as The Great Women Artists (Instagram), and on podcasts, I have been able to talk about the importance of the missing mothers in the Magdalene Laundries and the impact of their history on social change in Ireland. Many works of art have focussed on the mothers in the Magdalene Laundries, so this work is one of many. But in its way, this work has become a visible site of political discourse and a reminder of missing mothers.

Works Cited

Beatty, John. "Aprons and Their Symbolic Ambiguity." *Department of Anthropology, The City University of New York*, 2021, http://userhome. brooklyn.cuny.edu/anthro/jbeatty/resume/writing/aprons.pdf. Accessed 6 Sept. 2024.

Blackledge, Catherine. *Raising the Skirt, the Unsung Power of the Vagina.* Weidenfeld & Nicolson, 2020.

Clann Project. "Clann Press Release." *Clann Project*, 2021, www.clann-project.org. Accessed 6 Sept. 2024.

Giszczak, Mark. "Nine Biblical Metaphors for Sin." *Catholic Bible Student*, 26 June 2013, https://catholicbiblestudent.com/2013/06/biblical-metaphors-sin.html. Accessed 6 Sept. 2024.

Justice for Magdalenes Research (JFMF). "What Were the Magdalene Laundries?" *JFMF*, http://jfmresearch.com/home/preserving-magdalene-history/about-the-magdalene-laundries/. Accessed 6 Sept. 2024.

Mbah, Ndubueze L. "Judith Van Allen, 'Sitting on a Man' and the Foundation of Igbo Women's Studies." *Journal of West African History*, vol. 3, no. 2, 2017, pp. 156–65.

McAleese, Martin. *Report of the Inter-Departmental Committee to Establish the Facts of the State Involvement with the Magdalen Laundries.*

Government of Ireland, 5 Feb. 2013, https://www.gov.ie/en/collection/a69a14-report-of-the-inter-departmental-committee-to-establish-the-facts-of/. Accessed 6 Sept. 2024.

Murphy, Yvonne. *Final Report of the Commission of Investigation into Mother and Baby Homes*, Government of Ireland, 5 Feb. 2013, https://www.gov.ie/en/publication/316d8-commission-of-investigation/. Accessed 6 Sept. 2024.

Noonan, John-Charles Jr. *The Church Visible: The Ceremonial Life and Protocol of the Roman Catholic Church.* Viking, 1996.

O'Rourke, Maeve, and James Smith. "Ireland's Magdalene laundries: Confronting a History Not Yet in the Past." Research Repository, 2016, https://researchrepository.universityofgalway.ie/server/api/core/bitstreams/309cf074-7e27-4c3e-912e-1e0b645605dc/content. Accessed 6 Sept. 2024.

Polizia Penitenziaria. "La Stemma Araldico." *Polizia Penitenziaria*, 1999, https://poliziapenitenziaria.gov.it/polizia-penitenziaria-site/it/stemmaaraldico2.page. Accessed 6 Sept. 2024.

Rich, Adrienne. "The Burning of Paper instead of Children." *Poetry Society*, https://poetrysociety.org/poems/the-burning-of-paper-instead-of-children. Accessed 13 Sept. 2024.

Sillem, Tanya. "Prime Time—Magdalenes." *RTE*, 25 Sept. 2012, https://www.rte.ie/news/primetime/2012/0925/358798-25september2012_primetime/. Accessed 6 Sept. 2024.

Wilson, Laurel Ann. "Common Threads: A Reappraisal of Medieval European Sumptuary Law." *The Medieval Globe*, vol. 2, no. 2, 2016, pp. 141–65.

5.

Art's Otherwised Orphans: Conceiving the Disoeuvre, Recognising Art's Cultural Mothers

Felicity Allen

Introduction

For women artists of my generation (b. 1950s), it was unlikely we would develop the progressive, life-long oeuvre that we were trained to identify with so-called real artists, such as Picasso, whose life's work was promoted as an exemplary model. In this chapter, I introduce the concept of the "disoeuvre" (my neologism) to discuss this concerning higher education for artists in Britain in the 1970s, with an apparent dearth of well-recognized women artists comparable to Picasso. That is, for most of the twentieth century, women artists' education presented an absence of artist-mothers in the public eye who could be seen as famous forebears or, less remotely, recruited as artist lecturers who might help pave the way for women studying art. I show how the experience of growing up as a girl without a living mother can be compared with working as a woman artist without recognized precedents. This frames the exposure to harm and absence of recognition, normally associated with orphaning, for artists marginalized by identity issues.

I am using the elasticity of the term "missing mothers" to think through several different ideas, for instance, my own experience of my

mother, after her death, as repeatedly both missing and present. I am also noting the experience of missing motherhood for artists of my generation: either missing out on becoming mothers to maintain a reputation as an artist or missing out on being recognized as artists because we became mothers. I am employing the term "cultural mothers" to discuss the idea that women artists of my generation were effectively "cultural orphans." We were thus treated as mere proxies alongside our male peers who were the real thing, with the possibility of garnering reputations and self-confidence. The neologism disoeuvre can help to explore the complexities of women artists being cultural orphans and missing making an idealized artist's oeuvre (or continuous progressive career), in some instances as a result of becoming mothers themselves. Although it is important to add women artists' names to the canon, it is nevertheless also important to disrupt conventional analytic structures, for instance, by developing concepts such as the disoeuvre to dismantle the elevated oeuvre.

Informed by and participating in identifying women artists after my graduation, I discuss the 1978 development of the Women Artists Slide Library (WASL), the confusion around the construction of its history, and its transformation into the Woman's Art Library, now curated by Althea Greenan as a special collection in Goldsmiths Library. Collaborating through WAL with other artists and historians, I have been developing a dispersed, open-ended series of dialogues through which to interrogate the concept of the disoeuvre and its possibilities. Finally, I discuss a recent iteration of these dialogues, a series of *Disoeuvre Household* exhibitions, focussing on the second, *The Disoeuvre: Household Mix*, with eight women artists, held at Roseville, Ramsgate in 2022.

The Disoeuvre

I first published the word disoeuvre in my PhD in 2016, and in 2017, my supervisor Alexandra Kokoli invited me to give a presentation about the term as part of a panel discussion hosted by the artist Susan Hiller at London's Raven Row Gallery. I witnessed the concept's warm reception from a full and generationally diverse audience. Since then, I have been working alone and with others to help identify its potential meanings, through an artistic discourse that includes my studio and exhibition practice, public discussions, academic texts, and, now, a series of

Household exhibitions. I am delighted that others are starting to incorporate the term into their work, either as a citation, for instance by Hilary Robinson, or included in a performance art event, such as that by Oriana Fox. Other people's interpretative emphases are likely to be different from my own.

For the 2022 annual conference of the United Kingdom's Association for Art History (AAH), a group of us convened a session on the disoeuvre for which we produced this brief definition:

> People positioned as marginal to art's production must work socially and institutionally, as well as in the studio, not only to make work but to change existing structures so that their work can be recognized and critically received as art. Rather than disregarding those whose conventional oeuvre seems interrupted and inconsistent, we should look for artistic consistency in an artist's work made in and beyond the studio, through employment at art institutions, or connected, for instance, to the labour of care, activism, and other social practices. As a critical tool, the disoeuvre takes account of artists' training in adaptability and their working lives across different sites. It responds to practices encountering and persisting through "feminized" labour (as maintenance or precarity), domestic instability, transience of documentation, new recognition for overlooked visual activisms and curatorial strategies, archival gaps and is open to more. (Allen, "Unattributed")

The aim is to explore the concept's possible resonances while maintaining a collective, feminist criticality. As part of her performance *Better Late Than Never* for the 2023 Spill Festival Think Tank, Fox recorded me reading the poem "The Disoeuvre, a speech" which includes lines personifying the disoeuvre as

> cradling a life's work
> a labour of beings, process and product
> made through and with people and institutions
> and the not (yet) identified as art
> revealing the not (yet) identified as artists
> the not (yet) identified as good

The Disoeuvre accommodates shifts of
direction, language or discipline
an artist sustaining a practice
despite and in response to contingency
whether structural-political or fluke

She builds on feminist and black critiques of exclusive conventions to
dismantle the elevated
oeuvre

She's backing off judgement
holding paradox
sloughing off the binary

(Allen, "The Disoeuvre, a Speech").

The poem calls for recognition of "art's otherwised orphans / unaligned,
unbranded, disowned in a fog of expanded field" (Allen, "The Disoeuvre,
a Speech"). I had previously performed the poem with Althea Greenan
and audience participants in the 2019 exhibition *Dark Energy: Feminist
Organising, Working Collectively,* and included its text in *The Disoeuvre:
an Argument in 4 Voices (WASL Table); 6:27* (38–39). Recognizing that
part of the concept's appeal is its looseness, different individuals can
identify with it because of quite dissimilar experiences, even the word's
pronunciation is ambiguous.

For myself, the memory of a significant woman curator dismissing
Meret Oppenheim's work in the 1980s as inconsistent has been
instructive; she said that Oppenheim's famous fur teacup work ("Object"
1936) held in New York's Museum of Modern Art was a "one-hit wonder."
I reflected on this apparently gender-neutral criticism. In the 1970s, my
BA lecturers (all men) regularly dismissed women's work as decorative
or twee. Was the apparent gender neutrality of "inconsistent" a disguise
for a similar gendered dismissal? Years later, when my oeuvre was
interrupted, I realized that from the point of apparently stopping making
work to the point when I started again, considerable mental and sometimes
physical work had taken place that connected the two, although work
made at either end of the interruption might look different. It was partly
to consider the need to join the dots between a stop and a start that the
concept of the disoeuvre developed. Interruptions have been extremely
likely for women artists, whether caused by structural exclusions and

the work it takes to challenge these, or by domestic circumstances including maternity, or simply caused by one's gendered training to adapt and therefore apparently shift direction. But the idea developed also because during one interruption when I was employed full-time to run gallery education programs at Tate Britain, I became aware as I worked on a particular project, *Nahnou-Together* (exhibited at Tate Britain in 2008, see *Tate Papers*' "Border Crossing") that I was bringing all my artistic experience to bear on the work I was producing. I was drawing on my multiple experiences and practices as an artist, and the feelings I had were comparable—a feeling of concentrated, disciplined but borderless focus—to those I might have in the studio preparing for an exhibition.

Missing Women Artists: Missing Mothering

As an undergraduate studying English and fine art at the esteemed but parochial Exeter University and College of Art in the 1970s, my lecturers were all male. The only woman lecturer at the art college, artist Lesley Kerman, taught liberal studies, although my BA offered me no opportunity to be taught by her. Her image/textbook, *Advice to Women in Management*, wittily and evocatively relays aspects of her experience: "It is clear to me now that women in academia have no idea how threatening they appear to be. It seems that to take her place in that world, a woman must have abilities which then become the seeds of her rejection" (32). I was a bright, challenging, frustrated, and frustrating student, identified by peers and lecturers as the standout feminist. Trying to engage with me, over lunch one day a lecturer casually asked me, "Why do you think that some women have managed to become writers, but there have never been any women artists? Perhaps there was something intrinsic about the physical aspects of art?" Indeed, several lecturers were explicitly attached to Renoir's apparent claim to paint with his prick. Research into obscured women artists published by feminist art historians during this period had not penetrated the lecturing echelons of Exeter.

In this sense, there were no artist-mothers—no women lecturers or artists alive worth looking up to, no historic women artists at all. Referring to Freud's psychoanalysis, which makes "the Father/Hero central to his analysis of art history," Griselda Pollock argues that this exposes "the desires and fantasies which have so far made it inconceivable to imagine

women in the canon. Women, as representatives of the Mother, are not Heroes" (18). I want to connect the emotional experience of being a woman art student and a young woman artist without artist-mothers with what I experienced following the death of my actual mother when I was eleven. I will then reflect on the *Disoeuvre Household* exhibitions I have curated as one form of the reparative work I have undertaken.

With my mother's death, my domestic experience had turned upside down. I was the youngest of four daughters, and within a year, a new stepmother had moved into the household, causing the older three to leave. The household's ethos had previously been culturally and politically engaged, a somewhat borderless family, including a dog, lodgers, foster siblings, a flow of friends and relatives, and so on. The stepmother eliminated the people, furniture, and all the visitors from the house, leaving only me with a father immersed in his work in a new town and school. The switch from one era to the next was as dramatic as moving from a family home to a foster home. My school reports went from good to bad, just as my world had done. At sixteen, I left home, becoming a peripatetic guest in other people's lives, eventually making it to university when I was nearly twenty-one.

Here is the allegory for women artists. As my mother's domestic ethos went missing, so did my culture. I lost the person who might have encouraged me, celebrated my successes, ridiculed or challenged my bullying headteacher, protected or retrieved me from sexual predators, withstood my challenges, taken an interest in my next educational or career steps, and provided a home—that is, a social, institutional framework from which my emergence could be gradual and supported. Exposure without a mother through adolescence produced classic long-term pathologies. Everything took longer.

I suggest this might resemble the exposure women artists have been dealing with as we have tried, for much longer than my career, to get not just our work but also our potential recognized as significant and to be supported through artistic networks and institutions while we reinvoke and breathe life into our missing cultural mothers. Although in this chapter, I am writing specifically about women and the concept of cultural mothers, the argument I am making applies to anyone positioned as marginal to art production.

The intense form of patriarchy at Exeter School of Art manifested unpredictably as sexually predatory behaviour from lecturers. I took a

year out—rare at the time—and throughout the year hitched five hundred miles back and forth to a Scottish rural commune. Its origins in 1972 came from conversations between two women in a London women's group, who had decided to give up the nuclear family model. Most residents were about ten years my senior, reminding me of my older sisters; the commune's warm welcome and its bohemian spirit felt like home. The commune, based in a sixty-room mansion, was also a key part of my education, hosting national summer alternative education workshop programs with up to one hundred and fifty visitors at a time, all involved in sharing domestic duties. (Histories of the commune are now emerging, for instance the anthology *Anatomy of a Commune*.) For four months during the memorably hot summer of 1976, I lived there and remember the artist Monica Sjöö visiting during Women's Week and showing her painting *God Giving Birth* in the great entrance hall. I was already familiar with this work through discussions by Roszika Parker in the monthly British feminist magazine *Spare Rib*, and given the setting's egalitarian and feminist ethos, I was critical of Sjöö's flying visit and presentation without time for reciprocal listening or mutual learning. As women in the 1970s searched for feminist cultural icons, the image of the earth mother suggested by Sjöö's work seemed reactionary, as if she was reinforcing the then-current cultural norm that women must be defined as maternal. Today, Sjöö's work is understood differently and contextualized by her more overtly political work—for instance by Jo Widoff and Amy Budd, curators of the 2023–24 solo exhibition at Moderna Museet and Modern Art Oxford and editors of the accompanying catalogue and by Harriet Loffler, curator of the 2024 Women's Art Collection exhibition, *The Goddess, the Deity and the Cyborg*.

The feminist commune offered me what I now see as a vital informal education, revealing possible cultural mothers, whether they were the commune's feminist originators or the feminist artists I was learning to critique. It has been vital to recognize women artists who have recovered from patriarchal obscuring. However, as Catherine Grant illuminatingly notes, it is the dialogue between women who are unlikely ever to be recognized, as well as their creative work, that also nourishes us. She cites commentaries stating the significance of anonymous women's cultural contributions from writers of different cultures and eras, such as Virginia Woolf, Alice Walker, Audre Lorde, the Milan Women's Bookstore Collective and Teresa de Lauretis, bell hooks, and Adrienne

Rich. Grant writes: "She needs an imagined community, a feminist constellation, in which she can place herself and with whom she can converse" (137). The multiplicity of networks hosted by the commune offered such a community.

Having completed my degree, in 1978 I moved to London. I would visit the newly opened women's bookshop, Sisterwrite, in Islington (not yet a fashionable area) to delight in the new publications, American journals such as *Feminist Art News* and *Heresies*, or the British *Feminist Review*, whose first issue included an article by Tricia Davis and Phil Goodall about their work. Davis and Goodall were Birmingham-based artists associated with the group *Feministo*. The second issue of *Feminist Review* included Pollock's important analysis of male critics' reviews of the significant "women's" 1978 *Hayward Annual*, which was a prestigious annual exhibition of British art that until that point was typically selected by men and frequently exhibited only or mainly men. Selected by four women artists, in 1978 it showed two-thirds women artists and received mixed and frequently patronising reviews. Roszika Parker's articles and reviews on women artists in *Spare Rib* had been a lifeline while I was in Exeter between 1973 and 1977, and I was keen to find out more. *Old Mistresses: Women, Art and Ideology*, the 1981 book Parker wrote with Pollock, is still in print. Its significance lay not simply in accounting for women artists who had been determinedly overlooked, but also in its fundamental critique of art history as a single, defining discipline. Like the analysis of the *Hayward Annual* reviews, Parker and Pollock consistently offered new ways of thinking about art's histories, rather than simply adding in women's names which, nevertheless, seemed essential work. As Victoria Horne has noted, quoting Deborah Cherry:

Feminist intellectual enquiry therefore ascended, entwined with the expanded participation of women in art and academia, but [was] not reducible to it. As Deborah Cherry informed readers of *Art History* in 1982 this enquiry was not intended to be additive but deeply transformative: "Our project is not to add to art history as we know it, but to change it." Thus, feminism's explicitly political scholarship was fuelled by a profound aspiration to reshape the historical imagination of the late twentieth century.

The Women's Art Library, formerly WASL

Having befriended each other for a year or so at school as ten-year-olds, photographic artist Annie Wright had reintroduced herself to me at a feminist artists' day of workshops held at UCL's Slade School of Art (usually known as the Slade) in the autumn of 1977. She and artist film-maker Catherine Elwes had given a presentation about their work, and once I had moved to London in February 1978, Annie and I attempted to join a collective of women artists that Catherine was part of.[1] The group was closed but we agreed to take up a previously attempted idea of developing what became the Women Artists Slide Library (and later the Womens Art Library). Later, Annie invited her acquaintance Pauline Barrie to join us while announcing that she, herself, was moving to the Netherlands, where she still practises. At various stages, Annie and I attempted to develop a collective, although this was less of a priority for Pauline, who ultimately became the library's first director. I stopped volunteering with the library in 1983, but previously Pauline and I had mostly split the labour over the five years we worked alongside one another. By 1979, I was teaching adult education courses about women artists, so taking slides to show in class was my priority. Pauline undertook to set up a legal framework and by 1981 had found a free cupboardlike space for the library at Battersea Arts Centre in south west London, which meant we could go public with the library. Still aspiring to create a collective, I gathered a rota of women to join us from the classes I was teaching in north east London's Holloway: the journey to the library was demanding and could take up to two hours each way, either by bicycle or several buses (the tube didn't stretch either to Battersea or to the areas of north east London we lived in). Curator Elizabeth Shepherd travelled from Finsbury Park, the educationalist Pam Job from Stoke Newington, and I travelled from Dalston. Pauline brought in art historian Gillian Elinor, and each of us contributed to the rota to staff the library, opening it to the public for evenings or a weekend afternoon. Soon others were joining us.

When I started teaching in 1978, there were only two sources of slides of women artists that I could then find in London, the V&A, and Middlesex University (then Middlesex Polytechnic). Borrowing from the V&A's extensive slide loan collection of almost entirely male artists entailed elaborate planning, form-filling and then receiving and returning boxes by post. I spent hours in the V&A Library looking through

long lists of artists, many of whom I had never heard, although my BA education had included history of art. I would scan the V&A lists for women's first names and order slides if I thought I might have struck lucky. They included Elisabeth Vigée-Lebrun, Angelika Kauffman, Mary Moser, Sofia Anguissola, and Mary Beale. It was through learning about these individual artists that I started to become familiar with art's histories, but I needed the artist-mothers to escort me there.

At Middlesex Polytechnic (now University) art historian Lisa Tickner was developing a feminist slide collection for the polytechnic's slide library. In the spirit of sisterhood, I wrote and asked if I might borrow from this collection for my classes; had I understood how different the academic world was from the rural communal feminism I had known and the collaborative feminism I had found through adult education institutes, I might not have had the courage. Tickner generously let me borrow the slides if I booked them in advance and travelled to the Polytechnic, then at the northern end of the Piccadilly tube line, to collect them on the day of the class, to return them the following day. I was getting to know London's outer reaches in the search for slides. (As I proved myself trustworthy, I was given greater leeway. I remember breaking down in tears on one occasion when the trains weren't running.) Having written proposals to lecture or run seminars on women's art to many schools of art, if an invitation was proffered, I would take the newly published books I had bought or borrowed to use their resources centres to take professional quality slides. I was also able to use the Inner London Education Authority's Resources Centre in Islington in the same way, because I was teaching in London's adult education centres. When the opportunity arose, I would phone galleries in advance for permission and cycle with my SLR camera and tripod to photograph the occasional exhibitions of women artists' work.

This work was reparative. I was trying to repair the peculiar feeling of horror I had felt as a girl and a young woman growing up learning that women had apparently contributed nothing to art. It had seemed I had no artist-mothers. Histories of suppressed women artists were just beginning to emerge as I was emerging with my BA. I was horrified and furious at their—I felt it as "our"—suppression. Fury energized me. Fifty years later, I want to connect these feelings and the need to repair, not only with the concurrent feminist critiques I was lucky to encounter in the 1970s but also with the personal feelings of loss I had at the death of

my mother, within a year of first befriending Annie Wright, when I was eleven. I recount the detail of the labour involved in acquiring slides to teach women's art histories because I think otherwise it might be hard to imagine.

Before university, I had already trained to be a secretary, a route merely to provide myself with essential, flexible economic independence. In the 1950s and 1960s, middle-class girls were educated to take one of three jobs (no career) to be adapted to family life as a nurse, teacher, or secretary. By 1978, when we started WASL, like many of the women I knew, throwing off the mantle our women teachers seemed happy to hand down to us, I was determined not to undertake unnecessary administrative work. Liberation was saying no to paperwork and refusing the subservience of secretarial duties. Rachel Warriner has written about the increasing rise of administration resulting from the development of public patronage in the United States (US) in the 1950s and 1960s, the rise of the "pink-collar worker" (a term she ascribes to Anna Lovat), and administration as a form incorporated in conceptualist art practices. Warriner's work interrogates the role of administration, its obscurity, and debasement in a hierarchy of values about WAR (Women Artists in Revolution), a 1970s New York feminist artist collective. Equally, Naomi Pearce has written illuminatingly that the British artist Shirley Read's practice was in possible conflict with the administrative role she held as caretaker for the London studio block in which she was renting a studio in the 1970s and 1980s. In my PhD, I discuss the relative inattention I gave in my contemporaneous diary to developing WASL in contrast with the attention I gave to my affective labour in trying to change my domestic and romantic relationships (put simply, trying to produce a new self while creating a "new man" with whom to form a new type of domestic relationship).

The early development of WASL is unclear. I was recently notified of an article about British feminist art history in which the well-established feminist art historian Amelia Jones mistakenly records that the library had been set up by Pauline Barrie and Katy Deepwell.[2] For some time I had believed that Annie Wright and I were the first to do any real work on establishing it but in conversation with feminist textile historian Victoria Mitchell, it became clear that she had been briefly active with others several years earlier. I think it is likely that several groups of women had attempted something similar without necessarily being aware

of one another. This sense of fluidity is important to note: the idea of one or two originating individuals, so frequently sought latterly, was not only antithetical to the collective aspirations that many British feminists had at the time but, also, unlike the gendered cultural ethos we had been trained in—that is, women fluidly collaborated, for instance in childcare and other work not seen as such, with no individual recognition beyond their friendship groups. Although ideas are generated across different groups and individuals, feminism has also demanded that we name women and their contributions, which is in tension with the demands of the market and its academic validating mechanisms to single out original artists or, as Pollock puts it, "heroes." The development of branding and its associated self-promotion manifested in the wider British art cultures with American-styled policies after Thatcher's election in 1979. From my own experience and from observing my friends, I suspect that for many British people of my generation, say, not more than a decade older than the Young British Artists (YBAs), we'd been schooled, domestically and implicitly through state education, to despise self-promotion, especially if we were state-educated, female, and left-leaning.[3]

The 2015 exhibition *CAN DO: Photographs and Other Material from the Women's Art Library Magazine Archive*, curated by Mo Throp and Maria Walsh, inadvertently demonstrated the political ambiguities in a time of transition from an absence of recognition for women working in art, a desire for collectivity and its apparent adverse, a desire for individual recognition. The many-minute changes to the WASL logo over a relatively short time revealed a naïvety about branding and a tussle for dominance through mark-making. At my invitation, the original logo was designed, for free, by graphic designer Sophie Gibson. Employing a simple drawing of a slide mount as a frame, she had written in her own italic and legible handwriting "Women Artists Slide Library". Before printing and without discussion, Pauline Barrie substituted Gibson's handwriting for her own. This was the first of many tweaks that were visible in the logos shown in the exhibition.[4]

It was not simply the logo, though. The curator of the WAL archive, Althea Greenan, has worked with the Library and its archive for three decades and has developed her knowledge throughout that time. She has repeatedly encouraged a wide, diverse, and creative engagement with its collection. One important strand of this work has been to develop bursaries for artists, art historians, and others to develop their engagement

and practice with the archive, and some of this work has revealed different versions of the library's disputed early history.[5] The various trails of the library's possible histories and the breadth of artists' work now recorded within the archive confuse and expand possibilities for imagining ancestral artist mothers. Indeed, the slippages and tweaks of graphic design manifested in the library's stationery are poetically captured in Greenan's domestic collection of her two young daughters' drawings made in the 1990s and early 2000s on the reverse side of discarded printed materials from the library. The papers inadvertently but poignantly demonstrate a repeated lack of confidence in WAL's brand and its indecision to either support a collective or a leader. Observing the many changes of typeface, design and, in the case of the library's magazine, its actual name, suggests a compulsive dissatisfaction. Seeing this apparent insecurity on display in the *CAN DO* exhibition, it felt to me analogous to an over-anxious maternal interference with a child, fussing its face with a flannel and telling it to sit up, stay clean, and be quiet. Sometime later, to see Greenan's daughters' fresh, confident, and funny drawings on the ever-changing papers felt like a wonderful counterpoint to that interference, comparable with Greenan's generous stewardship of WAL's archive. It also gave me hope that fusing one's labour in the workplace (in this case, WAL) with one's labour in the home (for instance, childcare) could be shown to enrich creative, cultural work promoting forms of collective dialogue and recognition. The drawings wryly question prevailing definitions of amateur and professional, as well as consistency and inconsistency, making a small contribution through which to think about the significance of WAL, the meanings of the disoeuvre and, by extension, the domestic as a site of artistic labour.

I do not want to attribute motives to individuals involved as directors of WAL or editors of the journal it produced. I do, however, want to connect women's insecurities more generally between the 1970s and the 1990s, as artists and critical leaders in the various mainstream art worlds, with what seems like a somewhat fumbling relation to the library's brand and its products. A key question in the early days was about selection: Would we allow anyone to join? Would there be no decisions about quality? Would too many so-called bad artists make for a lack of influence or respect? I suspect several impulses generated the many design tweaks in the 1980s and 1990s. As well as fashion and being open to ideas, I wonder if some of those working with paid contracts for the library were

conscious of their own brand and professional ambitions. Although they might see the library as a relatively short-term stepping stone, they needed to feel confident that the design quality was something they could embrace. They might be ambivalent about the art the slide collections represented, but that would be less inspected than the logo. Neoliberal politics introduced in the 1980s by Prime Minister Thatcher created pressures for those working in the arts to self-brand, which was frequently problematic for people I knew in terms of trained ethos, knowledge, temperament, mental health, and politics. These tensions have continued, discussed by many, poignantly and notably by Mark Fisher.

Despite my historic anxieties about the library's inclusiveness, as Althea Greenan has demonstrated, it is precisely its strength now. To see evidence of the diversity and multiplicity of work made by women through looking at the archive's many slides gives a profound sense of a history of women as artists. Many are not widely known and are often overlooked, cultural orphans, but for our children's generation, potential cultural mothers – having been actively and intensively engaged in the discourse and production of art.

The Disoeuvre Household Exhibitions

In 1955, my mother wrote to her sister about some short-term hourly-paid interviewing she was doing for a London School of Economics research project. She was horrified by how many women were leaving an inter-esting job where they used their brains and had a social life to do jobs requiring no skills. Referring to a friend she thought had been "sent round the bend" by loneliness, she notes in the letter that "It certainly is amazing how many lonely wives there are."[6] As Amy Tobin has de-scribed, referring to Betty Friedan's US-based research begun two years later and published in *The Feminine Mystique* in 1963, Friedan's "activism ... linked women's liberation with freedom from the 'trap' of domesticity" (79). An apparent release from this trap might be to enter professional forms of employment, which, as the collectively made AAH argument for the concept of the disoeuvre expresses it, necessarily involved women artists in working over decades to change the social and the institutional in addition to making a studio practice.

The home, or the domestic, is not necessarily intrinsic to the concept of the disoeuvre, but the conceptualization of reproductive labour by

Silvia Federici and others certainly is. Born in the 1950s, I probably have a stronger image of a mother labouring solely in the home than younger generations based on my childhood friends' households (from memory, mostly lower middle class) as well as those of my mother and stepmother. Referring to Pollock's analysis of gendered scholarship concerning the historicization of modern art, Lara Perry writes that "the pressure to dissociate the production of art from the material context of family life has been tremendous" (19). Equally, discussing Alexandra Kokoli's analysis recognizing "the deep epistemological foundations that have rooted the home with a negated concept of femininity," Tobin argues that "the home could also provide a site to manifest resistance" (79).

Responding to the impact of the pandemic lockdowns, in the autumn of 2021, I curated the first in a series of *Disoeuvre Household* exhibitions. These exhibitions relate to missing mothers in three ways. First, my own public re-enactments within the home of my mother's values of inclusive welcome, discussion and improvisation. Second, presenting women artists in unexpected groups as cultural mothers who might otherwise be overlooked, and creating records for posterity. Third, considering the work of women artists and questions of maternity in relation to their working lives.

Unlike the three 1970s household exhibitions that Tobin examines, the *Disoeuvre Household* exhibitions have been held in a lived-in, not a derelict home. The derelict house might signify my mother's and Friedan's isolating trap with additional implications concerning economic and other precarities concerning housing. Gill Perry summarizes political and psychological attachments to the idea of home in writing about the house in contemporary art; second-wave feminism, she writes, "has helped to uncover the many social and psychic connotations of 'home', revealing a site both of feminine 'homeliness' and crisis" (17). Equally, the *Disoeuvre Household* exhibitions were unlike Maureen Paley's Acme house in east London's Beck Road, where, after Jane Gifford had left the house they had shared, and before establishing an independent gallery in her own name, Paley depersonalized and opened part of it in the 1980s as her gallery, Interim. In the first, the *Disoeuvre: Household Solo* (Nov. 19, 2021, to Feb. 11, 2022; referred to as *Solo*), I showed my work throughout the modest Victorian artisan's terraced house I share with my partner, Simon Smith, in Ramsgate. At the time of the first two *Disoeuvre Household* exhibitions, Smith was still employed but mostly working from

home. I was working mostly in the "master bedroom" requisitioned as my studio. Our bedroom was the only space off limits; while visitors were asked not to step into the half of the sitting room that is Smith's study, a proportionately large painting was viewable within walls otherwise covered in books.

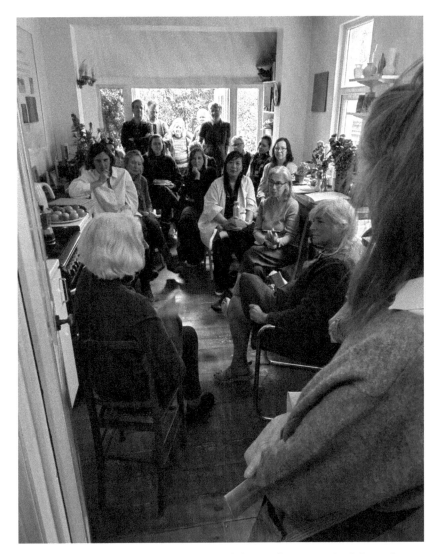

Figure 1. *The Disoeuvre: Household Mix* exhibition, finissage paired discussion event in the kitchen, Roseville, 2022.

Ramsgate is eighty miles east of London on the Kent coast, from where France is sometimes visible. The relatively narrow sea forming a border with the European continent is currently a fundamental tension for many Ramsgate residents, as demonstrated by the Brexit vote (2016) and the election in 2015 of a far-right Tory MP, Craig Mackinlay, a former founding member of UKIP.[7] The coastline is a common arrival point for refugees and questions of hospitality, welcome, and hierarchies of citizenship have been an important undercurrent in curating the *Disoeuvre Household* exhibitions.

I suggest I was performing the sequential and concurrent acts of conceiving, curating, producing, promoting, installing, maintaining, and administering the exhibitions, as well as hosting and creating pedagogical exchanges with and between artists and visitors. I was enacting the multiplicity of roles required of "the female personality" interrogated by Anne Wagner in *Three Artists (Three Women),* her brilliant study of artists Georgia O'Keeffe, Lee Krasner, and Eva Hesse. I was also reenacting a type of householder resembling my own missed mother. Her letters to her sister indicate an infinite range of roles she played within the household, comparable to Wagner's description:

> The long-standing tendency to view the female personality itself as specially labile, defined by multiplicity ... the social identity of the woman has been equally subject to elaboration by recourse to roles or types ... what is striking about this list of roles is ... that she could be understood, if not simultaneously to occupy them all, then at least to put them on and take them off with the practised frequency of a trouper in the Christmas pantomime. (6–7)

Memories of my childhood suggest this multiplicity was enacted throughout the home: turning bedrooms into a political hub for the 1959 general election; making improvised meals as unexpected guests arrived; and sharing my sisters' beds to accommodate a range of additional people for months at a time. Key modes in hospitality I learned from my mother were warmth and improvisation, both of which have been essential components in the enactment of the *Disoeuvre Household* exhibitions. Not wishing to overinterpret, I nevertheless reflect on this work as, in some way, reenacting my missing mother's role in making a so-called good home as one of many attempts to neutralize the trauma of that loss and living in my stepmother's "hostile environment" (in the infamous

phrase of former Conservative Home Secretary, Theresa May [Kirkup]). Equally, filling the house with art, events, artists, and visitors created a vibrancy to fill the gaps left by losing employment concurrently with the end of active mothering in the home. Quoting Cathy Caruth in *Differencing the Canon*, Pollock writes of trauma's "possession of the one who experiences" (108). In addition to Caruth's statement that trauma makes survival possible through engaging with "therapeutic, literary, pedagogical encounter," Pollock comments, "And, I would add, artistic, and even historiographic, encounter" (108).

The Disoeuvre: Household Solo

Between 2020 and 2023, I completed a long-term residency with the research project *People Like You: Contemporary Figures of Personalisation*, but the lockdowns prevented planning a proposed gallery exhibition for either the series of watercolour Dialogic Portraits or the film *Figure to Ground—A Site Losing Its System*, both made for the residency.[8] The portrait series aimed to consider with sitters the changing idea of self, occasioned by medical science and other forms of new technologies, including social media and AI. The Dialogic Portrait series included work made with refugees with experience of the United Kingdom's (UK) policy of indefinite detention.[9] Questions of lineage, heritage, race, colour, and border crossing are referenced in the film. I relate this to contemporary feminist discourse challenging conservative, privileged perspectives of kinship, for instance in the many essays included in the anthology *Making Kin Not Population*. As Michelle Murphy implicitly clarifies, racist border policies philosophically link to gender, race, and economically defined power relations and the place of mothers:

> Radical reproductive justice takes as its starting point the affirmative making of the conditions that support collective life in the face of persistent racist, colonial, and heteropatriarchal life-negating structures. Thus, reproductive justice bleeds into environmental justice … If you cannot drink the water, there is no reproductive justice. (109)

Who one welcomes, whether at the border or in the home, is critical to an inclusive feminist perspective that recognizes value where governments fail to. From my observations, this is an important role that older

women frequently take on, possibly as much informed by a sense of extended social mothering as an identified feminist perspective.[10]

I curated *Solo* as the first in what I propose to be an intermittent series of household exhibitions to manifest ideas of the disoeuvre to be accompanied by a composite series of catalogues. To shift into a public mode for exhibitions, the house became Roseville, the name painted in its fanlight, afterwards reverting to its habitual number fifty-eight. My work to date involved community, gallery, higher education, and curating and exhibition interpretation. I pursued the idea of dialogue—me as an artist and host as a conduit to develop a discourse ranging between individual and group—that is a basis for my Dialogic Portraits series. Thinking of the exhibition as a didactic manifestation, the tour I gave was intrinsic to the exhibition itself. Employing discussion and improvisation, visitors' comments were frequently absorbed into the subsequent tours. The house was open frequently and for special events to relatively small groups of the public; some unknown to me, some only known previously online, others a mix of old friends, local acquaintances, or artists mostly coming from London or neighbouring towns Margate or Whitstable. Events involved hosting visitors with food, drink, and discussion, sitting around the kitchen table, as well as a tour; dissimilar from the conventions of, say, open studios or galleries, when visitors usually expect to wander independently.

Insights from the *Solo* catalogue essays clarified the significance of giving tours. Celia Lury describes the "furniture, kitchen equipment, papers on a table, evidence of an ongoing domestic life: the exhibition made the portraits part of a home ... a house-holding of portraits" (10–11). Referring to the work she has produced with others from the *People Like You* research project, Lury writes, "The show extends the dialogue from which the portraits emerge to a discourse or narrative in which references shift, and points of view merge and rotate in a combination of private and public, personal and impersonal perspectives" (11). Citing art historian Kris Cohen, Lury adds, "People like you and me, singular and plural, a group form ... in which we are akin" (11).

The Disoeuvre Household Mix: Proxies

Six months after *Solo* closed, I opened the second exhibition in the series, *The Disoeuvre: Household Mix* (August 19 to September 18, 2022, referred to as *Mix*). This was different from *Solo*. Alongside a few examples of my work to address the concept of the disoeuvre were works by seven other artists. Expanding on the gendered concept of women (or mothers) in Wagner's terms as "specially labile," three main motives underpinned the selection. The first motive was to consider the use of proxying made by women artists as a radical or survival strategy concerning the disoeuvre, and the second was to work with artists with divergent artistic interests with whom I hoped to develop the disoeuvre concept. Third, I paired artists to make recorded discussions about their work; each of the artist's works was installed mixed with all the others, making cumulative and associative sense rather than linear or literal.

To varying degrees, each artist worked with proxy or anonymity for different motives but often with a need to disguise or reinvent themselves because of gender. Gifford and Denise de Cordova both use their own and an alternative name from which to make different types of work, as has Chiara Williams. In contrast to their humorous play with their proxies, Reem Khatib's work, disguised as the form of a proxy, is deadly serious since she lives under the totalitarian rule of Bashir Al-Assad in Syria. Equally, the subjects of Jenny Matthews' work in this exhibition are Afghan women who have been professionally active as poets, teachers, and doctors but are now governed by the Taliban, their cultural presence has gone missing to such an extent that they are unable to reveal their faces in public, let alone have their work socially acknowledged. They are the epitome of missing cultural mothers. Where location is significant in Khatib's and Matthews' work, it is time, history, and discipline informing the idea of proxy in Moyra Derby's and Vanessa Jackson's work. I will come back to situating my work later in this chapter.

I had known four of the artists—sculptor de Cordova, dream diarist and painter Gifford, constructivist painter Vanessa Jackson, and documentary photographer Jenny Matthews—since the 1980s as relatively recent graduates living in London. I had been ruminating on the somewhat disparate painting practices my peers and I were making in the early 1980s. We were, I think, a specific social set of artists, following in the footsteps of the feminist artists already active through the 1970s but swiftly sidelined by the heady arrival of the highly promoted YBAs.

I was not alone in painting despite feminist strictures against it (a variation of the conceptualist stance: painting was doomed to reinforce patriarchy, as if video technology's newness kept it clean). Like others who pursued painting, I felt a physical compulsion to paint; the embodied intelligence felt when making and looking at the painting is discussed, for instance, by Vanessa Corby concerning maternity in the work of my contemporary Virginia Bodman.[11] Curator Linsey Young's groundbreaking exhibition *Women in Revolt!* at Tate Britain covers this period but omits some of the more problematic aesthetic or art-structural issues tackled by feminists working with drawing and painting in the early 1980s.

Gifford had been painting public murals; some were directly political (for instance to support Nicaragua's resistance to American imperialism). Vanessa Jackson has consistently worked with constructivist abstraction; she sees its basis in geometry as a site of democracy. As painters, we were looking to establish radical modes, such as murals and constructivism, and introduce references to crafts associated with women (for instance in Mikey Cuddihy's work among many others). Objecting to the masculinist, binary limitations implied by the mainstream's polarization of Picasso versus Duchamp, it was only in the later 1980s that I heard pluralism being discussed in the art schools in which I taught. To me, the common conflation of the experimental with new technology seemed simplistic and consumerist. However, my friends and I appreciated Helen Chadwick's sensuously intelligent work made through different technologies as they became available. It shifted between figurative realism and abstraction, and her ability to work with changing technologies was as brilliantly mercurial as she was herself. Her early death continues to leave a real sense of an artist who is deeply missed, who should have become a leading cultural mother.

For *Mix*, while I knew each artist individually, there was little overtly shared artistic practice. Over thirty to forty years, our level of contact with one another had varied at different times, and for some periods, we had been out of touch. For me, a significant rupture occurred in my late thirties when I had two babies in quick succession, during which time I quit my lecturing post and moved out of London. *Mix* enabled me to reenact my mother's spirit through cultural hosting and to exhibit potential cultural mothers for younger generations. It helped me reconsider the 1970s idea of a feminist sisterhood, a form of women's solidarity that might include actions of mutual care performing shifting roles, including

the maternal, for one another in collegiate friendship. The "missing mother" idea is still critical in later life.

Becoming a Missing Mother

The simplest reason to explain my moves in the early 1990s is that, in my lectureship, I was consistently bullied by the head of the Sculpture Department, a man whose aggressive reputation was already established when he was appointed in 1987, when I was also appointed to set up a new program within the Fine Art department. My role was contentious; the sculptor's bullying campaign was immediate and dogged. I was eight months pregnant when he sent a handwritten memo warning me he would "have me ejected" if I entered "his" studios in which our shared students worked. Systems to moderate behaviour to support women or minorities in higher education art departments were not yet generally established. On my return from maternity leave, he carried on and, with no respite and, indeed, the target of victim blaming, I left to take up a role developing the National Association for Gallery Education, now known as Engage.

I write about my experiences not because they are unique but precisely because they are indicative of what Lesley Kerman calls patriarchal "exclusion devices" (26); they were multiple and came in many forms. In my lecturing role, I was replaced by a series of women artists and curators, none of whom stayed more than two years, all subject to the sculptor's bullying, until the post was eliminated. Around the time we were colleagues, the sculptor was having his first work collected by Tate. This, one might argue, combined with his misogynist bullying, is a classic way that cultural mothers are disappeared. During the same period, I thought about how ambivalence and desire are associated with maternity, and the apparent catastrophe to the artistic reputation associated with it. I made a series of large black-and-white photographs of babies moving, possibly falling, against a dense black background. Having been shown in a solo exhibition at Mario Flecha in 1989 and the Ikon Gallery's *Mothers* exhibition in 1990, *Baby II* was not shown again until 2022, in *A Very Special Place: Ikon in the 1990s*. It was included in *Mix* and Hayward Gallery Touring's *Acts of Creation: On Art and Motherhood*, 2024–25, and its accompanying book by curator Hettie Judah.[12]

Figure 2. Felicity Allen, *Baby I & Baby II*, 1989.

Although a (very) few other artists who were also mothers taught in fine art departments, I knew of none who had dared make use of the relative novelty of paid maternity leave. My leave coincided with the shift from local statutory funding for art schools to their integration into a new business model the government imposed on universities. In that atmosphere of anxiety, I was informed by a more senior colleague that my maternity pay would have a detrimental impact on the department's finances. This wasn't the case but expressions of anxiety about women artists having children went far beyond my friends and my conversations about the reputational risk of maternity. Leaving the hard-won lectureship, as an artist who was a mother, my women students missed out on one of the still rare cultural mothers.

It had taken ten years of working peripatetically, repeatedly developing lectures, workshops, and courses before being appointed to a permanent position which I only managed to hold for three years. I was horrified to remind myself of the artist Kate Walker (1938–2015), who, I knew and admired, who was, as Tobin writes in the catalogue *Women in Revolt!*, "a constant collaborator, an organiser and a mother" (33). She was a catalyst in the British feminist art scene, including with the Women Artists Slide Library. It felt like a victory when I heard that Walker had

finally gained a post at Brighton University's School of Art. However, another cultural mother had gone missing when after only three years, she had given up not just the job but working as an artist altogether. As the *Women in Revolt!* catalogue notes in the artist's biography: "Like many of her women artist peers, Walker found it difficult to gain a teaching position at an art school, despite her hugely varied and influential career" (283). As the text label beside her final work *Art of Survival—A Living Monument* (1987), remade for *Women in Revolt!*, describes it: "She retired in the late 1980s, frustrated by the lack of interest in her art." Her Artist's Statement, part of the work, states "The living artist is too busy creating to wait until death for recognition. / A NEW WORK, therefore has been declared. The artist has become A LIVING MONUMENT." In a conclusion pertinent to the labour involved in retrieving missing mothers as well as to problems with recognizing cultural mothers, the text label reveals that "Art of Survival was re-configured with the help of Walker's daughters and is a monument to women artists who have been overlooked." The catalogue also quotes a recorded discussion in which Walker, Monica Ross, and Su Richardson, together working as *Fenix*, state,

> The generation which this trio represents is the first in which working-class women have had access to art education. Some of these women are making a conscious collective attempt to combine motherhood with a professional career. Individual careerist "solutions" such as we have seen throughout art history do not work in their interest.[13]

I left my lectureship, and leaving London seemed almost like a declaration of artistic failure. Several artists I considered close friends chose not to stay in contact. Losing my higher education network, I missed receiving peers' and former students' potential recognition of me as a cultural mother. Domestically, I was restaging aspects of my own mother's multiple strategies to support a family. The fact that my mother was "missing" strongly affected my action; a lack of maternal support isolated me further.

Exhibiting the Disoeuvre: Household Mix

Three more artists helped form the exhibition: Moyra Derby, introduced to me by Vanessa Jackson who taught her in the 1990s at the Royal College of Art, a Ramsgate neighbour; Reem Khatib, a Syrian artist still living in Damascus, with whom I have worked institutionally and individually; and Chiara Williams who upon moving to neighbouring Margate in 2016, hosted *Dry Run* in her flat, a monthly artist salon that contributed to Margate's artistic revival.

Figure 3. *The Disoeuvre: Household Mix,* Roseville, 2022. The hall, Moyra Derby and Vanessa Jackson. Photo credit Ollie Harrop.

Vanessa Jackson was an important interlocutor. I wanted to include her work, but I initially saw her as the exception that proved the rule of the disoeuvre: She had gone straight from school to higher education. While still in her twenties, she had developed her language of geometric abstraction to which she has remained inventively but visibly consistent. Since her mid-twenties, she has had three long-term (permanent) lecturing contracts, including the Royal Academy of Art. As she has informally discussed with me, she constructed her domestic life at a time that

meant foregoing the possibility of children. With her partner, she decided to take on a near-derelict property and spent several years creating an environment for uninterrupted studio practice.

Since I first met Jackson in 1981, the British state-funded galleries, museums, and public collections, which confer status on artists' work, had neglected her. One possible reason is that her work came out of a modernist Constructivist tradition (that acknowledged many women artists from Liubov Popova onwards) that by the 1980s and 1990s, as Alan Fowler's thesis on British Constructivism clarifies (172), had fallen out of fashion in Britain. Generally, Jackson's exhibitions—in the UK, US, and elsewhere—have been developed by or with artists, including her former students or peripatetic curators. In 2015, she was elected to the Royal Academy of Arts, and since that time, her work has gained status. The proxy, therefore, is the alternative to the standard recognized routes of museum and gallery recognition. Without being significantly troubled by economic or critical success, recognition has come from other artists, comparable with John Baldessari, who despite global recognition in art auction houses is still famous for having eschewed the market in favour of a significant career teaching fine art students. The question of how Jackson might be positioned as a cultural mother in the future—missing or present—is open for debate, but she has been decidedly present as a cultural mother for generations of students.

I paired Vanessa Jackson with Moyra Derby, as both work with geometric abstraction. Derby's recent practice-based doctorate involved number theory developed by the mathematician Sophie Germain (French, 1776–1831). New Sophie Germain primes and their corresponding safe primes are still being discovered, yet Germain had to use a male pseudonym to bypass the gender restrictions she faced in becoming and eventually publishing as a mathematician. As Derby points out, had Germain not taken on a proxy, her work would not have been published and we would not have known of her existence.[14]

Derby's abstract work makes subtly witty figurative references. The individual tab or notch on each of the ten panels in *Number Key for Disoeuvre* indicates the numbers zero to nine and gives us the basis from which to decode digits in other works representing a Sophie Germain prime. The shape of each panel suggests card index systems, now mostly transferred to digital records, whose design still renders tabs ubiquitous. Derby's work resonates as an acknowledgement of administration and

its degraded status, linked historically with gender, precarious, or colonized classes. The shift from analogue to digital administration is a vehicle for the political shifts from public to private ownership; thus, Derby's figurative inflection punctuates the demotic aspirations of geometric abstraction.

Figure 4. Jane Gifford, *Three Babies (Dream Diary)*, 2018.

Sculptor de Cordova and painter Gifford both use proxy names for aspects of their work. Though different, their work exudes sensitivity, humour, and pathos. While de Cordova's figurative sculptures are made with a range of materials and imagery, her alter ego Amy Bird's practice is specifically limited to working in a weekly ceramics class making women out of pots. Proxies can relieve ambivalence about the complex legislative forces we inhabit through patriarchy, whether external or internalized as criticism. As de Cordova puts it, "With another self you can use a different voice that's in your body," which "attaches to a different line of stories ... pot woman doesn't mind the cliché of the pot; she loves all that stuff." However, Amy Bird's female figure *Grows Her Own Stones* gives a strong sense of the weight of emotional ambivalence some

women endure, almost as much as the brilliant de Cordova sculpture of a slight, neat woman titled *The Quiet Heroine (The Keeper of Secrets).*

As well as making drawings and paintings from her dreams over the last thirty years, Gifford has a proxy who is specifically engaged in earning a living, for instance through sales and commissions. This includes making paintings as props for films imitative of other artists' work (for instance, the retrieved cultural mother Dora Carrington's paintings as reproduced for Christopher Hampton's 1995 film *Carrington*). The dream work, however, suggests confessionalism and its disavowal all at once: These works are by Gifford and of her but also not locatable as the real her. Concerning the dream drawings and text she regularly uploads to Instagram, Gifford said to de Cordova, it "is very revealing on one level, because it's my subconscious, it's my dreams as I recall them ... but I would never put [on social media] a diary of what I was actually doing."[15] This consciousness of a multiplicity of selves, presented as proxying in the exhibition *Mix*, echoes Wagner's discussion of the list of roles expected of wives and mothers. Like the shifts in graphic design and naming evident in the archive of the Womens Art Library's development, this proxying identifies a problematic history of multiplicity which also acts as anonymity in identifying women artists as cultural mothers. Where de Cordova and Gifford have exploited this with strategic wit, the work of documentary photographer Jenny Matthews and Syrian artist Reem Khatib reveals the violence located in the need to anonymize the gendered self as a proxy to prohibit any possibility of recognition and therefore forego recognition as a cultural mother.

In the 2000s, Khatib and I worked together on a durational international project with artists and young people. She had been running a small art school in Damascus, and I was running the education department at Tate Britain. Since then, we have worked together independently to make an anonymized video installation, exhibited in the United Kingdom, initially in 2020. As most of her artist friends have left Syria, international partnerships are a lifeline along with her Instagram feed of occasional street photographs taken with her mobile. (A high proportion of civilians deployed as undercover government spies results in levels of social distrust in her city unknown in the Global North, making photography difficult and potentially dangerous.) Her life and work as an artist are constrained by threats posed by Syria's totalitarian regime, its international backers and the Global North's border controls.

Figure 5. Reem Khatib, *Damascus Street* (possibly homeless child sleeping), 2021.

Proxies are essential to Syrians' online presence.[16] Jenny Matthews's work "Afghan Women: Facial De-recognition" stems from photographs of women she took when visiting Afghanistan in the 1990s and 2000s. With the Taliban's takeover in 2021, Matthews has reprinted her portraits onto cloth, obscuring the women's faces with embroidery: suggesting gendered caress, punitive constraint, or obliteration. Stitched onto an Afghan scarf, the portraits represent the professional, academic, and creative roles now denied to Afghan women. When showing visitors, I read the titles aloud, each was attached to a portrait of an individual representing the dedication:

> Dedicated to all Women Teachers; Dedicated to Poets and Writers; Dedicated to Widows and Abandoned Wives; Dedicated to all Health Workers; Dedicated to Teachers, Pupils and Students; Dedicated to all Young Girls and their Hopes and Dreams; Dedicated to Young Women with dreams of studying and becoming Doctors, Lawyers, Teachers.

The work was draped over a single bed with Khatib's photos printed, framed and hung on the surrounding walls, on which my family photographs also hang.

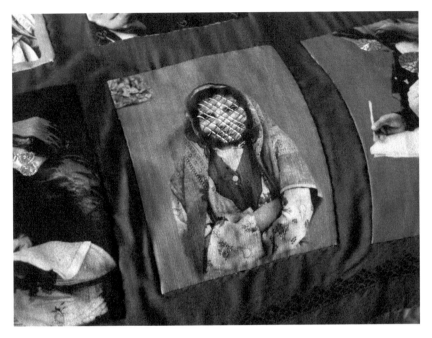

Figure 6. Jenny Matthews, *Facial De-Recognition*, 2022.

Chiara Williams, like me, has taken time out from studio practice to take another role within art, in her case as a gallerist curator and in my own as an education curator. We appeared to others to be these roles, yet in my case, the role felt like a proxy suppressing the self I felt myself to be. Like Gifford, Williams also uses Instagram to play with questions of self-identity and proxies. It is her series of closely observed figurative paintings through which we share, from my perspective, an aesthetic about the weight of the arm, hand, and brushstroke concerning the observing eye, a light touch or a touch of light. Williams is younger than me, and, like me, her early years of motherhood have coincided with her departure from London. When I was in a comparable position to her, I was involved in setting up a local group with other artists and art historians I named *The Want Club*, a smaller scale but similar to Williams's *Dry Run*. Together, we made another pair across generations.

Whereas Williams modelled conceptualist conventions with a sequence of household objects painted on standard lino samples, I showed a few disparate works made at different intervals. Along with *Baby II*, there was a substantial oil painting from a 1990s series of cooling towers and more recent text and image works reviewing incidents from employment. A poem, "The Disoeuvre, a memoir (1999–2002)," related to prints commissioned from Sonia Boyce and Michael Landy for young people looked after by Social Services participating in a project I developed at the Hayward Gallery. That project drew on the range of roles I had enacted through my practice, commonly performed by and potentially obscuring cultural mothers. It is, therefore, part of my disoeuvre.

Disoeuvre Household. Hypothesis

In each case, whether playful or deadly serious survival strategies, proxies question how we as women artists position ourselves and others in relation to power, its histories, and its entanglements with conscious and unconscious life. As domestic exhibitions, *Solo* and *Mix* situated works and practices (our disoeuvres) that up-end the historic mutability demanded of women. They called to other women in other places, other histories, to our missing cultural mothers. For the *Solo* catalogue, Rachel Warriner wrote the following:

> Unlike an open studio, the display was entwined in its domestic setting, lived with and evolving through its interactions with everyday objects ... I encountered works from the series *As If They Existed*, for example, in Allen's spare bedroom. There, the portraits of women who since the 1970s have contributed to the increased attention to women artists through art, activism, curatorial practice, and theoretical and art historical work, was inflected by their proximity to personal photographs of family and friends, sitting alongside each other in a way that invites consideration of the nature of relationships, influences, care and community. (17)

Observations like Warriner's in *Solo*'s catalogue informed the tour I gave of *Mix*, making sure that certain household objects, not curated for the exhibition, were nevertheless visible, potentially to be discussed, such as Syrian pictures and objects, particular portraits, and so on. Visitors

on the tour contributed to my understanding of the work: A film theorist helped me think more deeply about Gifford's film references; an eleven-year-old Arabic-speaking boy translated text on a Syrian picture juxtaposed with Reem Khatib's photographs; and another visitor helped decode the Sophie Germain prime numbers in Derby's work *Pseudonym Pairings*. Having made recordings of de Cordova in conversation with Gifford, Derby in conversation with Jackson, and Williams in conversation with me in advance of the exhibition, as well as having individual discussions with Khatib and Matthews, I hosted the British-based artists in the house for the exhibition's final weekend. An evening for the artists to share discussions was followed by a public series of discussions transforming the kitchen and backyard into a seminar room.

The entrance hall was small and narrow. Vanessa Jackson's *Wall Work* tipped down from the ceiling onto the top of two walls as blocks of angled cobalt blue paint spliced with yellow and grey lune shapes. It worked dynamically with Moyra Derby's *Pseudonym Pairings* and Jackson's *Drawings* above the picture rail. Derby's *Room Diagram*, a line of tape reflecting the staircase wall's triangular shapes, sent one's eyes unexpectedly towards *Baby II* whose upside-down baby seemed to tumble from the landing. Pivoting at the bottom of the stairs, one's peripheral vision took all this in, alongside a cartoonish self-portrait by Gifford, from a dream of herself toppling over. The household seemed joyously destabilized, alive to the presence of women's work, containing ambivalence and ambiguity, or in Gill Perry's words, "homeliness and crisis."

The *Disoeuvre Household* exhibitions have several aims, including acknowledging the work of artists who might be missing cultural mothers for those following in their footsteps; disrupting art histories' tendencies to reinforce only singular ideas of originality; creating a series of small catalogues that, together, situate cultural mothers helping; identifying and defining the disoeuvre; and to create home as an open cultural space in which women in all our diversity feel at home.

Endnotes

1. These artists had also performed at the Slade event where I met Annie Wright. Pauline Barrie was not associated with this group.

2. I have not been able to trace the article, but I gather it was read on Jones's Academia.edu account. Katy Deepwell and I were not concurrent in our work with WASL.

3. YBAs (aka Young British Artists) was a group of artists newly emerging from Goldsmiths and other schools of art in the late 1980s and promoted by the advertising magnate Charles Saatchi and new gallerist Jay Jopling. Artists included Sarah Lucas, Tracey Emin, Damien Hirst, Michael Landy, and many others now less well-known. The subject of their acclaim and its politics have been widely recorded, as has a broader discussion of capitalism's co-option of feminism, and, for instance, the tensions between recognition and identity politics (e.g. Fraser).

4. The exhibition was held at Chelsea Space in tandem with the publication by Throp and Walsh. The magazine was produced by the Womens Art Library (formerly WASL).

5. See, for instance, Lily Evans-Hill's account, whose opening illustration is an original, and inaccurate, account written by Pauline Barrie.

6. In a letter from Margaret Laing Allen (aka Rita, née Sharp) to Catherine Bennett Thackray (née Sharp), 20 May 1955, in the possession of Felicity Allen.

7. The UK Independence Party, a right-wing populist party that was pivotal in the politics of the Brexit vote in 2016.

8. Although the research team had always intended to exhibit the work online, the plan was also to have a physical exhibition. *People Like You* has a time-limited website with full details about the research project, its print publications, and its artists' residencies; the film *Figure to Ground—A Site Losing Its System* is available along with images of the portraits. A fuller textual examination from the research, which includes a discussion of the Dialogic Portraits series, is included in *Figure: Concept and Method*. I have employed this method since 2010.

9. See Refugee Tales, an organisation I have engaged with since 2016.

10. It is notable that in the organisation Refugee Tales, post-institutional women activists significantly outnumber any other group. I don't

have numbers but the ratio must be between five to one and ten to one.

11. Virginia Bodman was appointed the first annual Artist in Residence at Durham Cathedral (1983–84). I was the second. We were housed in an all-male university college whose students included an activist group campaigning to maintain women's exclusion, and the studio was in the grounds of the cathedral, part of the established Church of England, which prohibited the ordination of women as vicars for another decade. I add this detail to give a structural context to the complexities of working as a woman artist in the 1980s.

12. After five years of research, Judah's book, *Acts of Creation: On Art and Motherhood* was published in August 2024.

13. Kate Walker's "Artist Statement" is reproduced in the catalogue. As one of a number of artists consistently working collectively and individually throughout the 1980s, making numerous contributions to feminist art debates and structural change, with regular exhibitions, but omitted from this important historical retrospective and its catalogue, I am personally indebted to Kate Walker for the monument to the women artists overlooked! Of the artists exhibited in *Mix*, only Jenny Matthews was included in the Tate exhibition. Survey exhibitions inevitably leave people out; their apparent comprehensiveness undermines what may seem like a potential feminist strategy; there is always more work to do.

14. Conversation with the author, 15 August 2022.

15. De Cordova and Jane Gifford quotations are from a conversation recorded with the author on 22 June 2022.

16. While it is important to make this clear to people living in the Global North, for the safety of Syrian artists, it is not possible to give further detail.

Works Cited

Allen, Felicity. "Border Crossing." *Tate Papers no. 11.* Tate, 2009, https://www.tate.org.uk/documents/349/tate_papers_11_felicity_allen_border_crossing.pdf. Accessed 17 Sept. 2024.

Allen, Felicity. Creating the "Disoeuvre": Interpreting Feminist Interventions as an Expanded Artistic Practice in Negotiation with Art's

Institutions. Dissertation. Middlesex University, 2016, https://repository.mdx.ac.uk/item/86y04. Accessed 17 Sept. 2024.

Allen, Felicity. *The Disoeuvre: An Argument in 4 Voices (WASL Table); 6:27.* Ma Bibliothèque, 2019.

Allen, Felicity. "The Disoeuvre, a Speech." *Felicity Allen/The Disoeuvre,* https://felicityallen.co.uk/the-disoeuvre/. Accessed 17 Sept. 2024.

Allen, Felicity, with J. Cheddie, L. Dzuverovic, A Greenan, A. Kokoli. "Unattributed Preface" *The Disoeuvre: Household Solo,* Felicity Allen. Edited by Clare Carolin. Ramsgate: Roseville, 2022, p. 2.

Cherry, Deborah. "Feminist Interventions: Feminist Imperatives." *Art History,* vol. 5, no. 4, 1982, pp. 501–08.

Cohen, Kris. *Never Alone, Except for Now: Art, Networks, Populations.* Duke University Press, 2017.

Corby, Vanessa. "Maternity beyond Metaphor: Painting, the Studio, and the Lived Experience of Sexual Difference in the Work of Virginia Bodman." *Journal of Contemporary Painting,* vol. 7, no. 1–2, 2022, pp. 3–38.

Davis, Tricia, and Phil Goodall. "Personally and Politically: Feminist Art Practice." *Feminist Review,* vol. 1, no. 1, 1979, pp. 21–35.

Hill, Lily. "A Brief History of the Women's Art Library." *Goldsmiths, University of London,* https://sites.gold.ac.uk/animatingarchives/a-brief-history-of-the-womens-art-library/. Accessed 17 Sept. 2024.

Federici, Silvia. *Revolution at Point Zero.* Common Notions, 2012.

Fisher, Mark. *Capitalist Realism: Is There No Alternative?* Zero Books, 2009.

Fowler, Alan. *Constructivist Art in Britain: 1913–2005.* Dissertation. University of Southampton Institutional Repository, 2006, https://eprints.soton.ac.uk/465988/1/1025387.pdf. Accessed 17 Sept. 2024.

Fox, Oriana. "Better Late Than Never." *Spill Festival and Think Tank,* 11 May 2023, https://www.spillfestival.com/oriana-fox. Accessed 17 Sept. 2024.

Grant, Catherine. *A Time of One's Own.* Duke University Press, 2022.

Greenan, Althea. "*Household Solo:* A Corporeal Counterpoint." *The Disoeuvre: Household Solo, Felicity Allen.* Edited by Clare Carolin, Ramsgate: Roseville, 2022, pp. 12–16.

Horne, Victoria. "'Our Project Is Not to Add to Art History as We Know It, but to Change It.' The Establishment of the Association of Art Historians and the Emergence of Feminist Interventions, 1974-1990." *Journal of Art Historiography*, vol. 18, 2018, https://arthistoriography. wordpress.com/wp-content/uploads/2018/05/horne.pdf. Accessed 17 Sept. 2024.

Judah, Hettie. *Acts of Creation: on Art and Motherhood*. Thames and Hudson. 2024.

Kerman, Lesley. *Advice to Women in Management*. Little Silver, Goldsmiths, 2012.

Kirkup, James. "Theresa May Interview: 'We're Going to Give Illegal Migrants a Really Hostile Reception.'" *The Telegraph*, 25 May 2012, https://www.telegraph.co.uk/news/0/theresa-may-interview-going-give-illegal-migrants-really-hostile/. Accessed 17 Sept. 2024.

Kokoli, Alexandra, et al. "History or Not: Addressing Omissions in the Retelling of Art's Stories." *Middlesex University Research Repository*, https://repository.mdx.ac.uk/item/86y67. Accessed 17 Sept. 2024.

Loffler, Harriet. *The Goddess, the Deity and the Cyborg*. Women's Art Collection, Murray Edwards College, 8 Mar.–8 Sept. 2024. Exhibition.

Lury, Celia. "Akin: Character, portraits and Persons." *The Disoeuvre: Household Solo, Felicity Allen*. Edited by Clare Carolin. Ramsgate, 2022, pp. 9–11.

Murphy, Michelle. "Against Population, Against Alterlife." *Making Kin Not Population*. Edited by Adele E. Clarke and Donna Harraway. Prickly Paradigm Press, 2018, pp. 101–124.

Parker, Roszika, and Griselda Pollock. *Old Mistresses: Women, Art and Ideology*. 1981. Bloomsbury Academic, 2020.

Pearce, Naomi. *Continuity Girl: The Case of Shirley Read*. Unbidden Tongues, 2022.

Perry, Gill. *Playing at Home: The House in Contemporary Art*. Reaktion, 2013.

Perry, Lara. "The Artist's Household: On Gender and the Division of Artistic and Domestic Labour in Nineteenth-Century London." *Third Text*, vol. 31, no. 1, 2017, pp. 15–29.

Pollock, Griselda. *Differencing the Canon: Feminist Desire and the Writing of Art's Histories*. Routledge, 1999.

Pollock, Griselda. "Feminism, Femininity and the Hayward Annual Exhibition, 1978." *Feminist Review*, vol. 2, no. 1, 1979, pp. 33–55.

Robinson, Hilary. "Not White, Not Male, and Not New York: Race, Feminism and Artists in Pittsburgh." *ResearchGate*, 2020, https://www.researchgate.net/publication/348521601_Not_White_Not_Male_and_Not_New_York_Race_Feminism_and_Artists_in_Pittsburgh. Accessed 17 Sept. 2024.

Throp, Mo, and Maria Walsh. *Twenty Years of MAKE Magazine: Back to the Future of Women's Art*. I.B. Tauris, 2015.

Tobin, Amy. *Women Artists Together*. Yale University Press, 2023.

Wagner, Anne, M. *Three Artists (Three Women): Modernism and the Art of Hesse, Krasner, and O'Keeffe*. University of California, 1996.

Warriner, Rachel. "The Disoeuvre: Intimacy, Experience, Connection." *The Disoeuvre: Household Solo, Felicity Allen*. Edited by Clare Carolin. Roseville, 2022, pp. 17–21.

Widoff, Jo, and Amy Budd. *Monica Sjöö: The Great Cosmic Mother*. Modern Art Oxford, 18 Nov–25 Feb. 2024. Exhibition.

Young, Linsey. *Women in Revolt! Art and Activism in the UK 1970–1990*. Tate, 2023.

6.

Mother Ireland and Missing Mothers: Staging Maternal Encounters in Alanna O'Kelly's *The Country Blooms, a Garden and a Grave* (1990–1996)

Kate Antosik-Parsons

Introduction

Throughout the twentieth century, the maternal figure of Mother Ireland, imagined as the self-sacrificing mother who called her children to defend the nation, has loomed large in Irish culture. *Bunreacht na hÉireann* (1937), the Irish Constitution, defined a woman's duties through her maternal contributions to the nation, which included her childbearing capabilities and work within the home. The female body was controlled, disciplined, and subjected to containment in places like Magdalene Laundries and Mother and Baby Homes, institutions that effectively sought to reform and erase women deemed as transgressive. Although feminist advocacy for women's access to contraception, divorce, and abortion brought about expansive changes in Irish society from the 1970s onwards, these gains were hard-won, and the cultural legacy of Mother Ireland endured. The feminist artmaking of Alanna O'Kelly—an

Irish artist who gained international recognition for her time-based works addressing the marginalization of women in Irish history, culture, and society—placed her own lived experience as a mother at the forefront of her artistic practice. O'Kelly's use of the maternal body highlights the complex entanglements of colonialism, the Irish Famine, capitalism, nationalism, and patriarchal control. I argue that in the multimedia artwork *The Country Blooms, a Garden and a Grave* (1990–1996), O'Kelly innovatively uses her own maternal body to complicate and dismantle colonial and nationalist versions of Mother Ireland. In this chapter, I explore the figure of allegorical Mother Ireland in Irish art, surveying her representation in several key works, and consider how such representations reinforce a dominant view of the maternal. Next, by foregrounding maternal lived realities, I examine feminist artmaking to detail how artists counter the cultural erasure of missing mothers. Turning to O'Kelly's Famine series, *The Country Blooms, a Garden and a Grave*, I analyze how O'Kelly staged maternal encounters with the lactating body and negotiated the presence and absence of the maternal body. Through these encounters with the maternal, O'Kelly's work responds to missing mothers and dismantles Mother Ireland by magnifying the multiplicities of maternal lives.

The Allegorical Mother Ireland in Irish Art: Reinforcing the Dominant Maternal

Throughout the twentieth century, Irish culture, reflecting political and religious ideologies, has co-opted women's bodies as sites of the feminine imaginary. The personification of Ireland as a woman has occurred in many guises, for example, Róisín Dubh, Hibernia, and Cathleen Ní Houlihan, with the female body envisioned as the bearer of culture, the guarantor of the rights of kingship, a maiden in need of saving, and a mother who demands a blood sacrifice. The composite "Mother Ireland" is an allegorical figure conflating nationalism, self-sacrificing asexual motherhood, and the Virgin Mary. In Irish art, the idealized Mother Ireland is deeply connected to the Virgin and Child iconography in the Western European art historical tradition. Examining maternal bodies in visual art, Rosemary Betterton argues the Virgin Mary is a "palimpsest," as "she appears in a number of stories that were condensed historically into an established pictorial typology" (65). John Turpin identifies a

specific cultural flourishing of devotional Marianism in Ireland between the 1850s and 1950s, with the celebration of the Marian Year (1954) coinciding with the centenary of the Dogma of Mary's Immaculate Conception. Arguably, the pictorial typology of Mother Ireland exists in Irish art as I discuss below in more detail.

Beatrice Elvery's *Eire* (1907), a cloaked, seated maternal figure, rests a young male baby on her knee. Inspired by political activist Maude Gonne's portrayal of the title role of Lady Gregory's and W.B. Yeats's play *Cathleen Ní Houlihan* (1902), this painting was purchased for Patrick Pearse's all-boys nationalist Irish-language St. Enda's School. It exemplifies how the cultural resonances of the nation-building project were located in the maternal body. Margaret Clarke's *Mary and Brigid* (1917) depicts Mother Ireland; it supplants the male child with Brigid, referencing the Irish abbess St. Brigid of Kildare, the patron saint of healing and protection. Sean Keating's *An Allegory* (1924) centres on the bitter divide of the Irish Civil War (1922-1923) while a young mother nurses a baby at her breast. Incorporating the virgo lactans, or nursing Virgin iconography, highlights mother's milk as nourishing and sustaining the young nation's development, implying the perceived stability associated with the maternal during this turbulent period. The modernist abstracted forms of mother and child fit together harmoniously in Mainie Jellett's *Decoration* (1924), a radical interpretation of religious icon painting. In Jellett's later *The Virgin of Eire* (c.1940), the figures of Madonna with child, flanked by St. Patrick and St. Brigid, merged in seamless unity with the landscape. In the period of political and economic insularity in the 1940s and 1950s, Ireland also witnessed the construction and retouching of existing outdoor Marian statues and shrines in popular and official devotion.

Aligning the maternal with the reverent Mother Ireland bolstered the rigidity of social norms for Irish women. The idealized Mother Ireland, like the Virgin Mother, informed the feminine imaginary of what constituted an acceptable mother—someone who fulfilled her duties to the fledgling nation by reproducing its citizens. Meanwhile, the unacceptable mother reproduced outside strict parameters acceptable to the church and state. Gerardine Meaney notes that identifying with the virgin/mother role was one of the few routes to power accessible to women under patriarchy if women conformed to societal expectations (4). Writing on the dichotomy between good and bad mothers, Abigail L. Palko

identifies that culturally mothers are constantly surveyed in their care-giving, and society remains "ever alert to signs of deviant mothering," labelling any deviation as "monstrous" (582). Micheal Farrell's *Madonna Irlanda or The Very First Real Irish Political Picture* (1977) and Patrick Graham's expressionist *My Darkish Rosaleen, Ireland as a Young Whore* (1982) deviated from the purity of the Mother Ireland trope, instead representing Mother Ireland's sexualized body and commenting on the shifting political landscape at the time of production. In Farrell's paint-ing, a nude young woman, presumably postcoital, lies face down on a fainting sofa, golden halo overhead with her rosy buttocks exposed, having done her duty for her country. In Graham's work, a half-nude woman wearing stockings and suspenders, with her vulva exposed, stands over a small greying figure resembling a dead baby. Political sym-bols and shamrocks decorate the canvas, as this figure expels something vile from her mouth, indicating the unacceptability of the maternal that fails to align with political, social and cultural norms. Both paintings challenged the cultural purity of the idealized Mother Ireland trope but did so in a manner that was deeply patriarchal and heteronormative. They represent the female body as an object of consumption, produced at a time when the church and state strictly regulated maternal bodies.

Feminist Artmaking and Missing Mothers: Countering the Cultural Erasure

Counter to the iconic Mother Ireland, missing mothers were those whose bodies and reproductive capabilities were policed in tandem by the Catholic Church and the Irish state. The cultural purity of Mother Ireland was sacrosanct, and in Ireland, contraception, abortion, and divorce were illegal, while publications mentioning the prevention or termination of pregnancy were censored by the state. The feminine imaginary envisioned by political and religious ideologies left a gaping void in representing maternal lived realities. Illegitimacy was seized upon as posing a threat to the Irish social order, and, as historian Lindsay Earner-Byrne argues, a mother's status "was legitimated by marriage, reflecting a cultural understanding of the family as patriarchal and only bona fide when headed by a male obligated to the role of fatherhood by marriage" (173). Motherhood outside of marriage was "a symbol of the perceived moral degeneration of the nation" (174). This underpinned the widespread

belief that Irish motherhood "was besmirched by the few who became pregnant outside the legal and religious boundaries of the family" (179); thus, these women were not only seen as a threat to their children but also to other mothers and families. Women who transgressed the boundaries of acceptable behaviour, or were in danger of doing so, were disappeared from society and sent to Magdalene Laundries—punitive and carceral institutions run by female religious congregations with little or no state regulation. Deemed as "penitents" who needed to atone for their sins, these women worked in forced-labour-like industrial laundries and other for-profit enterprises (O'Rourke et al. 13) Moreover, unmarried women and girls who were pregnant outside of marriage were confined to Mother and Baby Homes, related institutions, where they gave birth and were separated from their children by forced and illegal adoption. Deborah McNamara and colleagues argue that mothers who experienced closed adoptions in these institutions were often dehumanized, lacking agency and autonomy. Maternal experiences outside the narrowly defined and regulated confines of Irish motherhood were suppressed because they threatened to dismantle the idealized Mother Ireland.

Feminist artmaking in the 1980s, 1990s, and beyond has engaged with the Mother Ireland trope, destabilizing the allegory concealing women's lived realities. I have argued elsewhere that women's bodies in Ireland have historically been the "physical and metaphorical site where injustices occur, deploying them in art, visual culture, and activist gestures constitutes interventionist acts of resistance" (Antosik-Parsons, "A Body" 36). The insertion of the prolife Eighth Amendment (1983) to the Constitution in which the mother and unborn child were granted an equal right to life and the failed divorce referendum (1986) demonstrated the struggle to control women's lives and bodies. Feminist artists challenged the seemingly passive representations of Mother Ireland by proposing different encounters with the maternal. Pauline Cummins's *Celebration: The Beginning of Labour* (1984), a joyful mural featuring two naked women holding a pregnant woman aloft at the National Maternity Hospital, was later censored after completion by hospital authorities. Patricia Hurl's expressionist mother and child dyad *Madonna (Irish Gothic 2)* (c.1984–1985) conveys the anxieties of motherhood through the ominous background, loose brushwork, and obscured faces.

In Alanna O'Kelly's live performance *One Day... in Time (Extracts from Una O'Kelly's Diary November '81)* (1988), she challenges the construction

of a unified maternal figure and transgresses the private and public divide when reading aloud from her mother's journal. O'Kelly's related work *Dancing with My Shadow* (1988), an elegiac moving image work, in which the artist films herself throwing letters into the sea written to her deceased mother, mourns the loss of the maternal. The formidable maternal bodies of *Mother Ireland* (1988) and *Mother Ulster* (1988) in Rita Duffy's paintings labour under the weight of oppressive Northern Irish nationalist and unionist stereotypes. In Cummins's and Louise Walsh's *Sounding the Depths* (1992), the monstrous female body is a site of agency and desire. In Dorothy Cross's solemn *Virgin Shroud* (1993) a vintage wedding dress, a cowhide, and soft-tipped udders, alludes to the Irish ceremonial rites of marriage and kingship in which the divine right to rule was bestowed upon through masculine ruler through a metaphorical marriage with a female goddess. Amanda Coogan's sub-versive pocket-sized mass card *Madonna in Blue* (2001) offers her breast to the viewer, whereas in *Mad with Child* (2007), Coogan, in a shimmering blue sequined gown, exposes her breast to nurse her infant. Coogan's work recalls Jamaican American artist Renée Cox's powerful *Yo Mama* (1993), each evoking culturally specific maternal stereotypes. Áine Phillips's performance of the *BVM (Blessed Virgin Mary)* in the Alternative Miss Ireland (2001) drag contest is what EL Putnam describes as "mak[ing] apparent the hidden reality that many Irish women and mothers experience through the institutional regulation of their bodies" (68). Áine Phillip's lactating body in *Sex, Birth, Death* (2003) provokes a strong sensory experience, described by Helena Walsh as "an unstoppable outpouring, an explosive flooding that soaks the senses" (36).

Figure 1. Amanda Coogan, *Mad with Child,* 2007, photograph, reproduced with permission of the artist.

In Aideen Barry's gothic horror *Possession* (2011), a housewife's body is dominated by the domestic space actively imprisoning her while also commenting on the materialist values of Celtic Tiger capitalism, the fall-out of the economic crash and the difficulties mothers faced as a result. Helena Walsh's performance *Passageway* (2014)—with a vintage colonial atlas, Virgin Mary-shaped bottles of holy water, bread, and roses—comments on colonialism, nationalism, and women's duties. Barry's *Enshrined* (2015) critiques the imagined nation and capitalism as a woman simultaneously works and pumps breastmilk, intermittently knocking eggs to the floor. Jesse Jones's *Tremble Tremble* (2017) envisions the reawakening of women's embodied knowledge against the backdrop of patriarchal restrictions on bodies in Ireland. Léann Herlihy's

performance works *The sacrificed calf feeds from the swollen udder* (2017) and *a Glove is a Gift* (2017) powerfully reference missing mothers' lactating bodies in Mother and Baby Homes. EL Putnam's *Quickening* (2018) responds to the border on the island of Ireland, the body's boundaries, and the hypervisibility and absence of the maternal body. Rachel Fallon's clever *Mother Medals* (2018), comprised of kitchen sponges and embroidery, is inspired by the pronatalist honours awarded to mothers for (re) producing a large number of children. *Mother Medal 7—Medal for Endurance* (2019), a nursing mother and child image, features the phrase "forward through the night," recalling exhausting night feeds and continuous care routines from which there is often little respite. Michelle Browne's *Unrequited Love II* (2023), a moving image double portrait in which a mother leans in to kiss her teenage daughter and the daughter turns her head in avoidance, illustrates the often-unspoken tensions of parenting. Feminist artists have responded to the erasure of missing mothers by exploring subject matter probing lived experiences and undermining the illusion of Mother Ireland.

Figure 2. EL Putnam, *Quickening*, 2018, interactive installation with sound, reproduced with permission of the artist.

Figure 3. Rachel Fallon, *Mother Medal 7—Medal for Endurance,* 2019, embroidery thread and pastel on cotton rag paper, private collection, reproduced with permission of the artist

Alanna O'Kelly's *Maternal Encounters* with the Lactating Body

The feminist artmaking of Alanna O'Kelly is concerned with temporalities, memory, and embodiment. O'Kelly gained international attention for her radical live performance *Chant Down Greenham* (1984–1988), which uses keening, the Irish funerary custom of crying for the dead, to explore pressing issues of politics, gender, and identity in the 1980s. In the 1990s, O'Kelly focussed on the void in cultural representation of the Great Famine (*An Gorta Mór*) (1845–1852), producing the fluid, collectively titled *The Country Blooms, a Garden and a Grave* (1990–1996) that crosses multiple temporalities.[2] Complex and multi-layered artworks, the series of works is comprised of *The Country Blooms, a Garden and a*

Grave (1990), *No Colouring Can Deepen the Darkness of Truth* (1990), *Sanctuary/Wasteland* (1994), *Omós* (1995), and *A'Beathú* (1995–1996). This body of work incorporated performance, photography, video, tape and slide installation, archival research, and oral histories engaging with the Famine. Two successive years (1845 and 1846) of blight destroyed the majority of potato crops that the Irish relied on for subsistence. The inability to pay landlords led to many tenant evictions, with thousands ending up in workhouses where poor living conditions, widespread starvation, and disease led to between five hundred thousand and 1.5 million deaths while a further four million people emigrated abroad in the decades after the Famine, nearly halving the population of the island. (O'Rourke 407) According to art historian Fionna Barber, "The memory of the Famine was a reminder of Ireland's humiliation"; it was not a common subject in Irish art, as it did not align with the newly crafted vision of Ireland as an independent nation (239). Perceiving a gap in the engagement in Irish culture with the Famine, O'Kelly situated her work at the intersections of postcolonialism, anticapitalism, and feminist critique to consider its unspoken traumatic legacy.

The collectively titled *The Country Blooms, a Garden and a Grave* problematizes the sacrosanct figure of Mother Ireland, reimagining the maternal body in Irish culture through the lens of the Famine. Discussing the history of colonization as a history of feminization, Meaney asserts: "Colonial powers identify their subject peoples as passive, in need of guidance, incapable of self-government, romantic, passionate, unruly, barbarous—all of those things for which the Irish and women have been traditionally praised and scorned" (6). The feminization of Ireland under British colonial rule can be understood as directly connected to the Famine. In the ground-breaking text, *The Feminization of the Famine*, Margaret Kelleher argues that the Famine was feminized through the maternal subject. Examining historical and contemporary Famine literature, Kelleher considers the ambivalent relationship between life, death and the maternal body, and the recurring motifs of mother and child scenes and women's starved bodies. The repetitive nakedness and borderline madness of these texts construct the maternal as a failure of the "primal shelter" to protect and nourish the child (Kelleher 7). The ambivalent maternal figure was a transgressive mother, one capable of abandonment, desertion, and even infanticide. This maternal figure stands in contrast to the passive Mother Ireland. O'Kelly's Famine works

collapse the duality of fecundity and mortality, proposing maternal encounters manifesting the complexities of missing mothers and maternal lived realities. O'Kelly stages encounters with the maternal body, offering what Lena Šimic´ terms as "maternal performance," which conflates representation and action "to invoke more complex and connective social relations" (401).

Figure 4. Alanna O'Kelly, *The Country Blooms, a Garden and a Grave*, 1990, photomontage, Collection Crawford Art Gallery, reproduced with permission.

Figure 5. Alanna O'Kelly, *No Colouring Can Deepen the Darkness of Truth*, 1990, video stills compilation, reproduced with permission.

To orient the reader to these works, I offer a brief description. *The Country Blooms, a Garden and a Grave* (1990) are six coloured photographs: three rectangular panels of landscape images and three square panels of the same images overlaid with text relating to the Famine. O'Kelly has likened the images—the green undulating waves of potato furrows, the dramatic oranges and reds with deep black vertical gashes etched into the landscape, and the starkly lit turf with spade cuts—to the marks the body leaves on the earth. *No Colouring Can Deepen the Darkness of Truth* (1990) is a fourteen-minute moving image work composed of richly coloured elemental imagery, with slow dissolve transitions. The imagery includes a pink breast with creamy swirling milk, flowing water, a sand dune, jellyfish, bones, hands outstretched, an eye, luscious green seaweed, a grave, dried spade marks in a peat bog, fingers covered in caked mud, and floating archival documents. The sound is a fluid arrangement of a woman's voice chanting place-names, a love song, keening, didgeridoo, and whale sounds. *Sanctuary/Wasteland* (1994) is a slide installation of the mass Famine grave Teampall Dumhach Mhór, translated to English as the "Church of the

Great Sandbank." The unchanging rocky mound was projected onto a gallery wall while colour images, of seaweed, rocks, grasses and bones, appeared like spotlights onto the static image as they emerged and gently dissolved into the fixed background. The audio accompanying the visuals were the mournful sounds of keening, Sean-nós singing and a bodhrán. *Omós* (1995) was a live performance and subsequent sound installation in which O'Kelly combines the action of running and breathing. It was first staged in the crypt of St. Mary's Abbey, Dublin. The work is based on a historical account by Rev. Sidney Godolphin Osborne of an encounter between a starving young girl and two male British observers surveying the Famine's effects in Ireland. The girl runs alongside a carriage while the two men inside debate the merits of alms-giving. *A'Beathú* (1995–1996) is an eighteen-minute moving image work with imagery of a lactating breast intercut with an infant's closed eye, mouth, and navel, and the performed actions of the artist running are set against a soundscape of keening and laboured breathing. As is typical of the temporal nature of O'Kelly's artworks, parts of these individual works have been recomposed or refined depending on the exhibition.

Figure 6. Alanna O'Kelly, *A'Beathú*, 1996, video stills compilation, reproduced with permission of the artist.

In *No Colouring Can Deepen the Darkness of Truth* and *A'Beathú*, O'Kelly's lactating breast is an intimate and intense bodily performance of memory incorporating sensory and emotional aspects. Immersing herself in a bathtub of water, O'Kelly and artist Frances Hegarty capture the flow of her breastmilk, using the video camera in a "very intimate way" (Antosik-Parsons, "Alanna O'Kelly" 14). O'Kelly calls upon the intense connection with her nursing infant to surrender herself to that bodily memory. Allowing her emerging embodied response to overtake any psychological inhibitions, O'Kelly's action engages with memory's power and reiterates an exquisite tension in her work between temporality and timelessness.

The lactating maternal body is deeply connected with the image of Mother Ireland. In Marina Warner's astute study of the myths and cultural meanings of the Virgin Mary, representations of the nursing Virgin and her breastmilk reflect the "extraordinary shifts of meaning contain a microcosmic history of Christian attitudes to the physicality of the female" (192). Although Catholic doctrines associated "natural suckling" with good, ever-present was the disquieting idea of women submitting "to the biological destiny of the Fall" (204). This resonates with the similar idea that labour pains, like breastfeeding, are women's human penance for Eve's originating sin. The representation of the lactating body in popular culture and visual arts is multifaceted and complex. Iris Marion Young asserts "One of the most subversive things feminism can do is affirm this undecideability of motherhood and sexuality" (88). Rhonda Shaw suggests that the potential pleasure a mother receives from breastfeeding her child destabilizes lactation as solely an act of giving (128). Through the performance of her lactating body, O'Kelly intends "to illustrate and enjoy the flowing, endless, powerful awesomeness" of the maternal body representing "energy and immense possibilities" (Deepwell 141). This relates to what Putnam understands as the challenge feminist artists pose to "the limitations that such understandings of the maternal place on Irish female sexuality" (66).

Lactation occurs because of birthing, but breastmilk is a substance that must be discharged from the maternal body to be functional. According to Margrit Shildrick, substances that cross corporeal boundaries like blood, fecal matter, and breastmilk are "a significant focus of cultural anxiety and regulation" (81). Responses to O'Kelly's lactating breast express such anxiety, as one viewer commented that "'smoke' coming out of a woman's nipple was a violent depiction of womanhood"

(Kelley 94). Another stated "A particularly chilling image is that of breast-milk trickling from the nipple to be wasted in the water; it appears like smoke and plumes away" (Olson 58). In *A'Beathú*, the appearance and disappearance of the lactating breast, mediated by a hand covering and revealing it, similarly produces a certain anxiety. As the breast imagery dominates the work, one becomes transfixed by its appearance; it becomes familiar and produces a longing for its return.

The leaking breast in O'Kelly's work, like the missing mothers in Irish society, is threatening because of its potential to elude patriarchal control. Ireland has a complicated history with breastfeeding, and as Tanya Cassidy identifies, historic linkages between breastfeeding, poverty, and malnutrition harken back to the time of the Great Famine. Cassidy writes that maternal malnutrition "is directly related to a myriad of infant health-related issues, and can contribute to lactation supply problems" (53). In her memoir detailing her employment in the Bessborough Mother and Baby Home in the early 1950s, midwife June Goulding witnessed enforced cross-nursing, one incident in which a newborn was given to another mother to nurse: "The violation of this natural maternal instinct seemed to be common practice in this Home and I found it difficult to breathe evenly as I witnessed it" (18). She also witnessed a young mother with a breast abscess denied proper medical treatment and pain relief, and a four-month-old exclusively breastfed baby taken for adoption without being weaned. The dehumanization of the mothers in Mother and Baby institutions, demonstrated here through such infant feeding practices, also spilled over into the malnutrition of both mothers and infants.[17] Abby Bender understands breastfeeding as part of the Irish body politic governing women's bodies through biopower and shame (106). This extends from restrictions on birth control, abortion, obstetric violence, and maternity care through to the institutionalization of women's bodies in Magdalene Laundries, with a direct line drawn from Mother and Baby homes through present-day Direct Provision centres for asylum seekers. With what Irish society now knows about the harms perpetrated in different institutions, O'Kelly's work points to the layered entanglements of colonialism, Famine, nationalism, capitalism, the maternal body, and patriarchal control.

The frontal imagery of the pink breast emitting its swirling breastmilk in *No Colouring Can Deepen the Darkness of Truth* and *A'Beathú* summons to mind Margo Harkin's ground-breaking feminist film *Hush-a-bye Baby* (1989)—a story about Goretti Friel, a Catholic teenager from Northern

Ireland who faces an unintended and unwanted pregnancy. In the film's opening scene, a fetus moves in amniotic fluid in the womb, although it is revealed to be the hair of a doll repeatedly plunged head-first into the soapy bathwater by Goretti's young niece. This sequence chillingly foreshadows a later scene in which the fifteen-year-old Goretti drinks gin and submerges herself into the same hot-water-filled bath attempting to abort her pregnancy. Throughout the film, there is an ongoing tension between the impossible ideal of Mother Ireland, visualized most clearly through the Virgin Mary, and Goretti, who rejects the nationalist constructions of motherhood. O'Kelly's imagery of the lactating breast and its profusion of milk strongly echo *Hush-a-bye Baby*'s opening scene, serving as a reminder of the conservative sociopolitical climate for women on the island of Ireland.

Presence and Absence in O'Kelly's Maternal Encounters

The staged encounters of presence and absence in O'Kelly's Famine works allude to the missing mothers and their cultural invisibility. In *Sanctuary/Wasteland*, the presence and absence of the maternal body are staged through the shape of the mass Famine grave in Thullabhawn, Co. Mayo; it is described as a "sandy, bony breast" and evokes the mother whose breastmilk dried up from hunger (Kelley 94). Katy Deepwell notes "synchronicity" between the breast and the barren landscape (141). Known locally as both a sanctuary and a wasteland, Teampall Dumhach Mhór was originally the site of St Colman's sixth-century monastery, and later a mass unmarked Famine grave. The gradual erosion of the sandy grave revealed the bones of the dead, and after several harsh winter storms in 1993, the Atlantic Ocean fully reclaimed the grave. Projected against a wall, the large negative image of Teampall Dumhach Mhór, devoid of colour, was temporarily spotlighted with changing coloured images that slowly emerged and receded from sight. These exposed images were read in bodily terms, appearing like a scar or a gaping wound in the breastlike mound. According to Patricia Lysaght, the severe economic and cultural disruptions of the Famine eroded social customs, such as traditional funerary rites, including laying out the body, lamenting the dead, procuring the coffin, and transporting the dead for burial (110). Rampant infections and high mortality meant that people were buried in unmarked mass graves or at times left on the side of the road while some mothers brought dead children to mass graves in baskets or tied to their backs (116).

Figure 7. Alanna O'Kelly, *Sanctuary/Wasteland* (1994), video, Collection Irish Museum of Modern Art, reproduced with permission.

Figure 8. Alanna O'Kelly, *Sanctuary/Wasteland* (1994), video, Collection Irish Museum of Modern Art, reproduced with permission.

The title *Sanctuary/Wasteland* further suggests the duality of the maternal body. A sanctuary is somewhere sacred and peaceful; it can offer a haven, recalling the former monastic site. The Famine caused a massive displacement of people who emigrated abroad for sanctuary. Concerning Ireland's body politic and the maternal body, dialogues about emigration and sanctuary converged in the 2004 citizenship referendum that halted the right to claim Irish citizenship based on place of birth. Before its passage, scrutiny focussed intensely on pregnant migrants, specifically African asylum seekers, with supporters alleging that certain women sought to give birth in Ireland to gain European citizenship (Shandy 804). That Ireland does not provide a haven for certain maternal bodies was made evident by this referendum. Likewise, the tragic death of Savita Halappanavar—who at seventeen weeks pregnant presented miscarrying at her local maternity hospital in Galway and was denied a life-saving abortion due to the presence of a fetal heartbeat—suggests the threat certain maternal bodies pose in the absence of regulation.[3]

The Famine grave as a wasteland signifies unusable or barren land and recalls the harsh conditions of the rocky landscape in the west of Ireland; it also represents the failure of the mother's body to nourish her children. According to Kelleher, in the absence of its ability to nourish, the maternal body is the ultimate symbol of death: "The mother's milk is a central metaphor of the gift of life; her dry breast is thus one of the Famine's deepest horrors, expressive of a primal fear, where the 'fountain of life' is now death-giving" (29). Deeply affected by a news report of a Kurdish mother, a refugee from the Gulf War who said, "tell the world that I hold my dead baby in my arms because my breasts have dried up," O'Kelly drew connections between Irish history with contemporary current events including war and famine in other parts of the world. Presence and absence in O'Kelly's Famine works are located in her desire to address what she perceives as a physical and psychological lack: "People were buried with no name, no identification, no marking" (Deepwell 142–43). Parallels also exist between the mass Famine grave, unconsecrated burial places for stillborn and unbaptized infants, known as cillíní, and the mass unmarked graves of women and children who died in Mother and Baby Homes and Magdalene Laundries. In *Sanctuary/Wasteland*, Mother Ireland becomes a haunting spectre of hunger, desperation, and death. The bleak Famine stories of the shallow burials of bodies in mass unmarked graves, similar to the darkness of infanticide and cannibalism during the Famine, all render the maternal problematic.

The invisible encounters with the maternal body in *Sanctuary/Wasteland* enable a means to contemplate the layered nuances of Ireland's missing mothers. It is also relevant that O'Kelly's gestures and actions at the mass Famine grave were performed on three separate occasions, with footage being lost or unusable, as she repeatedly, and insistently, returned to that site as a place of meaning, establishing the relationality between that place and the maternal body (Antosik-Parsons, "Alanna O'Kelly").

O'Kelly's affective vocal strategies offer further pathways to understanding how the Famine works negotiate presence and absence. O'Kelly reclaims the marginalized gendered practice of keening, caoineadh na marbh, or crying for the dead, and her voice as a site of power. O'Kelly's keening is affective and corporeal, "formed deep within the body and expelled in a tactile aural quality" (Antosik-Parsons, "Caoineadh na marbh" 210). Women keeners composed and recited complex Irish-language laments to the dead as part of funerary rites. The cries of these professionals, often not the deceased's kin, were unintelligible to those unfamiliar with the Irish language. The practice highlighted the othering of Irish culture and language under colonization (211). Likewise, Catherine Marshall identifies the use of the Irish language in O'Kelly's work to signal the impact of the Famine on Gaelic Ireland (27). As an integral part of O'Kelly's works, sound conveys the depth of emotion; for example, when O'Kelly plays the sound from *No Colouring Can Deepen the Darkness of Truth* without the visuals to give an understanding of it. In *Omós*, O'Kelly conceptualizes the sounds as communal, familial, and multi-generational, identifying them as female: older sister, mother, and grandmother. In *Omós*, the vulnerability and the intersubjective relationship are present. The sound of breath, inhalations, and exhalations produce the sound of the keening, while shaky breaths punctuate the actions of O'Kelly's running maternal body. Joining together keening and her leaking engorged breasts in *A'Beathú* recalls the hunger cries of an infant. Writing on maternal encounters, Lisa Baraitser discusses the infant's cry as the first interruption, with the cry interrupting the mother's durational activities (73). The mouth is "a strange inside/outside space through which, and out of which, emanates the most terrifying, and perhaps also exhalating sound" (70). The cry and the resulting corporeal response, evident in the involuntary leaking of the engorged breast, represents the emotional and physical triggers of the let-down response, signifies in *A'Beathú* the flow of emotion and affect.

Figure 9. Alanna O'Kelly, *Omós*, 1995, live performance, reproduced with permission.

Figure 10. Alanna O'Kelly, *A'Beathú*, 1996, video still, reproduced with permission.

In O'Kelly's work sound asserts the presence of the absent body, but it also signals the important interconnections between self and other and in terms of communal connections. The aural in the Famine works draws upon different sound elements, such as chanting, singing, speaking, and keening. Although the different voices suggest presence, for example in the work *Omós*, their bodily absence is important. The witness negotiates the ocular and the aural, and the lack of visible physicality holds implications, both in reception to the work and in contemplating one's bodily relationship to the work. The use of keening highlights a particularly powerful dynamic of presence and absence. Traditional keening occurs in the presence of or over the deceased's body, whereas in O'Kelly's work, keening recalls an absent body. The structure of her keening—for example in such works as *Chant Down Greenham, No Colouring Can Deepen the Darkness of Truth, Sanctuary/Wasteland, Omós*, and *A'Beathú*— alternates between a series of cries and silences, marking the presence and absence of that intense sound. Importantly, these sounds do not function independently of the witness's bodily experience but resonate

throughout their body, particularly in the chest and ears. The affect produced by this sound as it reverberates corporeally means that witnesses become intimately aware of the presence and absence of sound, allowing for remembering to be experienced in different ways.

Conclusion

O'Kelly's Famine works underscore the complexities and nuances of maternal lived realities. In Irish culture, the constructed feminine imaginary of Mother Ireland, an allegory reflecting patriarchal and heteronormative values, erases women's actual lived experiences. Instead, representations of Mother Ireland in Irish visual art from the early half of the twentieth century mirror the expectations of women's maternal roles and their domestic duties in service to the conservative, fledgling nation. Since the early 1980s, feminist artmaking has sought to engage with and attempted to destabilize the unified image of Mother Ireland by responding to the gaps and omissions around the missing mothers in Irish culture. Feminist artists have claimed space to critique the dominant conservative religious and political ideologies that shamed and silenced women who transgressed social norms, by turning to the maternal body and experiences of the lived body in an attempt to evade the strict controls governing women in Irish society. In acknowledging maternal anxieties, the tensions of parenting, and the impacts of capitalism and economic austerity on women's lives, feminist artists have offered new ways of visualizing the maternal and amplifying the voices of missing mothers by insisting on the unacceptability of an allegory obscuring the multiplicities of motherhood. O'Kelly's centring of maternal performances in *The Country Blooms, a Garden and a Grave*, through the intimate and intense bodily performances of memory through breastfeeding, which incorporate rich, sensory, and emotive aspects, counters the emptiness of the austere Mother Ireland, instead making the maternal of flesh and blood. Addressing the cultural invisibility of missing mothers, O'Kelly's work pointedly draws upon physical and psychological lack to traverse the presence and absence of the maternal body. The emotional and affective qualities of the work, enacted by O'Kelly's visual and vocal strategies, signal important interconnections between the self and the other. In O'Kelly's work, maternal encounters enable the remembering of missing mothers to surface and in doing so counters their cultural erasure.

Endnotes

1. *The Final Report of the Commission of Investigation into Mother and Baby Homes* (2021) details how the British pharmaceutical company Glaxo undertook experimental infant milk trials on infants at Bessborough and Pelletstown in 1968 and 1969 without maternal consent.

2. The titles of O'Kelly's works vary, due in part, to the artist remaking or recomposing the works. Based on extensive archival research, I am referring to the collective Famine works as *The Country Blooms, a Garden and a Grave*.

3. Abortion in Ireland was illegal under the *Offenses Against the Person Act* (1861). In 1983, the Republic of Ireland amended the Constitution by popular referendum, inserting the Eighth Amendment, which grants the mother and unborn child equal right to life. This blocked abortion without further referenda until 2018 when the Eighth Amendment was repealed and abortion was legalized. Abortion became legal in Northern Ireland in 2019 after a legislative change was imposed by Westminster after the collapse of the power-sharing of the Northern Ireland Executive.

Works Cited

Antosik-Parsons, Kate. "Alanna O'Kelly Interview." *L'Internationale Project Interviews*, National Irish Visual Arts Library, National College of Art and Design, 2021, pp. 1–31.

Antosik-Parsons, Kate. "A Body is a Body: The Embodied Politics of Women's Sexual and Reproductive Politics in Irish Art and Visual Culture." *Transnational Perspectives: Women's Reproductive and Sexual Rights*. Edited by Tanya Bahkru. Routledge, 2019, pp. 33–58.

Antosik-Parsons, Kate. "Caoineadh na marbh: Vocalising Memory and Otherness in the Early Performances of Alanna O'Kelly." *The Nordic Irish Studies Journal, Special Issue: Cultural Memory and the Remediation of Narratives of Irishness*, vol. 13, no. 1, 2014, pp. 205–21.

Baraitser, Lisa. *Maternal Encounters: The Ethics of Interruption*. Routledge, 2009.

Barber, Fionna. *Art in Ireland Since 1910*. Reaktion Books, 2016.

Bender, Abby. "Shame and the Breastfeeding Mother in Ireland." *Eire/Ireland*, vol. 3, no. 4, 2021, pp. 104–29.

Betterton, Rosemary. *Maternal Bodies in the Visual Arts*. Manchester University Press, 2014.

Boyle, Phelim P., and Ó Gráda, Cormac. "Fertility Trends, Excess Mortality, and the Great Irish Famine." *Demography*, vol. 23, no. 4, 1986, pp. 543–44.

Cassidy, Tanya, "Historical Ethnography and the Meanings of Human Milk in Ireland." *Ethnographies of Breastfeeding: Cultural Contexts and Confrontations*. Edited by Tanya Cassidy and Abdullahi El Tom. Bloomsbury, 2015, pp. 45–57.

Clancy, Luke. "Fertile Images of Famine." *Irish Times,* 5 Nov. 1996, p. 10.

Deepwell, Katy. *Dialogues: Women Artists from Ireland*. I.B. Taurus, 2005.

Earner-Byrne, Lindsey. *Mother and Child: Maternity and Child Welfare in Dublin, 1922–60*. Manchester University Press, 2013.

Goulding, June. *The Light in the Window*. Ebury Publishing, 2005.

Kelleher, Margaret, *The Feminization of the Famine: Expressions of the Inexpressible*. Cork University Press, 1997.

Kelley, Jeff. "Remember, Re-Member." *Artforum*, vol. 31, no. 3, 1993, pp. 94–95.

Liss, Andrea. *Feminist Art and the Maternal*. University of Minnesota Press, 2008.

Lysaght, Patricia. "Perspectives on Women during the Great Irish Famine from the Oral Tradition." *Béaloideas*, vol. 64&65, 1996, pp. 63–130.

McNamara, Deborah, et al. "'My Scar Is Called Adoption': The Lived Experiences of Irish Mothers Who Have Lost a Child through Closed Adoption." *Adoption & Fostering*, vol. 45, no. 2, 2021, pp. 138–54.

Marshall, Catherine. "History and Memorials: Fine Art and the Great Famine in Ireland." *Visual Material and Print Culture in Nineteenth-Century Ireland*. Edited by Ciara Breathnach and Catherine Lawless. Four Court Press, 2010, pp. 20–29.

Meaney, Gerardine. *Sex and Nation: Women in Irish Culture and Politics*. Attic Press, 1991.

Olson, Sean. "Video Positive '93, Liverpool, May 1993." *Circa*, vol. 65, 1993, pp. 57–58.

O'Rourke, Kevin. "Emigration and Living Standards in Ireland since the Famine." *Popular Economics,* vol. 8, no. 4, 1995, pp. 407–21.

O'Rourke, Maeve, Claire McGettrick, Rod Baker, and Raymond Hill. *CLANN: Ireland's Unmarried Mothers and their Children: Gathering the Data: Principal Submission to the Commission of Investigation into Mother and Baby Homes,* Justice For Magdalenes Research, Adoption Rights Alliance, Hogan Lovells, 2018.

Palko, Abigail L. "Monstrous Mothers." *Maternal Theory: Essential Readings.* Edited by Andrea O'Reilly. 2nd ed., Demeter Press, 2021, pp. 579–92.

Putnam, EL. "Not Just 'A Life Within the Home': Maternal Labour, Art Work and Performance Action in the Irish Intimate Public Sphere." *Performance Research,* vol. 22, no. 4, 2017, pp. 61–70.

Shandy, Dianna J. "Irish Babies, African Mothers: Rites of Passage and Rights in Citizenship in Post-Millennial Ireland." *Anthropological Quarterly,* vol. 81, no. 4, 2008, pp. 803–31.

Shaw, Rhonda. "Performing Breastfeeding: Embodiment, Ethics and the Maternal Subject." *Feminist Review,* vol. 78, no. 1, 2004, pp. 99–116.

Shildrick, Margrit. *Embodying the Monster: Encounters with the Vulnerable Self.* Sage, 2002.

Šimic', Lena. "Encountering Performing (M)Others: Feminist Maternal Practice in Contemporary Performance." *Contemporary Theatre Review,* vol. 28, no. 3, 2018, pp. 401–12.

Turpin, John. "Visual Marianism and National Identity in Ireland: 1920–1960." *Art, Nation and Gender: Ethnic Landscapes, Myths and Mother-Figures.* Edited by Tricia Cusack and Sighle Bhreathnach-Lynch. Ashgate Publishing, 2003, pp. 67–78.

Young, Iris Marion. *On Female Body Experience: Throwing Like a Girl and Other Essays.* Oxford University Press, 2005.

Walsh, Helena. "Performances of Autonomy: Feminist Performance Practice and Reproductive Rights Activism in Ireland." *Scene,* vol. 8, no. 1&2, 2020, pp. 29–45.

Warner, Marina. *Alone of All Her Sex: The Myth and the Cult of the Virgin Mary.* Picador, 1985.

7.

The Regenerative Potential of Myth in Reconstituting the Missing Mother

Martina Cleary

Using an autoethnographic approach, this chapter explores the missing mother as it relates to the control of maternity within the Irish cultural context. This includes discussion of the implications for mothers and daughters of living within a culture where maternity is the most contested of all territories. Drawing upon feminist and depth-psychological sources, this chapter will discuss the potential of myth to provide more woman-centred sources for navigating the psychological space between mother and daughter. Here myth will be examined for its potential to regenerate and reconstitute what has been suppressed, erased, or forgotten.

Ambivalence

My mother died on May 29, 2022, passing away in the small front room of the semidetached suburban house she lived in for most of her married life. There was nothing left of her but bones. At seventy-three, her frail body resembled that of a woman in her nineties. She couldn't open her eyes, speak, eat, or even drink for the final week, but we took turns sitting by her bedside, sometimes alone, more often in twos or threes. It was a prolonged struggle, a pitiful suffering, and an unspoken wish for a merciful release. Eaten away by cancer, unable to move or respond beyond an exhalation of pain when the day or night nurses came to

administer, it was difficult to witness. Yet her spirit held on as if refusing to surrender to oblivion. Outside the lace-curtained window, the spring sky was crystalline blue. The place she loved the most, her garden, was just coming into bloom. We played her favourite music, shared memories, and spoke in slightly hushed voices, watching each rise and fall of the space between her breaths, until they too ceased and she was gone. She passed as the sun set on the eve of summer. There was no death rattle, no spasms of the body, nothing to announce the immanence of the moment—just one last exhalation of the lungs into silence. I'd already left. I had put my hand on her hair to kiss her goodbye and said I'd see her again soon. Struggling to navigate that threshold space, I knew her absence would soon enough become more than an underlying avoidance. She would be truly gone, permanently lost. In my moment of leaving, for the first time in that final week when she was entirely unable to move or speak, she tried to respond. Trapped in a body that would no longer obey her, she uttered sounds where words wouldn't form. If it was a goodbye, a plea for me to stay, or a last attempt to reach across the distance between us, I will never know.

At her eulogy, the priest spoke of her faith and her passing on the day of the ascension. He described a heaven where she and all the faithful would meet again. But as I sat in silence, marked out by my refusal to participate in ceremonies I felt no place in, my mother receded ever further from view. Not only in life but now in death, she was a colonized land, emptied, silenced and spoken for. The rituals surrounding her death as meaningless as one of those plastic Virgin Mary holy water bottles she loved so much, filled to the brim with tap water masquerading as miracle. My own faith in such things had worn thin long before, as I observed her vanish into a performance of the good Catholic wife and mother. Our relationship as mother and daughter was strained, especially as her overpolicing of my teenage years sparked a fierce resistance in me, which became a silent stand-off, sometimes lasting years into adulthood. I'd always sensed in our relationship what Luce Irigaray describes as an essential absence at the centre, a feeling of obliviousness of self—something the daughter can temporarily assuage, never accept, but ultimately inherits.

In her poem, "Re-forming the Crystal," Adrienne Rich observes, "Tonight I understand my photo on the license is not me, my name on the marriage-contract was not mine. If I remind you of my father's

favourite daughter, look again. The woman I needed to call my mother was silenced before I was born" (228). It wasn't that my mother was silenced before I was born but rather that she went missing gradually until there was little of real substance remaining between us. All I remembered of the warmth and the fun in her faded, disappearing proportionally with her enmeshment with the patriarchal values of Catholic dogma. This dissolution of the woman went hand in hand with an overbearing attempt to control and limit expectations for me as a daughter. There was no real space of relatedness here, no symbolic order to contain, represent or navigate the complex psychodynamic of our mother-daughter relationship. The more conservative she became, the more rebelliously I resisted her worldview and religiosity, realizing instinctively before I ever understood the wider sociopolitical Irish context or anything of feminism that this resistance was a necessity for my survival. I would never sacrifice myself to a destiny requiring her lack of autonomy and what I felt was the performance of motherhood—the carrying out of a pre-determined role devoid of respect, concern or genuine love for anything to do with the feminine. Her fate seemed innately damaging, demanding acceptance of inferiority in all aspects of life and limiting to the development of a healthy sense of self as a woman.

When it came to my mother, I experienced what Jane Flax describes as an ambivalence at the heart of the mother-daughter relationship as it exists in a patriarchal culture, where the mother function is founded upon a doctrine of inferiority and self-sacrifice. As Flax notes, daughters who refuse this role "call into question the meaning of their mothers' lives and risk the hostility that arises from the mother's own anger at her situation" (181). What I needed was an alternative and what I was experiencing as a missing mother wasn't some post-Freudian sense of resentment towards her for bestowing upon me an anatomical lack. It was rather a sense of the absence of mother love, particularly when it came to a parity of care, value, and respect extended to me as a daughter—within a cultural complex where attention, position, privilege and power—would first and foremost prioritize the male. I would come to understand that this devaluation of the feminine was formative in the lack of presence, centredness, and self-belief my mother had in herself, me, and all women. Even during that final rite of passage, her death, I felt no alternative but resistance. I could never subscribe to the beliefs, and rituals of a religion that demanded her real or symbolic loss. It felt

hollow, hypocritical, and a perpetuation of the repressions that had governed her life. The laws of the Church fathers were not mine, and I knew that had my mother followed them completely, it wouldn't be only my mother who was missing; it would also be me. I would have to mourn alone, come to terms alone, and reconcile myself to the absence of my mother in death but also in life, alone.

Outlaws

In her thesis on unmarried motherhood and Irish legislation between 1921 and 1979, Ann-Marie Graham notes that "The secrecy and taboo that surrounded unmarried motherhood and illegitimacy in the twentieth century is still apparent in today's society" (11). Her observations made in (2012) unfortunately remain relevant to the present day, in a culture where access requests for personal records by those who suffered abuse in Catholic Church-run industrial and reformatory schools, mother and baby homes, adoption agencies, and Magdalene Laundries, described by James M. Smith, as Ireland's "architecture of containment" (3) continue to be denied. Along with a history of state-supported incarceration for the transgression of unsanctioned motherhood, Irish legislation has also enforced a repressive regime of control over the female body, sexuality, and the maternal since the adoption of the Irish Constitution in 1937. To become a mother outside of marriage in twentieth-century Ireland, was, as Smith notes, to simultaneously become a criminal: It "necessitated a series of punishments to negate and render invisible those women unlucky enough to countermand social conventions" (169). Repression, fear and a culture of secrecy ensured unmarried mothers and their children went missing. Hidden behind high walls and locked gates, even the acknowl-edgement of this regime of incarceration, punishment and cruelty has taken decades, in an ongoing struggle for state-supported redress. Silence and silencing became the modus operandi, in what Kate Holmquist describes as a "shame-based society where the victim is again victimised by speaking out." In this context, the concept of the missing mother is interwoven with a sociopolitical reality where motherhood is the most contested territory of all.

When my mother went missing in 1974, I had no idea it was because we were both outlaws within this complex and unnatural web of patriarchal enforcement and hegemony. My mother had transgressed

four years previously, when at twenty-one, unmarried and with little financial prospects, she found herself pregnant with me. It was a miracle I survived unmolested for those early years, due primarily to the strength of my grandmother who refused the local clergy's attempts to remove me from the maternal home. That was an accomplishment in a society where unmarried mothers were institutionalized in the Magdalene Laundries until 1996; their children violently and mercilessly stolen for enforced adoption. The diocese where we lived would also become notorious as an epicentre of systematic child abuse. The Ferns Report (2005) revealed over one hundred allegations of child sexual abuse in that diocese from 1962 to 2002, implicating twenty-one local priests. When my mother spoke of that time, she said it was difficult. I was born in the national maternity hospital in Dublin in the middle of the night. She endured the casual brutality of the delivery and shaming of registering my fatherless birth alone. It was only much later, in the 1990s, when the true extent of church abuses in Ireland emerged, that I realized how unique our non-nuclear family unit was. Raised by women, a maternal grandmother and mother, who resisted the external forces that destroyed the lives of so many, I'd been spared the worst of it, or so I thought.

In those early years I experienced something of the older ways between us—what Mary Condren describes as an earlier Irish society that was matrifocussed, where "one's relationship to the mother was the crucial factor in determining one's status" (27) and when the relationship between children of the same mother or sisters ensured belonging. A time as Condren also notes, when "under the matrilineal system, all children born to a woman would automatically become members of the clan" (85). The status of illegitimacy, only legally abolished in Ireland in 1987, was in this earlier Irish culture entirely unknown. Condren also describes this as "a society where women were highly honoured, where female symbolism formed the most sacred images in the religious cosmos and where the relationship between women through motherhood were the central elements of the social fabric" (28). This was unfortunately erased over the centuries, under the increasingly repressive dogma of Catholicism, culminating in the horror of not only the Magdalene Laundries but the Mother and Baby Homes.

The Final Report of the Commission of Investigation into Mother and Baby Homes (2021) reveals eighteen of these institutions existed throughout Ireland between 1922 and 1998. Within these, the Catholic Church

incarcerated women for the "crime" of giving birth outside of marriage. It is estimated that nine thousand children died in these institutions, 15 per cent of all children who were born or lived within their walls. The highest rate of infant mortality recorded was in Bessborough in 1943, when 75 per cent of the children died before their first birthday. Many were unaccompanied when they died, and their mothers were forced to go missing, forced to abandon their children to an uncertain fate. The major causes of death in these institutions included poor living conditions, the spread of disease, inadequate facilities, lack of access to running water, malnutrition, the absence of trained staff, and wilful neglect. In addition to the church, these institutions were overseen by the Irish Department of Local Government and Public Health. This toxic collusion of church and state ensured there was no recourse to justice and slim chances of escape for those unfortunate to find themselves in such circumstances.

The most notorious of these institutions known to date was the Mother and Baby Home in Tuam, County Galway, where in 2014, following investigations by local historian Catherine Corless, the bodies of an estimated 796 children were discovered dumped in a septic tank. It took until May 2023 for the Irish Minister for Children, Roderic O'Gorman to announce the excavation of this site, in what he described in an interview with Sarah Burns in *The Irish Times* as "one of the most complicated forensic excavations in the world" as if the exhumation of these missing children was some benchmark of accomplishment for Ireland. Meanwhile, as Sarah Burns notes in her article, the Irish state continues to exclude forty per cent of survivors from the Mother and Baby Institutions Payment Scheme, established to provide redress for survivors. Considering this sociopolitical backdrop, where children born outside marriage were forcibly removed from their mothers and where mothers were also forced to go missing, locked up behind the walls of inhumane church-run and state-sanctioned institutions, the strength of my grandmother was remarkable. Through my early years, she protected me as best she could from the worst consequences of being born beyond the law but not all of them. To survive, to even exist within this system, was a radical refusal of enforced erasure.

A Hole through the Centre

Two works of art created in the 1990s express something of the paradox of the ever present but entirely absent archetype of the mother, central to Catholic ideology: Dorothy Cross's *Bible* (1995) and Robert Gober's *Untitled* (1995). In both of these works the artists signify an emptiness, an absence, a hole through the centre, a violent, deliberate gouging out of the feminine within the sacred and symbolic. For Cross, this takes the form of a large incision of removal drilled through the Christian Bible, opened on a page representing the three Marys. The remaininig void in the image is through the heart and between the women. In Gober's sculptural work, a similar incision is cut through the central core of the body and womb of a statue of the Virgin Mary, in part of an installation simulating a holy well or shrine. These works challenge the iconic and collectively venerated ideal of Catholic motherhood, the Virgin. Both give symbolic form to a deliberate emptying and wounding. Like all significant artworks, they also speak to the subconscious, to what exists below the threshold of perception and articulation. They could be interpreted as resisting an ideology where the symbolic maternal at its most sacred is founded on absence. In place of what is most needed in a mother, we have instead a white phantom of passivity, voided of authentic embodiment, sexuality, warmth, or relatedness. Stripped of the multifarious diversity of older forms of the feminine, traces of which still survive in Irish myth, this new vassal of vestal virginity also lacks the expansiveness and embodied wisdom of the maternal. There is little in a plaster-cast virgin for an Irish daughter to identify with. Just a gaping void of expanding nothingness shrouded in the expectation that being good, perfect, and worthy also means being entirely humble, silent, self-effacing, self-erasing and alienated from conscious embodiment and selfhood.

My mother slipped away through the years into this gaping hole of absence. The fun-loving young mother, so full of stories and laughter I'd known, went missing not only physically but also psychologically, to be replaced by a woman who with each passing year grew more frozen out and frozen in by the feeling she was lesser than those who professed but rarely lived up to their good Catholic piety. She would never be forgiven for having a child outside marriage and would spend her life performing an overzealous religiosity to redeem herself for that sin. She married into a conservative Catholic family when I was four years old, believing this

would offer us both protection and security. Instead, we entered a life where I wasn't to be named, seen, or even spoken of in front of her new in-laws. The prohibitions and taboos surrounding my existence were a constant stigma, hanging over us until the very end. It is not surprising in this context that an ambivalence existed at the centre of our relationship as mother and daughter. In one of our last conversations, what we knew might be a final farewell, she apologized, telling me it was never what she wanted. She truly believed she was doing the right thing for us both. It was a rare glimpse of the mother I remembered, an affirmation I hadn't imagined a kinder, warmer, more hopeful woman who believed we could be free. I'd prepared myself for that moment, knowing I'd have to overcome my anger and let her go peacefully to her grave. I would have to find the words she needed in that final encounter, what Edna O'Brien expresses so well in her writing as a kind of terror at the threshold of death, leaving both mother and daughter forever suspended on the precipice of the abyss but never really reconciled.

I'd survived all the years of her absence by populating the image of my missing mother with an amalgamation of fragments. Like piecing together the remains of a broken vase, I begged, borrowed, and stole what I could to fill this absence. To try to heal the wound I thought was my own, but realized was far greater and pervasive within the wider cultural matrix and its symbolic order. I found solace in the company of women through which something of the missing mother was restored. The mothers I'd never had, the mothers I wished I'd had, the mothers who still retained something of the archetypal depths I instinctively recognized. Their guidance, care, and wisdom provided insight into a space between women. An intuitive connection and ability to speak of inhabited and uninhibited female experience. This search for an intrapsychic connection as Carlson describes it was also a kind of homesickness, a longing for the lost mother where: "From an archetypal perspective, it is our Selves we are longing for, and a mother as spacious and vast as our souls need" (Carlson 87). Unknown to myself, I had joined a community of wounded motherless daughters, women on the edges, the margins, who feeling outcast were in search of a lost tradition. Rich writes of a similar "trip through the gorges and canyons, into the cratered night of female memory." (228) This is an individual search, but it is also common to many women seeking the missing mother as a transpersonal, intrapsychic bridge to the archetypal and sacred. Living within what Condren

describes as a mythology based on the premise of separation from the world of the mother and denigration of her right to the sacred, finding alternatives was a psychological necessity. Sylvia Brinton Perera describes this as a "return to the goddess, for renewal in a feminine source-ground and spirit" (7) to reconstitute a sense of wholeness.

Regenerating the Myth

On the day my mother died, I noticed that overnight her bed linen had been changed. Her head rested on a pillowcase covered in red poppies. An unconscious random selection, a choice made by one of my sisters or a visiting nurse, I doubted any of them realized the symbolism in the poppies, the lost connection to what was once a sacred rite of passage associated with the twin goddess Demeter/Persephone and the death-rebirth cycle of the Eleusinian mysteries. Considering my early life, it is no surprise that this myth would also have a personal resonance. It tells the story of a sudden and violent rupture of the mother-daughter dyad, caused by the advent of change within the wider symbolic order of culture when a former matricentral belief system was being overwritten by the patriarchy of ancient Greece. While the Homeric hymn to Demeter and Persephone is Greek, the story has far older origins stretching back to the earliest human civilization that kept written records. In Mesopotamia, it is the descent of Inanna. In Egypt, this became the descent of Isis, and in Greco-Roman mythology, it became the story of Psyche and Eros. Brinton Perera notes how this archetypal structure also exists in the Japanese Izanami and the stories of Baba Yaga and Mother Hulda. All describe an essentially female journey of descent, initiation, and return, revealing psychodynamics within the inner life, feminine intersubjectivity, and mother rites. In the absence of connection to a meaningful symbolic order, I knew there were secrets here to understanding not only the larger cycles of life and death, but a deeper more complex understanding of the mother-daughter relationship as it pertains to loss, death, healing, and transformation.

In writing about the importance of myths, R.D. Laing notes that their knowledge is intrinsically connected to our deep psychology and physiology. Comparing the reoccurring patterns in mythologems, to psychologems, and even embryologems, Laing believes that these stories are not obscure but repeating patterns that are well-recognized within

psychology and anthropology. Mythology, he notes, provides us with "a coherent, ordered and systematic way" of understanding interconnections between events in external reality, with the inner world of our psyche, a form of "ready-made extended metaphor" (112). C.G. Jung describes the patterns within myths as structural elements within the unconscious psyche, identifiable as reoccurring motifs that arise within the individual but are linked to collective or cultural memory. He observes how these patterns operate as "autochthonous revivals independent of all tradition" (99), often manifesting spontaneously in dreams, visions, or eruptions of material into everyday life, what he describes as the collective psychic substratum of the collective unconscious. If these stories, with their archetypal figures, are innate, it means we also carry within us the potential to access their psychic and symbolic function no matter how lost their origins. Jung also notes how myths hold "a vital meaning" connected to the collective lives of a community, such as shared heritage or belief systems, which when forgotten lead to a state of decline, fragmentation, and decay. He compares the loss of such knowledge to being "like a man who has lost his soul" (102). For contemporary women, the need to reconnect with and regenerate the wisdom of feminocentric myths is even more important where women's heritage has been forcibly silenced, erased, or overwritten. Myths can provide insights to comprehend and contain the profound, mysterious, and sacred. They can also restore a fuller image of what is missing within the mother as icon, archetype, and complex.

Brinton Perera also notes how women have been exiled from the knowledge contained in certain myths for over five thousand years. In the contemporary context, these stories can function as "projection screens" to heal the "unmothered" women we have become (11). They provide a language to frame, perceive, and come to terms with the psychodynamics of experience, particularly wounding and trauma. Mythology can also link the individual to transcendent functions within the sacred or divine rooted in matricentric spiritual and ritual practices. These practices once served the purpose of assisting the individual and community through significant life events. As Jung notes, "The most we can do is dream the myth onwards and give it a modern dress. And whatever explanations or interpretation does to it, we do to our own souls as well with corresponding results for our own well-being" (109).

A Myth to Contain

The Demeter and Persephone myth is about the splitting of the mother-daughter dyad by forces that render both missing to each other. The story is one of the search for and return of what has been lost, as part of the larger cycle of life, death, fragmentation, and reconstitution. Tamara Agha-Jaffar observes that on the surface, the story appears as an early metaphor to describe the agrarian cycle, the seasonal arrival of winter followed by spring. On a deeper level, however, it communicates something of what it is to be a woman, mother, and daughter who refuses subordination by the patriarchy. It shows how to fight back and to navigate the experience of loss, grief, trauma and healing. It is "a myth that honours a female deity or deities" and shows "alternatives for action, models of behaviour, and ways of being that resonate with the experience of being female" (Agha-Jaffar 10).

The story begins with Kore, the unnamed one. While with her friends, she discovers the narcissus or cosmic flower, often interpreted as the coming into consciousness or growing self-awareness. While she is momentarily distracted, the ground suddenly opens up, and Hades, the dark brother or shadow of the father God, Zeus, pulls her under. She is lost to the upper world and all she knows of her former life. This descent can be understood as an allegory of the change that suddenly plunges a life into darkness, whether through a destructive relationship, separation, loss, or death. Unlike the earlier Mesopotamian story of the descent of Inanna, Persephone's journey is not self-initiated. Where Inanna, the Sumerian goddess of fertility and war, set her ear to the underworld and decides to descend, what we see in the story of Persephone, is violence, which also includes rape. The myth of Persephone reflects a change in the symbolic within a culture when belief in female divinity was being erased by an increasingly patriarchal and warlike culture. Condren describes similar change in the symbolic order of Irish mythology, identifying the story of the overthrow of Macha, when mother rights, particularly fertility, were suppressed. She identifies the humiliation of Macha, including the disrespect of her power to give birth, as being "the foundation myth of Irish patriarchal culture" (30).

In Demeter and Persephone, we see the dyad, the dual aspects of what was once a triple divinity of mother, daughter and crone, further split. As Barker Woolger observes, Demeter and Persephone "represent two major opposite aspects of the primordial Great Mother that the Greek

psyche was struggling to maintain" (261). Demeter, the mature maternal aspect of the feminine, is left bereft and wandering the earth in search of her daughter after her abduction. Zeus, the father of the new pantheon, is complicit in this act and violence and the offering up of the daughter to Hades the lord of death. Demeter's reaction is to withdraw her power and attributes of nurturance and fertility. She also withdraws from the assembly of the gods, taking on the shroud of an old woman and wanders until she reaches Eleusis, the place of ritual. In her sorrow, she abducts a human child and tries to forge him through fire into an immortal replacement. Her mourning and rage are displaced into avoidance, transference, and substitution. To appease Demeter's wrath a temple is built at Eleusis and the correct rites are performed. Demeter returns to her former self regaining her power and also the strength to restore her daughter. Judith Herman's description of the three stages of psychological recovery from trauma follow a similar pattern. Firstly, there is the necessity of finding and establishing a space of safe retreat. In the myth of Demeter and Persephone, this is where Demeter wanders the earth, finally arriving at Eleusis. Her true form is hidden and she is a shadow of her former self. This is followed by remembrance, and mourning, what Herman describes as a coming to terms with events, but also the necessary work of piecing events back into a coherent narrative after trauma. Only then can the process of healing begin and the self be re-membered and re-constituted. The presence of Baubo in this myth is also significant. She represents an aspect of older divine feminine and often appears with the Demeter and Persephone mother daughter dyad. She is the raucous trickster or crone, who lifts up her skirts to expose her naked vulva to Demeter, which makes the Goddess laugh, breaking her cycle of depression and despair. Victoria Angela Jennings notes how this action, often referred to as the performance of anasyrma can be found in myths from Greece, Egypt and Persia and even the mysterious Sheila Na Gig figures of Ireland. The gesture, in many instances seemed to have an almost magical potency, even stopping armies in their tracks, through reminding the onlooker of whence they came (27). The vulva, the womb, the aging female body simultaneously signifies both origin and end. This lifting of the skirt has a shock value rather than erotic charge. For Demeter it reminds her of this dual aspect of her nature as both life giver and destroyer, a power she can use to force the male gods to return her daughter. She is prepared to withdraw fertility from nature and the crops

until this happens. This is the death-wielding aspect of the Mother Goddess, a powerful example of the assertion of mother rights and also matriarchal lineage. This is also evident in how Demeter describes herself to Metaneira Queen of Eleusis, crediting her mother with naming her. She locates her origins in Crete, which at the time was goddess worshipping, signifying a link to an older symbolic order.

Agha-Jaffar contrasts the resolve we see in Demeter to the experience of abused women: "The tendency is usually to make excuses, to hesitate, to try to find an alternative, to hope against hope that things will improve" (19). In contrast, Demeter as an archetypal force shows the potential to defy the gods, reclaim what has been stolen, and reintegrate what has been drawn into darkness. Demeter experiences the cycle of loss, trauma, and mourning but is also tactical, unrelenting, and knows her power over the natural world, fertility and its cycles.

Demeter and Persephone are aspects of a dyad present in the far earlier figure of Inanna, the one who descends to the underworld (Kur) to meet her dark sister Ereshkigal, Queen of the Dead. From a depth psychological perspective, Ereshkigal could be viewed as the shadow side of Inanna's psyche, the dark side of creation linked to cycles of decay, degeneration, and death. As Inanna passes through the seven doors of the underworld, she is stripped of all power and accomplishment. It is also apparent from this older myth that Inanna's descent happens at a later time in her life. She has already been the young bride, the mother, the queen, the wanderer, and even the warrior. When she has gained everything life offers, she descends to the depths to encounter previously unknown aspects of herself to prepare perhaps for that final encounter with death herself. Brinton Perera says the following of Inanna that "Lived consciously, the goddess Inanna in her role as suffering, exiled feminine provides an image of the deity who can, perhaps, carry the suffering and redemption of modern women. Closer to many of us than the Church's Christ, she suggests an archetypal pattern which can give meaning to women's quest" (21).

Interestingly, unlike Persephone who is forever caught in the cycle of descent and return to her shadow husband, Hades, it is Inanna's husband Dumuzid (later Tammuz or Tamlin in the Celtic traditions) who is sacrificed to ensure her return from the underworld. However, both myths contain a warning that nobody returns from the realm of the dead unmarked, that the journey whether by force or choice brings unalterable

change. However, as Brinton Perera observes, the darkness cannot be avoided or left unredeemed, whether on a personal or collective level. She comments: "Until the demonic powers of the dark goddess are claimed, there is no strength in the woman to grow from daughter to an adult who can stand against the force of the patriarchy in its inhuman form" (41). In this older myth it is Ereshkigal, rather than the usurper Hades who signifies the potency of the shadow and part of the bivalency of the older sacred feminine. Light and dark, upper and lower realms are integrated into the life-death cycle. This darker aspect of the Great Mother is however so repressed, hidden and missing in contemporary patriarchal versions of the sacred, it is a difficult usually terrifying journey of descent to find her, within the self and the wider cultural symbolic. Lacking the rites and rituals that once existed to contain the encounter, myths are the only remaining maps.

Some have suggested that Persephone ate the pomegranate seeds willingly, a decision which binds her in cyclical return to Hades, The fruit is here interpreted as a signifier of sexual initiation, which releases the young woman from an overly osmotic relationship to the mother. Agha-Jaffar, for example, claims: "A woman's journey to autonomy, power, and selfhood ... entails the difficult process of severing the connection to mother" (47). Elizabeth Eowyn Nelson also questions whether Persephone chose or was tricked, speculating "that eating the seeds of the pomegranate may symbolize the nameless Kore's desire to end the fused state with the mother, a desire that originates from the maiden's self" (9). This argument, however, presupposing that feminine maturation requires patriarchal intervention, violence, and even rape, sounds far too Freudian. Julia Kristeva goes further, stating "For man and for woman the loss of the mother is a biological and psychic necessity, the first step on the way to becoming autonomous. Matricide is our vital necessity, the sine-qua-non condition of our individuation" (27–28). In contrast, Irigaray believes that honouring the maternal is essential to understanding who we are and possessing a sense of self beyond the limitations of the patriarchy. Warning against the matricide at the base of Western psychological traditions she cautions: "We must not once more kill the mother who was sacrificed to the origins of our culture. We must give her new life...within us and between us. We must refuse to let her desire be annihilated by the law of the father. We must give her the right to pleasure, to jouissance, to passion, restore her right to speech,

and sometimes to crisis and anger" (43). Instead of being "exiled in the house of the father," she advises remembering the names of our mothers, grandmothers, and great-grandmothers. This remembering is also about knowing and restoring the missing aspects of the mother, the parts that have been excised, in the overwriting of our heritage as women. Knowing our lineage and remembering who we were before violent life-altering events are especially important in a traumatic experience, which ruptures memory and the integrity of the self. As Brinton Perera observes,

> Unfortunately, all too many modern women have not been nurtured by the mother in the first place. Instead, they have grown up in the difficult home of abstract collective authority – cut off at the ankles from the earth ... full of superego should and aughts. Or they have identified with the father and their patriarchal culture, thus alienating themselves from their own feminine ground and the personal mother, whom they often see as weak or irrelevant. (7)

While separation from the individual mother is a psychical necessity for individuation, I would argue that reconnection to a transpersonal form of feminine archetypal wisdom, central within these myths is essential if we are to mature into anything but ghosts or shadows within a patri-archal symbolic, which will always alienate us from ourselves.

The dyad of mother-daughter also reveals a duality at the core of the feminine. As Irigaray has observed, "In our societies, the mother/ daughter, daughter/mother relationship constitutes a highly explosive nucleus. Thinking it, and changing it, is equivalent to shaking the foundations of the patriarchal order" (50). This duality within the feminine, is perhaps the crux of the dilemma. Rather than allowing it to be split we must recognize and avail of its bivalency. Carlson describes how twin goddesses have existed as far back as 6500 BC, represented as double-headed or breasted. This was the "power of two", which also contained both light and dark aspects of the female psyche. In the story of Demeter and Persephone this dyad is split by the violence of the male characters. They are as Carlson (1997) observes "reunited but altered." However, "In a culture in which the Divine is not imaged as Mother and Matrix of All; in our culture the archetypal dimension of Mother is not consciously named as such.... its potency and bivalence overloads the human being who becomes its unwitting carrier – the personal mother"

(143). The result is a projecting onto our personal mothers or other women, aspects of the light or dark within an archetypal complex, which no longer has a name, iconic representation, or ritual presence. The "Greater Personality", behind the human mother remains lost, or unconscious. As Carlson also observes, like "Kore without Demeter, the motherless daughter we have all become, under patriarchy has left an absence, at the very centre of the female being. Without this fuller aspect of the Mother within the Self, a woman is "without connection to her source, without grounding, without an authentic body, without a Matrix" (144).

In his work on the Eleusinian mysteries, Carl Kerényi describes another important function of the rites associated with this dual goddess. This relates to the rituals and beliefs surrounding death, which were once the space to contain the potential for not only transformations of consciousness when approaching the sacred, but a safe and mediated way to encounter the mystery of death itself. These rites were performed annually from 1400 BC to 394 AD when they were abolished by Christian emperor Theodosius, who issued a decree in 392 AD banning the spiritual activities of pagans. Alaric then destroyed the temple of Demeter at Eleusis in 395 AD. Erich Neumann notes that "The one essential motif in the Eleusinian mysteries and hence in all matriarchal mysteries is the heresies of the daughter by the mother, the 'finding again' of Kore by Demeter, the reunion of mother and daughter" (73).

As I stared into the face of my dying mother, I sensed the real need for a meaningful way to approach the strangeness and the sacredness of the moment. Something perhaps that such rites once contained. I didn't expect to find my legs had buckled under me and that I would experience the closeness of death as an instinctive and visceral fear. Witnessing the dying of the mother's body was to see beyond the veil, the end of your origins. Nevertheless, I refused to look away. Reaching out I kept my hand close to her shrinking form, offering whatever comfort I could, so she wouldn't feel so alone. My sister said, "It's a lot like birth really, you just don't know when it will happen." I observed also, how it was only the women who could bear to tend to her dying body. In a culture where female embodiment in all its forms, even the maternal is so repressed, it was a shock to realize that the first time I saw my mother's body was on the day she died. As we sat with her, we shared memories putting into words the moments we thought might ease her fear of leaving. Following

the older ways, I asked my sister to open the window. I remembered the Caoineadh of the female keeners, who were also banned by the Catholic Church. They had once stood at the four corners of the bed to help the soul depart while offering the mourners a form of cathartic release. They inhabited what Narelle McCoy describes as "a liminal state between the living and the world of the dead ... entering a kind of 'divine madness' which allowed the keener to express the collective outpouring of grief" (207). Their guttural song of breath and tears provided what Catherine Clément and Julie Kristeva term a pathway "effaced by the centuries," where "The sacred among women may express an instantaneous revolt that passes through the body and cries out" (10). This moment needed a form and language of its own to express our experience—one in which her presence and soon-to-be unending absence could find containment, as Mater Dolorosa passed to Mother Kali.

In the months following my mother's death, there have been many moments in the natural process of mourning, of forgetting, and then suddenly remembering she's gone forever. Like so many women, she left behind little by way of monuments or memorials—some old clothes in a wardrobe, a few mismatched pieces of tarnished jewellery, and some of her favourite books worth saving. There was little time to salvage the scant material mementoes of her life. The clearing out of her home shortly after her burial was more raw and revealing than any church ceremony. For some in the family, this verged on an almost neurotic ritual of removal, destruction, and erasure—as if clearing away all traces of her would heal unresolved emotions. The futility of this denial was both tragic and absurd. Now that she is gone, it's even easier to recognize her in the very flesh and bone we inhabit. I catch her staring back from the mirror sometimes or hear her in the intonation of my voice, the turn of a phrase, a gesture of my body. I carry her within me as she once carried me.

Works Cited

Agha-Jaffar, Tamara. *Demeter and Persephone: Lessons from a Myth*. McFarland & Company, Inc, 2002.

Barker, Jennifer Woolger, and Roger Woolger. *The Goddess Within: A Guide To The Eternal Myths That Shape Women's Lives*. Columbine, 1989.

Brinton Perera, Sylvia. *Descent to the Goddess: A Way of Initiation for Women*. Inner City Books, 1981.

Burns, Sarah. "Excavation at Former Tuam Mother and Baby Home to Be 'One of the Most Complex' Ever," *Irish Times*, 2 Mar. 2022, https://www.irishtimes.com/news/politics/oireachtas/excavation-at-former-tuam-mother-and-baby-home-to-be-one-of-most-complex-ever-1.4816734. Accessed 9 Sept. 2024.

Campbell, Joseph. *The Hero With A Thousand Faces*. New World Library, 2008.

Carlson, Kathie. *In Her Image: The Unhealed Daughter's Search for Her Mother*. Shambala, 1990.

Carlson, Kathie. *Life's Daughter/Death's Bride: Inner Transformations Through the Goddess Demeter/Persephone*. Shambala, 1997.

Clément, Catherine, and Julie Kristeva. *The Feminine And The Sacred*. Columbia University Press, 2001.

Condren, Mary. *The Serpent and The Goddess: Women, Religion and Power in Celtic Ireland*. Harper & Row, 1989.

Flax, Jane. "The Conflict between Nurturance and Autonomy in Mother-Daughter Relationships and within Feminism." *Feminist Studies*, vol. 4, no. 2, 1978, pp. 171–89.

Holmquist, Kate. "Our Culture of Shame." *The Irish Times*, 16 June 2009, https://www.irishtimes.com/culture/our-culture-of-shame-1.785115. Accessed 9 Sept. 2024.

Irigaray, Luce. *The Irigaray Reader*. Basil Blackwell, 1991.

Jennings, Victoria Angela. *I Sing the Body Magical: Baubo and Her Apotropaic Power*. MA Thesis. University of California, Santa Barbara.

Jung, C.G. *Introduction to a Science of Mythology*. Routledge and Kegan Paul, 1951.

Kerényi, Carl. *Eleusis: Archetypal Image of Mother and Daughter*. Bollingen Foundation, 1967.

Kristeva, Julia. *Black Sun Depression and Melancholia*. Columbia University Press, 1989.

Laing, R.D. *The Voice of Experience*. Pantheon Books, 1982.

McCoy, Narelle. "Madwoman, Banshee, Shaman: Gender, Changing Performance Contexts and the Irish Wake Ritual." *Musical Islands, Exploring Connections between Music, Place and Research*. Cambridge Scholars Publishing, 2009.

Nelson, Elizabeth Eowyn. "Embodying Persephone's Desire: Authentic Movement and Underworld Transformation." *Journal of Jungian Scholarly Studies*, vol. 11, no. 1, 2016, pp. 5–17.

Neumann, Erich. "The Woman's Experience of Herself and the Eleusinian Mysteries." *The Long Journey Home: Revisioning the Myth of Demeter and Persephone for Our Time.* Edited by Christine Downing. Shambala Publications, Inc, 1994, pp. 72–76.

O'Brien, Edna. *The Light of Evening.* Weidenfeld & Nicolson; First Edition 2006.

Rich, Adrienne. *Poems: Selected and New, 1950–1974.* Norton, 1974.

Smith, M. James. *Ireland's Magdalen Laundries and the Nation's Architecture of Containment.* University of Notre Dame Press, 2007.

Section II
The Missing Mother
in the Self

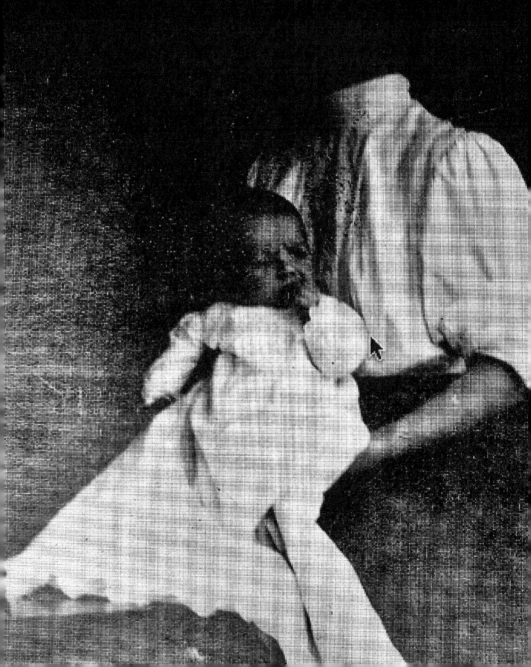

8.

Critiquing, Correcting, Defying, and Displacing Normative Motherhood:

Reading Five Narratives of
Mothers Who Leave as Demon Texts:
Hiroshima in the Morning, Patsy,
The Shame, I Love You But I've Chosen
Darkness, and *When I Ran Away*

Andrea O'Reilly

In her article "Is the Walk-Away Mother Really Insane, or Is That What Society and Culture Want Us to Think," Shachar Peled argues that while men can leave their children "without being subjected to psychiatric judgement, when a woman leaves her family, she is often severely judged." "A mother who abandons her child," Peled continues, "is deemed abhorrent and unnatural, and often suicidal, in both fiction and reality." Similarly, "When it comes to social sins," questions Kasey Edwards, "is there anything worse than a woman who leaves her kids? It's such a taboo that there are no extenuating circumstances to excuse it." Indeed, as Edwards emphasizes: "When a father leaves his kids it's unfortunate. When a mother leaves it's a scandal." Given the shame and stigma of maternal abandonment, it is rare, as Madeline King argues "to hear the voices of women who choose to leave their children."

Over the last few years, a handful of journalistic articles have explored, as in the title of one such article, "What Kind of Mother Leaves her Kids?" (Lea Goldman), by interviewing mothers who have left their children or examining maternal abandonment in fiction and film. Scholarly investigations of the topic include the early but important book *Mothers Who Leave: Behind the Myth of Women Without Their Children* by Rosie Jackson (1994), which argues that because women "who leave children go against the grain of the selfless, masochistic, and self-sacrificing function that our society expects of mothers, they invariably invite censure from the system they seek to offend" (41). More recently, Jenny Björklund's *Maternal Abandonment and Queer Resistance in Twenty-First-Century Swedish Literature* (2021) examines the representation of maternal abandonment in twenty-two female-authored Swedish novels concerning discourses on motherhood, family, and gender equality in contemporary Sweden. In her analysis of the texts, Björklund explores why do mothers leave, and how are they portrayed? And how do the novels relate and respond to Swedish cultural and sociopolitical discourses on motherhood? Björklund argues that these novels "confront and challenge contemporary ideals of good motherhood and open up new ways of conceptualizing motherhood and family life" (8). In *Modern Motherhood and Women's Dual Identities: Rewriting the Sexual Contract* (2018), Australian scholar Petra Bueskens explores how the periodic and strategic absences of "revolving mothers"—ranging from a few days to a few months—disrupt and reconstruct the gendered dynamics of household labour. Revolving maternal absences, Bueskens argues, "offer mothers a break from normative allocations of labour and leisure in the home [and] literally forces fathers (and others) to assume caregiving and domestic responsibilities *routinely* assigned to mothers" (261). The key empirical finding of Bueskens's research is that periodic absence from the home can rupture "the 'default position' assigned to mothers in families," generating "a structural and psychological shift in the family" (299).

This chapter contributes to this emergent research on mothers who leave by exploring the theme of maternal absence and abandonment in five contemporary narratives: *Hiroshima in the Morning* (2010) by Rahna Reiko Rizzuto, *Patsy* (2019) by Nicole Dennis-Benn, *The Shame* (2021) by Makenna Goodman, *I Love You But I've Chosen Darkness* (2021) by Claire Vaye Watkins, and *When I Ran Away* (2021) by Ilona Bannister.

The selected titles include four novels and one memoir, although one novel is autofiction (*I Love You*). All are authored by Americans and were published in the last four years. I also included the earlier book *Hiroshima in the Morning* (2010) because it is a unique and important work in this conversation—a memoir written by a Japanese American author and taking place in Japan. One of the novels, *Patsy*, is written by a Jamaican American writer. In four of the narratives, the mothers are heterosexual and married, while the mother in *Patsy* is queer and single (until near the end of the novel). The maternal absences in these five texts range from a few hours (*The Shame*, *When I Ran Away*), to several months (*I Love You*, *Hiroshima*), and to a decade plus in *Patsy*. In *The Shame* and *When I Ran Away*, the mothers return to their children and their marriages, while in *I Love You* and *Hiroshima*, the marriages end, but the mothers are reunited with their children albeit with part-time custody. With *Patsy*, the mother and daughter reconnect and reconcile at the novel's end, although they live apart in different countries.

This chapter takes up several avenues of inquiry. Like Jackson's research, the chapter considers "all that is rotten in the state of motherhood [that] no longer can be ignored" (277). Similar to Björklund's work, it asks why these mothers leave and explores how this leaving is portrayed and if the narratives challenge normative motherhood to reconceptualize mothering and family life. Significantly, in her study, Björklund found that most of the mothers in twenty-first-century Swedish literature leave because of ambivalence about motherhood rather than to pursue emancipation. Like Bueskens's research, this chapter will also consider if and how maternal absences generate structural and psychological shifts in the family to reconfigure gendered household and care labour. Overall, this chapter explores how these narratives of maternal absence expose the maternal discontents of normative motherhood and considers if and how the trope of mothers leaving functions to critique, correct, defy, and displace this patriarchal institution.

In this way, these narratives may be read as what Ann Snitow has defined as "demon texts"—those texts centring on a "pre-emptive and radical questioning [of motherhood]" (295). However, many of the demon texts have been misread and mispositioned as being anti-mother and mothering when their aim, Snitow emphasizes, is to critique the patriarchal institution of motherhood. Building upon Snitow's 1992 use of this term, Judith Levine, in her article "Hating Motherhood," argues

that demon texts describe the anger and ambivalence of mothers and that many such texts, such as Betty Friedan's *The Feminine Mystique* and Shulamith Firestone's *The Dialectic of Sex,* position motherhood as the cause of women's oppression and call for its eradication. Compellingly, the maternal anger and ambivalence described in the demon texts of this chapter are activated and exposed through maternal abandonment. Moreover, and again compellingly, the defiance and displacement of normative motherhood are also enacted and achieved in three of the demon texts of this chapter through the trope of mothers leaving their children. In this chapter, I read these five narratives of maternal absence along a continuum from critique to displacement to argue that although temporary absences away from husband and family may result in a critique of normative motherhood, as *The Shame* does, or give rise to possible changes, as seen in *When I Ran Away,* it is only when maternal absence is more lengthy and mothers do not return to their marriages that normative motherhood can be fully defied and displaced to make possible the empowered mothering of the demon texts championed by Levine. In other words, these texts of maternal absence suggest that empowered mothering can only be achieved outside the nuclear family and with the mother living apart from her children as a noncustodial parent, as seen in *I Love You* and *Hiroshima,* and most powerfully in *Patsy,* wherein the text fully displaces normative motherhood and daughterhood across the motherline through a queering of identity and family.

The Shame: "An Acknowledgement of a Story That Needs to Change"

Significantly, Levine includes *The Shame* in her discussion on demon texts and describes the novel as "mainly about the ways that motherhood can plunder—or cleave—the self." Indeed, as Alma, the mother in *The Shame,* laments: "I had no idea who I was anymore, or what I liked to do" (3). The slim novel of 148 pages opens with Alma reflecting on a riddle as she drives through darkness on the interstate feeling "free, unmistakably good, even euphoric" (3) as two car seats sit empty in the back of the car and with "no one asking [her] for a snack, no one's nose need[ing] to be wiped" (3). Although Alma considers returning home while the kids are still asleep, she keeps driving, reflecting that her husband, Asa, would be "amazed [she] had gone as far as [she] did" (3). The reader does not

know yet where Alma is travelling to, only that she has left her "increasingly conventional marriage" (15) and her life as a full-time mother who earns some income with her part-time indexing job as she dabbles with painting and aspires to be a writer. Alma is the traditional mother and wife who "makes dinner, who is in charge of no one drowning in the bath, who washes up" (25) and who feels "invisible" for not having anything to show for herself except her kids (17). Alma knows that she "is being stretched to [her] limit when it came to mothering" and tries "to access a feeling of selfhood from small bouts of writing, daydreaming, and painting" (67). For Alma, "the weight of motherhood is a backpack full of stones" (25). The experience is deadening: "It's the kind of feeling that grips me like I'm in a foggy valley early in the morning surrounded by thick white air, unable to see even my hand in front of my face, and I don't realize that a hundred feet up, the sun is out. I have no way of knowing. 'Cherish it,' a woman told me at the market, smiling at the kids. I wanted to punch her in the fucking face" (25).

When asked in an interview about Alma's experiences as a mother and writer and whether she has faced similar challenges, Makenna Goodman replied: "Motherhood is a trap—there's no way for women to do it all; we're fucked either way and yet we continue trying to better ourselves. I love being a mother, don't get me wrong. But raising children can be deafening" (qtd. in Grgas). Similarly, Alma describes herself as "trapped ... responsible for [her children] (35). "By leaving them, she would never be able to escape being a bad mother" (35). Later, Alma realizes that although "mothering was supposed to be [her] area of expertise, [she] had no idea how to be a good mother" (61). In exposing Alma's maternal anger and ambivalence, *The Shame* recalls the Swedish novels of mothers who leave studied by Björklund and may be read as a demon text as Levine proposes. But does Alma's leaving generate structural and psychological shifts in her family, as shown in Bueskens's study, or signify and enact the defiance and displacement of normative motherhood found in demon texts and as theorized by Levine?

The novel concludes with Alma returning to her family after travelling to New York to meet Celeste, the Instagram influencer Alma earlier discovered on social media and who has captivated Alma with her seemingly perfect life as a single mother of three children and a successful local artisan. Celeste practises yoga and meditation, dabbles in cyanotypes, sings in a band on weekends, has beautiful taste in furniture, and

weaned her son when he was two by throwing him a cupcake party (58). Celeste's beauty impressed Alma because of how effortless it was. For Alma, Celeste represents the person she might have become if she had learned to like herself (66). As the novel unfolds, Alma becomes increasingly obsessed with Celeste and is completely "caught up in her story" (59). However, although Celeste makes Alma "feel less lonely and less bored" (65), she also makes her less happy.

Later, Celeste is injured in a car accident and decides to return to her law career and hire a nanny. Reading Celeste's Instagram post, Alma realizes that "something in [her] was let out of its little cage. Here was an opening" (109) and contacts Celeste to apply for the nanny position. When Celeste replies and asks Alma to come to New York, Alma walks out of the house with her children asleep and her husband in the shower knowing that she "had found [her] purpose" (122). Once in New York, Alma visits the places Celeste frequents and finally finds herself in the same store as Celeste. When she sees Celeste, she realizes she shares some of her secrets: "I knew how badly she needed help, how she wanted to work full-time but didn't have childcare. I knew what motherhood felt like, the suffocation" (135). Alma follows Celeste out of the store and catches sight of her on the corner with her son sobbing. Celeste had unwrapped a croissant, offered it to her son, and after the boy threw it in a puddle, "Celeste picked up the sodden croissant and rammed it into the little boy's face" (137). Alma pursues Celeste into the subway, needing to confirm that it was her who had done this to her child "because the Celeste she knew was patient, something [she] had never been" (138). Alma then collides with Celeste, falls, and loses consciousness, only to wake up later on the subway platform with Celeste gone. Alma then returns to her car and begins her drive home. With her "mind blank, for what felt like the first time, like a sheet of white paper," she thinks: "I had nothing to distract me; I was completely open. But eventually the blankness began to fill in" (142).

Alma realizes that Celeste is not the ideal mother she imagined her to be, which gives rise to Alma's new awareness and appreciation of her life. "Alma had given Celeste power over her story," Goodman explains, "but Alma reclaims the narrative from the spiraling path it's on" (qtd. in Taylor). Once she has reclaimed the narrative, Goodman continues, "[The novel] asks what Alma will do with it? What comes next?" (qtd. in Taylor). The novel's final scene, with its many descriptive sentences

beginning with "I can see," suggests, as Kaitlyn Teer notes, that Alma's journey has resulted in a shift in perception. However, the reader can only wonder if Alma's shift in perception will result in changes in her life. As Teer questions: "If upon her return home Alma would complete her children's book. Would she return to the novel draft? How would she resolve the 'deep conflict' she projected onto Celeste: the conflict between the desire to work and the need to protect her children?" When Goodman is asked if the novel concludes "with a resonating sense of freedom, escape, or something else entirely?" she reflects: "I think there is a palpable sense of awareness. An acknowledgement of a story that needs to change. I hope readers will interpret the ending as a beginning of a new one, perhaps the same story, told again, told differently. Isn't that the case with life? There's no neat bow, no solution, just new perspectives on patterns" (qtd. in Tyler). What this change will bring can only be speculated upon by the novel's ambiguous conclusion, which one reviewer describes as "surprising and heartbreaking" (Grgas).

Preceding this final scene, which renders it even more perplexing, are two divergent narratives: One is Alma's children's story suggesting that Alma will return to her writing and publish her book, and the other is Alma baking a berry buckle pie for a fundraiser, although she was initially reluctant to do so, she is now resolved to make one every season. This latter scene concludes with Alma cheering and waving to her sons on a parade float and reflecting: "I had done my duty. I had given people what they wanted, and I was there, dependable as always" (141). This image of a dutiful and dependent mother baking pies does not denote a reconstruction of gendered household labour as found in Bueskens's research on revolving mothers, nor does it open up new ways of conceptualizing motherhood and family life like the Swedish novels studied by Björklund. The image certainly does not enact or signify the repudiation and eradication of normative motherhood as theorized by Levine in her discussion of demon texts.

Nonetheless, this scene contrasts with the preceding narrative of the children's story Alma is authoring, which ends with two friends, an owl and a raccoon, flying side by side "in pockets of light, dancing in tandem with the music of the earth" (145), signifying joy and freedom. I suggest that like the Swedish novels studied by Björklund, *The Shame,* as a novel about a mother who leaves, is less about the pursuit of emancipation than about the mother's ambivalence. Alma leaves because of her ambivalence

and returns, it would seem, with a new awareness and appreciation of her life to suggest, if not promise, a new story for Alma and one in which, like the children's story she is writing, there is hope for contentment and freedom. Thus, as the novel exposes the maternal ambivalence and anger of normative motherhood, it does not imagine new and empowered ways of being a mother or creating a family. Although the novel in using the trope of the mother who leaves may critique normative motherhood, it does not aim to defy or displace the institution. In providing only a critique of normative motherhood, *The Shame* does not, I argue, deliver the "pre-emptive and radical questioning" (Snitow 295) of normative motherhood as in the demon texts studied by Snitow and championed by Levine.

When I Ran Away: "Starting to Feel Better and Remembering That I Was Good at Something"

Lisa Opdycke describes the novel *When I Ran Away* as "about a mother who runs away from her family under the weight of grief, guilt, and the struggles of motherhood." The novel, Opdycke continues, "creates a raw, honest depiction of a woman who has lost all sense of herself and struggles to find a way back." In her article, "Writing Wasn't in the Plan," Ilona Bannister explains how the novel was drawn from her own experience of trying to return to her work as a lawyer when she was a new mother with a baby and toddler and never being hired because she requested flexible hours. She elaborates: "I panicked. I felt that I had thrown everything I had ever worked for away and I was never going to get it back. What I had to offer the world, other than motherhood, was no longer required.... Gigi [the mother in the novel] then became my mother alter ego, the woman brave enough to say things about motherhood that I wasn't."

The novel opens in London, England, in August 2016 at 7:00 a.m. when the mother, Gigi, walks out of the house leaving her two sons, seven-year-old Johnny and eight-month-old Rocky, and her husband, Harry, behind. After she trips on the shoes Harry once again haphazardly left in front of the door, Gigi hurls them out the front door, setting off a neighbour's car alarm. The car's alarm, the baby's cries, Johnny's screams, and her husband's yelling "shatters her skull from the inside," and Gigi realizes "it's time to go. So [she] leaves them and starts walking"

(4). After checking into a hotel, Gigi receives a text from her husband asking "What do I do with Rocky? Who do I call? What are you doing?" (45). She then decides to block Harry's number because "it's easier than telling him the truth" (45). Thinking about how Rocky would now be screaming with tiredness because her husband would have "misread his signs, or forgot the sleeping bag he likes, or couldn't find his lamb" (46), Gigi waits for "a feeling [she] doesn't have" (46). Realizing that it was "someone else's turn to have feelings today" (46), she turns on the TV to watch her favourite show, *The Real Housewives of New Jersey*. Gigi receives another text from her husband, saying he is worried about her and loves her, but then ends his text with "PS: I can't find Rocky's medicine" (71). Reading his message Gigi wonders: "Is this about making sure I'm OK? Or is it about making sure I come home and handle all the shit he doesn't know how—doesn't *want*—to do" (72). Gigi then finds herself screaming and writing an enraged response on how he should know the antibiotics are kept in the fridge because the children have needed them at least four times in the last year. But she deletes the message realizing the following: "The intimate management of shit and dirt and food and children is of little interest to him. Of so little interest that he doesn't even know it exists for him to have no interest in" (73). Instead, she simply tells him that the amoxicillin is in the fridge and "to make sure that he gives it to Rocky on time at lunch and at 4" (77).

Gigi then remembers one morning when she was pregnant and vomiting before getting ready for work and Johnny reminded her that he needed a shoebox for a class project. Gigi reflects:

> The point was I had done everything the night before. Packed the waterproofs with the rain boots in a named plastic bag for forest school; signed the homework diary, checked the spelling sheet; packed the pre-karate-snack; labeled the water bottle; tested him on his five-times table. I did a nit check with a metal comb because somebody in the class has friggin' lice again. After he went to bed I finished three client letters and emailed a brief to counsel. I knew I'd be throwing up in the morning so I did everything the night before. (74)

When Gigi asks Johnny to have his father find a shoebox, Harry gives his son an extra-large bedding box. Seeing the box, Gigi realizes: "I wasn't angry about the box.... Or the insanity of waking up early to vomit and dealing with every last tiny detail of Johnny's life and then working ten hours a day. I wasn't angry at how unfair it was—I was angry because I know a woman would never hand me a half-ton of cardboard when I asked for a shoe box. I was angry because Harry wasn't a woman" (76). But Gigi does not say any of this to Harry nor does she tell him that she is "terrified of the pain [she] feels and that [she] is afraid that [she] can't get better, that [she] will always be like this, brittle and cracked and empty" (77).

Gigi's contemplations illuminate the emotional and mental labour of motherwork or what Sara Ruddick has described as "maternal thinking"; both terms refer to the remembering, worrying, planning, anticipating, orchestrating, arranging, and coordinating of children and the household. Mothers remember to buy the milk and plan the birthday party. Although the father may sign the field trip permission form or buy the diapers, the mother in most households reminds him to do so. But delegation does not make equality. As Gigi reflects: "My mind is flooded, overflowing with lists and needs and wants and musts. Dental appointments, school assemblies, vaccinations ... shopping lists, holes in school uniforms and outgrown shoes to replace" (180). There are always worries and questions: "How do I get the children to like books and vegetables?; Did I explain homelessness right when we walked by the man under the railway bridge?; Did I explain that girls and boys are equal but it's not okay to tackle girls on the playground; that's it's never okay to hit women?" (182).

Significantly, an argument about the gendered labour of motherwork precipitates Gigi's leaving. In the morning after being up most of the night with the baby and comforting Johnny after a nightmare, Gigi is frantically looking for the Sudocrem for Johnny's eczema. When Harry says that he heard her up in the night and asked her what she wanted him to do, Gigi replies: "GET-THE-FUCK-OUT-OF-BED!" (301). Harry then explains that the cream is in his bathroom as he used it when he ran out of his cycling chaffing cream. Gigi then opens the jar of cream, only to find it empty. Gigi drops the empty jar to the floor, grabs her keys, wallet, and phone and "walks past a stack of mail on the floor and a pile of laundry festering in a corner" and out the front door (302–03). Gigi cares for the baby and comforts Johnny each night while Harry uses the

last of the cream, which symbolizes and enacts the gendered dynamics of carework. Harry is oblivious to the emotional and mental labour that his children require and that his wife performs. "The overwhelming theme of the novel," as Lulu Garcia-Navarro remarks, "is the invisible work that women do." Bannister elaborates: "It was actually very satisfying to give voice to [the invisible work women do] and to explain what that burden is...[how] the mother's life is everyone's life. Everyone has a piece of it" (qtd. in Garcia-Navarro). Indeed, as Gigi reflects: "[The children] are at the top of every thought, still they are the first, even when the rest of me has gone to dust" (183).

Reminiscent of Alma in *The Shame*, who had "no idea who she was anymore," (3) Gigi's "old self [is] so far gone that even [her] fingerprints have worn off her hands" (182). But I suggest that Gigi, more so than Alma, is enraged by this loss of self in motherhood, particularly as it is enacted in the invisible labour of motherwork. Indeed, as Gigi reflects: "[My] anger permeates every room, sits heavily on every surface, blocks the doorways, thickens the air" (186). And Gigi, far more than Alma, voices this maternal rage. However, as noted by Bannister in an interview: "In the context of motherhood, we're really uncomfortable with thinking about mothers as people who get angry ... the idea that motherhood can take you to an angry place, it is frightening" (qtd. in Garcia-Navarro). But this "uncomfortable" and "frightening" maternal rage disrupts the normative motherhood Gigi is expected to perform, which makes *When I Ran Away*, more so than *The Shame*, a demon text as theorized by Levine.

In her foreword to *Of Woman Born*, Eulu Biss argues that Rich's embrace of rage is "useful and liberating" (xix). I suggest that Gigi's rage is likewise "useful and liberating": It empowers her to seek to correct and change normative motherhood. Significantly, it is when Gigi articulates her anger and despair that Harry listens to her and begins to understand her unhappiness. One evening when Harry comes home and finds Gigi sobbing in the kitchen overwhelmed with dirty dishes, he sends her to the shower, cleans the kitchen, and then says to her: "We can't go on like this. Your mother isn't here, my mother isn't here.... You just cannot do everything on your own. You're not supposed to do this all alone" (230). Although Gigi initially refuses Harry's offer to hire a cleaning woman, one is eventually hired who not only cleans the house weekly but comforts Gigi: "You are a good mother. Very soon you will do what they say in America—push [sic] your shits [sic] together" (239).

Furthermore, in an email sent to Gigi while she is at the hotel, Harry writes: "I'm so sorry. I didn't know things were this bad. I'm worried. Please can we talk? We'll fix it, I promise, we'll fix all of it" (228). Harry then offers help, such as having the cleaning woman come more often and hiring a babysitter and a night nanny. However, as she reads his words, Gigi realizes "why [she has not] asked for help... he doesn't know how to help. He doesn't know what help [she] need[s]" (228). Significantly, while Harry does offer to hire people to help Gigi, he does not propose to take on this work himself. Only when Gigi's friends call her at the hotel and demand that she tell them what has happened does she find the understanding, validation, and support that empower her to make the needed changes in her life. When Gigi tells them "that it went sideways with the baby," they assure her "that happens to everybody" (297). When she asks, "What do you do after you fuckin' fall apart like this?" they reply: "It's like a rubber band... it goes back to the same size once you let it go" (297–98). Her friends tell her to sober up, eat something, and then get out of there. Hearing their words, Gigi reflects: "I followed their instructions. It's a relief to be told what to do" (298). She then retraces her steps out of the hotel and back to her home.

The novel's end suggests that, unlike *The Shame*, the mother in *When I Ran Away* acts upon her newfound awareness to bring about real changes in her life. She shares with her husband for the first time how she drinks during the day to stay calm, how she misses home, how lonely she is, and how she "fucked up at work" (308). Significantly, this telling is described by Gigi as "confessions fly[ing] out of me like angry crows beating their wings against my chest to get free" (308) signifying how her anger, as Rich theorized, has liberated and empowered her to identify and change the oppression which brought that anger into being. After listening to her words, Harry promises Gigi that "we'll deal with it" (308). *When I Ran Away* not only conveys the maternal discontent of normative motherhood but also seeks, unlike *The Shame*, to remedy it, which is signified through the symbol of the red coat that concludes the epilogue. At the end of the novel, we learn that Gigi is taking medication for her anxiety and depression. She has revised and submitted her resume, and her husband has arranged a babysitter so they can spend an evening together. She is taking her son to playgroups and meeting women friends for walks and lunches. She is starting to feel better. (313). As she reflects on these changes, Gigi organizes her closet to discard clothing that no

longer fits, symbolizing this changed self, and in doing so, she inadvertently finds her red patent coat. As she puts the coat on, she looks in the mirror and smiles at her reflection (314).

A year earlier Gigi and her colleague had purchased matching red coats to celebrate winning a legal case that reunited a mother with her children after a visa rejection had separated them. Thinking about this coat, Gigi reflects: "On days when it felt too hard to be a mom, live in England, and have a job, and be pregnant, and wonder what the fuck I was doing all this for, I'd look at the coat, and I'd remember that I was good at something" (249). That the novel ends with hopeful changes Gigi has made in her life suggests a reconceptualization of mothering as found in Björklund's study along with familial structural and psychological shifts as observed by Bueskens. With this, *When I Ran Away*, through its use of the trope of the mother who leaves, challenges and seeks to correct and change normative motherhood as it is done in the demon texts championed by Levine.

I Love You but I've Chosen Darkness: "Doing the Best That She Can with What She Has, to Let go… to Make Everything Better"

Katy Waldman argues that *I Love you* breaks the mould of books about ambivalent motherhood: "Claire [the mother in *I Love You*], risks more than other sad-mom protagonists, pulling off a jailbreak that they can only dream of." Indeed, unlike the mothers in *The Shame* and *When I Ran Away*, Claire leaves her infant daughter Ruth and husband Theo for months and never does return home, choosing instead to live apart from them and to have custody of her daughter a couple of times a year. Unlike the mothers in the aforementioned two novels, Claire has a successful career as a published author and is a tenure-track professor with her infant daughter in full-time daycare. The novel centres on what Natalie Zutter describes as a "surreal odyssey, propelled by [Claire's] maternal rage," and one that is "unequivocally triumphant to witness." It is Claire's acceptance of maternal ambivalence—"doing the best that [she] can with what [she has], choosing darkness, choosing light" (288)—that empowers her "to let go… to make everything better" (287). In this, Claire defies normative motherhood and creates a life on her terms to enact outlaw motherhood, as theorized by Rich. Following Rich's theorizations, Claire

journeys from the oppression of patriarchal motherhood to the potentiality of empowered mothering.

The novel opens with Claire completing the Ten-Item Edinburgh Post-Natal Depression Scale, which requires her to reflect upon whether "she has felt sad or miserable" or whether "things have been too much for [her]" (9;11). Reflecting upon her answers, Claire realizes that "she is always swinging from being a banshee to playacting sweetness and back" (9) and from expressing her authentic maternal feelings to performing the niceties of normative motherhood. Significantly, this chapter is followed by a chapter that presents and describes Claire's vaginal dermoid cyst as a "Vagina Dentata" (14). While Claire is initially afraid and disgusted by the teeth in her vagina and "feel[s] herself mutant," (14) she learns "to love the teeth and to be unafraid of that love" (15). The teeth, "hard and unequivocal," (14) are also "the hardest substance in the body" (16), causing Claire to "understand [her]self to be mythical and rare" (15). Claire also realizes that after her teeth came in, "[her] orgasms became longer and stronger, more intense and ... easier to come by" and she "filled [her] alone time with them" (15). "The teeth," as Claire reflects, "are her secret companion. She told no one [about them]" (15). Claire's vaginal teeth come in at the same rate as her daughter's baby teeth (14). For Claire, as Rachel Jo Walker emphasizes, the teeth are a "cherished source of strength." Moreover, as Walker argues further, the symbolism of the teeth "repurposes the existing myths of vagina dentata to claim feminist power." The teeth signify Claire's loved and strong, yet still secret, authentic maternal self, which the "despair, bewilderment, and rage" of normative motherhood represses (15).

In a later chapter, Claire travels to Reno, where she is to give an author talk and attend a launch of her book. On the plane, as Claire reads through her novel, she "realizes that the book made [her] want to cry [because she] didn't feel like the person who wrote it" (71). After the book launch, Claire converses with a woman who congratulates her on her new baby, to which Claire responds that she is "a messenger from the future. I am you in ten years" and warns the woman to "Pay attention! Don't fetishize marriages and babies" and that "even a shitty, shitty St. Patrick's Day in Vegas is better than the best day at home with an infant" (104). When the woman later asks Claire what she is now working on, Claire reflects: "The woman they admired, who'd written the books they liked ... was on the other side of the canyon. Someone else had written them,

elves-and-shoemaker style" (105). Thus, like Alma in *The Shame,* who had "no idea who she was anymore" (3) and like Gigi in *When I Ran Away,* whose "old self was so far gone that even [her] fingerprints have worn off her hands" (182), motherhood for Claire "has cracked [her] in half. Her self as a mother and her self as not were two different people, distinct" (105). As Claire reflects further: "She was a new person now... remade. She had often wished [for this]. But now that she has been made anew she found it frightening. She did not know anything about this new person who was her ... the new woman was a mystery and a blank" (108). Although people assure Claire that these feelings are normal, she asserts the following: "[She] wasn't comforted by being normal, that [she] took normal as an insult ... and that it only meant that on top of [her] avoidance and guilt and shame and numbness [she] now felt boring, a kind of death" (101). Instead of normalcy, what Claire ultimately wants, as she confides to her friends, is "to behave like a man, a slightly bad one" (105). Not surprisingly, Claire, wanting to behave like a slightly bad man, does not return to her husband and daughter. As she begins to feel claustrophobic on the homebound flight and receives a text from a former lover asking her to stay, she abruptly gets up and disembarks the plane. As the flight attendant opens the door for Claire, she hears the voice of the goose from *Charlotte's Web: "An hour of freedom is worth a barrel of slops"* (189).

The remainder of the novel narrates this freedom as Claire, with a leave of absence from her university, lives with Noah, her former lover, on a ranch caring for horses and sheep and working part-time at a brunch shack. Claire wins a Guggenheim award, goes to yoga five nights a week, gets a library card, and reads books to the pigs in the barn (203). With this, Claire now feels "safe enough," and "language returns to her" (203). She then intentionally drops her wedding ring in a forest. Later, she describes herself as "full-on Medusa" (203). However, Noah eventually ends their relationship, and Claire arrives once again at the airport with "the teeth inside [her] puls[ing] with longing and lostness" (219). However, Claire realizes: "That's how [she] likes it. That's where [she is] at. (219). After arriving in Las Vegas from her flight from Reno, Claire learns her connecting flight home to Michigan has been delayed and then cancelled. With her longing and lostness, as signified by her teeth, Claire leaves the airport and embarks on another journey to the places of her childhood. In Tecopa, she joins a women's public bath and later travels to Shoshone and visits the Crowbar, the place where her mother worked

and where Claire spent part of her childhood. When Claire is once again at the airport for her rescheduled flight, she interprets the airport sign "The Way to Rideshare Pick Up Zone" as a message to go to her sister Lise, who she finds at her usual spot at the casino (233). After visiting their grandma's house, the sisters venture to the Tecopa house, where they lived as children to find only the chimney remaining. Claire decides to stay with a collective of women residing on the Tecopa land who made her feel "exuberant and illicit" (263). However, the collective eventually asks Claire to leave, and she then spends several weeks alone in the desert, "letting everything that was wrong with [her] bounce off the canyon walls" (270). These travels through the land of Claire's childhood symbolize and enact her journey from patriarchal motherhood to empowered mothering. During this time, Claire calls her husband several times and eventually invites him and their daughter to visit. Later, they do.

The novel concludes with Claire living alone in Nevada with her daughter occasionally visiting. She describes her life as "a spell of love and solitude" (288). She describes her current situation: "I read and write and nap and teach and soak and sew and cook and fuck around on the internet and with various lovers" (288). When her daughter Ruth comes to visit, they "walk into the mountains ... eat dinner on the splintery picnic table in front of the cabin, watch the sun go down and the stars come out" (288). This description recalls Rich's celebrated passage from *Of Woman Born* wherein she describes herself and her sons as "conspirators and outlaws" from the institution of motherhood as they "lived like castaways on some island of mothers and children ... and when [Rich] felt enormously in charge of [her] life" (194–95). At the end of the novel, Claire is likewise a mother outlaw in charge of her life, a mother who has journeyed from the oppression of patriarchal motherhood to the possibility of empowered mothering. In this way, the novel does more than list hopeful changes, as *When I Ran Away* does, but shows them to be fully realized and enacted in outlaw motherhood. The novel critiques normative motherhood, as *The Shame* does, and seeks to correct and change it, as *When I Ran Away* does, but it also delivers a defiant mothering, arguably more empowering than that theorized by Björklund and Bueskens. In its trope of a mother who leaves and does not return, *I Love You* becomes the defiant demon text that Levine championed.

Hiroshima in the Morning: "My Problem Was Not with My Children, but with How We Think about Motherhood"

In her article "Why I Left my Children," Rahna Rizzuto confides the following: "I never wanted to be a mother. I was afraid of being swallowed up, of being exhausted, of opening my eyes one day 20 (or 30?) years after they were born, and realizing that I had lost myself and my life was over." In her memoir, Rizzuto elaborates: "Motherhood was not for me.... I wanted my own time, my own money. My own life" (63). She continues: "It was Brian, [her husband] who wanted to have children and when I tried to picture myself as a mother, I disappeared" (106). She explains that with the writing of her first novel "she tested the possibilities of [her] own motherhood" (63) only to discover herself accidentally pregnant a few days after completing the manuscript. In her memoir, she asks: "If my first novel took me into motherhood, where will this one take me?" (64). In "Why I Left My Children," Rizzuto explains, "My problem was not with my children, but with how we think about motherhood. About how a male-time caretaker is a 'saint' and how a full-time caretaker is a 'mother'.... We punish the very idea that there are other ways to be a mother." In her memoir, Rizzuto imagines and then enacts this other way to be a mother—namely, as an outlaw from normative motherhood as theorized by Rich and observed in *I Love You*.

Like the mothers in the other three novels, Rizzuto describes herself as "the domestic centre" of her family (14). However, in June 2001, Rizzuto left for Hiroshima, Japan, on a six-month fellowship to interview the Hibakusha, survivors of the atomic bomb, leaving behind her two sons, ages five and three, and her husband and partner of twenty years. Reflecting upon the upcoming trip Rizzuto realizes that "[she'd] never lived on [her] own, for six days let alone six months" and that "something about this opportunity had exploded all [her] patterns" (14). Rizzuto's interviews with the Hibakusha and her time away from her family prompt Rizzuto "to reflect on her life and motherhood," and by the end of her six-month journey, she is a "changed person" (Tsang). But at the start of her memoir, Rizzuto wonders: "If I understood I was about to become someone new, someone I was proud of, who I loved, but who was too different to fit here ... would I still have gotten on the airplane" (15). The emergence of Rizzuto's new and changed self begins just eight days after she leaves her family. On the phone with her husband, Rizzuto realizes

that her tears "are not simply a bit of homesickness, they are for loss" 42). She dreads change as much as she wants it (42). Later, Rizzuto reflects: "In all my thirty-seven years, as a daughter, a wife, and a mother, I've never had the luxury of waking, with my eyes closed and thinking, without any recrimination or guilt, without any other person's needs to consider: *What do I want to do today?*" (81). However, later in the memoir, Brian calls her angry with the news that the family may need to move out of their home—"an issue," as Rizzuto reflects, "that [her husband] would normally leave to [her] to negotiate. It would have been [her] role, [her] logic, [they] called on" (103). However, all of Rizzuto's responses only make her husband angrier, as she realizes that he is "the one who can't find peace in his own house [while she is] having a great time in Japan" (103). After this conversation, Rizzuto reflects: "I AM A BAD MOTHER: this is what I'm being told. Or rather, my mother-in-law has adopted a recurring email sign off—*Your family needs you*—and Brian doesn't understand how I'm not miserable so far away" (106). But as Rizzuto thinks this, she also wonders: "In the growing gap between my notion of a good motherhood and everyone else's, there is a question rising: what is a good mother supposed to be?" (106).

Significantly, this question of what a good mother is supposed to be prompts and parallels Rizzuto's growing estrangement from her husband and the emergence of her authentic selfhood. Rizzuto wonders: "If Brian's vision of me is not quite my own vision, is that just a simple misunderstanding born of the fact that we're apart? Am I changing, or was I never that person in the first place?" (110). Later, she reflects: "I am changing—not because I don't belong—but because I can. Without identifying anything wrong with my life.... I am losing things ... like fear" (138). Rizzuto realizes that she "is beginning to recover an even earlier lifetime—the barefoot girl, the child running through the pastures behind her home in Hawaii, writing bad poetry beside the waterfall, embraced by the hills" (139). This girl, as Rizzuto reflects, "waits for me to fall back beside her, back to the moment in my life where I can begin again and learn to leap" (139). Not surprisingly, as "this rift" between Rizzuto and her husband grows—"[with them] no longer living in the same world" (110)—Rizzuto begins to understand and then enact an empowered identity and practice of mothering. She wonders: "How can it only be now, at the age of thirty-seven, that I am learning that a mother is also a woman? A female adult with her own name?" (190). Reflecting

on her own mother's life, Rizzuto asks: "Who was my mother alone?" (192) and then realizes the following:

> Before coming to Japan, I never thought of myself as auxiliary, nor did I think of my mother that way ... but of course I must have felt it because I did not want to be a mother; I did not want to give up the independence I had, at least in my imagination, only to find myself buried so deep beneath the needs of others I could no longer breathe. I must have noticed I was missing definition because I am here, in Japan, following [the Hibakusha], who, after obeying every rule and requirement of citizenship, found themselves abandoned in the rubble at the end of the world. (191)

Here Rizzuto likens herself to the Hibakusha she is interviewing because she too obeyed every rule and requirement of normative motherhood only to find herself abandoned to "the needs of others and with no definition" (191). Rizzuto writes: "There is a narrative we are creating called motherhood. We define it in relation to others. It is a rigid story, without permutations or breathing space. It is measured by sacrifice and loss" (200). Rizzuto then asks: "I was a mother once. But if I can no longer find myself in this story, am I still?" (201). Rizzuto's epiphany that a mother is "a female adult with her own name" (190) empowers her to "define her own motherhood" ("Why I Left My Children") and create a "new story of motherhood," one not "measured by sacrifice and loss" (201). Rizzuto elaborates: "My trip to Japan changed me. I went from being uncertain, ambivalent, loving but overwhelmed to being a damned good mother. My marriage failed, and I gave primary physical custody to my husband. But I kept joint custody.... I moved down the block" ("Why I had to Leave"). In becoming a part-time noncustodial mother, Rizzuto emphasizes that her "relationship with [her] children has improved" ("Why I Left My Children"), and she can "remain a part of their lives joyfully and not as a stifled, resentful failure" ("Reviled for Living apart from My Kids").

As this noncustodial mother, Rizzuto, like Claire in *I Love You*, achieves the outlaw motherhood described by Rich. Rizzuto and her sons "cook dinner, clean up together, talk about their day...cry watching their favourite TV shows ... and do a lot of hugging, even in public, even though they are now boys entering their teens" ("Why I Left My Children"). Significantly, and like the findings of Bueskens's research on revolving



mothers, Rizzuto can only see and understand her maternal discontent apart from her husband and can only defy normative motherhood and enact empowered mothering outside of marriage as a noncustodial mother. The mothers in *The Shame* and *When I Ran Away* return to their marriages, as the former novel provides a critique of normative motherhood, and the latter suggests corrections to it. The mothers of *I Love You* and *Hiroshima* leave their marriages and become noncustodial mothers; both texts defy normative motherhood to achieve empowered mothering. In this, these two narratives suggest that the trope of the mother who leaves can defy normative motherhood and become the demon text extolled by Levine only if this mother does not return to her marriage and lives apart from her children.

Patsy: "Society Tells Us That Once You're a Mother, Every Other Part of You Dies. I Wanted to Write against This"

In an interview with Nicole Dennis-Benn, Maya Clark remarks: "[The novel] explicitly questions the idea of women as inherently maternal, and explores what it means to feel ambivalent about becoming a mother in the first place." Dennis-Benn elaborates: "[Women] don't have the privilege of choosing whether or not they want to be mothers. In my culture [of Jamaica], motherhood just happens upon a woman" (qtd. in Clark). Indeed, as Patsy reflects in the novel: "That's what it all comes down to—choice. When has she ever been given a choice? Never. She was never given the choice to say no the first time her legs were pried open, never given the choice to rid her body of the grievance she had to carry for nine months" (202). *Patsy* explores, as Dennis-Benn explains, "What happens if [a woman] doesn't rise to that role [of motherhood]? What happens to the woman who admits to herself that this is not for her?" (qtd. in Clark). These are the questions that the novel asks in telling the story of Patsy, who leaves behind her five-year-old daughter Tru in Jamaica with her father, to be with Cicely, her best friend and lover in New York. However, as Dennis-Benn confides: "When the character Patsy revealed to me that ... her motive was to actually leave her daughter/abandon her daughter, I felt myself judging the character.... Then I challenged myself to get the story out" (qtd. in Clark). She wanted to write "a woman who couldn't own that motherhood role and an immigrant



who does not give back to her family ... but leaves to be a new person" (qtd. in León). Through Patsy leaving to become a new person, I suggest that the novel critiques, corrects, and defies normative motherhood, as the above four novels do, while ultimately displacing this institution to enact outlaw motherhood, which empowers both the mother and daughter.

At the novel's start, Patsy confides: "Truth be told, she never loved her daughter like she's supposed to, or like her daughter loves her" (33). Recalling her first time alone with Tru as a baby, Patsy remembers "experience[ing] a small burst of regret" (47). Patsy longs "for a life without worry or care or want" (32). For Patsy, this life is symbolized by her cherished snow globe, and when Tru loses it, Patsy "felt she had lost *her* fairy tale ... and [begins] to plan and dream [about a life] without Tru" (33). Patsy begins letters to Cicely about staying with her in Brooklyn (33). On the day of her departure, Patsy lies to her daughter, saying she will be away for only a few months and asks her daughter to promise that she will be a good, obedient girl (61). As she says goodbye, Patsy reflects: "A good mother would have snapped a photograph of her daughter ... a good mother would have taken the time to use the very last second to inhale her daughter's scent of Blue Magic hair oil mixed with baby powder" (63). Ten years later when Patsy explains to her new lover, Claudette, why she left her daughter behind, she says: "I tried. I tried to love my baby, but I couldn't. She wasn't enough because I wasn't enough" (388). Patsy continues, "I came here hoping dat Cicely would make everyt'ing right. But it didn't work dat way" (388).

Once in New York, Patsy has no contact with Tru for ten years, apart from one phone call made to her daughter soon after her arrival, which Patsy cuts short before Tru is on the line, and a card that Patsy sends to Tru her first Christmas away. As she waits for her daughter to come to the phone, Patsy feels herself "losing courage" and realizes that "hearing Tru's voice will only make it harder" (115). Knowing that Tru will ask the inevitable and dreaded question "When are you coming home?", Patsy becomes "paralyzed with grief and fear of uttering yet another lie," and hangs up the phone saying sorry and "hoping her apology will carry over the dying autumn landscape across the brooding ocean" (115). Later, as Patsy thinks about Tru's upcoming sixth birthday, she remembers "the failed phone call and her cowardice, [and feels] weighed down by sin" (155). With the card she sent to Tru her first Christmas away, Patsy

hoped to include a message "to communicate something other than a greeting ... to offer an apology, to say that someday [Tru] will understand ... but Patsy decides against this and signs off with *Your mother, Patsy with love*" (190). Ten years later, as Patsy reflects upon this card, she realizes that "with much force, she severed all communication with her daughter, thinking it easier this way for both of them to move on. The absence of a mother is more dignified than the presence of a distant one" (263). On her first Christmas in America, Patsy's friend, Fiona, gives her a Statue of Liberty snow globe. Holding this snow globe, which reminds her of her own snow globe that Tru lost, Patsy realizes: "She's beginning to get used to the notion of a future without Tru.... She's determined to be a new woman in America" (189). As Patsy thinks this, she understands that "she must separate the past from the present.... [but yet] she always wonders in the quiet of her thoughts how Tru is faring without her" (189).

After a short stay at Cicely's home in New York, Patsy is asked to leave by Cicely's husband, as Patsy realizes that she has "lost Cicely to her American dream" (202). Patsy spends the next ten years in New York living with different friends and taking on various jobs until she becomes a full-time live-in nanny for white mothers and their children. As she cares for these children, "the words [Patsy] could never say to Tru at that age flow from [her] at the sight of these children who aren't hers. All the love she has never known pours out of her now" (234). And "Patsy is reminded every day ... of what she is missing out on by not raising Tru" (262). As Patsy realizes she has spent nearly a decade caring for other people's children, she becomes "plagued by guilt and regret" (264). After standing in line at Western Union "multiple times willing herself to send something" (264), Patsy finally decides to fill a barrel of gifts to send to Tru, realizing that "she cannot go on forever feeling sorry for herself, and making Tru pay for it" (319). At the store where these barrels are sold, Patsy meets a clerk, Claudette, who helps Patsy fill the barrel for her daughter and later becomes Patsy's lover and partner.

Like Gigi's girlfriends in *When I Ran Away*, Claudette gives Patsy the needed understanding, validation, and support to reconnect with her daughter. Patsy tells Claudette she has not reached out to her daughter in ten years: "My mother always told me ah child is a gift from God. But I could neva bring me self to ask har what if I neva wanted it. What about what I want. No one evah asked me what I want? No one evah asked me

ah want, besides you" (354). To which Claudette replies: "You won't be able to earn yuh daughter's forgiveness by jus' trying to do what people expec' you to do. Do what yu t'ink is right, from a place of honesty. She will respect yuh honesty" (355). Patsy and Claudette then fill the barrel "with things a sixteen-year-old girl would like: handbags, lip gloss, and perfumes" (372), and they send it to Tru. However, unknown to Patsy but known to the reader through the novel's interweaving of the mother's and daughter's narrative is that Tru identifies as queer and gender nonconfirming and would be hurt by these traditionally feminine gifts sent by her mother. The morning after a strong hailstorm, she receives a call from Tru's father telling her that Tru tried to commit suicide after receiving the barrel and that Patsy should have called to find out what Tru liked and disliked (400). He asks: "What kinda of mother?" And then goes to say: "Fah those ten years yuh neva t'ink of picking up the phone to call or pen to write yuh dawta. Yuh really t'nk one barrel could erase dat fact?" (401). Patsy then writes and sends a letter to her daughter. She tells her that she is "following advice from a wise woman [Claudette] who told her she will be respected more for her honesty" (441). Patsy then confesses:

> My biggest regret is that I didn't figure out how to love you sooner. I couldn't even love myself. I was guilty, because I had brought you into a world I couldn't change—a world I feared would break you too. I also could not bear to pretend that motherhood was for me...I know I may not be qualified to call myself your mother...but I can only hope that one day you will find it in your heart to forgive me. I also may not be the best at shopping for gifts but I will leave you these words that I wish someone had told me when I was your age. Never let anyone define you. Always know you matter...As your mother-in-training, the least I can do is set you free. (411–12)

Later we learn that while it took a year to happen, Tru and Patsy now talk weekly on the phone and that Tru has begun to forgive her mother (418). In her review of *Patsy*, Adrienne Green argues: "Tru's inheritance from Patsy isn't years of doting or gifts from America, but instead the permission to thrive in a society that always threatens to crush her will and desire." In an interview, Dennis-Benn similarly emphasizes that while "parts of the novel are tragic [e.g., Patsy's abandonment of Tru] I

think it is a redemptive story as well, in that there is this epiphany of, I'm not too different from this person who I have grown to resent" (qtd. in Iversen). When an interviewer asks Dennis-Benn what happens with Patsy and Tru after the book ends, she explains:

> I know that they'll definitely still transform their relationship, because there are so many missed years. But, in my mind, it ultimately ends up as two women seeing each other as women for the first time. It took me a long time to see my mother as a person...So when you realize that mothers are human beings as well, I think that's really when we feel most enlightened, when there's an epiphany, like Oh okay, I can begin this forgiveness process. And so that's what I wish for Tru, ultimately. (qtd. in Iversen)

Green argues that the novel is "a portrait of a black queer women grasping for self determination and a challenge to the conventions of what is expected of good mothers and good women and good immigrants." The novel, however, does more than challenge these conventions to displace normative motherhood: It creates an outlaw motherhood in which the mother and daughter are mutually empowered and empowering. *Patsy* moves beyond *I Love You* and *Hiroshima* to leave the reader with the promise of a new and redemptive maternal narrative in which a mother and daughter become women outside the scripts of heteronormative motherhood and daughterhood. Indeed, as Dennis-Benn emphasizes: "Society tells us that once you're a mother, every other part of you dies.... I wanted to write against this" (qtd. in Iversen). In writing against this script of normative motherhood, the novel delivers an outlaw mothering that empowers the mother Patsy and models the possibility for her daughter Tru to live a life in which "her thoughts, feelings, decisions, and happiness matter" (412). With this, *Patsy* reconceptualizes motherhood, as Bueskens and Björklund advocate, and shows how a mother leaving can empower both the mother and daughter. *Patsy* critiques normative motherhood, as *The Shame* does, offers changes to the institution, as *When I Ran Away* does, and models an outlaw motherhood, as *I Love You* and *Hiroshima* do. But the novel does so to empower the mother and model and mentor this same empowerment for the daughter. Rich argues that what daughters need are mothers who want their and their daughter's freedom: "The quality of the mother's life—however embattled and

unprotected—is her primary bequest to her daughter, because a woman who can believe in herself, who is a fighter, and who continues to struggle to create livable space around her, is demonstrating to her daughter that these possibilities exist" (247). Indeed, in the letter to her daughter, Patsy calls her "a warrior" (411), who has, like her mother, made a life in which "she matters" (412). And in this, *Patsy* becomes the definitive demon text, bequeathing resistance intergenerationally and displacing normative motherhood across a motherline.

Conclusion: "To Bring about Real Change We Must Forget and Reject the Nuclear Family and Start from a New Place"

In her article "Hating Motherhood," Levine concludes: "We can improve motherhood: we can make it less onerous and more egalitarian and stop criminalizing 'bad' mothers ... but these are incremental reforms. They will not solve the real problems of motherhood, which as the demon texts plainly show, simply adapt to the times.... Motherhood will always find ways to screw mothers. The only solution is to abolish mothers." Kaitlyn Teer makes a similar argument in her article "The Maternal Gothic and Maternal Ambition": "Though the gothic mode succeeds at depicting the anxieties of motherhood, as well as critiquing the power structures that reproduce them, one of the maternal gothic's limitations is the genre's failure to cast an alternative vision for the possibilities of motherhood." Likewise, Björklund argues in her chapter "Happy Endings: (Re) Producing the Gender Equality Ideal" that in many of the novels studied "the solution is not to abandon heterosexual coupledom and find other ways of organizing those relations; instead gender equality is seen as the solution that saves heteronormativity" (69). In this process, as Björklund explains, "both women and men need to change ... but not too much" (69). Björklund goes on to argue that to bring about real change, we must forget and reject the nuclear family and "start from a new place" (89). Drawing upon the work of Jack Halberstam, Björklund defines "this forgetting of family as a queer kind of project ... as a possibility embedded in the break from heterosexual narratives" (89). Indeed, in her study, Björklund shows how mothers, through their strategy of leaving heterosexual families, reject norms and ideals of the family to disrupt heteronormativity to make possible this "starting from a new place" (89).

In *Mothers Who Leave*, Jackson likewise argues: "Mothers who leave are not exceptional aberrations, but signs that the institution of motherhood has inherent flaws" (87). Mothers who leave, as Jackson elaborates, "are trying not to exit from their children, but from the travesty of the institutionalized form of being with her children that this culture presents as natural" (278). In my reading of these five demon texts of mothers who leave across a continuum of critique, correction, defiance, and displacement, I have made an argument similar to that of Björklund and Jackson. Temporary maternal absences ending with a return to the nuclear family may provide a critique of normative motherhood, as with *The Shame*, and deliver some corrections to this institution, as with *When I Ran Away*. However, it is only when the demon text fully breaks from institutionalized motherhood and the heteronormative narrative, with the mother leaving her marriage and becoming a noncustodial mother, as in *I Love You* and *Hiroshima,* or with the mother being a queer parent living apart from her daughter, as in *Patsy*—as these mothers exist outside the dictates and confines of the heteronormative nuclear family—that normative motherhood can be fully defied and ultimately displaced.

Works Cited

Bannister, Ilona. *When I Ran Away.* Doubleday, 2022.

Bannister, Ilona. "Writing Wasn't in the Plan: *When I Ran Away* by Ilona Bannister." *Writing,* 13 Mar. 2021, https://www.writing.ie/interviews/writing-wasnt-in-the-plan-when-i-ran-away-by-ilona-bannister/. Accessed 1 Sept. 2024.

Biss, Eula. Foreword. Of *Woman Born: Motherhood as Experience and Institution,* by Adrienne Rich. W. W. Norton & Company, 2023, pp. xl–xx.

Björklund, Jenny. *Maternal Abandonment and Queer Resistance in Twenty-First-Century Swedish Literature.* Palgrave MacMillian, 2021.

Björklund, Jenny. "Why Mothers in Novels Leave Their Families." *My News Desk,* 21 Jul. 2021, https://www.mynewsdesk.com/uu/pressreleases/why-mothers-in-novels-leave-their-families-3118052. Accessed 1 Sept. 2024.

Bueskens, Petra. *Modern Motherhood and Women's Dual Identities: Rewriting the Sexual Contract.* Routledge, 2018.

Clark, Naya. "Truth Through Fiction: Talking With Nicole Dennis-Benn."

The Rumpus, 3 June 2019, https://therumpus.net/2019/06/03/the-rumpus-interview-with-nicole-dennis-benn/. Accessed 1 Sept. 2024.

Dennis-Benn, Nicole. *Patsy.* W. W. Norton & Company, 2019.

Edwards, Kasey. "Why Does Society Vilify Mothers Who Leave Their Families?" *Stuff,* 17 Feb. 2016, https://www.stuff.co.nz/life-style/parenting/mums-life/76927998/why-does-society-vilify-mothers-who-leave-their-families. Accessed 1 Sept. 2024.

Firestone, Shulamith. *The Dialectic of Sex.* Bantam Books, 1970.

Forcey, Linda. *Mothers of Sons. Toward an Understanding of Responsibility.* Praeger, 1987.

Friedan Betty. *The Feminine Mystique.* 1963. Dell, 1974.

Garcia-Navarro, Lulu. "Ilona Bannister's Debut Novel Depicts the Struggles Of New Motherhood." *NPR,* 4 Apr. 2021, https://www.npr.org/2021/04/04/984203826/ilona-bannisters-debut-novel-depicts-the-struggles-of-new-motherhood. Accessed 1 Sept. 2024.

Goodman, Makenna. *The Shame.* Milkweed Editions, 2020.

Green, Adrienne. "A Novel That Weighs the Costs of Love and Motherhood." *The Atlantic,* 7 June 2019, https://www.theatlantic.com/entertainment/archive/2019/06/review-patsy-nicole-dennis-benn/591193/. Accessed 1 Sept. 2024.

Grgas, Lisa. "The Monster I Have Created: A Conversation with Makenna Goodman." *The Android Journal,* 13 June 2020, https://theadroitjournal.org/2020/05/13/the-monster-i-have-created-a-conversation-with-makenna-goodman/. Accessed 1 Sept. 2024.

Iversen, Kristin. "A Brilliant New Novel Shows All the Different Things a Woman Is." *Nylon,* 4 June 2019, https://www.nylon.com/nicole-dennis-benn-interview-patsy. Accessed 1 Sept. 2024.

Jackson, Rosie. *Mothers who Leave: behind the myth of women without their children.* Pandora Press, 1994.

King, Madeline. "Why Do Some Mothers Choose to Leave Their Children?" *SBS News,* 7 June 2016, https://www.sbs.com.au/news/insight/article/why-do-some-mothers-choose-to-leave-their-children/u782b2rfw. Accessed 1 Sept. 2024.

León, Concepción de. "'We Are So Secretive': How Nicole Dennis-Benn Depicts Working-Class Life." *The New York Times,* 30 May 2019, https://www.nytimes.com/2019/05/30/books/nicole-dennis-benn-patsy.html. Accessed 1 Sept. 2024.

Levine, Judith. "Hating Motherhood." *The Boston Review*, 3 Mar. 2022, https://www.bostonreview.net/articles/hating-motherhood//. Accessed 1 Sept. 2024.

Opdycke, Lisa. "When I Ran Away." *Read Between the Spines*, https://readbetweenthespines.com/2022/03/07/when-i-ran-away/. Accessed 1 Sept. 2024.

Peled, Shachar. "Is the Walk-Away Mother Really Insane, or Is That What Society and Culture Want Us to Think?" *Medium*, 8 Dec. 2019, https://medium.com/@shacharpeled/is-the-walk-away-mother-really-insane-or-is-that-what-society-and-culture-want-us-to-think-fe0c11a60e44. Accessed 1 Sept. 2024.

Rich, Adrienne. *Of Woman Born: Motherhood as Experience and Institution.* 2nd ed., W. W. Norton, 1986.

Rizzuto, Rahna Reiko. *Hiroshima in the Morning.* Feminist Press, 2010.

Rizzuto, Rahna Reiko. "Reviled for Living apart from My Kids." *CNN*, 10 May 2012, https://www.cnn.com/2013/05/10/opinion/rizzuto-judging-mothers/index.html. Accessed 1 Sept. 2024.

Rizzuto, Rahna Reiko. "Why I Left My Children." *Salon*, 1 Mar. 2011, https://www.salon.com/2011/03/01/leaving_my_children/. Accessed 1 Sept. 2024.

Ruddick, Sara. *Maternal Thinking: Toward a Politics of Peace.* Beacon Press, 1989.

Snitow, Ann. "Feminism and Motherhood: An American Reading." *Maternal Theory: Essential Readings.* Edited by Andrea O'Reilly, Demeter Press, 2007, pp. 290–310.

Teer, Kaitlyn. "The Maternal Gothic and Maternal Ambition." *Ploughshares*, 20 May 2022, https://blog.pshares.org/the-maternal-gothic-and-maternal-ambition/. Accessed 1 Sept. 2024.

Tsang, Michael. "Stop and think: Rahna Reiko Rizzuto's *Hiroshima in the Morning.*" *Cha: An Asian Literary Journal*, Feb. 2011, https://www.asiancha.com/content/view/793/115/. Accessed 1 Sept. 2024.

Tyler, J. A. "The Tragedy of Self: The Millions Interviews Makenna Goodman." *The Millions*, 24 May 2021, https://themillions.com/2021/05/the-tragedy-of-self-the-millions-interviews-makenna-goodman.html. Accessed 1 Sept. 2024.

Waldman, Katy. "Claire Vaye Watkins's Anti-Pandering Novel." *The New Yorker*, 28 Oct. 2021, https://www.newyorker.com/books/page-turner/claire-vaye-watkinss-anti-pandering-novel. Accessed 1 Sept. 2024.

Walker, Rachel Jo. "Thrilling and Harrowing: On Claire Vaye Watkins's 'I Love You but I've Chosen Darkness.'" *Los Angeles Review of Books*, 18 Nov. 2023, https://lareviewofbooks.org/article/thrilling-and-harrowing-on-claire-vaye-watkinss-i-love-you-but-ive-chosen-darkness/. Accessed 1 Sept. 2024.

Watkins, Claire Vaye. *I Love You But I've Chosen Darkness*. Riverhead Books. 2021.

Zutter, Natalie. "Claire Vaye Watkins Goes on an Autofictional Odyssey Out West in Her Latest." *NPR*, 5 Oct. 2021, https://www.npr.org/2021/10/05/1043174602/claire-vaye-watkins-i-love-you-but-ive-chosen-darkness-review. Accessed 1 Sept. 2024.

The Missing Mother in *King Lear*

Emma Dalton

T his chapter argues that playwright and director Rachel McDonald's 2012 staging of her adaptation *Queen Lear* made manifest Goneril, Regan, and Cordelia's missing mother. Furthermore, it argues that this action (having actress Robyn Nevin embody the missing mother) resulted in harsh criticism. The critics may have blamed McDonald for the play's apparent failure, but I argue it was Queen Lear, and not McDonald, that caused them discomfort. In this chapter, I discuss the loss of the self that occurs when a woman becomes a mother (Stone); "gender switching" (Kelly; Tait) adaptations; authenticity criticism (Bradley; Meyrick); English renaissance motherhood (Rose); and contemporary intensive mothering and neoliberalism (Hays; Ennis). Utilizing scholarship from theatre studies and motherhood studies I demonstrate the capacity of motherhood studies to bring greater depth to the analysis of mother characters in play texts and live performances. In *Queen Lear*, the now-present missing mother struck me as complex and flawed. However, I argue that it was her complexity and failure to live up to expectations which caused the critics' discomfort.

On Becoming a Mother and Losing Oneself

Alison Stone writes about the upheaval women experience when they become mothers, which splits their sense of self (325). Stone's description of the phase women step-into when they care for a young child suggests the mother becomes a fractured creature who lives in the child's shadow.

McDonald's Queen Lear shares her mind—or psyche—with three internal voices (four if you count her own). McDonald's staging of *Queen Lear* focused on the possibility of a mother sharing her psyche by having Queen Lear's internal voices spoken by the performers who played her daughters. Her mental landscape was represented by multiple and fractured selves, perhaps Lear's own thoughts and internal voice, and the voices of her daughters. Although these three characters were abstract, they spoke the lines normally spoken by the Fool. Since there was no Fool, these words became symptoms of Lear's traumatized mind. Her psyche was not her own; rather, it was the play space of her daughters. Just as Stone describes Ann Oakley (a prominent British feminist sociologist) as having become the context for her child's subjectivity to develop through (325), Lear's psyche existed as a playground for foolish voices (the voices of the performers who played Lear's daughters) to wreak havoc upon.

Stone and Oakley do not point to a time when a mother may return to being a complete subject after the birth of her child. Rather, Stone positions the mother as bearing full responsibility for the child's outcomes: "Popular psychologist Oliver James alleges that month-old babies left by their mothers to cry will predictably suffer from insecurity 30 to 40 years later" (332). If we are to follow this line of reasoning, Queen Lear may be viewed as responsible for her daughters' behavior. However, I would suggest that Stone is not arguing that James is right (when she quotes him), but that perspectives like his influence society's thinking about mothers and the consequences of their actions for their children.

Donald Woods Winnicott describes the relationship between the mother and child in the first weeks of a child's life as having the potential to elicit a feeling of oneness between the two. This feeling of oneness results from the mother's instant responsiveness to the child's needs. In the child's early life, they require their mother to meet their needs almost completely. However, as the child grows, they can accept that the mother will not meet their needs and/or wants completely and can process a less instant and less complete fulfilment of their wishes. The child begins to perceive themselves as separate from the mother. Significantly, four voices exist within Lear's mental landscape: Goneril, Regan, Cordelia, and Lear, reflecting the oneness of which Winnicott speaks. All four exist within Lear's internal landscape, becoming, in a sense, one. However, Lear does not respond instantly to the needs or wants of her

daughters. Goneril, Regan, and Cordelia's missing and longed-for mother does not live up to expectations. The refusal of the mother to fulfil her children's wants wholly and completely, I argue, created discomfort for the critics. The tragedy of *Queen Lear*—with the missing mother found— became not her absence but her failure to resolve the play's problems, and her children's problems, with her presence.

Gender Switching Adaptations

McDonald adapted and directed *Queen Lear*. The script is not much changed from Shakespeare's original text. However, McDonald replaces Shakespeare's king with a queen, so the adaptation can be understood to be a "gender-switching" (Kelly 221) adaptation. Lear's gender switch changed the relationship between Lear and Kent, as it appeared Kent harbored romantic feelings for Lear. Also, Lear's hotness on the hearth suggested that Lear's descent into madness may have had something to do with the symptoms of the menopause.

Peta Tait refers to the "gender change" (78) in adaptations of *King Lear* in which the king is a queen, saying that it "expands the play's emotional dimension" (78). Tait also touches upon the implications of the mother-daughter relationships within McDonald's adaptation. However, I would argue, her references to Lear's role as a mother would benefit from reference to works from the discipline of motherhood studies (Rich; Ruddick; O'Reilly). Although paying attention to mother characters within performances and play-texts is a positive endeavor, the discipline of motherhood studies provides rich scholarship to help theatre scholars and theatre critics interpret the mother characters they encounter. Australian theatre scholars and critics can benefit from engaging with motherhood studies scholarship to enrich their analyses and critique of the mother characters they encounter in Australian performances and play texts. Perhaps this might be suggested to be especially true in cases where mother characters—once lost—are found.

Authenticity Criticism

I disagreed strongly with much of the criticism of *Queen Lear*. I asked myself why I so passionately disagreed and investigated the root of the negative criticism targeting the play. My findings suggested that Queen Lear—Goneril, Regan, and Cordelia's missing mother—brought discomfort to the theatre critics. Julian Meyrick describes the negative critical response to McDonald's staging of *Queen Lear* as a "critical furore" (4). Cameron Woodhead, who reviewed *Queen Lear* during and after its 2012 run at the Melbourne Theatre Company, blamed McDonald's poor direction for what he considered the failure of *Queen Lear*. However, I argue that the negative critical response to McDonald's Shakespearean adaptation *Queen Lear* was a response to the missing mother in *King Lear* being given form, with Mother Lear now doing as King Lear does (e.g., seeking flattery, shedding responsibility, and being present). Australian theatre critics wished the missing mother would stay missing; her presence made them unquestionably uneasy.

As reviews of the production started to circulate, the adaptor and director—McDonald—received more attention. Woodhead's criticism of *Queen Lear* was targeted most pointedly at its director: "Rachel McDonald's direction is dire. It neither distracts the eye, nor achieves the emotional intelligence or practical know-how to drive a coherent embodiment of the play." The final paragraph of Woodhead's review reflects the central message and tone of many of the reviews written in response to the production: "*Queen Lear* confronts us with the spectre of a formidable actress undermined by a lack of help: from the actors playing her daughters, from the staging and design, but most of all from the confused and unsophisticated direction." Woodhead's critique of *Queen Lear* places the blame for the arguable failure of the play firmly upon McDonald's shoulders. Reviewer Chris Boyd's criticism of *Queen Lear* is similarly scathing. However, Boyd distributes the blame across many elements of the performance. Rather than aiming his criticism bluntly at McDonald, he highlights faults in the "conception, direction, design and acting." Woodhead and Boyd consider many elements of *Queen Lear's* staging as problematic. However, Woodhead focusses on McDonald and what he calls her "confused and unsophisticated direction." Although Nevin's celebrity status was used to promote *Queen Lear*, McDonald was blamed for its failure.

Queen Lear received harsh criticism from many other quarters. Meyrick claims that the criticism surrounding *Queen Lear's* staging can be understood to echo "the witter of a seemingly indestructible national neurosis" (4). Meyrick discusses Australian audiences' responses to canonical plays and their responses to the accents they hear Australian actors using onstage. Arthur Phillips argues, "The core of the difficulty … is that, in the back of the Australian mind, there sits a minatory Englishman" (qtd. in Meyrick 10). Part of the reason *Queen Lear* experienced harsh critique was that it was met with a "tributary mentality" (Meyrick 13).

Yet Meyrick pays little attention to the "gender switches" (Kelly 221) occurring within *Queen Lear*. Furthermore, he quotes from an interview with McDonald in which she states: "*Lear* is not really a play about gender issues, it is beyond that. The *Lear* story is about life and death, since in one sense the gender switch feels almost irrelevant" (qtd. in Meyrick 8). In the same interview, however, McDonald also says: "In another sense it [the gender switch] changes everything. Leadership, parenthood, ageing and loss are experienced differently by women" (qtd. in Meyrick 8). McDonald justifies why the reversal of gender in *Queen Lear* is significant. The statements made by McDonald illustrate one of the problems inherent in researching authorial intention. Authors and directors contradict themselves. McDonald appears to contradict herself, stating "the gender switch feels almost irrelevant" and "in another sense it changes everything." Meyrick does not comment on McDonald's oscillation, perhaps because he takes it as a given that performed gender can be changed in the theatre, or because it serves his argument to quote McDonald when she says, "the gender switch feels almost irrelevant", but not when she says, "it changes everything." This chapter argues that the gender switches within McDonald's 2012 staging of *Queen Lear* significantly affected the interactions between its central characters.

English Renaissance Motherhood

This chapter proposes that the negative critical response to Rachel McDonald's staging of *Queen Lear* at the Melbourne Theatre Company's Southbank Theatre in 2012 may have been due to her choice to replace Shakespeare's father-king with a mother-queen, rather than due to the quality of her direction. By considering *Queen Lear* in the context of the

options available for the representation of mothers within the English Renaissance (Rose), we can begin to understand what an authentic and acceptable mother may have looked like at that time. Furthermore, I argue that contemporary "intensive mothering" (Ennis; Hays) can offer a suitable lens through which to understand some of Queen Lear's behaviors from a contemporary perspective.

In her paper on the presence and absence of mothers within Shakespeare's plays, Mary Beth Rose writes, "feminist inquiries must involve a full scrutiny of the discourses distinctive to, and options available in, Renaissance England" (291). Rose argues that there were limitations around the representation of acceptable mothering in English Renaissance performance, including the material circumstances and legal status of mothers within English Renaissance society. According to Rose, when writing his plays, Shakespeare chose from the public options available to him. Hence, Shakespeare's mothers do not break from the normative gender roles of his time. Rather, he adheres to convention in his representation of mothers. Shakespeare's representation of mothers may have adhered to the normative conventions of his time, but McDonald's does not. McDonald's Queen Lear does not fit within the category of options from which Shakespeare's mother characters were developed. We may choose to associate McDonald's Lear with a different category of options identified by Rose and that category of mother characters was written by the female writers of the English Renaissance. These female writers (e.g., Elizabeth Cary) were writing about new possibilities for the performance of motherhood, including behaving in an unruly manner. Perhaps McDonald chose to write Queen Lear as an unruly mother because mothers do not typically adhere to all the expectations society has for them, or because she was writing a female Lear who was much like the male Lear. However, what is acceptable for a father is not acceptable for a mother.

Rose focuses on "the relation between Renaissance sexual ideologies and dramatic genres: in particular, on the ways in which motherhood is represented (or pointedly *not* represented) in various forms of Shakespeare's drama" (291). She notes there are few mothers in Shakespeare's major plays and describes their absence as "[conspicuous]" (292). Rose explains that scholarship on the English Renaissance draws on historical data to explain issues which include the absence of mothers (292). She summarizes some of those arguments. For example, because women

did not perform on the stage when Shakespeare's plays were written, it may have been considered difficult, or inappropriate, for young boys to perform as mothers. Rose describes the act of young boys playing "fully grown mothers" to be a "potential representational problem" (Rose 292). However, she suggests that this line of reasoning may be proven insubstantial when the diversity of female roles performed by boys in Shakespeare's plays is considered. Instead, Rose cites the material and legal status of married women and mothers in Renaissance England as a more viable reason for the absence of mother characters within some of Shakespeare's plays. She frames their absence in the context of "Renaissance legal discourse" (Rose 293). According to Rose, when viewed in this light, "the exclusion of mothers from Shakespeare's father-dominated plays could be viewed as a dramatic economy, the conflation of two characters into one" (293), the father. Rose may be pointing to cost-cutting with her choice of words (one less actor to pay). However, she also appears to be highlighting the loss of power experienced by married women in Renaissance England, as she states, "According to the law, in sum, the married woman did not exist" (Rose 293).

During Shakespeare's time, marriage meant the husband and wife becoming "one person in law—and that person was the husband" (Lawrence Stone qtd. in Rose 293). Rose suggests that the absence of mothers from Shakespeare's plays may be explained when one considers the married woman and mother lacked rights in Renaissance England. Furthermore, "Because of the risks associated with childbirth, the chance that a wife would die in the first fifteen years of marriage was almost one in four, more than twice that of her husband" (Rose 293). Aristotle states, "the function of the poet is not to say what *has* happened, but to say the kind of thing that *would* happen, i.e. what is possible in accordance with probability or necessity" (Aristotle xxvi). It might then be suggested that, in choosing to represent relatively few mothers in his plays, Shakespeare was reflecting the high mortality rate of women in childbirth in Renaissance England. This makes the mother characters Shakespeare chose to represent even more important.

Many of the mother characters Shakespeare included in his plays were present in his comedies. Rose tells us that, according to Louis A. Montrose, within *A Midsummer Night's Dream*, women are shown as "[containers]" for unborn children (qtd. in Rose 302). Rose offers the scene in which Titania gives Oberon her charge as an example of the way

in which a mother figure would submit to a father figure (Rose 302). She also describes Rosalind's speech in which she offers herself to Orlando as an act. When Rosalind discards her gender-ambiguous costuming, it is an act signifying that she "[is a heroine who] 'unquestionably' [identifies her] interests with those of the [hero]" (302). Rose states: "That Rosalind's unrepresented future will be motherhood clarifies a basic structural principle underlying Shakespeare's comic interpretation of marriage and the family: the harmonious, stable, wished-for society is based upon the sacrifice of the mother's desire" (303). The mother characters within Shakespeare's comedies are built upon the assumption that women are the lesser sex and that women's desires and interests must always be sacrificed for the interests and desires of the hero—who is a man, brother, husband, and/or father—to be realized.

Concerning the representation of mothers in Shakespeare's tragedies, Rose writes, "Generations of criticism have pointed out the ways in which Gertrude's refusal to forfeit her desire contributes to Hamlet's cosmic bewilderment and sexual nausea" (304). Gertrude chooses to remarry after her husband's death. Within Shakespeare's tragedies, female sexuality is presented as deeply problematic, and this is accentuated when the bearer of that desire is a mother. Shakespeare's mother characters can be associated with the first category of options available for the representation of mothers in Renaissance England. Rose describes this category as the most conservative. Within it, motherhood happens in the private, domestic space and involves childrearing and nurturing (313). In this category, Rose writes, "motherhood in this formulation can be dramatized only as dangerous or as peripheral to adult, public life" (313). By extension, it might be suggested that mothers of adult children can only be presented in a positive light when they are distant from their children. The second category of options involves "the Protestant valorisation of marriage" (Rose 313).

In this construction, mothers are seen in the public and private realms. Rose states in the second category of options, there is the possibility of the mother being depicted as a powerful figure (313). McDonald's mother character, Queen Lear, is irreconcilable with the first and second categories of options. However, the third category permits mothers to be unruly and survive. Queen Lear can be associated with this category, even though she does not survive. The third category of options originates in women writing about themselves in the English Renaissance. Female

writers instigated change, despite their attempts "to extinguish them-
selves as presences in their own first-person narratives" (Rose 313).
However, as Rose writes, Shakespeare's plays fit within the social norms,
rather than seek to challenge them (313). This adherence to social norms
and acceptable representations of mothering may provide specificities
for staging authentic Shakespearean performances. Transgressions
against these social norms and acceptable representations will be con-
sidered inauthentic by critics who (consciously or unconsciously) seek
authenticity (e.g., Woodhead).

Cary's *Tragedy of Mariam* (1603-4) provides a rare example of a play
by a woman contemporary of Shakespeare (Rose 314). Rose claims that
Cary's tragedy "participates notably in the illogic of the third, female-au-
thored conception of motherhood" (314), involving "the mother-authors'
technique of presenting themselves as dead and then going on to write
treatises" (Rose 314). Rose posits that Cary finds this challenging, and
this is apparent as she criticizes and praises her heroine's self-determi-
nation (314). For Rose, Cary's ending is radical because the death of
Mariam is potent and disturbing (314). Her mother (Alexandra) follows
her march towards her execution "heckling" (Rose 314). Alexandra is
aware of Mariam's innocence, but she shouts accusations at her daughter
as she is marched to her death. Rose points out that Alexandra's only
other appearance in the play involves her chastising her daughter for
"loving and marrying Herod, who killed several of her closest relatives"
(314). But in this, she heckles her daughter for having betrayed Herod,
although she knows she has not. Rose asserts that Cary's ending is "in-
coherent, impossible to evaluate and absorb; the mother's contradictory
appearances cannot be reconciled within the existing dramatic structures"
(312). Mariam's unruly mother, Alexandra, survives. She is alive at the
end of the *Tragedy of Mariam*. Rose suggests that this is radical because
she is an unruly woman and is permitted to live: "If she is to remain
onstage, an alternative logic must be found, one that, accommodating
her presence, transforms the given structures into a new and different
story" (314). Although Rose associates the act of women writing about
mothers in Renaissance England with creating a third category of options
for representing mothers, it might be suggested that with her example of
Alexandra from Cary's *Tragedy of Mariam*, Rose indicates that the female
playwrights who wrote mother characters at that time wrote them as
people who could not be contained within limiting social structures.

Although McDonald's *Queen Lear* may not contain a mother character that would have been found in any of Shakespeare's plays, Queen Lear could have aligned with a figure created by the female playwrights of the English Renaissance. It is a shame that McDonald followed Shakespeare's plot so closely; perhaps a different ending for Queen Lear could have been envisaged—one involving further contradictions and conflicts but that did not end in death. Even though McDonald found the missing mother in *King Lear*, she could not keep her. Perhaps McDonald did not choose to rewrite Shakespeare's ending and have Queen Lear live because she feared audiences and critics would not accept that ending. Perhaps she chose to keep an ending where Lear dies to avoid the wrath of the authenticity critics. However, even in her choice to let Queen Lear die as King Lear does, McDonald did not avoid the wrath of the critics.

At the end of the performance, all the women were dead. In *Queen Lear*, female friendship and familial love between women are not permitted to survive onstage for long. Goneril and Regan are competitors for the love of Edmund. Goneril kills Regan out of jealousy. Cordelia loves her mother, consistently and forgivingly, but she is not permitted to survive. Lear eventually sees the value in Cordelia, a daughter who speaks plainly and truthfully and who will not frame her emotions with flattery. However, Lear does not see Cordelia's value until it is too late. Queen Lear's love for Cordelia is depicted as her sole reason to live as the play's end nears. Lear's love for Cordelia outlasts Cordelia, and in the end, it is this love, and Lear's lack of purpose without Cordelia, that seems to bring on her death. Lear dies without Cordelia. This might be understood to suggest something about the strength and depth of maternal love. The female characters within *Queen Lear* are depicted as killing and dying for love but not surviving it (or living for it).

Contemporary Intensive Mothering and Neoliberalism

If adaptations have a relationship to both the time in which they were written and the moment of their performance (Bradley), how might *Queen Lear* be read in relation to contemporary mothering? Linda Ennis proposes that the tendency of contemporary mothers to engage in the practice of intensive mothering "operates today" (9) within the context of neoliberalism. Intensive mothering involves the mother working to ensure that her child remains in (or surpasses) the economic and social class of

their parents. Sharon Hays explains that there is "a gendered model that advises mothers to expend a tremendous amount of time, energy, and money in raising their children" (qtd. in Ennis 1). Ennis extends Hays' conclusions, acknowledging that "the backdrop for intensive mothering is consumerism" (Ennis 2). For Ennis, it is crucial to recognize that intensive mothering occurs within the context of a patriarchal and capitalist society.

While it appeared that McDonald's *Queen Lear* was set in Shakespeare's time, the audience who witnessed McDonald's 2012 staging of *Queen Lear* watched it from the perspective of Western twenty-first-century theatregoers. Read in the context of intensive mothering within a neoliberal society, Queen Lear's actions could be analyzed quite differently from the way in which the options for representing mothers within Renaissance England position them. By giving her daughters her worldly possessions and property in exchange for declarations of love, Queen Lear is teaching Goneril, Regan, and Cordelia that to gain power, property, and possessions, they need to tell people what they want to hear. In a sense, Queen Lear's love test is evidence of the maternal practice of training (Ruddick). She rewards Goneril and Regan for behaving in the manner that she wants them to behave and chastises and punishes Cordelia for behaving inappropriately (and not comprehending her lesson).

Hays argues that "the contemporary cultural model of socially appropriate mothering takes the form of an ideology of *intensive mothering*" (x), which is "a gendered model that advises mothers to expend tremendous amounts of time, energy and money in raising their children" (x). In this framing, the maternal practice of mothering (Ruddick) is positioned as hard work, and the mother who is not mothering intensively is positioned as not working hard enough.

Ennis describes the beliefs which lead to intensive mothering as perpetuating contestable ideas about mothering that have now grown to include men, although unevenly (1). The underlying issue has become consumption (Ennis 2). Ennis presents the following examples as ways in which mothers engage in intensive mothering: doing homework, befriending their children's friends, allowing their social lives to be directed by their children, expecting constant contact with their children, doing all domestic tasks, speaking on behalf of their children, as well as putting children first for the duration of their childhoods (6).

Queen Lear asks her daughters to make extravagant verbal declarations of love to her, just as King Lear does. However, I propose that within the context of McDonald's adaptation, this act might be understood differently from its original context. King Lear seeks to divest himself of his responsibilities, and Queen Lear claims to seek to do the same. However, her actions can be understood by contemporary audiences to be those of a mother seeking to hold on to her daughters, rather than the actions of a parent seeking respite from their employment or duties. Perhaps this may be one of the reasons *Queen Lear* prompted such discomfort in the critics. The missing and longed-for mother cannot demand attention or reciprocal affection. However, Queen Lear as the unruly mother (Rose) demands attention and affection. Ennis states: "Being left in the empty space is especially painful for mothers, who have overinvested in their children and the guilt is likely to be excessive in their children for having flown the nest" (21).

With two of her daughters married, Lear's actions might be understood to be the actions of a mother seeking to hold on to her daughters. By involving them in her role and responsibilities, she becomes the source of their success. Furthermore, in McDonald's adaptation, there are no suitors for Cordelia, which suggests that Lear wishes to keep Cordelia all to herself. McDonald removed King Lear, the father, from her adaptation and also France and Burgundy. These removals make the relationship between Queen Lear and Cordelia significant. Furthermore, the fact that Cordelia is not passed from father to husband, but from mother to no one, emphasizes Cordelia's loss. It is within this context that Cordelia's refusal to make an extravagant declaration of love is particularly hurtful. The one Lear loves most dearly is the one who will not reciprocate Lear's affections (at least not verbally). After relinquishing her responsibilities, Lear divides her time between her daughters' homes and expects Goneril and Regan to provide for and house her and her men. I argue this is a characteristic of Hays' and Ennis' understandings of the ideology of intensive mothering. By giving her daughters her worldly possessions and property in exchange for declarations of love, Queen Lear is teaching Goneril, Regan, and Cordelia that nothing comes without a cost. Lear passes on her inheritance to retain power, property, and possessions for herself and her children. She is ensuring that her daughters inherit what is rightfully theirs, given the frequency of usurpation. Lear's initial actions function to ensure that her daughters are established in

terms of wealth and status. However, Lear and her daughters meet with the same end. By the end of *Queen Lear,* the mother and her daughters are dead. Although the missing mother is found, she is destined to die.

Conclusion

In this chapter, I have engaged with scholarship from theatre studies and motherhood studies to analyze McDonald's 2012 staging of *Queen Lear.* Furthermore, I have considered the critical response to *Queen Lear,* suggesting that the critics may have responded negatively to more than McDonald's direction. Engaging with psychoanalytic ideas of the loss of self (Stone), adaptation (Kelly; Tait), authenticity criticism (Bradley; Meyrick), English renaissance motherhood (Rose), and intensive mothering (Hays; Ennis), I have endeavored to illuminate the complexity of McDonald's Lear. When missing mothers are found in theatrical adaptations, both theatre studies and motherhood studies are needed to unravel the implications of their presence. Sharing the scholarship of motherhood studies far and wide is, thus, an important project. We need to encourage theatre critics and scholars to consider their presumptions and responses more deeply when there are complex mother characters involved.

Works Cited

Aristotle. *Poetics.* Translated by Malcolm Heath, Penguin Classics, 1996.

Boyd, Chris. "Melbourne Theatre Company: Queen Lear, Adapted and Directed by Rachel McDonald." *The Morning After: Performing Arts in Australia,* Chris Boyd, 17 July 2012, http://chrisboyd.blogspot.com/2012/07/melbourne-theatre-company-queen-lear.html Accessed 4 Sept. 2012.

Bradley, Lynne. *Adapting King Lear for the Stage.* Ashgate Publishing, 2010.

Ennis, Linda Rose. "Intensive Mothering: Revisiting the Issue Today." *Intensive Mothering: The Cultural Contradictions of Modern Motherhood.* Edited by Linda Rose Ennis, Demeter Press, 2014, pp. 1–24.

Hays, Sharon. *The Cultural Contradictions of Motherhood.* Yale University Press, 1996.

Kelly, Philippa. "Performing Australian Identity: Gendering *King Lear.*"

Theatre Journal, vol. 57, no. 2, 2005, pp. 205–27.

Meyrick, Julian. "Shakespeare, Classic Adaptations and the Retreat into the Theatrical." *Australian Studies*, vol. 4, 2012, pp. 1–18.

O'Reilly, Andrea, editor. *Maternal Theory: Essential Readings*. Demeter Press, 2007.

O'Reilly, Andrea. *Matricentric Feminism*. Demeter Press, 2016.

Rich, Adrienne. *Of Woman Born: Motherhood as Experience and Institution*. Bantam Books, 1977.

Rose, Mary Beth. "Where are the Mothers in Shakespeare? Options for Gender Representation in the English Renaissance." *Shakespeare Quarterly*, vol. 42, no. 3, 1991, pp. 291–314.

Ruddick, Sara. *Maternal Thinking: Toward a Politics of Peace*. Ballantine Books, 1990.

Shakespeare, William. *King Lear*. Translated by George Hunter, Penguin Books, 1972.

Stone, Alison. "Psychoanalysis and Maternal Subjectivity." *Mothering & Psychoanalysis: Clinical, Sociological and Feminist Perspectives*. Edited by Petra Bueskens. Demeter Press, 2014, pp. 325–42.

Tait, Peta. *Forms of Emotion: Human to Nonhuman in Drama, Theatre and Contemporary Performance*. Routledge Advances in Theatre and Performance Studies, 2022.

Winnicott, Donald Woods. *Getting to Know Your Baby*. Heinemann, 1945.

Winnicott, Donald Woods. *The Child, the Family and the Outside World*. Penguin Books, 1964.

Woodhead, Cameron. "Queen Lear." *Sydney Morning Herald*, 14 July 2012, https://www.smh.com.au/entertainment/theatre/queen-lear-20120713-22ley.html. Accessed 3 Sept. 2024.

Fictions of Maternity: Reading and Rewriting the Mother in Three Narratives of the Abandoned Wife

Jill Marsden

Introduction

What is it to be a mother when you have been forsaken as a wife? This question is surprisingly absent from the analysis of the abandoned wife in literary texts and the cultural narratives informing them. Taking Simone de Beauvoir's *The Woman Destroyed* (1967) as the classic account of the abandoned wife, this chapter argues that the mother is missing from the dominant patriarchal discourse of marriage. Too frequently, critical attention is devoted to the plight of the failed wife at the expense of any acknowledgment of her successful mothering, an omission attesting to the invisibility of motherwork within the ideological construction of motherhood as natural, normative, and apolitical. Situating Patricia Highsmith's *Edith's Diary* (1977) and Elena Ferrante's *The Days of Abandonment* (2002) in dialogue with Beauvoir's text, this discussion shows how each text renders visible the labour of mothering, revealing not only how the literary protagonists read their respective maternal scripts but also how motherhood might be rewritten once divested of patriarchal assumptions. Significantly, each protagonist uses writing to process her changed circumstances, revealing the power

of narrative to shape the material conditions of experience.

In what follows, I argue that the missing mother in the narrative of the abandoned wife can be retrieved through a matrifocal reading. First, I briefly outline the oppressive patriarchal ideology obscuring the autonomy of the mother, and I then show how each literary wife suffers a profound crisis of identity when she loses her role as wife, turning to writing to articulate her plight. Finally, I argue that if we attend to what the texts show rather than what they tell, we can discern empowering narratives of strong mothers that have hitherto gone unremarked in these novels' critical reception. Indeed, a matrifocal reading reveals the literary protagonists actively engaged in rewriting the maternal script.

The Mother-Wife Role

Our dominant narratives determine what we recognize as reality. The self-sacrificing, perpetually nurturing, and nonsexual mother is a patriarchal fiction that is at odds with the lived experience of mothers, yet it exerts a powerful influence on the discourse of mothering nonetheless, stifling the expression of maternal ambivalence and dissatisfaction. As Elizabeth Podnieks and Andrea O'Reilly have asserted, the "idealized and hence unattainable image of motherhood" (3) causes women to feel guilt and anxiety about their own imperfect experience of mothering. Accordingly, articulating and theorizing "the voice of the mother" (2) is a central aim of motherhood studies. Borrowing the term "matrifocality" from the work of Miriam Johnson, O'Reilly proposes that the role of a matrifocal reading is to "attend to and accentuate the maternal thematic in any given text" (*Matricentric Feminism* 3). This chapter addresses this focussed attention on the missing mother in the narrative of the abandoned wife.

In her *Strong Mothers, Weak Wives*, Miriam Johnson argues that femininity is a "cultural construct that emphasizes women's weakness as wives and ignores women's strength as mothers" (6). She contends that within the male-dominated system of heterosexual marriage, husbands are granted a "measure of control over mothers and children" (5) by their marital status alone without their identity as a father conferring any obligation to participate in parenting. By contrast, the "mother-wife role" is regarded as a single entity and is all-encompassing (25). Insisting that "women are one thing when seen as wives and quite another when seen

as mothers" (26), Johnson argues that women will never be empowered as mothers so long as they define themselves with their role as wives.

In the three literary texts to be analyzed in this discussion, each female protagonist has hitherto understood her sense of self as the wife of her husband rather than as the mother of her children. The three protagonists share much in common. They are white, middle-class, and middle-aged. Each has been deserted by her husband for a younger woman. Each has experienced a loss of identity and a mental breakdown, and each has turned to writing as a means of adapting to her new circumstances. Owing to the elision of wife and mother roles that Johnson identifies, the abandoned wives cannot recognize their autonomy as mothers or appreciate the success of their mothering on its terms. Since the mother role has been bequeathed within the context of marriage, it is regarded as subordinate to the prior, dominant wife identity. Indeed, each literary mother fails to perceive her maternal role as positively independent of her wife identity, a failure perpetuated in the critical commentaries on these novels, which tend to focus on the concept of maternal ambivalence. Lacking a matrifocal perspective, these readings miss the strong mother within the narrative of the broken wife.

(Mis)Reading the Maternal Script

In her 1976 novella *la femme rompue* (translated into English as *The Woman Destroyed*—literally "the broken wife"), Simone de Beauvoir depicts the emotional ordeal of Monique, who is devastated when she is abandoned by her husband Maurice for another woman. Wife of a successful Parisian doctor and mother of two adult daughters, Monique acknowledges that her image as Maurice's wife has defined her sense of self. She did not look at this image often, "but it was there, in the background, just as Maurice had drawn it" for her (207). In her diary, Monique confesses: "He has been enough for me. I have lived only for him" (115). Initially believing that her husband still loves her, and then later convincing herself that his affair will end soon, Monique is finally compelled to admit her bad faith. Facing the prospect that her certainties about her marriage were fiction all along, she is forced to reevaluate her entire life: "I realized that it was my past and my whole life that were going to be taken away from me" (202).

This classic narrative of the abandoned wife is a key reference point

for two other works of fiction that implicitly and explicitly take up the plight of Beauvoir's destroyed woman. Published ten years after Beauvoir's renowned text, Patricia Highsmith's *Edith's Diary* offers a comparable chronicle of marital desertion. It tells of the move of Edith Howland and her family from New York to rural Pennsylvania and the subsequent twenty years during which her husband, Brett, divorces her for a younger woman, leaving her sole carer for their somewhat feckless son and Brett's invalid uncle. Like Monique, Edith had fostered her sense of self as part of a married couple. In the wake of her rejection, she is overwhelmed by feelings of loss: "She had a sense of empty time, lots of time, years, months, days, evenings" (119). She felt that it "had been her destiny to meet Brett Howland ... to become his wife and have a son by him" (119). Moreover, "if that were taken away" and she "was going to be alone" then the utter meaninglessness of things "was going to be that much more terrifying" (119).

The third literary tale of abandonment is a more recent text, Elena Ferrante's *The Days of Abandonment*. Living in Turin with her husband, Mario and her two young children, Olga is thrown into complete disarray when Mario abruptly informs her that he wants to leave. In long letters that she does not know where to send, Olga struggles to make sense of the fact that Mario has so casually thrown away fifteen years of feelings, emotions, and love: "He had taken for himself time, time, all the time of my life, only to toss it out with the carelessness of a whim. What an unjust, one-sided decision. To blow away the past as if it were a nasty insect that has landed on your hand. My past, not only his, ended up in the trash" (31). Like Monique and Edith, Olga is left to question whether "It really had been a waste of hours, months, years" (32). Later and much more bleakly, she expresses her situation as one of extreme hopelessness: "For what could I do, I had lost everything, all of myself, all, irremediably" (73).

With the loss of her identity as a wife, each literary protagonist experiences a more profound psychological breakdown. Beauvoir's image of the broken wife is reprised in *Edith's Diary*, when the protagonist Edith declares in a rare confessional moment: "I have the feeling sometimes that something's sort of cracking in me" (152). Similarly, Olga in *The Days of Abandonment* exclaims: "I was in bad shape, definitively broken" (107). What is striking is that in all three novels, the abandoned wives continue their socially invisible motherwork regardless of their emotional

disorder and grief. Stoical and self-sacrificing, each wife accepts the patriarchal assumption that the responsibility of childcare should fall to her, despite having entered motherhood within the tacit coparenting contract conferred by marriage. For example, Monique's diary details constant visits to the bedside of her ailing adult daughter, whereas Edith continues to cater to her adult son, who remains in a state of semipermanent adolescence. Ferrante's Olga must contend with the trials of caring for young children while mentally unwell, yet even here it is the loss of the children's father that is foregrounded: "I was afraid I would be unable to take care of them, I even feared harming them, in a moment of weariness or distraction. Not that, before, Mario had done a lot to help me; he was always overloaded with work. But his presence—or, rather, his absence, which, however, could always be changed into presence, if necessary—reassured me" (27). As these remarks indicate, Olga's reading of her maternal script is patriarchal. Indeed, in each text, the suffered loss is the fiction of a loyal, supportive husband and the fantasy of a happy family life. Fatherhood is exposed as a role with the authority to pronounce on the care of children without any responsibility to assume it for oneself. By contrast, it is only as a wife that each literary protagonist understands her role as a mother, even though the work of mothering falls exclusively to her.

Within the patriarchal narrative of heterosexual marriage, the labour of mothering goes unrecognized, whereas the power of the father is everywhere (Johnson). In the three literary texts under examination, each wife protests the authority of her husband to dictate domestic matters, yet in each case, she appears powerless to change the narrative. In *The Woman Destroyed*, Monique struggles with the fact that in the aftermath of the marital collapse, her husband criticizes her parenting of their daughters. Maurice had wished for a different future and now holds his wife responsible for the life they have. She is stung by the accusation that she has ruined them, obsessively recording Maurice's unkindnesses in her diary: "I was possessive, overbearing and encroaching with my daughters just as I was with him. 'You encouraged Colette to make an imbecile marriage; and it was to escape from you that Lucienne left'" (162). This "dreadful remark" about the children affects her deeply because she had been so proud of "having made a success" of them (163). The question disturbing her the most is whether she has failed as a mother in her husband's eyes. Although Maurice later apologizes for having

spoken so intemperately, Monique continues to fear that the girls are a disappointment to Maurice and that he holds her accountable: "If I have failed with the bringing up of my daughters, my whole life has been a mere failure" (186). In their argument, Monique does not criticize Maurice's role as a father. He judges Monique's parenting style, whereas his remains beyond discussion.

In the Highsmith and Ferrante novels, there are similar cultural messages that parenting is something that a father is at liberty to invest in as little or as much as he chooses. Edith's husband, Brett, announces that he has "a right to be happy" (103) and leaves Edith to start a new life with another woman, giving up on their slothful son, Cliffie, whom one of Edith's friends says she will still "be taking care of ... when he was forty" (123). Brett also leaves his bedridden uncle in Edith's long-term care. His attitude infuriates her: "Did Brett think she was running a hospital?" (232); "What would a nurse's salary have been for all the meals, the time, the bedpan emptying?" (245). Even though Brett uses Edith as "an unpaid nurse for over a decade" (263), she cannot effect any change until Cliffie comes to her aid (in a dark turn of events characteristic of Highsmith). What Edith struggles against are the cultural scripts that reinforce a gendered division of labour. Maternal care extends to all members of the household, adult men as well as children.

The latter point is emphasized in Ferrante's *The Days of Abandonment* which relates how Olga has sacrificed all her needs to tend to those of Mario: "I had taken care of the house, I had taken care of the meals, I had taken care of the children, I had taken care of all the boring details of everyday life, while he stubbornly climbed the ladder up from our unprivileged beginnings. And now, now he had left me, carrying off, abruptly, all that time, all that energy, all that effort I had given him, to enjoy its fruits with someone else, a stranger who had not lifted a finger to bear him and rear him (*partorirlo e allevarlo*) and make him become what he had become" (63). It is scarcely fortuitous that in this angry litany of injustices, Olga should speak of "bearing" and "rearing" (*partorirlo e allevarlo*) her husband. Effectively, she has mothered Mario alongside their children and has done so at the cost of caring for herself. It is taken as a given that as a mother, Olga will put the needs of her children before her own, but this sacrificial contract extends to her husband who stakes an equal claim to her nurture, failing to see her maternal role as exclusive of him. This is a further example of the missing autonomy of

the mother within the patriarchal construct of marriage. In a further
irony, Olga's husband admits in a bout of frustration that he cannot stand
his son and that his daughter gets on his nerves (185). He only feels good
when he is not around them.

The three literary texts show how each female character is subdued
by dominant patriarchal narratives of motherhood that they feel power-
less to resist. As O'Reilly has asserted (following Adrienne Rich), the
patriarchal institution of motherhood is "male defined and controlled
and is deeply oppressive to women," whereas mothering is "female de-
fined" and potentially empowering ("Mothering" 728). While Monique,
Edith, and Olga read themselves as discarded wives rather than strong
mothers, a matrifocal interpretation of their texts seeks to reclaim the
potentially empowering stories of mothering obscured beneath the plot
of the abandoned wife. To this end, it is significant that as heirs to the
patriarchal narrative that Beauvoir lays out in *The Woman Destroyed*, Edith
and Olga should turn to writing to refashion their respective maternal
scripts.

Writing the Mother

Nancy Miller argues that the plots of women's literature "are not about
'life' and solutions in any therapeutic sense, nor should they be" (46).
They are about "the plots of literature itself"—namely, the constraints
of the narrative logic of the dominant discourse on "rendering a female
life in fiction" (46). Miller's point is that literary works by women must
contend with prevailing ideological conditions within which only certain
kinds of plots will be legible and with the gendered nature of their work's
reception. A relevant but somewhat unusual case in point is the reception
of Simone de Beauvoir's *The Woman Destroyed*. In her memoir *Tout Compte
Fait* (1972) (translated into English as *All Said and Done*, 1993), Simone de
Beauvoir states that in this novella it was a matter of "using Monique's
private diary to show how the victim tries to escape from the truth"
(124–25). Clues for Monique's propensity to self-deception are evident
from early in the story. "What an odd thing a diary is," comments
Monique, in an aside, in the early pages of *The Woman Destroyed*: "The
things you omit are more important than those you put in" (111). Later
in the story, she admits that the reason she kept it was because she "had
to exorcise a certain anxiety that would not admit its own existence"

(194). She reflects on her proclaimed passion for the truth and admits that she had been lying to herself, half-aware of her husband's estrangement from her before he revealed his secret lover. While this admission serves as a clue to Monique's bad faith, it also highlights how the silences of a literary work can often speak louder than what is said (Dow).

According to Beauvoir, the novella aimed to illuminate the plight of women in their forties who fail to understand why their husbands have left them for others. When the story was published in *Elle* magazine as a serial, Beauvoir received letters from many readers who deeply identified with Monique's anguish and despair. However, Beauvoir complains with some irritation that "their reactions were based upon an immense incomprehension" (126). She elaborates: "There is no reason at all why one should not draw a feminist conclusion from *The Woman Destroyed*: Monique's unhappiness arose from her having agreed to be dependent" (128). Like Ferrante's Olga, Monique has abandoned her career and failed to take sufficient interest in her husband's. It is the fault of the abandoned wife for having neglected her ambitions.

Nevertheless, the fact that Beauvoir's tale of self-deception can be read against the grain demonstrates that the author does not have a monopoly on the truth of her text. As Suzanne Dow has commented: "Beauvoir's intended reading of the story depends on a resisting reading strategy that explicitly acknowledges the capacity of narrative to be read contrary to the speaker's intention" (632). It is also interesting that Beauvoir's mainstream readers should see the story in more feminist terms than its author, as they are effectively rewriting its meaning. The readers of *Elle* could look beyond Monique's privilege as a white and middle-class woman and appreciate something that Beauvoir perhaps did not—namely, that maintaining a career might conflict with the care of children within the more typical marriage.

It might seem as if not a positive word is said in *The Woman Destroyed* about Monique's success as a mother, not least because Monique torments herself with the idea that she has failed according to her husband's estimation. However, viewing the story through a matrifocal lens, it is telling that neither of Monique's daughters should find significant fault with their mother: neither Colette who has chosen a domestic destiny nor Lucienne who had been more rebellious as a child and who is now pursuing a career in New York. After the terrible argument with Maurice, Colette reassures her mother that she was not possessive and encroaching:

"Over and over again she assured me that I was an ideal mother and that her father and I got on perfectly well together" (164). Maurice had said that Monique "coddled the children over much" (165), but it is revealing that Colette should reject this: "*I* never thought you coddled us too much; I liked being coddled" (187). Colette is eager to comfort her mother (164), and even the colder, less sentimental Lucienne has only compliments for her. Hosting Monique in New York, Lucienne encourages her mother to relinquish responsibility for her daughters' life choices, refusing to find fault with her mothering, despite being urged to do so. Beauvoir has no agenda to depict Monique as a poor mother; her concern is to show only her misplaced priorities. However, the text demonstrates that her mothering has been welcomed and autonomous, and her daughters' love is its enduring testimony.

In *Edith's Diary*, Patricia Highsmith uses the device of journal writing for different ends than Beauvoir. Faced with an unpleasant reality after being cast aside by her husband, Edith starts to invent a happier version of affairs in her diary. In this space, Cliffie becomes the model son, who "looks with disapproval" (153) on his father for abandoning his wife. In the diary, Cliffie becomes engaged to a beautiful girl from an affluent family, graduates from Princeton, and is soon a successful husband and father in his own right. "When Edith got up from her desk, she felt happy. She felt in another world—but a real world—in which Cliffie went from strength to strength, with his nice wife, a good job to look forward to in June, when he graduated, aged twenty-three, with a masters degree. Perhaps by next autumn, Edith could even look forward to a grandchild" (161).

Edith's rewriting of her maternal script enables her to enjoy a family life that reality can never destroy. As Fiona Peters has commented: "A diary is a record, a *writing* of a life: for Edith, this is turned on its axis; the diary *takes the place of life, life* becoming the writing of the diary, with everything external to it stultified and moribund" (121). As a sort of surrogate life, Edith's diary entries function as a peculiar coping mechanism. Admittedly, she is concocting a fiction of a happy family, but this idea was already fictitious in the first place. Indeed, the remedy for Edith's woes succeeds in exposing the true malady oppressing her: the patriarchal construct of female fulfilment within a perpetually jolly family life. This act of wilful exaggeration calls to mind Luce Irigaray's strategy of "mimesis." By an "effect of playful repetition" (76), Edith's narrative

succeeds in making "visible" what was otherwise to have remained hidden: the ruses of the dominant patriarchal culture that pass for the truth of female experience.

Reading *Edith's Diary* in terms of the fantasies it exposes, Kathleen Gregory Klein sees Highsmith's text as following in the tradition of nineteenth-century writers who camouflaged their tales of anger beneath the more acceptable story of punishing female independence: "Jane Eyre and the nameless narrator-writer of 'The Yellow Wallpaper' are Edith Howland's literary ancestors. They write their own stories because they are unable to create their own lives; Edith's diary becomes a novel, like Highsmith's, in which the woman writer tells two stories" (183). Beneath the surface story of Edith's gradual descent into delusion, Klein discerns the powerlessness of the wife who is obliged to accept the decisions made by her husband on her behalf. Although Brett delegates responsibility for Cliffie to Edith, he makes it clear that he still wishes to control how she mothers their son. After Brett divorces her, leaving both Cliffie and his uncle in her care, Klein suggests that Edith starts to realize how few of the family decisions reflected her own choice. She turns to narrative to take control, both in her publication of a range of political tracts and in her diary. Klein emphasizes that although the diaries may be read as evidence of Edith's mental decline, they also function to make clear "her awareness of the life she is creating for herself in exchange for the one others would like to force on her" (185). For example, she kills off her meddlesome ex-husband Brett in her diary: "A pity B. did not live to see C. make such a success of himself" (279). We are told that in the last month, Edith had decided that Brett should be dead for about three years now: "It didn't matter that this conflicted with George's demise and funeral service at which Brett had been present. Edith was writing her diary for pleasure, and was taking poetic licence as she put it to herself" (280). As this example indicates, Edith's narrative fulfils her exorbitant wish for a story that would turn out differently. Her disposal of Brett is a significant gesture in her evolution as a mother who is no longer a wife. Indeed, she has the added pleasure of becoming a grandmother to Cliffie's two adorable children. Whatever else one might want to say about this novel, Edith comes to enjoy the pleasure of so-called normal mothering on her terms.

As Fiona Peters wryly remarks, "'Normality' is the most fantasy-ridden place of all" (136). This observation notwithstanding, Peters finds

Edith's actions wanting, suggesting that her "attempts to create, to 'write herself' into the world" are "an unmitigated disaster, leading to her death" (130). This is an unusual take on the novel because it conflicts with her interpretation of Edith's diary writing as a retreat from reality and the fatal fall occurs when Edith is harried by her interfering ex-husband who insists on bringing psychiatrists to the house to assess her. According to Peters, Highsmith—not unlike Beauvoir—"was of the opinion that women, especially those who chose to have children, had to bear the responsibility for any subsequent drudgery in their lives" (130). Perhaps influenced by this view, she cannot distinguish between what the text appears to tell and what goes unsaid. Peters asserts that Highsmith "allows no bond to develop between mother and child, except perhaps with the child as *problem*, and child as *fantasy* in *Edith's Diary*" (130). Yet despite Cliffie's general indolence, the reader is encouraged by the fact that Edith and Cliffie form a companionable and loyal unit in the absence of Brett. It is Cliffie who relieves his mother of the burden of Brett's uncle, and unlike Brett and Edith's friends, Cliffie does not think his mother should see a psychiatrist. Although neither mother nor son is demonstrative in affection, Edith thinks fondly of Cliffie as a small boy in her dying moments, and Cliffie rescues her diary, touchingly vowing to keep it unread. Edith does not use her diary to fantasize about a different life with her husband or any man; rather, her child occupies her emotional world.

Unlike *Edith's Diary*, Ferrante's *The Days of Abandonment* engages explicitly with Beauvoir's *The Woman Destroyed*, which, along with *Anna Karenina*, features as an intertext for the novel. After Mario's departure, Olga had been rereading these novels and making notes in her journal, yet in the throes of a serious mental breakdown, she cannot remember having done so. Maybe she had seen herself in these books, she muses, but she cannot make sense of them and feels utterly broken. In particular, she is assailed by the memory of an abandoned woman from the local area of her childhood who was known simply as "that poor woman" (the *poverella*) (16). Besotted with her misery, the *poverella* made a gaudy display of her grief, with drawn-out cries, desperate sobbing in the night, and lamenting that when you do not know how to keep a man, you lose everything. At one point, this woman became angry with her children: "She said that they had left the odor of motherhood on her, and this had ruined her, it was their fault that her husband had left. First they swell your belly, yes, first they make your breasts heavy, and then they have

no patience. Words like that, I recalled. My mother repeated them in a low voice so that I wouldn't hear, gravely agreeing" (91).

In Ferrante's novel, things climax on one particularly awful day. Olga must contend with her son's sickness, an ailing family dog, the apartment's invasion by hordes of ants, and a disconnected phone. As if to underline the point that Olga is confined by her domestic role, Ferrante depicts her imprisoned in her apartment by a failing lock on the heavily reinforced door. In her severe mental deterioration, the entrapped Olga has to tend to her son, daughter and dog while imagining the *poverella* sitting at her desk, writing in her notebook, her own blood pulsing in her veins (126). A composite of abandoned wife and abject mother, the *poverella* is a representation of all that Olga fears; indeed, she is grappling here with the scripts that earlier in the narrative she had counselled herself to avoid: "Don't act like the *poverella*, don't be consumed by tears. Don't be like the women destroyed in a famous book of your adolescence" (20).

Victor Xavier Zarour Zarzar suggests that the pressing question behind *The Days of Abandonment* is how a woman of today like Olga will react to the "inherited plots of abandonment" (336) and the "grand gestures of homicidal heroines" (337). As Miller has acknowledged, the plots of women's literature are in dialogue with the plots of literature that the dominant culture bequeaths. Reading the closing pages of the novel, Zarzar notes with dismay that at its denouement, "it is unsettling that Olga learns the potentialities of plotting from a man" (342), her new lover, Carrano. However, contra Zarzar, it must be recognized that what we witness in the novel is a reclaiming of the plot that takes place before the novel's end. In her mental dissolution, Olga struggles to distinguish herself from this hallucinatory apparition of the *poverella*, this resentful mother who ended her days by suicide. However, periodically, she slips into third-person narration as if plotting her narrative. Olga imagines the *poverella* speaking to her and advising her what to do as she struggles to cope. It was "as if I were writing my book and had in my head phantom people, characters" (114). In a state of simultaneous identification and dissociation, Olga sees the *poverella* writing out her disordered thoughts in her notebook: "To write truly is to speak from the depths of the maternal womb. Turn the page, Olga, begin again from the beginning" (127).

Olga succeeds in turning the page and evading the broken wife's fate. The story of the *poverella* is rescripted as Olga wrests free her narrative

from those she has inherited; now writing as a mother, she finds her true voice. Like Edith who forms an improved relationship with her son once she is no longer a wife, Olga comes to bond with her children in a new way. To do so, she has to let go of the attempt to rescue a familiar self-image, but despite the terrors of her collapsing psyche, she can salvage a relationship with her children that is hers alone: "Even if, oh God, I was only a disjointed composition of sides, forest of cubist figures unfamiliar even to myself, those creatures were mine, my true creatures born from my body, this body, I was responsible for them" (130). It is important that Olga claims the children as "hers" rather than "ours." At the end of the novel, Mario grumbles that having the children for visits is spoiling his new relationship and petulantly declares that she must have the children more often because she is "their mother" (185). Olga looks at her ex-husband and realizes that there is no longer anything about him that could interest her.

Matrifocal readings are common in Ferrante scholarship, but commentators tend to focus on novels other than *The Days of Abandonment* when discussing depictions of maternity (see Stefania Lucamante), or when they do, they tend to read themes of the maladaptive mother back into this early text. In a recent essay, Ting Yang claims that Ferrante's unconventional depiction of motherhood presented dilemmas for the translation and publication of the novel in English: "The editor thought Olga's treatment of her children during the days of her abandonment bordering on the verge of 'child abuse' and should not be considered for publication" (174). Writing in a similar vein, Stiliana Milkova highlights Olga's imperfect mothering, claiming that Olga "deals with her grief by neglecting her body and maltreating her children to such an extent that her eight-year-old daughter takes on a motherly role" (93). While it is unquestionably true that the scenes of Olga's derangement make uncomfortable reading, not least because the protagonist needs to enlist the help of her daughter to tackle her problems, what is most significant here is how well the little girl proves adept for the task. Alert to her mother's needs, Olga's daughter, Ilaria, steps up to the role, testifying to her experience of having been well-mothered: "'Shall I massage your temples?' 'Yes' ... 'I'll make everything go away,' she said. 'Do you feel better?' I nodded yes" (133). This is an example of the text showing something that perhaps even its narrator cannot see, the positive legacy of the mother's unacknowledged and socially invisible labour.

Conclusion

This chapter has offered a matrifocal reading of the missing mother in three narratives of the abandoned wife. These have been stories of women who have lost their images—ones drawn for them by other narratives. These stories demonstrate the power of pervasive maternal scripts to constrain literary mothers within their social roles and the potential for rescripting and reinterpreting them against the dominant patriarchal paradigms. It is by no means the case that the abandoned wives come to see themselves as strong mothers, but the successors of Beauvoir's broken wife definitively relinquish the fiction of needing a husband. Perhaps the problem was one of identity all along. If the mother's identity had been missing from the wife's image, the solution is not to craft a more robust image; perhaps, it is to deconstruct that image as Edith does in her diary. Or following Ferrante's Olga, perhaps, it is a matter of rewriting the plot of the forsaken women enshrined in culture. Writing can be a way of finding oneself, but it is also a mechanism for revising reality. This is no longer to see the missing mother as lost but a space that refuses to be confined.

Works Cited

Beauvoir, Simone de. *All Said and Done*. Translated by Patrick O'Brian, Paragon, 1993.

Beauvoir, Simone de. *The Woman Destroyed*. Translated by Patrick O'Brian, Fontana, 1984.

Dow, Suzanne. "Simone de Beauvoir's 'La femme rompue': Reception and Deception." *The Modern Language Review*, vol. 100, no. 3, 2005, pp. 632–44.

Ferrante, Elena. *The Days of Abandonment*. Translated by Ann Goldstein. Europa Editions, 2005.

Highsmith, Patricia. *Edith's Diary*. Virago, 2015.

Irigaray, Luce. *This Sex Which Is Not One*. Translated by Catherine Porter and Carolyn Burke. Cornell University Press, 1985.

Johnson, Miriam. *Strong Mothers, Weak Wives: The Search for Gender Identity*. University of California Press, 1988.

Klein, Kathleen Gregory. "Patricia Highsmith." *And Then There Were*

Nine... More Women of Mystery. Edited by Jane S. Bakerman. Green State University Press, 1985, pp. 170–97.

Lucamante, Stefania. *A Multitude of Women: The Challenges of the Contemporary Italian Novel.* University of Toronto Press, 2008.

Milkova, Stiliana. "Mothers, Daughters, Dolls: On Disgust in Elena Ferrante's *The Lost Daughter.*" *Italian Culture*, vol 31, no. 2, 2013, pp. 91–109.

Miller, Nancy. "Emphasis Added: Plots and Plausibilities in Women's Fiction." *MLA*, vol. 96, no. 1, 1981, pp. 36–48.

O'Reilly, Andrea. *Matricentric Feminism: Theory, Activism, Practice.* Demeter Press, 2016.

O'Reilly, Andrea. "Mothering Against Motherhood: The Legacy of Adrienne Rich's *Of Woman Born.*" *Women's Studies*, vol. 46, no. 7, 2017, pp. 728–29.

Peters, Fiona. *Anxiety and Evil in the Writings of Patricia Highsmith.* Routledge, 2016.

Podnieks, Elizabeth, and Andrea O'Reilly, editors. *Textual Mothers/ Maternal Texts: Motherhood in Contemporary Women's Literatures.* Wilfred Laurier Press, 2011.

Yang, Ting "Loss and Renewal: Elena Ferrante's Representation of Mourning in *Days of Abandonment.*" *Scholars International Journal of Linguistics and Literature*, vol. 5, no. 5, 2022, pp. 173–80.

Zarzar, Victor Xavier Zarour. "The Grammar of Abandonment in *I giorni dell'abbandono.*" *MLN*, vol. 135, 2020, pp. 327–44.

11.

Making Masculine Maternity Visible in A.K. Summers's *Pregnant Butch*

Christa Baiada

Pregnant bodies of all sorts are visible everywhere around us, but even so, representations of pregnancy in mainstream culture rigidly adhere to norms of femininity. Masculine maternity, which is unimaginable for most people, is therefore missing from representations of motherhood, which remain associated with highly feminine traits: domesticity, selflessness, beauty, and emotionality. Women who do not conform to these essentialist traits are judged by society as bad mothers and excluded from positive, or even neutral, conceptions of maternity.

A graphic narrative is a powerful form with which to address this particular absence because the story of masculine pregnancy must first be shown to enable us to imagine and, thus, acknowledge the masculine mother. Graphic narrative manifests the unseen. As literary critic Hillary Chute has convincingly argued, graphic narrative by women artist-writers has been efficacious in countering erasure and elision. Such narratives both show and tell, giving voice to the silenced and refacing the effaced. This chapter considers how A.K. Summers's graphic memoir or autographic[1] *Pregnant Butch: Nine Long Months in Drag* (2014) makes space literally on the page and figuratively in the cultural mindscape for missing images of masculine maternity. Much of the power of *Pregnant Butch* derives from the interplay of word and image, necessary here to make the missing butch mother present and visible. The images meaningfully interact with the text and engage the reader in an interpretation

necessitating grappling with and quite possibly disrupting highly gendered assumptions of pregnancy to bring the masculine mother to the forefront.

In this chapter, I explore how Summers effectively utilizes the graphic narrative's double mode of storytelling via image and text, and the interaction between the two, to prompt readers to cultivate new lenses through which to acknowledge pregnant bodies, thus creating an opportunity to broaden our collective cultural vision to include obscured masculine mothers. I begin with the hyperfeminized public perception of pregnancy that renders Summers's maternity invisible or suspect and then explore its effects on her protagonist Teek's anxieties about fertility and pregnancy. I analyze how, using the distinct forms of comics storytelling, Summers employs images in meaningful interaction with the text to defamiliarize maternity and engage the reader in an interpretation disrupting highly gendered assumptions of pregnancy. Third, I explore the especially fraught negotiation of identity challenged by a radically changing out-of-control pregnant body through multiple, overlapping, and diverging representations of her body's refusal to be reduced to the masculine gender, female biology, or lesbian sexuality. I analyze images of this body, portrayed at times as unruly, leaky, and boundary-busting, evoking Magrit Shildrick's concept of the "monstrous" to discuss how such portrayals complicate conceptions of the natural and subvert binaries to make space for the missing masculine mother. Finally, I propose that Summers ultimately queers maternity by rejecting dictates of femininity and, visually as well as narratively, recasts maternity as also or alternatively masculine.

Pregnancy and the "Cult of Femininity"

Changes in sociopolitical culture have enabled a recent, though far from prevalent or secure, acceptance of gay and lesbian families following the "gayby boom" in the 1990s and the legalization of same-sex marriage slowly expanding across the globe since the start of the twenty-first century to include over thirty nations since 2001.[2] Yet despite these notable changes, as sociologist Rachel Epstein has noted, lesbianism and motherhood have until recently been considered "mutually exclusive" (50); recognizing lesbian mothering, she argues, has partly been accomplished through sanitized, conventional depictions that cast lesbian mothers as conforming to the maternal ideal—that is, feminine. Butch

lesbians, in contrast, have remained stubbornly excluded from acknowledged motherhood. They embody a more radical challenge not simply to heterosexual reproduction and the patriarchal family but also to the gendered aspect of motherhood entrenched in patriarchal society. Scholarship across disciplines has established the social and cultural yoking of maternity to a hyperfemininity that Canadian anthropologist Michelle Walks calls a cultural fetish in Euro-American cultures that associates femininity with reproduction and maternity. Walks, who studies BTQ (butch lesbian, transmen, and genderqueer) fertility, pregnancy, and parenting, argues that gender expectations and mothering expectations are culturally connected; thus, "masculinity and pregnancy are not seen (by mainstream culture) as potentially coexistent" (130).

Moreover, the female body is scrutinized to ensure feminine compliance within patriarchy (Bordo; Young), and this scrutiny intensifies to surveillance during pregnancy in response to the way the pregnant body defies conventional standards of femininity: dainty, fit, controlled, and modest (Dworkin and Wachs). Anne Balsamo, scholar of media studies and biotechnologies, discusses how pregnant people are divested of privacy, becoming biological spectacles to be examined, disciplined, and controlled. We see this in myriad ways related to pregnant women's eating, smoking, and sexuality, for example, as well as in feminine styles of most maternity wear. Often, however, gender discipline of pregnant women is not perceived because enacted femininity is so deeply ingrained in the "performance of pregnancy" that, in effect, it goes unnoted. A consequence is that pregnancy is socially constructed and understood as incompatible with masculinity, and masculine pregnancies and masculine mothers are, thus, missing from discourses of maternity. The gendered lens of maternity/pregnancy, rarely acknowledged, cannot be easily opposed. Because we are conditioned to see pregnancy and feminine gender performed in tandem, when gender performance and pregnancy are not presented in congruence, many fail to see pregnancy as pregnancy. Gender studies scholar K.J. Surkan calls this the invisibility effect of masculine, genderqueer, and transgender pregnancies.

So deeply ingrained is the association of femininity with pregnancy and reproduction that even BTQ individuals are susceptible to this perception (Ryan). Despite an awareness that the logic is faulty, Teek, the protagonist of *Pregnant Butch*, "worried whether butchness itself might preclude my chances of getting pregnant. The more feminine, the

more fertile, right?" (Summers 11; see Figure 1). Teek fears her body is deficient. Adopted herself, however, she wants a family and strongly desires a biological connection to her child. While consulting doctors, friends, and books in planning a pregnancy, Teek expects to encounter an obstacle in her own body, be it an android pelvis or a tipped uterus. She doubts the fecundity of her body because it is not adequately feminine to accomplish what is commonly touted as the ultimate womanly achievement and fulfillment of feminine bodily destiny. Only when she and her partner Vee embark on the do-it-yourself path to fertilization and conception that she associates with butchness does she begin to feel confident she can carry and birth a child in her body. She is mindful, however, that she must develop around her "a core of self-love" (20) to sustain herself against the social hostility she is likely to confront. This hostility largely takes the form of negation and exclusion.

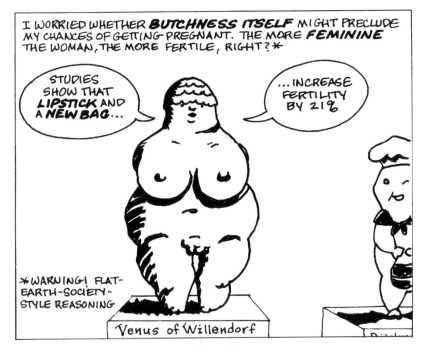

Figure 1.

The invisibility effect intensifies her maternal insecurity. Summers testifies to this experience on only the second page of the book. Teek asserts that "pregnancy *increased* [her] ability to pass" as male (Summers 2). Without the emblems of maternity wear, which Teek refuses to wear, her body is not read as pregnant or even female. She describes being mistaken for "just another fat guy" on the subway (2). Her intrusive landlord encourages her to resume riding her bike because she is putting on weight. While contemplating pregnancy, the opportunity to experiment with impractical masculine styles, like suspenders or smoking jackets, appeals to Teek. The reality, however, is disappointing—these wares are neither aesthetically attractive in a masculine sense, nor do they affirm her maternal identity. She describes the actual look she can achieve as clown pants with a plumber's crack. Yet maternity clothes would feel to her like an abdication of her hard-won butch pride and style.

Hitherto comfortably exempt from the world of feminine beauty norms, Teek finds herself simultaneously interpolated and excluded from the feminine, heteronormative world of motherhood. She must now worry about shoes and leggings and deal with a fear of being considered ugly. She yearns to be cared for but hates feeling vulnerable and weak. In attending a birth orientation at the hospital, she and her partner, Vee, are greeted with a "Welcome Mommies & Daddies" sign, and there are no same-sex or queer parents in their child birthing class, which is oriented toward traditional roles for birthing mother and husband. She fantasizes "a birth education class filled with queers": "I'd like to hear how others carved out their roles as 'birth giver' and 'birth partners' ... In my dream class there'd be at least one other pregnant butch. And some femme-on-femme, butch-on-butch action. A hot single, a bearded lady. Some highly idiosyncratic classifications. At least one threesome...some reinforcements" (Summers 72-73). The images in these frames present alternative representations of birthing and parenting communities that are inclusive of gendered and sexual differences. The final frame presents a carnivalesque ideal of community, which would provide support and acceptance that only becomes possible if reproduction is unmoored culturally from heteronormative gendered configurations of maternity and family. It is this work of disentangling gender from maternity and imagining new possibilities that *Pregnant Butch* undertakes.

Throughout the autographic, Summers not only counters the invisibility effect but also alters the visual conception of pregnancy as integrally

feminine. Repeated representations of Teek emphasize her butch identity—in the lines of her face, the style of her hair, posture, poses, and clothing choice—paired with visual and narrative markers of pregnancy, such as a growing belly and breasts, swollen feet and ankles, a frantic search for a bathroom, inexplicable outbursts of tears, and the loss and resurgence of her sex drive. Anyone pregnant would identify with some of these experiences; divorcing them from feminine embodiment paves the way for a more gender-neutral conception of pregnancy. Additionally, the glaring incongruity of Teek's consistent butch style juxtaposed with her flowered dressing gown at the obstetrician's office or her prominent third-trimester belly and breasts denies the easy conflation of pregnancy and femininity.

Changing the optics is essential because both pregnancy and gender are highly visual and highly scrutinized embodiments. We are trained not to see masculinity and pregnancy/maternity together, so our vision must be retrained to bring the missing masculine mother into view. To this end, Summers employs the hybrid form of graphic narrative and a strategy of defamiliarization.

Disrupting the Gendered Lens through Defamiliarization

Summers challenges preconceptions of feminine pregnancy not simply with her story but by presenting images of a pregnant body that refuses to perform within normalized gender codes and regulatory regimes. The autographic's double mode of storytelling via image and text, and the interaction without synthesis of the two, requires readers to cultivate new lenses to interpret images of pregnancy and dissociate the maternal from the feminine. One method Summers uses is defamiliarization. In literary studies, defamiliarization is the novel use of language to present the ordinary and familiar in ways that alter readers' accustomed perceptions. Estrangement via language compels the reader to look again, or in a new manner (Shklovsky). Graphic narrative can defamiliarize through the language of images and in combination with words. Comics involve the act of seeing through images but also through images as they engage with text in a given frame or the juxtaposition of frames. Words and images combine to transmit ideas to a reader who must coconstruct meaning from the various elements, fragments, inclusions, and exclusions

(Chute; Hatfield; McCloud). Summers exploits the full potential of the comics form to disrupt the reader's ingrained assumptions about pregnancy and gender with the tension between image and text.

One example of defamiliarization in *Pregnant Butch* is the fashioning of Teek in the image of Tintin, world-renowned cartoonist Hergé's boy reporter.[3] Summers's stylization of herself/Teek as Tintin has meanings concerning referentiality within the comics world and likely concerning artistic and masculine aesthetics I feel ill-equipped to address, but the spectre of Tintin, immediately recognizable, with breasts and a pregnant belly, causes productive dissonance. In an interview for *LAMBDA Literary*, Summers explains how presenting Teek as Tintin configures her pregnancy narrative as a "a man-boy on a ludicrous pregnancy adventure," acknowledging the (assumedly) absurd nature of the pregnancy. Many of Tintin's adventures were unlikely, even fantastic, and conjure associations with what Summers names Tintin's "indeterminate status"—that is, how he resonates "as something other than man or boy, while still decidedly masculine, a figure of action and heroism" (Camper). Tintin is so well-known that the character and his heroic adventures immediately register as male, but as cultural studies scholar Paul Mountfort argues, Tintin "appears to sit somewhere outside the heteronormative and in this respect evidences a form of queering" (632). His perpetual youth excludes him from becoming a man, and his masculinity is inclusive of many traits more characteristically attributed to femininity. In his adventures, Tintin is often the caretaker of others, especially the various unparented children he takes under his wing. The Chinese boy Chang is his closest emotional connection. In a world largely devoid of women, Tintin also exhibits conventionally feminine traits, such as tenderness, caring, patience, and silence. His feminine qualities are thrown in relief against his frequent companion Captain Haddock with whom he tends to adopt a more passive role. By inhabiting and subverting Tintin, Summers can play with normative expectations of gender in mainstream pop culture to accomplish an act of queer disidentification.[4] Jose Muñoz argues that queer disidentification involves the "recycling and rethinking of encoded messages" in popular culture by those positioned outside the mainstream who transform it to reflect non-normative perspectives and empower minority identities (Muñoz 31). By queering Tintin, Summers can queer pregnancy to reevaluate encoded messages about maternity and mothers. If Tintin can be

pregnant, then pregnancy is a heroic adventure. If Tintin can be pregnant, then his feminine-inclusive masculinity can be embodied by different bodies. Maternity can inhabit narratives formerly precluded, and maternal identity becomes more accessible to those who do not conform to the cult of femininity. New stories of maternity become possible, and the missing masculine mother can come onto the scene without the obstruction of orthodox feminine scripts and norms.

Dissonance, an essential function of defamiliarization, operates between image and expectation as in depictions of a pregnant Teek as Tintin and between image and text throughout the autographic. As Charles Hatfield explains, graphic narratives present dual modes of storytelling with "word and image as two different kinds of sign, whose implications can be played against each other—to gloss, to illustrate, to contradict or complicate or ironize the other" (37). The necessity for interpretive reconciliation between text and image requires what Hatfield calls "the contributory work of the reader" who may have to change his or her framework for comprehension to make meaning out of this interplay. Therefore, defamiliarization in the graphic narrative can retrain our vision to include missing masculine maternity by actively engaging the reader in meaning-making that demands more than unreflective seeing.

An excellent example of how Summers engages the reader's contributory work to create a new framework for comprehending pregnancy as separable from femininity occurs at the beginning of the second section of the memoir, chronologically at the beginning of Teek's second trimester of pregnancy (see Figure 2). The page is a single large panel of Teek, squatting low in the centre of the page over a puddle of vomit on a city sidewalk. Wearing jeans and an open pea coat over a hoodie and tee shirt, Teek holds herself steady with chunky black shoes as she wipes her mouth with the back of her hand. Scattered around her is an open food container and a partly obscured bottle. Behind her is a fence to a building and above the building, a shadowy, rotund figure peers out at her from within the apartment. For many, especially those living in urban areas, the drawing evokes a dude stumbling home drunk or hung over. The food container and bottle, the not uncommon detritus of city life, contribute to a sense of drunken disorder. The dark silhouette at the window suggests delinquency, suspicion, and spectacle. All of this seems to coalesce around the commonplace picture of a guy who has had too much to drink.

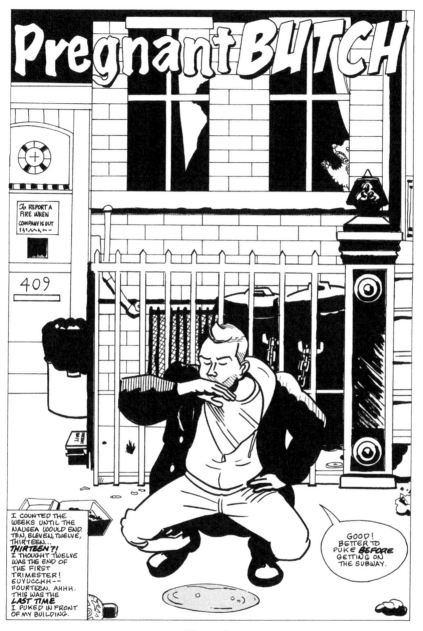

Figure 2.

The easy interpretation must be revisited based on the text in the bottom left-hand corner. Summers writes: "I counted the weeks until the end. Ten, eleven, twelve, thirteen... THIRTEEN?! I thought twelve was the end of the first trimester? Euyucchh—Fourteen. Ahhh. This was the LAST TIME I puked in front of my building" (37). Nausea in the first trimester of pregnancy is also a familiar trope; it is often visualized in our culture as a closed bathroom door or a not-yet-showing woman rushing away with her hand over her mouth. The image is familiar and leads to one perception; the narrative is familiar and attached to another dominant discourse. Putting them together demands reinterpretation on the part of the reader. Teek can't be read as a drunk dude on the street, and pregnancy can't be read as feminine. Instead, we must change our gendered lenses to accept that this too is what morning sickness might look like. This too is what pregnancy looks like. Chute calls this "productive disjuncture: a way of seeing and showing that is deliberately estranging" (152)—in other words, defamiliarization, which estranges readers from our habitual association of pregnancy with femininity and enables us to see and acknowledge masculine pregnancy. Moreover, multiple candid corporeal depictions of pregnancy illuminate an especially fraught negotiation of identity challenged not only by the hyperfeminized trappings and images of pregnancy at odds with masculine gender identity but also by an unruly and radically changing out-of-control female body.

Multiplicity of Self and Unruly Embodiment

Throughout *Pregnant Butch,* Summers counters the invisibility effect with Teek's hypervisible, centrally and repeatedly represented, pregnant butch body. Bodies are discursively constructed within a social order; they are read, categorized, ranked, and judged according to the norms, ideals, and expectations of a time and place. The way bodies look, feel, and act is affected by social expectations and norms, and those effects are experienced through the body. Moreover, as sociologists of the body have argued, we also exert agency over our bodies and how we move, adorn, alter, act, and live in them. Thus, bodies are sites of ideological struggle containing both the meanings we consent to and those imposed on us (Kosut and Moore). The struggle over meaning and experience of one's body is integral to Summers's text. Gender and pregnancy are both highly

embodied experiences. Teek had resisted conforming her body to the socially acceptable norms of gender that rendered her gender expression deviant but then interpolated herself into that realm of feminine expectation when she chose to engage in the highly physical act of reproduction. The result is conflict over normative assumptions about how her body (and by extension female bodies) is meant to look, act, and perform in mothering. Summers undermines the cultural dissonance of biology, gender, and maternity she embodies by pervasively combining them in multiple, diverging, and overlapping self-representations of self.

Autographic authors engage with identity in a continuous process of self-portraiture that Elizabeth El Refaie terms "pictorial embodiment" (51). Pictorial embodiment in *Pregnant Butch* keeps the attention on Teek's body as it changes in pregnancy but also reflects her innermost self. There are many iterations of Teek in different styles, different periods, and interior/fantasy scenes. Teek is seen as she appears but also how she feels. Multiple sequential representations mean identity is not essentialized because no single frame is definitive (Kolhert); rather, identity becomes plural and unified. As noted, Summers asserts Teek's intersecting social identities at every turn. Pictorial embodiment, intrinsic to the autographic genre, allows for play among and between the manifold elements of her identity. Summers refuses to flatten her representation to one facet, whether masculine gender, female biology, or lesbian sexuality. Instead, she underscores complexity and unsettles the notion of fixed subjectivity.

Teek maintains a masculine aesthetic, whether young and athletic on her bike, a charming boi Tintin, or a fat man in overalls. Her butch identity—though internally experienced during pregnancy as "beset from all sides" in the words of reviewer Samantha Meier (21)—is visually reconfirmed while demanding acknowledgement that masculinity is one part of a layered identity. Masculinity is juxtaposed with femaleness as well as lesbianism with Teek's biologically female body—her breasts and vagina are unapologetically asserted front and centre and at times are attached to her masculine face and body posture. We also see Teek and her girlfriend, Vee, having sex. And, of course, there are numerous depictions of the various visual tropes of pregnancy. The teasing apart of gender and sex occurs through the interactions between these multiple, layering images of Teek. She is a woman, a butch lesbian, and a mother. Since these identities do not line up in terms we are culturally habituated to accept, *Pregnant Butch* destabilizes assumed continuity between gender

and sex and also between gender and maternity by requiring us to see them incorporated into a unified body. In doing so, Summers works against visual traditions of women's bodies in comics and visual traditions of pregnant bodies in mainstream culture.

In addition to the pictorial embodiment emphasizing Teek's multiple and unified self, cartoon self-imaging also allows Summers to externalize her inward sense of self and the emotional impact of the meanings foisted on her body by others. Different styles and references are used to reveal emotion, doubts, anxiety, and pain. In a section titled "Coming Out," for example, Teek presents herself as a naked giant exploding the space of her barbershop to represent her fears of alienating others in her social environment with her changing pregnant body (see Figure 3). Exaggerated curves and circles of breasts, belly, and thighs evoke the ridiculed fertility goddess she feared presaged her inability to get pregnant. Her face, with Tintin hair flip, is depicted with oversimplified ooo's with open mouth. Motion lines surround her to suggest growth and expansion, and her shadow looms in front of her. The frame itself expands to twice the size of other frames and her hand transgresses the border of the frame, demonstrating her felt inability to be bounded and orderly.

Thus, Summers employs the monstrous and the abject to deconstruct binaries that uphold patriarchal norms of feminine maternity. Working within a tradition of women comics artists— such as Aline Kominsky-Crumb, Julie Doucet, and Phoebe Gloeckner—Summers "challenge[s] normative notions of female body through a process of signification based on parody and unruly embodiment" (Kohlert 20). Women's reproductive bodies threaten binaries of self-other and inside-outside that patriarchy relies upon, and they disrupt boundaries of the self-sufficient, bounded, and organized self. They are monstrous (Shildrick) and abject (Kristeva). Summers's pregnancy is more strongly monstrous due to her alienation from her own body resulting from gender incongruity, both her own felt incongruity and that of others' expectations. Her identity is threatened by the imposition of meanings that mark her, in her butchness and her pregnancy but especially in combination—as monstrous, that is, in opposition with corporeal norms. But *Pregnant Butch* embraces the abject and monstrous to complicate and deconstruct conceptions of natural—woman, mother—that uphold the sense of normal that excludes and erases her maternity. Monsters are liminal, transgressive, and refuse to stay in place; therefore, they are potentially transformative (Shildrick).

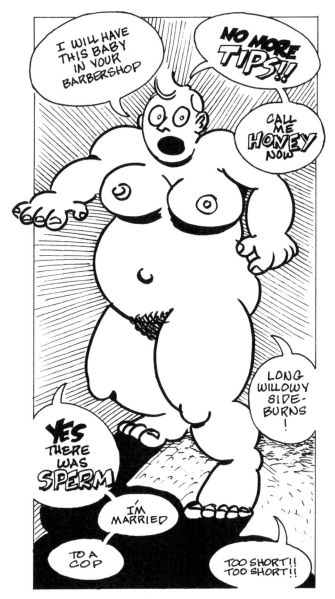

Figure 3.

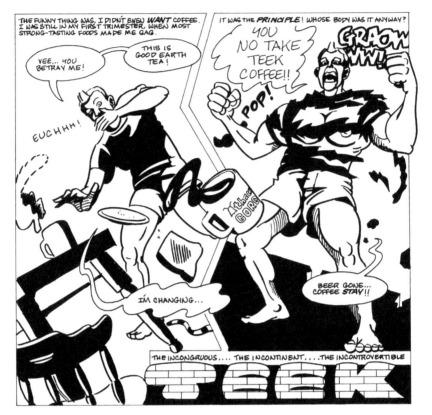

Figure 4.

When her partner Vee, who wants Teek to give up coffee for the baby's sake, gives her herbal tea in place of her morning joe, Summers depicts herself as transforming into the Incredible Hulk, or "The Incongruous... the Incontinent...the Incontrovertible TEEK" (Summers 45; see Figure 4). Here we see her once again exploding in size, this time in muscular enhancement with bulging biceps and pectorals shredding her shirt. Her face is darkened; she growls. The intertextual reference to the mild-mannered rational scientist who transforms into an inarticulate green rage machine emphasizes her desire to preserve some control over her body, which is already changing in ways she knows she cannot curb. Unlike the Hulk, who is incredible and a hero, Teek is incongruous: Her body is not aligned with her gender identity and former sense of self. She is unsettled and unsettling. Teek is incontinent, a joke about the frequency and urgency of urination during pregnancy but one that also evokes the

porous boundaries of the abject, leaky and, therefore, untrustworthy female body. Teek is, finally, incontrovertible: she is not to be denied, disputed, or questioned. Teek insists on still being Teek: a butch, agentic, and do-it-yourself coffee drinker. She embraces the monstrous rather than cede her body and self entirely to the demands of maternity—femininity, selflessness, and lack of agency—and in doing so begins to redefine maternity.

Maternity as Masculine

Throughout *Pregnant Butch*, Teek's body is a site of struggle as she grapples with integrating maternity into her butch lesbian identity. By the end, largely through the crucible of childbirth, she has reconciled the purportedly incongruent aspects of her identity by reconceiving maternity as a masculine act. Reconceiving maternity as something masculine people also do, not an uncommon strategy among BTQ mothers (Ryan), is one way that Summers encourages us "to view masculine gender expression in a context that is undeniably associated with women, illustrating the complexity of masculinity and femaleness" (Ryan 122). Again, she deconstructs gender binaries and queers maternity to include female masculinity.

In the late stages of pregnancy, physically exhausted and overwhelmed by a body she cannot control or even live comfortably in, Teek feels defeated by her body. Summers presents a fantasy scene to give outward form to her interior emotional state of feeling drastically distant from herself. In this two-page sequence, we see from behind a simplified Teek with Tintin flip looking through an enormous telescope pointed up and out of the right top corner. A circular inset in the lower frame shows an indistinct rotund figure in white attached by a long tube floating toward the moon. The second page is filled in with blackness and depicts a close-up of the white floating figure, tube attached to a rocket zooming off the page, revealing it to be an upside down pregnant Teek in a space suit with an absent expression on her face. "There was a time," she writes, "when slides could be a joke... when gender could be flouted... but yesterday Vee bought me a nursing bra. I thought I was a space alien, a do-it-yourselfer, **exempt.**/ Well, I quit./ There's no denying it. I am eternal woman" (Summers 80). Teek feels adrift and compelled to concede to the primacy of biology: "I am not myself. I am not Tintin. I am not

the Incredible Hulk. I am tears and I am snot. I am anemic and I am purple veins. I am boobies./ I am **done**" (81). She feels undone by pregnancy's rule over her abject, incongruent body.

Past her due date in the summer heat, Teek drinks castor oil to try to induce labour but to no avail. Over a week later when she finally goes into labour (after warnings about low amniotic fluid and lots more castor oil), Teek struggles to manage her pain. None of the strategies she has learned help. In a whole page frame, Summers illustrates the sensation of being overwhelmed with Teek's large pregnant body about to be engulfed in a cresting wave twice her size as she cries out "NO!/ I can't..." (95). Labour, thus, intensifies her experience of maternity as disempowering. She feels forced into an undesirable position of passivity and vulnerability. She imagines herself as being pushed off a diving board, flailing to grab on to something. She has no role except to "let it happen" (98), which directly conflicts with her butch sense of do-it-yourself agency.

However, when she is told to push, her perception and attitude begin to shift. The ability to act, to assert her effort, affirms her butch identity. She is agentic and formulates a sense of masculine gender expression in line with maternal identity. She depicts herself as a strong muscular figure who, letting out a primal "YHWHAA," pushes aside monumental boulders to which she is chained while shadowed figures in the background cower at the ferocity of her effort (Summers 104). This evokes the monstrous Hulk, but here Teek is herself, not a Marvel hero. Her body is strong and forceful, and unlike the Hulk, she is in control. Because this is a memoir and not fiction, this momentous push does not deliver the baby, and more monitoring and pushing follow until the midwife recognizes that the baby is breech and turns him, complimenting Teek's heroic performance thus far. With the encouragement of Vee and the midwife, Teek finally gives birth with a sense of accomplishment: "I did it./ I really did it/ I pushed the shit out of that motherfucker!" (109).

Childbirth in *Pregnant Butch* is depicted as a difficult physical trial to overcome through one's strength and effort, qualities in line with traditional masculinity. It is a hard-won victory that the mother achieves with her body and mind. The newfound association, forged in childbirth, of maternity with masculine traits associated with physical challenges, endurance, and force is solidified on the final page before the epilogue (see Figure 5). Here Summers presents herself as a prizefighter slumped

in the corner of the boxing ring, replete with a black eye, boxing gloves and shorts, with a baby nursing at her breast: "Call me POSTPARTUM BUTCH" is emblazed above her, asserting her new phase in life. Child-birth is cast in the framework of masculine endeavour. She is beaten from the experience but happy and victorious. She doesn't need to give up being butch to be a mother.[5]

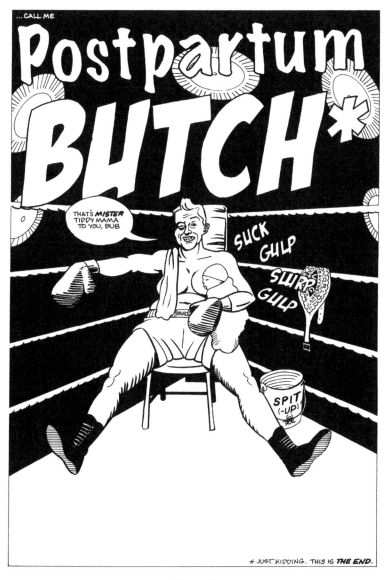

Figure 5.

Conclusion

Pregnant Butch enacts a visual queering of pregnancy and childbirth that contributes to a necessary unmooring of maternity from the "cult of femininity" that makes possible a broadening of maternal identities that includes masculine mothers like Teek. Eminently present, visible, and relatable in *Pregnant Butch,* she is no longer missing. Summers uses cartooning and narrative text to convey, with humour and complexity, her experience of maternity as a self-identified butch lesbian. The candid corporeal depiction of pregnancy illuminates an especially fraught negotiation of identity challenged not only by the hyperfeminized trappings and images of pregnancy at odds with masculine gender identity but also by a radically changing out-of-control body. It is indeed the images and interplay between image and text and the play of pictorial embodiment as constitutive of autographics that do this work, thus rendering the genre integral to the intended effect of Summers's memoir.

Summers experienced her pregnancy in 2003 and began writing about it as a serial webcomic a couple of years later. By the time the complete book was published in 2014, female masculinity, in Summers's words, had been "reframed as a transgender issue" (iv). She offers this note, in her introduction, to suggest her experience and identity may be dated; however, I believe that allowing for masculine maternity to be seen, regardless of the biological body it resides in, marks out a cultural space that could and should encompass transgendered and genderqueer individuals who decide to mother/parent also. *Pregnant Butch* works to recover missing masculine mothers in our cultural mindscape and makes visible the marginalized or denied lives and bodies of a wider community of masculine-identified mothers.

Credit: Illustrations from A.K. Summers, *Pregnant Butch: Nine Long Months Spent in Drag.* Copyright © 2014 by A.K. Summers. Used with the permission of The Permissions Company, LLC on behalf of Soft Skull Press, an imprint of Counterpoint Press, softskull.com.

Endnotes

1. The term "autographic" was coined by Gillian Whitlock to describe the relatively new genre in the field of graphic narrative to highlight the hybrid nature and interaction of visual and verbal text in graphic memoirs.

2. The Netherlands was the first country to legalize same-sex marriage in 2001. According to the Human Rights Watch, through 2022, thirty-three more nations have legalized same-sex marriage, through either legislation (as in Canada in 2005) or court decisions or mandates (as with the U.S. Supreme Court ruling of Hodges v. Obgerfell in 2015).

3. To be clear, Teek is depicted in various artistic styles. Sommers sometimes presents Teek directly in the style of Herge's Tintin. But even when employing more realistic or expressionist depiction, Tintin, with his easily recognizable front hair flip, is evoked and provides visual continuity throughout.

4. My reading of Summers's use of Tintin through Muñoz's theory of queer disidentification is influenced by Jessica Q. Stark's analysis of Ernie Bushmiller's iconic comic character Nancy and visual artist Joe Brainard's appropriations to emphasize how the multiplicity and the malleability of comics form allows for subversion of normative expectations.

5. Summers reinforces this message in her comic that followed *Pregnant Butch*: "Nursing While Butch" published in *Mutha* magazine, wherein she portrays herself as Superman (with identifying Tintin hair flip) with a baby at the breast—saving the day by putting the little one to sleep.

Works Cited

Balsamo, Anne. *Technologies of the Gendered Body: Reading Cyborg Women*. Duke University Press, 1996.

Bordo, Susan. *Unbearable Weight: Feminism, Western Culture, and the Body*. University of California Press, 1993.

Camper, Cathy. "A.K. Summers: Tales of the Pregnant Butch." *LAMBDA Literary*, 17 March 2014, https://lambdaliterary.org/2014/03/a-k-summers-tales-of-the-pregnant-butch/. Accessed 13 Sept. 2024.

Chute, Hillary. *Graphic Women: Life Narrative & Contemporary Comics*. Columbia University Press, 2010.

Dworkin, Shari L., and Faye Linda Wachs. "'Getting Your Body Back': Postindustrial Fit Motherhood in Shape Fit Pregnancy Magazine." *Gender and Society*, vol. 18, no. 5, 2004, pp. 610–24.

Epstein, Rachel. "Butch with Babies: Reconfiguring Gender and Motherhood." *Journal of Lesbian Studies*, vol. 6, no. 2, 2002, pp. 41–57.

Hatfield, Charles. *Alternative Comics: An Emerging Literature.* Mississippi University Press, 2005.

Kolhert, Frederic. *Serial Selves: Identity and Representation in Autobiographical Comics.* Rutgers University Press, 2019.

Kosut, Mary. "Not Just the Reflexive Reflex: Flesh and Bone in the Social Sciences." *The Body Reader: Essential Social and Cultural Readings.* Edited by Lisa Jean Moore and Mary Kosut. New York University Press, 2010, pp. 1–26.

Kristeva, Julia. *The Powers of Horror: An Essay on Abjection.* Columbia University Press, 1982.

McCloud, Scott. *Understanding Comics: The Invisible Art.* Harper Collins, 1994.

Meier, Samantha. "'Who Am I?' Review of *Pregnant Butch.*" *Woman's Review of Books,* vol. 31, no. 6, 2014, pp. 20–21.

Mountfort, Paul. "Tintin, Gender and Desire." *Journal of Graphic Novels and Comics,* vol. 12, no. 5, 2021, pp. 630–46.

Muñoz, José Esteban. *Disidentifications: Queers of Color and the Performance of Politics.* University of Minnesota Press, 1999.

Refaie, Elisabeth El. *Autobiographical Comics.* Jackson: Mississippi University Press, 2012.

Ryan, Maura. "The Gender of Pregnancy: Masculine Lesbians Talk about Reproduction." *Journal of Lesbian Studies,* vol. 17, no. 2, 2013, pp. 119–33.

Shildrick, Magrit. *Embodying the Monster: Encounters with the Vulnerable Self.* Sage, 2002.

Shklovsky Victor. "Art as Technique." *Russian Formalist Criticism: Four Essays.* Edited by Lee T. Lemon and Marion J. Reiss, University of Nebraska Press, 1965, pp. 3–24.

Stark, Jessica Q. "*Nancy* and the Queer Adorable in the Serial Comics Form." *American Literature,* vol. 90, no. 2, 2018, pp. 315–45.

Summers, A.K. *Pregnant Butch: Nine Long Months Spent in Drag.* Soft Skull Press, 2014.

Surkan, K. J. "That Fat Man Is Giving Birth: Gender Identity, Repro-
duction, and the Pregnant Body." *Natal Signs: Cultural Representations
of Pregnancy, Birth, and Parenting.* Edited by Nadya Burton. Demeter
Press, 2015, pp. 48–57.

Walks, Michelle. *Gender Identity and In/fertility.* Dissertation. University
of British Columbia, 2013, https://open.library.ubc.ca/soa/cIRcle/
collections/ubctheses/24/items/1.0073804. Accessed 13 Sept. 2024.

Whitlock, Gillian. "Autographics: The Seeing 'I' of the Comics." *Modern
Fiction Studies*, vol. 52, no. 4, 2006, pp. 965–79.

Young, Iris Marion. *On Female Body Experience: Throwing Like a Girl and
Other Essays.* Oxford University Press, 2005.

12.

Mother to the Other

Ciara Healy

Introduction

In recent decades, Europe and many other parts of the world have seen a rapid decline in fertility rates. Although many of the reasons for infertility are understood, and treatable, up to 20 per cent of infertility cases remain unexplained. This statistic has not changed since academic studies on infertility began in the nineteenth century. Infertility and involuntary childlessness place women in a marginal realm when it comes to their experience and perception of motherhood. According to psychotherapist and infertility advocate Jody Day, infertility and involuntary childlessness also affect how society perceives and represents women. To become a mother is to go through a rite of passage, a transformation that anthropologist Arnold van Gennep describes as "liminal" after the Latin word "limen," meaning to pass through a gateway or threshold (111). The rites of passage associated with birth, puberty, marriage, having children, and death are designed to prepare an individual for their new role and identity. In stepping over these physical or metaphysical thresholds, individuals enter new worlds and gain new identities. Human history holds multiple examples of ceremonies marking these transitional moments in a person's life. This chapter examines the anomalous, liminal space in which the involuntary childless woman dwells. Supported by animist philosophies, it proposes an alternative form of mothering and motherhood of becoming a mother to the other.

This chapter aims to broaden societal perspectives on infertility and involuntary childlessness to develop a more inclusive understanding of

motherhood. It explores this expanded view through folklore, art, poetry, music, autoethnographic writing, and the often-dismissed philosophies of nature, embracing what philosopher Jane Bennett describes as "the taint of superstition; animism, vitalism, anthropomorphism, and other premodern attitudes" (18).

In proposing an expanded understanding of mothering, this chapter claims we can generate deeper engagements between human, nonhuman, and ancestral worlds and, consequently, we might be better equipped to resist the impoverishment of subjectivity so often afforded to, or projected upon, those unable to conceive. In summary, therefore, this chapter is concerned with giving agency to those who cannot become mothers in the traditional sense—those whose identities are held in the margins, suspended on the threshold of grief and hope.

Infertility in Folklore: Pan, Selkies, and Mandrakes

Infertile women have been stigmatized throughout history or lived in fear of being the victim of that stigmatization. "Crazy cat woman," "witch," hag," and "spinster" are the terms Day highlights in her TED talk titled "The Lost Tribe of Childless Women" as being some of the insults regularly used for childless women. These terms often suggest that the woman is, by some measure, responsible for her infertility. Witches, hags, and spinsters were all associated with evil during the period of the Reformation in sixteenth-century Europe. This attitude, historian Emma Wilby argues, prevails, and infertile women continue to be seen as suspicious in the Western psyche. In her book on magic, shamanism, and witchcraft in seventeenth-century Scotland, Wilby analyses the origins of this mindset through the legal testimony of a young Scottish peasant called Isobel Gowdie, who was put on trial for witchcraft in 1662. Her testimony documents what it means to have an animistic and polytheistic perception of the world in sixteenth-century Britain and offers a historical account of how the boundaries of perception and multispecies entanglement evolved. In her confession, Gowdie reveals how she, along with her peasant neighbours, inhabited a reality that was profoundly influenced by the natural rhythms of the land, the body, and the movement of stars and planets across the sky and their impact on her fate. Her testimony also relates the magical and mystical powers (seen and unseen), which controlled both her physical and emotional

well-being. At times, this experience of existence was frightening, complex, overwhelming and violent, yet always animate.

By 1662, Isobel Gowdie's social superiors had, according to artist and cultural geographer Iain Biggs, largely internalized a strictly dualistic Calvinism. However, Gowdie and her neighbours did not. Their world remained shaped by many uncertain conflicting forces, including the dead, wise women and their familiars, revenants, wizards, old popular Catholic sites, elves or fairies. These animistic entanglements between humans and nonhumans share many similarities with contemporary theories and philosophies of new materialism, which regard the world as ensouled. Isobel Gowdie was put on trial in 1662, and although her fate is not documented, it is likely that she, like many thousands of women and men at that time, was executed for their animistic and polytheistic beliefs.

Despite the risks associated with engaging in pagan beliefs in post-Reformation Europe, measures to ensure fertility and avoid the stigma of childlessness continued to be imbued with animism. The goat, for example, was associated with fertility and reproduction in pre-Christian Egypt, Greece, and Rome. It was deified because of its propensity for copulation. This continued to be the case when the Romans conquered Gaul. Amulets were produced with depictions of goats and the goat phallus. Although the worship of the god Pan or any other type of horned God was rebranded as devil worship in post-Reformation Europe, such pagan practices sometimes found their way into churches and Christian worship. In the south of France for example, a large wooden phallus attributed to St Foutin was set up in numerous churches. In historian Beryl Rowland's 1975 book on animal symbolism, she describes how women scraped the surface of this wooden phallus and steeped the shavings in water to make a potion against infertility. Such practices continued in France well into the late seventeenth century.

The mandrake was also long associated with fertility and is described in the Book of Genesis (30: 14–17) as an aid to conception. Its roots and tubers resemble a human body about the size of a fetus. The female form of the root, which has, what looks like two legs, was the most sought-after type because of its likeness to a human child. These roots were carved into manikins in the Middle Ages in France and Germany and used for sympathetic magic to promote fertility. In Christian Europe, however, the political risks associated with using a mandrake as a charm

were high. As Kate Quarry and Lalite Kaplish point out, Joan of Arc, who was executed in 1431, was accused at her trial of carrying a mandrake root, which was seen as evidence of her witchcraft.

Just as the mandrake root was seen as an ensouled charm for fertility, in Scottish and Irish pagan folktales, there was a belief that seals also held magical properties and could lay aside their skins to take the form of humans. A selkie was therefore a mythological creature, shapeshifting between seal and human form by removing their seal skin. Much of these beliefs travelled down to Scotland and Ireland from Icelandic, Nordic, and even Sami folk tales (Mulk and Bayliss-Smith).

In practical terms, the selkie myth offered a useful cover story for a woman in an isolated island and community who could not conceive a child with her husband. It was somewhat socially acceptable to have selkie children, their ancestry was held in high regard as they were perceived as magical and supernatural. If a woman went to "lie with the seals," it was unlikely she would receive punishment for adultery. A union with a seal was a useful narrative allowing a pregnancy to take place in a small community, while preserving the dignity of that community and the marriages within it.

On an environmental level, these folk stories allow us to reconsider our interactions with the natural world and how we might come to regard the nonhuman lives surrounding us as more than a resource for human consumption and entertainment. Such a proposal challenges a paradigm originating in the reductivism of monotheism and later the commodification of life associated with capitalism. If, like the witches of Scotland, we too were to perceive the nonhuman world as our familiar, a new concept of mothering might emerge.

Infertility in the Twentieth Century

To do this, however, it is important to understand how the stigma associated with infertility and involuntary childlessness moved from the monotheism of Christianity to the monotheism of secular modernity. In the second half of the twentieth century, infertility was seen as a consequence of an emancipated (or what was often termed selfish) woman's lifestyle choices. By delaying starting a family to focus on her career, women were seen to compromise their fertility levels, leading to reduced chances of conception. But environmental pollution, poor water and air

quality, stress, and, most significantly, challenging socioeconomic ob-stacles facing women—such as an inability to find affordable housing, secure employment, and childcare—have also increasingly played a role in contributing to cases of infertility.

While these factors might paint a general picture of the causes of infertility, particularly in Europe, each story and journey of involuntary childlessness is different. Some people never meet the right person to get pregnant. For many others, fertility treatments fail, are unaffordable, do not work, or may not be readily available when trying to conceive. The IVF postcode lottery in England is one painful example of the inaccessibility of fertility treatments. Women in certain parts of England are denied the opportunity to avail of free IVF on the NHS because of the region in which they live. In 2013, for example, the number of clinical commissioning groups (CCGs) in England offering the recommended three NHS IVF cycles to eligible women under forty was halved. According to Fertility Network UK, Scotland is lauded as providing the Gold Standard of three full IVF cycles for women under forty. In England, IVF eligibility is determined by postcode and pay packet, not medical need.

By the mid-twentieth century, it was widely believed that women who seek help to achieve motherhood may not want that help, as they share, with their voluntarily childless counterparts, a reluctance to conceive. Margarete Sandelowski, professor of nursing at the University of North Carolina, in her journal article on female agency and infertility, argues that in this context, the infertile woman becomes not only a physical and social failure but a psychological one, too. Thus, female infertility in the psychological discourse of the twentieth century, much of which stemmed from Freud, was additionally depicted not only as a medical condition but also as a maladaptive disguise for, and defence against, the hostility and fear of reproduction.

This is where the assumption developed that the true desire for chil-dren would lead to children, while the true lack of desire, however un-conscious, would lead to infertility. This explanation proved useful for doctors, looking to understand why a woman might have unexplained infertility. The stigmatization and marginalization of infertile women from social, cultural, medical, and psychological discourse therefore inevitably led to many serious mental health issues. During the baby boom of the 1950s, the involuntary childless women constituted what

was often described as a "discarded group of blighted women" (Sande-lowski 478).

This stigmatization extended beyond patriarchal systems and thought, however. Second-wave feminists struggled to support the involuntary childless, infertile woman. As they petitioned to ensure the right of women to choose against motherhood, the involuntary childless woman found herself caught in a place where institutionalized medicine tacitly or overtly accused her of being responsible for her infertility. At the same time, many second-wave feminists equated her desire for children with her oppression as a woman. The anguish she experienced when her desire for children remained unfulfilled was, Sandelowski argues, a socially constructed pain rather than an authentic expression of grief.

There was, therefore, little empathy for the involuntary childless woman in both feminist and institutionalized medical discourse in the twentieth century. Women who are involuntarily childless challenge ideas of reproductive choice by underscoring the biological limits of re-productive freedom for women. They also challenge feminist efforts to celebrate women's unique biological capacities and reject this uniqueness as defining.

In the meantime, involuntarily childless women, remained, like their ancestors in the sixteenth century, caught in the crossfire. As they dwelled in that liminal place between motherhood and childlessness, they were now simultaneously perceived as the creator of and martyr to their circumstances.

Creative Responses to Infertility in Contemporary Art, Poetry, and Music

Trying to come to terms with this issue as an academic, a feminist, a wife, and a writer was a journey fraught with complex and conflicting emotions. When I wrote about the experience of my involuntary child-lessness, I gave voice to that grief, anger, jealousy, and frustration through poetry:

Reading station.
Platform 12B.
A familiar ache in my pelvis.
Standing back, behind the yellow line,

A sob of burst yolk,
Each carriage filled with schoolchildren.

I have unexplained infertility. For many years, I dared not discuss this subject publicly within the context of my career as an artist and writer because sometimes it was too painful. On other occasions, I was afraid I would be accused (by patriarchal and feminist decision-makers in the art world) of making work about something that was, strangely, too taboo. My experience did not fit in with the discourses and rigid ontologies that had formed around me, especially in the creative industries in which I worked.

In the introductory essay to a monograph publication titled *Carpe Fucking Diem*, published in 2015 by Finnish photographer Elina Brotherus, even the curator acknowledges that the subject of Brotherus's work on involuntary childlessness is still very much a taboo subject both in the art world and in everyday life. Brotherus was one of the first contemporary artists to navigate those rigid ontologies and give voice to the experience of involuntary childlessness as an artist and a woman in the twenty-first century. Rather than dwell, however, in the grief of that loss, she made a visual proposal for an expanded form of mothering. The photographs begin with the painful journey Brotherus took to become a mother. She presents the drugs, syringes, and bruises of IVF treatments, the alternating periods of hope and depression, and the intercepting calendar pages that tell the viewer that yet another year has passed. The central feature of the book is her "Annunciation" series of photographs. Not only do the images explore the personal experiences of Brotherus, but they also demonstrate to the viewer the religious and societal conditioning embedded deep into the psyche of Western women and the impact that conditioning has on one's identity and understanding of motherhood. In her photographs, she appropriates the compositional frames, colours, and symbolism of paintings depicting the Madonna in the canon of Western art history. The syringe in her belly delivering IVF drugs becomes the contemporary version of the angel Gabriel seen in paintings by Masolino and Fra Angelico.

Through making this body of work, Brotherus discovered that even an unhappy end is not the end; in fact, it allowed her to give preconceived ideas of normality—those rigid ontologies of motherhood—the finger as seen in works like *My dog is cuter than your ugly baby*. These aftermath images emphasize the notion that life continues. As she walks peacefully

through the woods with her dog or captures her partner lying naked with their dog on his chest, Brotherus reconstructs what it means to make a family.

Almost ten years before the publication of *Carpe Fucking Diem*, singer-songwriter Tori Amos released her album *Boys for Pele*. Although her music was radically different from pop culture at the time, what caused the biggest stir when the album was released was the series of photographs in the songbook artwork. In one image, for example, Amos sits beside a window, with a tired, distant look on her face; her red hair looks slightly dishevelled. She wears a tan, ruffled, and completely unfastened blouse. Against her breast, she holds a four-day-old piglet, whom she cradles like a baby; one hand is splayed to hold him, and his corkscrew tail rests against her thigh. He appears to be suckling from her left breast. His snout covers Amos's left nipple, and her right nipple is hidden by her blouse.

The songbook's images, created by photographer Cindy Palmano, were made into a billboard by Atlantic Records when the album was released. They proved so controversial that UK versions of the songbook had to be released without them. The dominant reading of the image is, like the work of Brotherus, a direct appropriation of Madonna-and-child poses, seen so often in religious artworks of the fifteenth and sixteenth centuries. This symbolic archetype is evident not only in the composition of the photograph but in its location too. Amos is in a barn; she's holding a piglet instead of a baby, and her distant gaze is representative of the way the Virgin was depicted in paintings by Francia, Da Vinci, Raphael, and Botticelli, all of whom were instrumental in constructing an idealized and sacred image of motherhood, the legacy of which, I argue, remains embedded in the Western psyche. Amos has a gaze that conveys a deep feeling of sacredness, which is made all the more shocking because she joins the sacred with the profane, with such great tenderness. The presence of this little animal at her breast was unsettling in a way that most could not articulate.

New Materialist Mothering

Brotherus, Palmano, and Amos appropriated early depictions of motherhood from the canon of Western art history. In so doing, they reclaimed the ancient animist sensibilities of the pagan world that had been silenced

so violently in the fifteenth and sixteenth centuries. Using animism to address our relationships with the nonhuman world is a practice philosopher Jane Bennett embraces in her book *Vibrant Matter*. Bennett aligns herself with the ideals of new materialism, as someone who lingers in those moments during which she finds herself fascinated by objects, taking them as clues to the material vitality she shares with them. Very simply, the philosophy of new materialism rejects the notion that one entity (e.g., the subject and human world) should be privileged over others (e.g., objects, animals, and environments). Certainly, humans have unique powers and capacities, yet new materialists argue that nothing about their powers should establish that they take precedence in every relationship. Rather than treating nonhuman entities as passive matter, new materialists believe that everything which makes up the nonhuman world is a genuine actor in its own right. Creating a new epistemology informed by new materialism does justice to these strange nonhuman actors, respecting them as strange strangers, and acknowledging our relationships with them, maternal or otherwise, as absolutely real.

Animism and new materialism as a philosophical proposal put us in the right direction to attend to an expanded understanding of mothering. This philosophy builds a discourse around plurality and simultaneity, giving agency to organic and inorganic things. It allows us to ascertain some, if not all, of the potentials that relational interactions can bring about.

This is important and necessary in discourses about motherhood, as the experience of involuntary childlessness remains shadowed by monolithic modernist narratives and prohibitions. If we wish to question the epistemology of those narratives predicated on division and classification rather than endorsing them, those working in the arts can become bridge makers who can generate alternative relations, which turn what the philosopher Isabelle Stengers describes as a "a divide, into a living contrast."

Mothering the Other

There is an image on my bookshelf in my home. I am thirty years old, holding a friend's baby. When that photograph was taken, I had been trying, unsuccessfully, and with much suffering, to become a mother for three years.

In her beautiful memoir *Afterglow*, the poet and writer Eileen Myles

describes her fifteen-year relationship with Rosie, a black-and-white pit bull terrier from a New York street litter. In her final days, as Rosie's health declines, and Myles has to decide if she should end Rosie's life, Myles notices that both she and her dog look radiant in their shared suffering and grief: "You can see it right behind their eyes. Terrible puts a candle in there. Terrible turns on the light. You wonder if people are just empty when they're moving forward with a plan. When it's all on the outside and the world is full of light, but when you suffer the light is in. It's all yours" (42).

Afterglow describes what it means to give agency to and care for sentient kin from the more-than-human world. Far from being a new age or neocolonial fantasy, making kin in our interspecies knots allows us, as feminist theorist Donna Haraway suggests, to "do something different" because she proposes "it matters which world's world worlds" (160).

As time went by, and the likelihood of conceiving, adopting or fostering a child became more unlikely, I became increasingly interested in finding a way of doing justice to the maternal intensity I treasured in my other nonhuman relationships. In my forties, I see that these relationships have allowed me to experience what I have come to call an enriched or expanded form of mothering, which mothers the more-than-human world. What Brotherus, Palmano, Amos, Myles, and Bennet offer is the realization that motherhood does not exclusively have to be about a sacred relationship with human kin. The suffering inside me that held me in a liminal space of grief and hope was now a place from where I could write without the fear of ridicule from the creative world in which I worked. I wrote about my little white dog, whom, like Brotherus, I brought into my home after my final failed attempt at conceiving a child. She often looks like a baby seal when asleep. She is my imaginary selkie child, whom I will inevitably outlive and whose life, like Myles's dog Rosie, I may have to bring to an end in the future:

Driving home, I catch sight of her small black nose.

Sifting through drizzle, dark farmyards and heather,

Hawthorn and oak, blurred furrowed peat fields.

A cyclone of fur in the left-wing mirror.

The small cloud of her head

On a grey backdrop of sea.

Inhaling the evening,

Searching the shadows

On the mountains ahead.

In the car, two places collide.

The one we approach.

The one left behind.

Exhausted from all those mornings of waiting,

The binding to hope, the always retracing

My steps back to longing,

I surrendered to her my cold empty house,

And she came knowing what she had to do.

My selkie child. Drowsy in the passenger seat.

I pass unhurried through all that gives her life,

Fearing the day, I'll be the midwife

That delivers her from this skin.

Conclusion

Stigmatizing involuntary childless women diminishes our agency as we internalize, consciously or unconsciously, a set of socially accepted rigid ontologies. This can lead to a sense of isolation and a fear of making creative work about an authentic lived experience.

As seen in the case of Isobel Gowdie, any attempt to inhabit a realm of ambiguity was and continues to be a dangerous activity. Women who have had cooperative, compassionate entanglements with nature have been persecuted and silenced in the past: from those accused of witchcraft and sorcery in the fifteenth and sixteenth centuries to nature writers like Nan Shepard, who only received the full recognition she deserved when Robert Macfarlane wrote about her work.

Being a mother to the more than human world offers an opportunity to dwell attentively with, and in, the moment. It is, as Haraway puts it, a "staying with," lingering on the threshold of this human world and its more-than-human counterparts. There is much of the real and mysterious in the tender and conscious dissolution of human and non-human

identities—in mothering the other.

The involuntary childless know what it means to survive an invisible loss and to be stigmatized and marginalized and to carry the burden of a disenfranchised grief that goes unacknowledged by society and, even at times, by the discourse of feminism. We know what it means to stay with this suffering to make meaningful relationships with other forms of sentience. While it remains an experience rarely articulated in art or life, those who find themselves involuntarily childless might be the ones who will reconsider and reimagine motherhood in this uncertain and fragile future.

Works Cited

Bennett, Jane. *Vibrant Matter: A Political Ecology of Things.* Duke University Press, 2010.

Biggs, Iain. "'Incorrigibly Plural'? Rural Lifeworlds Between Concept and Experience." *The Canadian Journal of Irish Studies,* vol. 38, no. 1/2, 2014, pp. 260–79.

Brotherus, Elina. *Carpe Fucking Diem.* Kehrer Verlag Heidelberg, 2016.

Day, Jody. "The Lost Tribe of Childless Women." *TED Talk,* 2017, https://www.youtube.com/watch?v=uufXWTHT60Y Accessed 12 Sept. 2024.

Gennep, Arnold van. *The Rites of Passage.* University of Chicago Press, 1960.

Haraway, Donna. *Staying with the Trouble: Making Kin in the Chthulucene.* Duke University Press, 2016.

Myles, Eileen. *Afterglow (a dog memoir).* Grove Press, 2017.

Mulk, Inga-Maria, and Tim Bayliss-Smith. "Liminality, Rock Art and the Sami Sacred Landscape." *Journal of Northern Studies,* vol. 1, no. 1–2, 2007, pp. 95–122.

Quarry, Kate, and Lalite Kaplish. "Mandrake, Medicine and Myths." *Wellcome Trust Journal.* https://wellcomecollection.org/articles/YjCgGhIAACAA3SSh. Accessed 12 Sept. 2024.

Rowland, Beryl. *Animals with Human Faces. A Guide to Animal Symbolism.* George Allen & Unwin Ltd, 1974.

Sandelowski, Margarete. "Failures of Volition: Female Agency and Infertility

in Historical Perspective." *Signs Journal of Women in Culture and Society,* vol. 15, no. 3, 1990, pp. 475–490.

Stengers, Isabelle. "Reclaiming Animism." *E-flux Journal*, 2012, https://www.e-flux.com/journal/36/61245/reclaiming-animism/. Accessed 16 Sept. 2024.

Pregnancy, Postpartum, and OnlyFans: Missing and Absented Performances of Motherhood

Clara Kundin

Let's begin with a timeline:

May 28, 2018: I launch a Patreon, a subscription site to support artists; I have tiers for artistic content and add one for erotic photos and videos, marking my first public commitment to online sex work.

March 2019: I take a pregnancy test confirming what my partner and I assumed would take several more months of trying.

May 2019: I announce a special on Patreon, encouraging new subscribers, and marking my continued sex work while pregnant.

June 18, 2019: I announce my pregnancy publicly on the Instagram account I use to market my sex work.

December 22, 2019: I give birth.

May 28, 2020: I announce the creation of my OnlyFans, an online subscription platform used for sex work. My daughter is five months old, and I am five months postpartum and missing from my life.

A positive pregnancy test gives way to a multitude of responses—joy, anger, despair, or shock perhaps—but it also marks the moment when a person with a uterus no longer holds just one identity. For women, their identity splinters into that of self and premother, shifting slightly after birth to self and mother. These identities are imposed upon women by a society that holds a multitude of expectations about how pregnant women and mothers should behave. Ildikó Rippel and Rosie Garton suggest that "In giving birth we lose ourselves, the child that was part of our body is now separate to us" (37). But in my own experience, I lost myself the moment I shared my pregnant state with others. My experiences as an online sex worker caused this fracturing and loss of my identity. Juggling societal expectations for mothers with expectations from my fanbase meant that I was constantly asked to perform the different roles of Madonna and whore depending on my audience. In this conflict, I found my own identity and needs were missing from any conversation about how I should behave or feel. As I navigated pregnancy and the postpartum months, I both leaned into and turned away from sex work, searching for a way to find my missing identity—the self who was not just a mother but a sexual being—by actively absenting or going missing from my identity as a mother.

In this chapter, I use an autoethnographic lens to examine the time-line of my struggle to exist while holding multiple identities revolving around sex and motherhood to raise awareness of the missing visibility of sexual mothers. Beginning with my pregnancy, I use the concept of the Madonna-whore dichotomy to articulate the struggle I faced as a pregnant sex worker to fit into societal norms. I then describe my attempt and ultimate failure to carve out space for my missing sexual identity away from the challenges of parenting by using performance theory to analyze my postpartum return to sex work on OnlyFans. Finally, I trace my continued difficulties to find representations of mothers like me and call for further acceptance of a sexual mother as a good mother—an identity currently missing from contemporary understandings of motherhood.

Pregnancy and Patreon: Performances of the Madonna-Whore

As someone who made a living from their body—whether through acting, modelling, or sex work—pregnancy and the resulting changes in my body threw me for a loop. I struggled to resituate myself in all my places of employment, simultaneously navigating a lack of work as an actor and an increase in work as a model and sex worker. Once I began showing, I was not cast in a show for the remainder of my pregnancy, but after announcing my pregnancy on Instagram, my Patreon payout for the following month was the highest it had ever been. This increase in my desirability as a sexual object, while exciting financially, was challenging to navigate due to dominant societal narratives dictating that I, a budding mother, should no longer live as a sexual being. I needed to work to support myself as normal, yet my friends and family seemed surprised that I would continue to participate in sex work while pregnant. Beyond disbelief that I would continue sex work, people expressed surprise that I would continue to even showcase myself as a sexual being in my daily life. On one occasion, I left the house for a walk, dressed in a revealing jumpsuit I had worn many times before. A neighbour with whom I was very close, referring to her as a second mother, admonished me. Referencing my swollen, pregnant breasts she cried, "What are you wearing? You're going to feed the whole neighbourhood!" The implication was that now, as a pregnant woman in a premother state, I should suddenly develop a chaste identity and display of my femininity. Never mind the fact that I still felt like a deeply sexual person; my new identity as premother was required to supplant any existing identities. Despite my lived experience, the existence of a sexy and sexual pregnant person was not possible in these social spaces.

As my sexual identity began to go missing in my personal spheres, my experience as a sex worker directly contradicted this push to desexualize myself while pregnant. My Patreon subscriptions increased, and I continued to receive requests for erotic pregnancy photos for the entirety of my pregnancy. Although I was content to continue my sex work, I found the experience of having my pregnancy sexualized to be jarring. I did not want to be desexualized, but I also didn't feel particularly sexy. My changing body and the resulting aches and pains of pregnancy impeded my usual confidence in my sexuality, but I still felt like the same

person underneath. My personality had not changed along with my body, and I wrestled internally with how I felt about my status as a pregnant woman. My complicated feelings about maternity were at odds with the public state of pregnancy, and that dynamic emerged in my work. A male photographer I worked with before my pregnancy now felt comfortable asking deeply personal questions about my growing breasts, despite the content of our photos being artistic nudes, not erotic shots. I would not qualify that particular shoot as sex work, although people out of the industry might disagree. But the combination of my nudity and pregnancy made this man feel entitled to ask me questions about my private bodily changes. More innocuous modelling work, either nude or explicitly erotic, continued to sexualize my pregnant body. I knew, of course, that pregnancy fetishes were common, and I was comfortable supplying that content, but I still struggled with being highly sexualized. I found it difficult to perform "sexy" in photo shoots when I felt so unsexy.

This juxtaposition of sexualization and desexualization challenged my sense of self as I attempted to please clients as well as family and friends while my feelings about my body and sexuality were missing from the conversation. I was simultaneously cast as the Madonna and the whore when I felt like neither. Different scholars and psychologists have interpreted the Madonna-whore dichotomy in a variety of ways, beginning with Freud's coinage of the term to theorize heterosexual male inability to view female tenderness as united with her sexuality (Bareket et al. 519). After general rejection of that interpretation of the term and debate over new definitions, a recent paper explores the Madonna-whore dichotomy as "an ideology designed to *reinforce patriarchy*" (Bareket et al. 520). The authors theorize that the dichotomy encompasses two interrelated beliefs: "(a) polarized views that women fit into one of two mutually exclusive types, Madonnas or Whores (e.g., women are either sexually attractive or suited to being wives/mothers), and (b) an implicit personality theory associating sexual women with negative traits (e.g., manipulativeness) and chaste women with positive traits (e.g., nurturance)" (520).

My position as a pregnant sex worker was missing from this dichotomy. My friends and family wanted me to leave my status as whore behind to move into my new Madonna identity (affirming the positive and negative traits associated with each identity), whereas my online fanbase wanted me to play both roles simultaneously, even though I did not feel

sexually attractive in the slightest while pregnant. Where was the space for my experience of a sexual being who didn't feel particularly sexy? Instead, I was forced to perform both roles for different audiences, and these audiences did not approve of the other's chosen performance and my performance of it. For my subscribers on Patreon I needed to be pregnant and hot. For my friends and family, I needed to be demure and focussed on my imminent motherhood. My difficulty situating myself in this Madonna-whore binary nevertheless validates Bareket's theory that such a binary reinforces patriarchy; my struggle to exist fully outside of the binary indicates the patriarchal pull to categorize women neatly. Koa Beck traces this contradiction of the sex-empowered woman to second-wave feminism as authors like Erica Jong and Germaine Greer published books showcasing and arguing for female sexuality. Beck references a woman quoted by Joan Didion who says, "The birth of children too often means the dissolution of romance, the loss of freedom, and the abandonment of ideals to economics" (60). I found these concerns of second-wave feminism were still relevant as I was chastised for my sexuality while facing a fanbase who oversexualized me but was my economic base. My pregnancy dissolved my ability to showcase my sexual self in my daily life, and my financial reality meant I had to perform a "sexy" identity that did not match my lived experience. My actual feelings were missing from these wants throughout my entire pregnancy.

And then I had a baby.

Postpartum and OnlyFans: Reclaiming Missing Identity

The first months of my postpartum experience were extraordinarily challenging. Any astute reader can tell from my opening timeline that I gave birth shortly before the COVID-19 pandemic. Even before the pandemic, I struggled to navigate my new identity as a mother. After one month of postpartum recovery, desperate to work again as an actor, I began auditioning while the new scar across my abdomen was still healing. I was immediately cast in a new play, ironically in the role of a sex worker, and was confronted with the difficulty of parenting in the theatre.

The theatre company was endlessly accommodating, but playing the triple roles of mother, actor, and character was challenging. My daughter slept while strapped to my chest as I pretended to sip laudanum and

seduce clients. We scheduled the staging of my character's assault on a day I had childcare, knowing it to be too difficult to play all those roles in that context. My struggle as a mother-artist was not singular. Shannon Jackson describes the common challenge of mother-artists to situate themselves within those roles, using the art of Mierle Laderman Ukeles as an example of an artist who developed the concept of "maintenance art" as a way to balance her dual roles of mother and artist while asserting the value of maternal labour (85). Jackson quotes Ukeles about her struggle: "I tried to be an artist half the time and a mommy the other half. But I was in my studio thinking about my kid and in the playground thinking about my work" (85). Like Ukeles, I struggled to play both mother and artist, with the added layer of character in my context of theatre artistry. I rehearsed distractedly while my child cried with a sitter in an adjoining room; I fed her on breaks. Yet at home alone with my child, I wished to be back at the theatre. During the early postpartum months, I largely stopped sex work, except in rehearsals. My body was still healing, and I was unable to participate in physically demanding photo shoots, erotic or otherwise, and was explicitly forbidden to engage in sexual intercourse. As a result, I had no outlet where I could fully escape my new maternal identity. I wanted to be a mother, but at times, I wanted a space to go missing from that identity so I could fully immerse myself in my other identities; that space was not possible.

When the pandemic decimated New York, like many arts workers, I lost all my work. The play closed before it opened, and a school program I worked for shut down weeks before the scheduled end of my maternity leave. Trapped in a one-bedroom with a three-month-old child and an asthmatic partner, the future was terrifying. We made an impossible decision to leave our home and move in temporarily with my parents on a remote farm in Kansas. As someone who deeply loves working, this scenario was agonizing. Isolated in a home away from home with a baby who refused to sleep for more than thirty minutes at a time, I slowly felt like I was losing my mind. Beck describes "the deep loneliness that can stem from caregiving in the United States, whether it's for very young children or aging parents" as "a low-current hum in women's history, echoing behind literature, statistics, mental health evolutions, and hand-wringing press narratives about social media" (70). Despite being surrounded by a supportive partner and my parents, the challenges and loneliness of postpartum parenting, exacerbated by the pandemic, made

me feel like part of myself was missing as my identity as a mother took centre stage. Searching for a way to claim something in my life as my choice, I returned to sex work, opening my OnlyFans, a subscription site used primarily for sex work, as a birthday present to myself.

Returning to sex work returned me to my sexuality. Trapped in a house with a baby sharing my bed and my parents in a room nearby, it was not a particularly sexy time for myself or my partner. OnlyFans offered me an outlet, a space where I could feel sexual even though I was now also a mother. In a recent study on the motivations of new sexual content creators on OnlyFans, the authors identify five key motivations for creators to join the platform:

> Overall, we find that our participants were motivated to join OnlyFans due to: 1) the visibility and acceptance of OnlyFans in society, which was created through a combination of celebrity hype, platform design, and peer conversation; 2) the potential earnings on OnlyFans, which they perceived as a (better) alternative to other forms of gig and service work; 3) a desire to engage in digital sexual expression; 4) already having existing content, audiences or skills that allowed them to quickly build a profitable OnlyFans page; and 5) pandemic factors such as increased flexible time, increased safety concerns about other forms of gig work, and loss of other forms of income due to economic impacts. (Hamilton et al. 8)

While motivated slightly perhaps by several of these reasons, the "desire to engage in digital sexual expression" most closely matches my motivation for joining the platform, but the study's summarization of data cannot capture the true "why" behind my engagement in digital sexual expression. The authors do reference motherhood as a motivation for using the platform but specifically because the flexibility of using the platform allowed creators to "attend to increased responsibilities as carers or parents" (9). My parental responsibilities had certainly increased after the birth of my child, but I was using the platform to both find myself and to go missing—to reclaim myself as a sexual being while temporarily absenting myself from my identity as a mother. The authors begin to capture my motivation in their discussion of pleasure: "More than one of our participants described a sense of enjoyment in the work, in addition to those looking to fulfill their sexual expression needs by sharing erotic

content" (13). My search for pleasure was centred around the complexities of my overlapping identities of sexual being and mother; searching for pleasure through sex work reaffirmed an identity that had gone missing when I became a mother.

While my family knew what I was doing, they largely ignored it. In their house, I was a mother to their grandchild, and what I did in the privacy of my room for work was better left unsaid. This implied disapproval meant that the origins of my work on OnlyFans felt even more private, more for just myself despite the audience for the content being outside viewers. Because of the privacy granted to me by this tactic of ignorance, for a brief period, I had what I wanted: space to go missing as a mother where I could reclaim my sexuality. When I returned to New York, however, continuing this line of sex work, I faced more resistance with friends questioning how my child would respond to learning her mother did sex work. In their questions was an implied disapproval of a mother expressing her sexuality, the implication being that mothers who did so were bad.

The phenomenon of erasing maternal sexuality is pervasive. Poet Arielle Greenberg references this disapproval of maternal sexuality in her poem "Pastoral: Mostly you are worried about my children." She opens her poem:

But I was fucked to make these children—
they came from fuck, from the way my o
opened and hugged in R's semen in a frothy late summer slick
of mucus.

The beginning "But" implies a mid-conversation start to the poem, the middle of an argument. Greenberg responds to the suggested question, "What about the children?", an implication that Greenberg's sexuality as a mother is inherently damaging to her children. Greenberg goes on to not only justify her maternal sexuality but to argue that she is, in fact, a better mother because of it:

And believe me, I'm a kinder mother
when my bottom is bruised from the smart round clap
of M's open hand.
I'm nicer after.
I'm happier picking up from school
when wearing his high school football jacket and feeling really owned.

While not referencing sex work explicitly, Greenberg links her kinky sexuality and her parenting as coexisting things that feed each other. By engaging in sex, Greenberg better engages in mothering. Most poignant in this poem is the simple line midway through the poem: "Believe me." By writing this line and this poem, Greenberg attempts to locate herself as a sexual mother in society, a society that wants the first half of that identity to go missing. I suggest that Greenberg's urge to write this poem stems from the absence of positive representations of maternal sexuality that would normalize this common and natural but missing representation of motherhood.

In *Notes Toward a Performative Theory of Assembly,* Judith Butler describes the right to appear: "For when bodies gather as they do to express their indignation and to enact their plural existence in public space, they are also making broader demands: they are demanding to be recognized, to be valued, they are exercising a right to appear, to exercise freedom, and they are demanding a livable life" (26). Butler focusses on bodies gathering in space and looks towards the performativity of gender, but this notion of the "right to appear" frames Greenberg's poem as well. By publishing a poem celebrating her identity as both a mother and a sexual being, Greenberg demands her right to appear in society, and she performs the fullness of her identity. In doing so, she finds a facet of the missing mother: the mother as a sexual person. Greenberg reinforces her bodily right to appear through writing this poem, which spreads her identity across a wide readership; she offers a possible answer to finding missing identities.

As I am not a poet, I instead attempted to find my missing self by asserting my right to appear and self-identifying as a "MILF," which stands for "mother I'd like to fuck." I placed this identifier in the biographies on all my social media accounts. Although I find this identifier amusing and use it to this day, the difficulty of such a label is that it places me in reference to an implied audience or consumer. The "I" in MILF means this label is usually given by someone to someone else they want to fuck. I attempted to subvert that by claiming the label myself, but the tension in the title manifested in my interactions with my clients. I returned to sex work to return to myself and my sexuality, but being a mother was not what made me feel sexy. This was not the case for many of my fans, who found my postpartum state highly desirable. Multiple photographers requested I stimulate my nipples during photoshoots to

begin lactation, and many fans requested this content as well. While I never referenced my child in conversations about sex work, fans regularly asked about my child in our conversations. I do not wish to imply that they were sexualizing childhood but instead sexualizing my status as a mother. Knowing that I was a mother was a turn-on.

This tension between my reasons for returning to sex work—to carve out space for me away from motherhood—against the reality of how my fans sexualized me as a mother echoed my original predicament as a pregnant sex worker. I was again caught in between multiple audiences, my family and friends and my clients, but this time, I was a third audience as I had resought out sex work to satisfy my desires. Instead, I found myself and my needs missing as I attempted to produce the content fans wanted, the financial incentives of OnlyFans taking precedence over my desires.

Ultimately, I failed to find a place for myself and my needs in the world of sex work, defeated by my clients' desires and the reality of my postpartum body. In a private video recording for a fan, I failed to notice that my breasts had begun to leak milk. When the fan received the video, he was overjoyed, referencing the moment and asking for more of the same content. I was mortified that the physical reality of my postpartum body had crossed over into the world I used as a sanctuary away from the challenges of motherhood. Rippel and Rosie Garton imagine how "Lactating mothers in theatre could potentially cause moments of non-performance, a rupture in the symbolic theatrical frame through the authentic presence of the maternal body" (38). As a lactating mother in sex work, the authentic presence of my maternal body defeated my desire to disappear as a mother "as the maternal body takes over from the performing body"—in this case, the performance of sex work. Sex work often breaks through performance. My orgasms were real, so the rupture of performance created by my lactation was only a rupture for myself. My client was happy, but his joy came as my mother identity again supplanted my desire to escape from motherhood temporarily. This moment marked the beginning of the end of my sex work on OnlyFans, exactly one year after it began. Because of my financial realities, however, I could not simply quit this world and instead gradually faded from it, producing less new content and marketing less often while I built up other revenue streams.

Contradictory Identities and Legacies of Sex Work

As I struggled to write this chapter, I felt continual pressure to explain myself and my identity. I am a human full of what are construed as contradictory identities. I am a mother who bristles against that identity while embracing that of a parent. The title of mother is given to me by society due to my biology, the same biology that broke through my desired performance of self with the visceral, biological reality of lactation. Psychologist Carl Pickhardt writes, "Although a father and mother can be equally active and important as a caregiver and be equally loving and loved as a parent with a growing child, there are biologically influenced role differences that I believe never entirely go away." Psychotherapist Naomi Stadlen describes these role differences as different parenting styles. She depicts mothering as emotional and instinctual, contrasting it with parenting as a "management style ... associated less with affection and intimacy and more with structure and discipline" (Dean). The many trans, queer, and nontraditional families successfully raising and nurturing children seem proof enough that this biological breakdown and arbitrary use of terms is meaningless. Likewise, I squirm at the assigned biological mother identity because in reclaiming my missing sexual identity, I sought, unsuccessfully, to escape my biological realities. My child grew up calling me "Mama" and has learned from daycare to call me "Mommy"—a development that made my stomach clench—but when I identify myself to other adults as a caregiver, I use the term "parent."

My contradictory identities continue. I am a mother and a former sex worker. I am a theatre artist, equally at home making work for and with young people and making R-rated work for adult people. I am an academic about to publish an article about my past sex work. To maintain access to my archive, I must maintain a semiactive presence on OnlyFans, meaning the "former" in "former sex worker" is always something of an untruth. Despite always working within legal boundaries, sex work, whether past or present, puts me at risk, as many graduate students like me have discovered. When classmates at Lenoir-Rhyne University discovered Cami Strella's OnlyFans, their treatment of her made her realize "that she couldn't be both a graduate student and a creator of sexually explicit content" (qtd. in Beachum). She gave up her academic goals at the recommendation of her adviser. I have support for the fullness of my identity from my current advisers, but I cannot predict what will happen once I graduate and search for jobs. While there is risk in my position, I

also entered and engaged in sex work from a position of privilege, able to engage largely online and leave the industry of my own volition. Holding all these identities within myself feels easy, except when I have to explain them to someone, perpetually outing myself as this or that. In that explanation, I go missing again. I am forced to justify my work, writing, or position in the world of youth, sex work, academia, or theatre. Even writing this conclusion, an effort to name myself, implies that I am missing because I see no representations of myself in my fields.

Even as I am more or less removed from the sex work industry, I still struggle to encompass the whole of my identity in my theatre world. After two of my professors attended a performance that included my nudity, one asked if I would allow my students to attend the show. Suddenly, I was thrust into this same struggle to make space for a missing identity—this time as an educator and academic who is also a sexual being (not to mention a professional performer who does what a role demands). In this particular show, where my character and actual identity often merge, not only am I briefly nude and often highly sexualized, but I am once again identified by my familiar MILF label. My status as a mother again enters the conversation, placing my sexuality and identity in conflict. My professor's question again reminds me that my sexuality is something that should always be hidden, even though that is not the fullness of my or, I would argue, anyone's being. Because of my comfort in using my nude body as material for theatre, a legacy from my sex work, I fear that I will never escape this conflict of identity and will always have to justify the why of who I am.

My child is now four, and I still have no answers. When she looks at the art of my naked body hanging on the walls of our house, she laughs and says, "Mama's butt." I don't know how she will react or how I will respond when she is older, but I imagine scenarios of embarrassment. Will she want to invite friends over to a house where nude images of her mother hang on the walls? Yet I know that I will continue to try to make space for myself and the fullness of my identity in this world as a mother, an educator, a theatre maker, and a former sex worker. Lisa Baraitser describes the pressing need for academia and art "to find a space of encounter for self-reflexive modes of auto-ethnography that can reveal the daily struggles to maintain one's sense of self while supporting the life of another (7). By writing this account of my parental journey, I hope my students, collaborators, clients, and child will struggle less to find

representations and acceptance of their whole selves. Most importantly, I hope for my child, in the words of Greenberg, the following:

> That they will be able to say,
> *We grew up in a warm house*
> *with lots of open window talking about hard things,*
> *with lots of grown-ups who were loved fully and loved us truly*
> *and we felt safe.*
> *There were pillows and books and a woodstove.*
> *We felt abundance, all ways.*
> *We felt our mother was a full being*
> *who lived thoughtfully and lived as she pleased.*

Works Cited

Baraitser, Lisa. "YouTube Birth and the Primal Scene." *Performance Research*, vol. 22, no. 4, 2017, pp. 7–17.

Bareket, Orly, et al. "The Madonna-Whore Dichotomy: Men Who Perceive Women's Nurturance and Sexuality as Mutually Exclusive Endorse Patriarchy and Show Lower Relationship Satisfaction." *Sex Roles*, vol. 79, no. 9–10, 2018, pp. 519–32.

Beachum, Lateshia. "She Was Less Than a Year from Finishing a Master's Degree. Then Classmates Discovered Her OnlyFans Page." *The Washington Post*, 12 Feb. 2024, https://www.washingtonpost.com/nation/2022/02/12/cami-strella-only-fans-masters-degree/. Accessed 5 Sept. 2025.

Beck, Koa. *White Feminism: From the Suffragettes to Influencers and Who They Leave Behind.* Atria Paperback, 2021.

Butler, Judith. *Notes Toward a Performative Theory of Assembly.* Harvard University Press, 2015.

Dean, Flannery. "To Mother or to Parent: Is There a Difference?" *Châtelaine*, 2 Nov. 2012, https://chatelaine.com/living/to-mother-or-to-parent-is-there-a-difference/. Accessed 5 Sept. 2024.

Greenberg, Arielle. "Pastoral: Mostly You Are Worried about My Children." *Tinderbox Poetry Journal*, Aug. 2015, https://tinderboxpoetry.com/pastoral-mostly-you-are-worried-about-my-children. Accessed 5 Sept. 2024.

Hamilton, Vaughn, et al. "'Nudes? Shouldn't I Charge for These?': Motivations of New Sexual Content Creators on OnlyFans." *Cornell University*, Apr. 2023, https://dl.acm.org/doi/fullHtml/10.1145/354 4548.3580730. Accessed 5 Sept. 2024.

Jackson, Shannon. *Social Works: Performing Art, Supporting Publics.* Taylor & Francis Group, 2011.

Pickhardt, Carl. "How a Father is Not a Mother." *Carl Pickhardt*, https:// carlpickhardt.com/page64.html#:~:text=The%20difference%20be-tween%20a%20father,a%20father%20can%20never%20know. Accessed 5 Sept. 2024.

Rippel, Ildikó, and Rosie Garton. "Maternal Ruptures/Raptures: Leakages of the Real." *Performance Research*, vol. 22, no. 4, 2017, pp. 36–43.

Notes on Contributors

Editors

Martina Mullaney Martina Mullaney is a practising artist and academic. She is the research coordinator for FilmEU European University at the Institute of Art, Design and Technology, Dublin, Ireland. She was formerly a postdoc researcher for the joint-funded Arts and Humanities Research Council (UK)/Irish Research Council Feminist Art Making Histories Project. She holds an MA from the Royal College of Art, London and an AHRC-funded PhD from the University of Reading. Her research asks how art on and of maternity can transcend its audience. She convened The Missing Mother Conference. She is a recipient of the Red Mansion Art Prize and has been an artist in residence with BALENCIAGA (Paris), the British Council in Sri Lanka and Tbilisi, Georgia, and the Gallery of Photography (Dublin). Her work has been shown at Yossi Milo Gallery (New York), Fraenkel Gallery (San Francisco), Artwall Gallery (Prague) and Cork Film Center (Ireland). She founded *Enemies of Good Art* in London after the birth of her child, and events took place at Tate Modern, the ICA, Southbank Centre and Chisenhale Gallery, Tranzit Display Gallery in Prague, Czech Republic, and Galerija Nova, Zagreb. *Enemies of Good Art* also broadcast on Resonance 104.4FM

Andrea O'Reilly is internationally recognized as the founder of motherhood studies (2006), its subfield maternal theory (2007), and creator of matricentric feminism (2016), a feminism for and about mothers, and matricritics (2021), a literary theory and practice for a reading of mother-focussed texts. She is a full professor in the School of Gender, Sexuality, and Women's Studies at York University, founder/editor-in-chief of the *Journal of the Motherhood Initiative*, and publisher of

Demeter Press. She is the co-editor/editor of over thirty books on motherhood topics, including maternal theory, feminist mothering, young mothers, monstrous mothers, maternal regret, normative motherhood, mothers and sons, mothers and daughters, and maternal texts. Most recently, in 2024, she published the co-edited collections *Care(ful) Relationships between Mothers and the Caregivers They Hire* and *The Mother Wave: Theorizing, Enacting, and Representing Matricentric Feminism*. She is the author of four monographs, including *(M)otherwords; Writings on Mothering and Motherhood, 2009-2024* (2024) and *Matricentric Feminism: Theory Activism, Practice, the 2nd Edition* (2021). She has published fourteen chapters, with another six planned on mother-centred novels/memoirs that will be published in the monograph *Matricritics as Literary Theory and Criticism: Reading the Maternal in Post-2010 Women's Narratives*. She is twice the recipient of York University's Professor of the Year Award for teaching excellence and was the 2019 recipient of the Status of Women and Equity Award of Distinction from OCUFA (Ontario Confederation of University Faculty Associations). She has received more than 1.5 million dollars in funding for her research projects, including her current one on millennial mothers.

Contributors

Felicity Allen has a solo and collaborative practice, manifesting her concept of the "disoeuvre." Cofounding Women Artists Slide Library (1978), she has led Tate education programs (2000s), lectured at Goldsmiths, and edited *Education* (Documents of Contemporary Art, MIT/Whitechapel, 2011). A Getty Guest Scholarship (2011) helped generate her PhD (2016), identifying the disoeuvre (*The Disoeuvre*, Ma Bibliothèque, 2019), currently a subject for her watercolour series *Dressing Up to Be an Artist* and film project *Life as Manifesto*. Her 1989 large photowork *Baby II*, shown in Hayward Touring's *Acts of Creation: On Art and Motherhood*, is reproduced in Hettie Judah's eponymous book (Thames & Hudson, 2024).

Kate Antosik-Parsons is a feminist art historian and postdoctoral researcher at Trinity College Dublin on the ReproCit Project, a cross-border study of abortion in Ireland since 2019. She coauthored the *Unplanned Pregnancy and Abortion Care Study* (2021). Her research

interests are contemporary art, politics, and the cultural discourses of the reproducing body, and her recent publications include *Say Nope to the Pope: Performance and Resistance in the Creative Interventions during the 2018 Papal Visit to Ireland* (2024), *The Embodied Histories of Performance Art in Ireland in the 1990s* (2023), and *Touch in Irish Performance Art* (2020). www.kateap.com

A. S. Compton is the author of *A Grandmother Named Love* (Inanna 2019) and has published poetry in *The Banister, Vallum* and Demeter Press. She is an editorial assistant at *Canadian Mennonite* magazine, lives in Waterloo, Ontario (Haldimand Tract), Canada, and spends much of her time on her family's intergenerational farm with her two children. Compton attended Western University, receiving her BA in English and Literature in 2012. She is passionate about social justice and lifelong learning.

Christa Baiada is an associate professor of English at Borough of Manhattan Community College of the City University of New York. She holds a PhD in literature from the CUNY Graduate Center and has published in various journals, including *Critique; Asian American Literature; Journal of Men's Studies,* and *Teaching English in the Two-Year College.* Her current research focuses on literary representations of embodied motherhood, particularly pregnancy, breastfeeding, and maternal sexuality, in twentieth and twenty-first-century American fiction and memoir. She lives in Brooklyn with her husband and daughters.

Victoria Bailey has a PhD in creative writing by practice and an MA in women's studies. Her poetry has been included in a variety of feminist-focused publications, including anthologies, magazines, and journals. She is coeditor, along with Andrea O'Reilly and Fiona Joy Green, of *Coming into Being: Mothers on Finding and Realizing Feminism* (Demeter Press, 2023) and *Revolutionizing Motherlines* (working title), Demeter Press, (publication date TBD). She is also editor of the upcoming poetry collection *A Mother(hood)fucking Arsenal of Poetry*, Demeter Press, (publication date TBD). She lives, mothers, writes, and sometimes teaches about writing in Alberta.

Martina Cleary is an artist, writer, and researcher based in the West of Ireland. She holds a PhD from the European Centre for Photographic Research e(CPR), an MEd from Aalto University of Art, Design & Archi-

tecture, and an MA from the Finnish Academy of Fine Arts Helsinki. She currently lectures at *The Technological University of the Shannon* (TUS). Her research areas include photography and memory, psychology, feminist critical theory, immersive media, and socially engaged practices. Over the past two decades, her work has been presented in over eleven countries, supported by the Arts Councils of Ireland and Finland.

Emma Dalton is an adjunct research fellow in the Department of Languages and Cultures at La Trobe University, Melbourne, Australia. This is her seventh academic publication. She has published under her maiden name, Emma Hughes, and her married name, Emma Dalton. Her publications largely engage with play texts and live performances. She considers theatre studies to be her disciplinary home. However, she considers motherhood studies to have been the making of her doctoral thesis and attributes her discovery of MIRCI in late 2014 to its eventual cohesion. Engaging with concepts from motherhood studies brought her thesis together.

Alice Diver is a senior lecturer in family law at Queen's University, Belfast, Northern Ireland. A former solicitor, she holds a PhD from Ulster University and is the author of two monographs on the law and literature of adoption, namely *A Law of Blood-ties* (Springer, 2014) and *Genetic Stigma in Law and Literature: Orphanhood, Adoption, and the Right to Reunion* (Palgrave, 2024). She has published widely on the topics of adoption and the human right to avoid origin deprivation. An adoptee of Mi'kmaw descent (in reunion since 2017), she is a trustee of Kinship Care (NI) and an associate editor of the *Liverpool Law Review.* She has recently become a grandmother.

Rachel Fallon is a visual artist using sculpture, drawing, photography, and performance techniques to deal with themes of protection and defence in domestic realms and address women's relationships with society. Recent works include *The Map*, with Alice Maher and Jelen Vagyok / I Am Present, commissioned by the Kiscelli Museum/ Budapest Galeria, Hungary. It is a collaborative performance-based art activist piece relating to queer and female representation in public spaces. Her work is held in public collections, including IMMA, the Arts Council of Ireland, and the Museum of Modern Art, Warsaw. She lives and works in Ireland.

Ciara Healy is a writer, book artist, curator, and head of fine art and education at Limerick School of Art and Design at the Technological University of the Shannon. She was the 2021 recipient of a Scottish/Irish Bilateral Network Award from the Royal Irish Academy. She has also been awarded an IMPACT Research Award from the University of Reading (2016) and a Large Grant Award from Arts Council Wales for a curatorial research project titled *Thin Place* (2015). She was one of the 2011 recipients of the Wales Arts International and Axis Critical Writing Award. Her research interests include developing strategies in writing, curating, and education for philosophy, poetry, literature, science, agriculture, and the visual arts to converge—that is, to explore new ways of "making room" for other ontologies. Her creative practice supports new dialogues between disciplines and facilitates more porous and heterodox ways of rethinking relationships with the world, especially in a time of climate change. Her bookworks are housed in numerous collections, including TATE Britain Artists' Book Collection, the V&A National Art Library, and many others.

Joanna Krotofil obtained her PhD from the Institute for the Study of Religions, Jagiellonian University. Currently, she is a principal investigator for the project "Religion, Mothering, and Identity among Young Mothers—Experiences of Catholic and Muslim Women in Poland." She has published on the relationship between identity, religion, and women in Islam and Catholicism and reproductive rights in Poland.

Clara Kundin is a theatremaker, educator, mother, and assistant professor of theatre at Eastern New Mexico University. She holds an MFA in theatre for youth and community from Arizona State University, a certificate in physical theatre from the École Jacques Lecoq, and a BA in theatre from St. Olaf College. Her research explores the intersection between theatre and learning disabilities, performances of motherhood, and new devising methods. Her work has been published by *Youth Theatre Journal, Journal of Performance as Research*, and Demeter Press.

Jill Marsden is a professor of literature and philosophy at the University of Bolton. She has written on feminism and the body in a range of different publications, including *Women's Philosophy Review, Women: A Cultural Review, Radical Philosophy, The Journal of the British Society for Phenomenology, Cyberpsychosis*, and *Gender in Flux*.

Dagmara Mętel is a psychologist and a PhD candidate at the Jagiellonian University Medical College, Krakow, Poland. Currently, she works as a researcher on the project "Religion, Mothering, and Identity among Young Mothers—Experiences of Catholic and Muslim Women in Poland." Her main research interests include the notion of space for mothers in the Catholic Church, both in a literal and a figurative sense.

Dorota Wójciak is a PhD candidate in studies in cultures and religions at the Jagiellonian University Doctoral School in the Humanities and a researcher in the project "Religion, Mothering, and Identity among Young Mothers—Experiences of Catholic and Muslim Women in Poland." The main subject of her scientific interest is contemporary Polish Catholicism. In her research, she focuses on the perspective of lay believers.

Deepest appreciation to
Demeter's monthly Donors

DEMETER

Daughters
Heather Olson Beal
Carole Trainor
Khin May Kyawt
Tatjana Takseva
Debbie Byrd
Tanya Cassidy
Myrel Chernick
Marcella Gemelli
Donna Lee, In Memory of Dee Stark, RN, LNHA,
Trailblazer for Women, Women's Rights Advocate
Catherine Cheleen-Mosqueda

Sisters
Fiona Green
Paul Chu
Amber Kinser
Nicole Willey

Mother
Mildred Bennett Walker (Trainor)

Grandmother
Tina Powell